LATER CHINESE PORCELAIN

The Faber Monographs on Pottery and Porcelain
Former Editors: W. B. HONEY and ARTHUR LANE
Present Editors: SIR HARRY GARNER and R. J. CHARLESTON

★

LATER CHINESE PORCELAIN

The Ch'ing Dynasty (1644-1912)

by

SOAME JENYNS

FABER AND FABER

3 Queen Square

London

First published in 1951
by Faber and Faber Limited
Second edition 1959
Third edition 1965
Fourth edition 1971
Reprinted 1977
Printed in Great Britain by
R. MacLehose and Company Limited
Printers to the University of Glasgow

ISBN 0 571 04761 0

To

CHARLES RUSSELL

who was one of the first to appreciate
Ch'ing porcelain in the Chinese taste.

FOREWORD

The history of European taste in Chinese porcelain deserves a book to itself, so much have action and re-action and the prevailing decorative styles affected taste and standards in the West. The later Chinese porcelain brought new to Europe in the late-seventeenth and eighteenth centuries was uncritically accepted, and when in the later-nineteenth century these wares began to be classified and more accurately dated, it was taken for granted that they were the finest porcelains ever made in China. That was, of course, all changed by the arrival in recent times of the wares of the earlier dynasties. The Ch'ing wares went out of fashion or were placed in a class by themselves as 'decorative porcelain', a term hardly of abuse, but one which splendour of colour had fully earned. More damaging to their reputation perhaps was the recognition that most of these wares were made specially for export and are not to be found in Chinese collections. Where, then, it was asked, were the wares in Chinese taste?

The great Chinese Exhibition of 1935–6 went a long way towards supplying the answer, while confirming the view that the popular *famille verte* and the rest were largely 'export wares'. A new discrimination was thenceforward called for, distinguishing from the latter the imperial and other wares in true Chinese taste.

It is to the identification and description and illustration of these wares that this book is chiefly devoted. Residence in China before his appointment to the British Museum gave Mr. Jenyns the advantage of familiarity with the imperial and other private collections rarely seen by Western eyes. No one is better fitted to expound this phase of Chinese taste, comprising as it does such diverse elements as the fantastic elaboration of the revolving openwork vases and the 'foreign novelties' made for Ch'ien Lung, as well as the most exquisite poetry of naturalism.

W. B. HONEY

CONTENTS

ILLUSTRATIONS

COLOUR PLATES

MONOCHROME PLATES
After page 112

PREFACE TO THE FOURTH EDITION

In the Preface to the third edition of *Later Chinese Porcelain*, written in 1965, Mr. W. W. Winkworth has summarised the outstanding problems in the study of the porcelain of the Ch'ing dynasty and has pointed out the special difficulties of the subject. He rightly says that Ch'ing porcelains are far more difficult than Ming. The main reason is that in the Ch'ing dynasty there existed, side by side, porcelain made in the Chinese taste, little of which was known in the west before the present century and an entirely different class of porcelain made for export. The latter varied greatly in quality, from cheap porcelain such as dinner and tea services made for daily use to vases of the highest quality, to which European owners added elaborate ormolu mounts which today are more highly prized than the porcelain itself. The essential difference between the two classes of porcelain was not one of quality—we find, for example, that the best of the exported *famille rose* eggshell porcelains are as fine as those made for the court—but of style. The dishes with simple sprays of prunus or magnolia, often inscribed with short poems, such as those illustrated in Plates LXXXII and LXXXIII, were made exclusively for the court and would have appealed, even in China, only to a limited group of highly cultured connoisseurs. They would not have appealed at all, even if they had been available, to European buyers. The brilliantly decorated *famille verte* and *famille rose* in the Pierpont Morgan and Salting Collections, overdecorated to Chinese taste, belong to a different world.

The two different classes of porcelain, with their widely different styles, must however have greatly influenced each other. They were made in the same city, Ching-tê Chên, and no doubt were often decorated in the same workshops. The techniques in enamelling appear to be identical. But the problem of co-ordinating them is a really formidable one and no writer up to the present has attempted this fully. The classical early writers on the later Chinese porcelain, Hobson and Honey, had little need, or even opportunity, to face the problem. The material available hardly included any of the porcelain

in the Chinese taste that first became familiar to the west from the pieces in the Chinese Imperial Collection shown at Burlington House in 1935 and those in the Percival David Collection. It is true that Hobson did, late in life, study some of the later pieces in Chinese taste, such as the so-called 'cloisonné porcelain', but his major work, written in 1925, was devoted almost entirely to the export wares. As for Honey, his *Guide to the later Chinese porcelain* is virtually a monograph on the Salting Collection.

Mr. Jenyns took a bold step, when asked to write his book on the later Chinese porcelain, by deciding to concentrate on porcelain in the Chinese taste. The book thus differs essentially from its predecessors and it is in fact the only major western work dealing at length with the imperial porcelain factories at Ching-tê Chên and the imperially appointed directors there, of whom the most famous was T'ang Ying.* A few vases decorated with landscapes in *famille rose* with poems composed by him have been handed down and some are illustrated in this book. On the other hand, the splendid large vases decorated with green, yellow, aubergine and black enamels on the biscuit hardly appear and the author is spared the formidable problem of sorting out the genuine pieces in this group, rather few in number, from the many copies made in the late nineteenth and early twentieth centuries, some of which still adorn the show cases of the Salting and other famous collections. This problem will have to be tackled sooner or later, but it lies somewhat outside the ambit of this book.

A special problem, to which Mr. Jenyns refers in his preface to the third edition, one of the most fascinating in the history of Ch'ing porcelain, is the origins of *famille rose*, or what the Chinese call 'foreign colours'. That these enamels were introduced from the west in the first place through enamels on copper and not on porcelain is beyond question. But the exact date at which the new enamels, in which the dominant colour is the rose-pink derived from gold, were first made is still a matter for controversy. My own studies have led to a date not earlier than the end of the K'ang-hsi period and to a date some five or ten years later before the brilliant *famille rose* we regard as typical was fully developed. As my views conflict with those of others and in particular with those of Mr. Jenyns I am not the right person to be asked to give an unbiassed view of the problem here. The important point to stress is that the disagreement in dates is of not more than ten years, say from about 1715 to 1723, for the date of introduction of *famille rose*. But this gap is critical because it spans

* But reference should be made to the *Introduction to the Catalogue of the Ch'ing enamelled wares of the Percival David Foundation of Chinese Art*, by Lady David, 1958.

the date at which the reign of K'ang-hsi ends and therefore affects the authenticity of some pieces with the K'ang-hsi mark. There are some experts, and particularly those in the Chinese National Palace Museum, Taiwan, who accept bowls such as those in Plates XXXIV and XXXV, 2 as belonging to the period, while others do not. There is no doubt that further study is needed to resolve the problem, in which the evidence from the export wares, and particularly the armorials, which can be precisely dated, Chinese enamels on copper made in Peking and the imperial porcelain wares themselves, as well as the contemporary literature, Chinese and European, must all be taken into account.

Mr. Winkworth has expressed some concern at the lack of interest among western art critics in Chinese art of the seventeenth and eighteenth centuries, although Chinese connoisseurs hold many of the paintings of these two centuries in very high regard. The Ch'ing decorative arts, and especially Ch'ing ceramics, suffer a good deal from the existence of the two conflicting groups already mentioned. Collectors tend to concentrate their interest on the one hand solely on the export wares, with their enormous influence on the art of contemporary Europe, or on the other hand on the pieces in Chinese taste, which requires a special connoisseurship. No pieces in the former group are to be found in the imperial collections of Taiwan or Peking, and few of the latter in the great Ch'ing collections built up in the early years of the present century. The gap must be closed before a full appreciation of Ch'ing porcelain as a whole is achieved and Mr. Jenyns' book provides the framework on which future work must be based.

In this, the fourth edition, a few corrections have been made and two new colour plates have been added to make the plates more representative of the whole field of Ch'ing ceramics. The first is a fine vase of the K'ang Hsi period decorated with enamels on the biscuit, the growing plants being decorated in green, aubergine, black and white enamels on a yellow ground (Colour Plate C). The second is a *famille rose* vase and cover, important not only for its fine quality but also because it has good claims to belong to the Yung-chêng period and so to be one of the early examples in the *famille rose* technique (colour Plate F).

HARRY M. GARNER

PREFACE TO THE THIRD EDITION

As compared with the volume on Ming porcelain which preceded it, the present attempt to deal with later Chinese wares must be judged by other standards; the mere quantity of objects to be considered is enormously greater, and the types of object involved are far more various. Strange as it may appear, Ming is easy compared with the later periods. Problems in the later periods have been less studied by specialists in Chinese ceramics during recent years, and the reasons for this are at once obvious: for after Ming a new factor appears; there were direct Western contacts, and these changed the whole situation, but increasing specialisation has abolished the type of student who is competent to deal with that situation.

It is not claimed that the present work has finally solved any of the outstanding problems. It will, however, be useful to explain here what some of them are. Western contact produced the 'foreign colours' which predominated after K'ang Hsi. But how early did they start? To what extent were they used before K'ang Hsi ended? And what was their relation to the 'Imperial Porcelain' of late K'ang Hsi and after? These problems await solution.

All problems connected with the 'Foreign Colours' depend on a type of scholarship which is fast disappearing, and never perhaps really became firmly established. Its last exponent was the late R. L. Hobson of the British Museum. He became keeper after the First World War, of a new department, now extinct, called 'Ceramics and Ethnography'. It included not only all ceramics, Eastern and Western, but also glass, Roman, Islamic, medieval and Venetian; and also of course Chinese glass and enamels on metal. It thus comprised the whole corpus of the 'arts du feu'. W. B. Honey, of the Victoria and Albert Museum, and his successor Arthur Lane, both now dead, continued the tradition. Meanwhile, the new British Museum Department of Oriental Antiquities had eliminated the independent study of ceramic and glass history and technique as such. Study was to proceed, and still proceeds, both in England and America, along linguistic and nationalistic lines.

But in order to understand the Ch'ing wares a much more general approach is needed. Far Eastern ceramics were inextricably involved with Europe, and not only Europe but the near East, and later, America. It may happen that dates have to be established by a knowledge of European heraldry, or by marks on silver mounts. A wide acquaintance with European art, its history, its subjects, the prints from which Chinese designs were derived, becomes necessary. It can happen, and has happened, that uncertainty exists as to whether a given object is Chinese porcelain or European; and this is not only a question of recent forgeries. The art of enamelling on metal was closely connected, in China, as also in the West, with other uses of enamel colours both on porcelain and on glass. To unravel the problems that arise in this way, it may be useful to have a knowledge of literary Chinese, but much more is needed.

It is in this period, too, that Japan comes into the picture. Is Shonzui porcelain to be considered as Chinese or Japanese, whatever its actual place of manufacture? Can one really understand it without a close acquaintance with the whole history of Japanese ceramics, down to the time of Zengoro Hozen in the mid-19th century? What is the connection between Frankfurt Delft, Chinese transitional blue and white, and early Imari? To what extent, if any, was Japanese porcelain influenced by Chinese, or may the influence have varied, sometimes one way, sometimes the other?

Apart from the international problems, those that are purely Chinese are hardly less numerous and interesting. The Ch'ing dynasty was a time when the masterpieces of Sung and Ming had already become classics. For the first time an intelligent and systematic archaism was possible; the Imperial collections had already begun to be formed, and a body of authentic early specimens was available for study and emulation. Only thirty years ago, Chinese and Western experts differed about a particular monochrome now in the David Foundation. Its actual date was only revealed when a mark of the Yung Chêng period was found, concealed by another mark incised in the glaze. Instances could be multiplied of cases in which confusion has occurred between later wares in early styles and their originals. In former times, numerous large private collections existed, chiefly in Europe, but also in the United States. This made connoisseurship easier, and there were formerly numbers of private collectors who could meet and compare notes without troubling about invidious questions of commercial value or professional status. In this way, a body of accepted values was built up by disinterested art-lovers, many of whom like the late A. L. Hetherington were by no means rich men. There were even, in that golden age, Museum authorities like the

late Margret de Vasselot and Nanne Ottema who were collectors as well as officials. The British Museum collections were founded by another of these devoted but not necessarily opulent enthusiasts, Sir Augustus W. Franks, who is known to have complained bitterly at having to give £60 for the K'ang Hsi hawthorn vase with a green ground, now at Bloomsbury; and, perhaps the last of these Founding Fathers, Sir Percival David has just left us.

One of the charms of the later periods is that there is still room for the modest collector. No one could now build up another Eumorfopoulos or David collection. But several collectors in recent years have materially advanced our knowledge by intelligent choice and study, notably, in England, Mr. P. J. Donnelly, for his Fukien, Sir Harry Garner, and Mr. G. Reitlinger, to name only a few. There are indeed many small collections, in the Home Counties of England alone, of which one may say that their value depends on the knowledge and taste of their owner rather than on his purse.

There are thus many people who have a knowledge and appreciation of old porcelain and pottery. But few are in a position to write about it. Many do, it is true; but unprofessional research is a vocation which is not possible for most people even after the age of retirement, and still less before; and public bodies can hardly be expected to help. Archaeology has long commanded a certain respect, even some endowment. But what impresses committees is excavation; even the best conducted historical research comes second; and it is even more difficult to imagine serious encouragement being given to those arts of appreciation and connoisseurship without which any artistic subject is empty and meaningless, but which are too intangible, too difficult to assess, by the business standards which are increasingly invading cultural subjects.

'Am I to understand we are paying Mr. Smith this annual sum for—er—let me see—cultivating the appreciation of old China? Can this Faculty really afford a Reader in connoisseurship?'

None the less, it was largely by an application of the methods of the connoisseur—comparison and appreciation—that the late Bernard Rackham laid the foundations of our present knowledge of English china; and it was largely by patient discussion with collectors that Hobson built up his deserved reputation as an authority on Chinese ceramics. Both had the advantage of very rich and mixed collections to help them. They were not compelled to rely on literature; indeed, at that time there was only a minimum. Theirs was a task of careful sorting and grouping with hardly any help from science or texts.

What corresponds, in this field, to the excavated site or the classified study-material of the historian, is the vast mass of potential evidence

to be found in old country houses, in private collections, in the widely scattered palaces and mansions of previous princely owners, and in shops and sale-rooms—sale catalogues, which are among the recognised tools of the art expert, are in this field still not usually helpful; engraving and photography was seldom in the past applied to ceramic objects as it was to pictures. To interpret the brief entries in the older inventories is a fascinating but seldom fruitful task. In the case of a multiple product like ceramics, which at quite an early date in the Far East was already more or less mass-produced and on a vast scale, any systematic study such as has been devoted to Greek vases is impossible; and there are those who would dismiss it as a waste of time. The Ch'ing dynasty, to judge by the reactions of the press during last year's Exhibition, has very little prestige-value at the moment. More informed opinion has recently come round to a more favourable view; but the general educated public still regards the seventeenth and eighteenth centuries as a decadent period. In China the paintings of these later periods has never ceased to be admired by advanced opinion. In literature, Dr. A. D. Waley has revealed a new world to us in his translations and biography of Yüan Mei, the great poet of the Ch'ien Lung period, has enabled us to see such a man as T'ang Ying in a fresh perspective. But it must be confessed that most people are still in the stage which art-history had arrived at in the mid-Victorian days, when Tiepolo was disparaged, El Greco was hardly known, and the eighteenth century was seen through the eyes of Macaulay. The splendours of T'ang are impressive even to a beginner; Sung has been invested with the spiritual values of Zen; but after that a decline is felt to come. No attempt will be made in the following pages to reverse these tendencies of popular opinion; that would require a different type of book. Ultimately, an impartial attitude is always useful in any study which is even partly historical. The aim of the following pages will be to put the evidence, historical and artistic, before the reader, and to allow him to draw his own conclusions.

W. W. WINKWORTH

INTRODUCTION

When Mr. Honey approached me with the suggestion that I should contribute to this series, of which he is the editor, the volume on the porcelains of the Ch'ing dynasty, my first reaction was to refuse. The field I felt had been covered already so happily and exhaustively by the works of my late chief R. L. Hobson and by the books of Mr. Honey himself. But as the process of reassessment is always silently at work, time gradually impairs in turn the value of each standard book on ceramics. A shift of emphasis, a change of date or provenance in the light of new information, may alter the whole surrounding scenery. In the world of scholarship to give and take criticism is all part of the day's work, and each of us in our turn may legitimately criticize our predecessors without being guilty of presumption, so long as we can look forward without rancour to being criticized in our turn by our successors, when our day is past. This is the inevitable destiny of all critics. But the author who is surpassed is not necessarily superseded. If the touchstone of his criticism proves his true metal he has added, like Hobson,*[1] one or more links to the golden chain, which long after his intervention is forgotten stands as his contribution to the subject. It is in this spirit, and with this excuse, that I have accepted Mr. Honey's invitation.

One of the problems of any author who works in the field of Chinese ceramics is to avoid raising the dust storms of controversy, without which any book is in danger of becoming dull, but which are peculiarly disagreeable when they wound collectors' susceptibilities or professional reputations. The real test of such a writer's ability is the imaginative quality and sensibility of his attributions, although he may be sometimes mistaken. Even Hobson was not infallible.[2] I can only plead the indulgence of my readers on this score.

In the study of Chinese porcelain the student is handicapped without some personal acquaintanceship with the country and some knowledge of the language. But it would be absurd to suggest that the ability to winnow fact from fiction in Chinese texts, of which the meaning is usually both allusive and ambiguous, is alone an adequate

* For textual footnotes, see ends of chapters. Notes on the introduction are at the end of chapter one.

equipment. Unhappy translators would be wise to remember Vignier's satiric remark—'it is a magic feat for a European to be able to translate Chinese; it would be a miracle if any two translations of the same text were to agree.' Without the discerning eye little can be accomplished by the greatest sinologues. As Honey gracefully puts it[3] 'This appreciation of beauty is in its essence a simple thing, direct and not dependent upon reasoning or even knowledge, scientific or other. It depends upon what Vignier called after Don Quixote "l'amoureux choix . . . ce discernement exquis, cette sensibilité quasi-infaillible" which govern the taste of the gifted amateur. Such discernment may reach the truth where the laborious analysis of the Teutonic method must always fail'. My ambition has been to help in a small way—in another of Vignier's felicitous phrases—'to break up by degrees the *terra incognita*, clearing away the brushwood of archaeology and enlarging the flower garden of aesthetics.' Not that we can afford to undervalue the labours of the archaeologist. In the whole field of Chinese art, apart from literary evidence, our chief hope lies in excavation.

The hasty and furtive nature under which most of the material which reached this country in the past from China had been excavated has been most unfortunate. For the Chinese dealer has so often either refused to impart the information, which he might have been able to acquire, for fear of retribution, or has produced a falsified or inaccurate version. But even excavation *in situ*, when the ground or strata have been disturbed, is not always conclusive evidence, and many of our conclusions derived from excavated material are still hypotheses awaiting scientific confirmation. Yet the scientist's habit of generalizing from laboratory experiments as carried out on a series of carefully selected specimens brings its own dangers. It is safer to argue from the observation of the eyes carried out on a large number of specimens over a long period of time.

The history of Ch'ing porcelain is in effect the history of the town of Ching-tê Chên, which in turn was dominated by the presence of the imperial porcelain factory which was situated there. Over 80 per cent of the porcelains of China during the Ch'ing period were made at this great ceramic metropolis in Kiangsi, or in its immediate neighbourhood; the provincial porcelain factories, with the single exception of Tê-hua in Fukien, producing porcelain of poor quality and negligible importance during this period. It has not been sufficiently emphasized that all the best ceramic productions of the imperial factory during the Ch'ing dynasty were made between 1683 and 1750—a period of slightly over seventy years—when the imperial workshops were under the care of three famous directors, Ts'ang Ying-hsüan, Nien Hsi-yao, and T'ang Ying. In the light of these circumstances I have

2

attempted a slightly different approach from that of my predecessors to this subject, by considering the porcelains not under the reign mark of the various Ch'ing emperors but as far as possible under terms of office of the three directors of the imperial factory. The Chinese themselves speak of certain porcelain as Ts'ang Yao, Nien Yao and T'ang Yao, and I have endeavoured to develop this theme.[4] But it must be understood that the Chinese porcelain which reached this country in the eighteenth century and in the early years of the nineteenth century was not the work of the imperial kilns. Our ancestors who visited China were merchants and were easily fobbed off with the porcelains which the Chinese offered them, while the Chinese preferred to keep their classic porcelains to themselves and have only parted with them in recent times from necessity. It is probably not until the reign of Chia Ch'ing (1796–1821) that any of the work of the great directors leaked out of the palace into Chinese markets, although no doubt some pieces were given away from time to time as imperial presents, and it was not until after the looting of the Yuan Ming Yuan in 1860 and the collapse of the dynasty ruined the old Manchu families that these pieces began to appear in Western collections.

The three chapters devoted to the three directors are preceded by some account of the porcelain produced during the period of transition between the fall of the Ming and the reorganization of the imperial kilns by Ts'ang Ying-hsüan in 1683.[5] The book ends with two other chapters; the first of these gives a brief description of the porcelain made in the Ch'ien Lung period after the departure of T'ang Ying up to the collapse of the dynasty in 1912; while the second gives an inadequate account of the problem arising from the provincial porcelains.

In my choice of illustrations I must plead further unorthodoxy. For I have omitted the well-known representatives of the *famille verte, famille noire, famille jaune* and *famille rose* and the more conventional types of underglaze blue, and I have only touched on the porcelain made for export, omitting all illustrations of the armorial dinner services made for Europe, and exported through the East Indian Companies. Instead of reproducing these old favourites I have searched for little-known examples of the Ch'ing wares. I have also attempted to eliminate the same old faces from public collections.[6] If I have not always succeeded it is because it has not always been feasible to debate the date of many interesting pieces in private hands.[7] Not unnaturally private collectors are apt to take offence if the critic suggests that one of their favourite Ch'êng Hua or Hsüan Tê pieces may after all be only an eighteenth-century copy!

3

In this context I hope that the shade of Mr. Harry Oppenheim will forgive certain suggestions I have put forward, as to the date of a few of the pieces of the magnificent collection, which he bequeathed to the British Museum, and which is the most important acquisition of Chinese ceramics the Department of Oriental Antiquities has received since the war.

In particular I have tried to emphasize in my illustrations—:

(*a*) Porcelain decorated in Chinese taste, the decoration of which is more subtle in its reticence, delicacy and suggestiveness than the heavy borders and florid enamels of the pieces made for the European market. Only a small proportion of these pieces has reached European collections and they are still insufficiently appreciated.

(*b*) Porcelain, however humble or provincial, carrying a cyclical year mark, which dates the piece to a given year, and as a result is of documentary importance. These year marks are not always reliable.

(*c*) Ch'ing copies of the earlier periods, particularly the reigns of Hsüan Tê and Ch'êng Hua of the Ming period and the monochromes of the Sung period. Many of these copies are easy to confuse, and are still confused, with their originals.

(*d*) Chinese porcelain with dated or datable European mounts, or with the mark of the Dresden Collection, brought together by Augustus the Strong, King of Poland and Elector of Saxony, roughly between 1694 and 1715. It is unfortunate that the mark is not difficult to imitate and has been forged. It is tragic that this magnificent collection has apparently been dispersed or destroyed, as it was for the student the best documented collection in Europe of the porcelain of the K'ang Hsi period exported to the West. Its importance does not seem to have been realized in Germany as no adequate pictorial record remains.

I have only reproduced a small selection of the monochrome porcelains, whose vitality of shape and fine colour and excellent potting—particularly during the reigns of K'ang Hsi and Yung Chêng—are admirable. Unfortunately they cannot be effectively presented except in colour. They too have never been sufficiently prized in Europe.

The porcelains of the Ch'ing dynasty were admired and collected by a previous generation. To-day they have fallen sadly in popular esteem. The pottery and stoneware of the Han, T'ang and Sung dynasties have replaced them in the favours of a critical public, while the belief that the wares of the Ming period were inferior to them in aesthetic attraction has been completely reversed. This loss of favour bids to be as ill balanced as the previous fascination exercised by the enormous *famille noire* vases of the K'ang Hsi period, or the decora-

tive *famille rose* models of birds of the Ch'ien Lung period, which still fetch prices out of all proportion to their interest or aesthetic qualities.

Whoever has the permission, patience and energy to dig into the kiln heaps of Ching-tê Chên may still make discoveries, which may establish a more correct chronology of the Ch'ing wares. If it is ever possible to excavate scientifically the site of the old imperial factory on Jewel Hill it may be possible to distinguish many of the Palace wares from those of the private kilns in the same neighbourhood. Anyone again who is prepared to spend the time and the labour and obtain the co-operation of the Chinese authorities might attempt to list the private factories of Ching-tê Chên and identify some of their output. The provenance and kiln sites of most of the provincial porcelains still remain almost completely unexplored.

The account books of the imperial factory, if they still exist, must one day reveal a continuous series of lists of pieces either made for the Palace or by imperial order and recorded on their dispatch to Peking. The local annals must still contain information on the history, organization, and administration of both the imperial factories and of many private kilns, many of whom accepted imperial orders for some particular ware for which they were celebrated.

The names of the majority of the directors of the imperial factory are still unknown—at least to Europeans—but however undistinguished they must have been recorded. In fact the whole investigation of both Japanese and Chinese ceramic literature[8] on Ching-tê Chên is far from complete. In other directions the study of shape, body, glaze, decoration and the calligraphy of the *nien hao*, and the work of the scientist in the laboratory will all in their various ways continue to contribute to our knowledge, although too exclusive a devotion to any single aspect would probably mislead us.

1

THE LETTERS OF
PÈRE D'ENTRECOLLES
FROM CHING-TÊ CHÊN

There exist two letters which present a contemporary account of an eye witness of the kilns at Ching-tê Chên during the K'ang Hsi period. These letters give a general picture of the factories during twenty years of the eighteenth century through European eyes, and any account of the porcelains of the period is incomplete without a knowledge of them.[9] These invaluable descriptions were written by the Jesuit missionary *Père* D'Entrecolles[10] to *Père* Orry, *procureur* in Paris of the Chinese and Indian missions. They were dated 1st September, 1712, and 25th January, 1722. No account of equal importance has come to light from Chinese sources. He provides a complete and vivid picture of the kilns. Beginning with the composition of the porcelain he describes how and when the petuntse rock is quarried and crushed; and how it is ground and washed before the 'cream' is skimmed off and pressed into blocks for use. He tells us how the kaolin clay is mined and prepared; and that it is mixed with a preparation of lime and bracken ashes to form the glaze. He explains the enormous labour required to knead the clay by treading, lamenting that 'those Christians who are employed at it find it difficult to attend church; they are only allowed to go if they offer substitutes, because as soon as the work is interrupted all the other workmen are stopped.'[11] His letters reveal to us the highly organized mass production of the porcelain factories. 'They tell me', he says, 'that a piece of porcelain . . . has passed through the hands of seventy workmen, and I can well believe it, from what I myself have seen, as their huge workshops have been to me a kind of Areopagus, when I have proclaimed Him, who fashioned the first man out of clay, and from whose hands we proceed to become vessels, either of glory or of shame.'[12] He tells us of the moulds which were used, and of the way in which the painters were graded. He has a poor opinion of these decorators. 'These porcelain painters are not less poor and wretched than the other workmen, which is not surprising when we remember that in Europe they would only pass for apprentices of a few months'

6

standing. All the science of these painters, and indeed of Chinese painters in general, is based on no principles and only consists of a certain routine helped by a limited turn of imagination. They know nothing of the beautiful rules of their art; though it must be acknowledged that they paint flowers, animals, and landscapes which are much admired, on porcelain as well as on fans and lanterns of the finest gauze. The painting is distributed in the same workshop among a great number of workmen. One workman does nothing but draw the first colour line beneath the rims of the pieces; another traces flowers, which a third one paints; this man is painting water and mountains, and that one either birds or other animals. Human figures are generally treated the worst.'[13] Elsewhere we learn that prototypes were made, large pieces by one good painter and small ones by another, which, if satisfactory, were issued as models to the other painters. The *T'ao Yeh T'ou Shou* (a series of pictures illustrating the manufacture of porcelain, with an explanatory text by T'ang Ying, published soon after 1743 on the instructions of the Emperor Ch'ien Lung)[14] gives us the same picture of mass production. 'The different kinds of round ware painted in blue, are each numbered by the hundred and thousand, and if the painted decoration upon every piece is not exactly alike, the set will be irregular and spoiled. For this reason the men who sketch the outlines learn sketching, but not painting; those who paint study only painting, not sketching; by this means their hands acquire skill in their own particular branch of work, and their minds are not distracted. In order to secure a certain uniformity in their work the sketchers and painters, although kept distinct, occupy the same house. As to other branches of work—embossing, engraving, and carving in openwork—they are treated in the same way and each is intrusted to its own special workmen. The branch of decorating in underglaze red, although really distinct, is allied to that of painting. With regard to the rings round the borders of the pieces and the encircling blue bands, these are executed by the workmen who finish the pieces on the polishing wheel; while the marks on the foot underneath, and the written inscriptions, are the work of the writers who attach the seals. For painting flowers, birds, fishes or water plants, and living objects generally, the study of Nature is the first requisite; in the imitation of *Ming* dynasty porcelain and of ancient pieces the sight of many specimens brings skill. The art of painting in blue differs widely from that of decoration in enamel colours. . . . In the decoration of porcelain correct canons of art should be followed; the design should be taken from the patterns of old brocades and embroidery, the colours from a garden as seen in springtime from a pavilion. There is abundance of specimens

7

of the *Kuan, Ko, Ju, Ting and Chun* (wares of the *Sung* dynasty) at hand to be copied.' Elsewhere speaking of the vases decorated in foreign colouring T'ang Ying writes: 'Clever artists of proved skill are selected to paint the decoration. The different materials of the colours having been previously finely ground and properly combined, the artist first paints with them upon a slab of white porcelain, which is fired to test the properties of the colours and the length of firing they require. He is gradually promoted from coarse work to fine and acquires skill by constant practice; a good eye, an attentive mind, and an exact hand being required to attain excellence.'[15]

Returning to *Père* d'Entrecolles, he explains to us how the enamel colours are compounded, united with gum and water and applied to the paste. The perforated and the crackled wares, the use of gold, the transparent painting of fish, nothing escapes him. Even the stacking of seggars in the kiln before firing is described by a carefully drawn plan. Next he dwells on the hazards of the enterprise, the virtuosity of the designers, and the difficulty of pleasing European merchants.

'Some one hundred and eighty loads of pine fuel (of a hundred and thirty-three pounds weight each)', he says, 'are consumed at every firing, and it is surprising that no ashes even are left. It is not surprising that porcelain is so dear in Europe, for, apart from the large gains of the European merchants, and of their Chinese agents, it is rare for a furnace to succeed completely; often everything is lost, and on opening it the porcelain and the cases will be found converted into a solid mass as hard as rock. Moreover, the porcelain that is exported to Europe is fashioned almost always after new models, often of *bizarre* character, and difficult to reproduce; for the least fault they are refused, and remain in the hands of the potters, because they are not in the taste of the Chinese and cannot be sold to them. Some of the elaborate designs sent are quite impracticable, although they may produce for themselves some things which astonish strangers, who will not believe in their possibility.

'I will give some examples of these. I have seen here a large porcelain lantern made in one piece, through the sides of which shone a candle, placed inside, so as to light a whole room; this work was ordered seven or eight years ago by the heir-apparent.[16] The same prince ordered, at the same time, various musical instruments, and among others a kind of little mouth-organ called *tsêng*, which is about a foot high, composed of fourteen pipes, and the melody of which is pleasing enough; but every attempt at making this failed. They succeeded better with flutes and flageolets, and with another instrument called *yun-lo*, which is composed of a set of little round and slightly concave plaques, each of which has its different note; nine of

these are hung in three tiers in a square frame, and played upon with rods, like the tympanum; a little chime is produced to accompany the sound of other instruments, or the voice of singers. It required, they tell me, many trials before they succeeded in finding the proper thickness and density to produce correctly all the notes of the scale. I imagined myself that they had the secret of inserting a little metal in the body of the porcelain, to vary the notes; but have been undeceived, for metal is so ill adapted to combine with porcelain that if a copper 'cash' happened to be put upon the top of a pile of porcelain in the kiln, the coin as it melted would pierce all the cases and porcelain in the column, so that a hole would be found in the middle of every one. To return to the rarer works, the Chinese succeed best in grotesques, and in the representation of animals. The workmen make ducks and tortoises which will swim in water. I have seen a cat painted after life, in the head of which a little lamp had been put to illuminate the eyes,[17] and was assured that in the night the rats were terrified by it. They make here too very many statuettes of Kuan-yin, a goddess celebrated throughout all China, represented holding an infant in her arms, and worshipped by sterile women who wish to have children.[18] . . .

. . . 'European merchants demand sometimes from the Chinese workmen porcelain slabs, to form in one piece the top of a table or bench, or frames for pictures. These works are impossible; the broadest and longest slabs made are only a foot across or thereabouts, and if one goes beyond, whatever may be the thickness, it will be warped in baking. The extra thickness does not facilitate the work, rather the contrary; and this is why the native slabs, instead of being made thick, are formed of two faces, with a hollow interior, traversed by a solid cross-piece; these slabs, used for inlaying carpentry, have two holes pierced at either end, so that they may be inserted in a bed, or in the back of a chair, when they look very effective.

'The mandarins, who know the genius of Europeans for inventions, often ask me to have brought from Europe novel and curious designs, in order that they may present to the emperor something unique. On the other hand, the Christians press me strongly not to get any such models, for the mandarins are not so easy to be convinced as our merchants, when the workmen tell them that a task is impracticable; and the bastinado is liberally administered before the mandarin will abandon a design which may bring him, he hopes, great profit.'[19]

The manufacture of pottery at Ching-tê Chên is said to date back to the Han dynasty, according to local annals. But it was not until the Sung dynasty that officials were appointed to superintend the manufacture and to send supplies at regular intervals to the imperial Court.[20]

'Ching-tê-chên is in the province of Kiangsi, on the south of the

great Yangtze River. . . . situated about four miles below Fou-liang, on the opposite side of the [Ch'ang] river, and is under its jurisdiction, although the mandarin in immediate charge is appointed from Jao-chou, with the rank of *T'ung-chih*, or sub-prefect. There is another official in charge of the imperial manufactory, who is usually deputed from the imperial household (Nei Wu Fu) at Peking, and who is at the same time commissioner of the important customs station at Kiukiang, established near the point where the Poyang Lake communicates with the Yangtze. The funds for the porcelain works are directed to be taken from the customs-chest. The commissioner forwards the porcelain by boats to Peking, which go down the Yangtze River to Chinkiang, and thence up the Grand Canal to Tien-tsin. At the junction of the Grand Canal with the Yellow River there is another large customs barrier, with an imperial commissioner, stationed at Huai-an-fu, who used formerly to be *ex-officio* superintendent of the porcelain works and privileged to find the funds. . . . To the south of the Poyang Lake, twenty miles distant by river, is the large city of Nan-ch'ang-fu, the capital of the province of Kiangsi, which is full of porcelain shops, its principal staple being the porcelain of Ching-tê-chên, which it distributes to all parts of the south of China. The trade route to Canton passes this city, and large quantities are conveyed thither, consisting partly of finished pieces, partly of plain white porcelain, which has to be decorated in enamel colours by the Cantonese artist before it is finally exported. The journey is made by water with the exception of a day's portage across the Mei-ling pass. . . . Fou-liang is situated in a hilly country surrounded by mountains of graphitic granite, from the gradual decomposition of which the kaolinic deposits have been formed. . . . The river runs down a rocky gorge till it reaches Ching-tê-chên, where there is a tract of open country about two miles in length and breadth, bounded on the north and west by the river, which makes a wide curve, on the south by a smaller stream flowing from the west to join the river, and on the east by the Ma-an Shan or "Saddle-back Mountains". These hills supply the red clay for the seggars and for the reproduction of antiques with coloured bodies. Across the south river is the hamlet of Hu-t'ien-shih, with a pagoda and the ruins of ancient potteries of the *Sung* dynasty. A quantity of potsherds of ancient porcelain were collected from these ruins in the eighteenth century and used as models for monochrome glazes. . . . Within the angle of junction of the two rivers there is an open space of waste ground known as Hsi-kua Chou, or "Watermelon Island", which forms a market-place where the porcelain pedlars display their stalls. The rest of the space is densely packed with streets of shops, temples, and guild-houses, the intervals being filled with the

10

kilns and workshops. There is a good general map of the place given in the *Ching-tê-chên T'ao lu,* as well as a bird's-eye view of the Yü ch'i ch'ang, the imperial manufactory.'[21]

The number of kilns at Ching-tê Chên in the eighteenth century is not known. D'Entrecolles speaks of three thousand kilns but it is unlikely he meant to be taken literally. Each kiln seems to have had its speciality; but all were willing to make wares to order to whatever pattern happened to be in demand at the time. There were many small kilns which appear to have been family affairs and probably sent goods regularly into Ching-tê Chên to be sold at the porcelain market. Outside the city Brankston speaks of hundreds of kiln sites.[22] A full twenty of these private kilns seem to have enjoyed a regular supply of imperial orders.

The Yü Yao Ch'ang (the imperial kiln) also called the Yü Ch'i Ch'ang was founded on the south side of the Jewel or Pearl Hill in Ching-tê Chên either in the second year of the reign of the Ming Emperor Hung Wu (1369) or in 1398—'in order that Imperial wares might be in larger numbers and of finer quality. At a later period the factory was increased in size until its circumference was about five *li* (nearly two miles).'[23] The site is well known to the potters of Ching-tê Chên to-day, and when a new road was cut through some of the kiln waste potters were eager to find Yung Lo, Hsüan Tê and Ch'êng Hua pieces in order to copy their marks and glazes. Brankston records that 'unless a trial pit were dug, it would be most difficult to estimate the depth of debris and kiln waste or where the town of Ching-tê Chên is built. Pearl Hill is not a very prominent landmark at present and it may be that the habitation level has risen considerably in that area.'[24] The inhabitants do not seem to have welcomed the imperial venture as the annals run, 'Tuan T'ing-kuei, style Pao-ch'i, a native of Ch'ing-ch'üan, who was sent by the Emperor *Hung-wu* with the rank of Secretary of the Board of Works, to superintend the porcelain manufacture built the *yamên* on the south side of Jewel Hill, in spite of the vigorous protests of the natives of Ching-tê Chên, who objected to being called upon to do any work outside their own industry.'[25] Their objection is not surprising since the imperial kiln was run on conscript labour until 1680, when a Board of Commissioners put an end to the enforced recruiting of local labour and paid a rate for the work. From this time onwards some of the labour seems to have been recruited in Fukien. The most irksome work of all must have been the production of the enormous imperial fish bowls which are said to have occupied a whole kiln to themselves and to have taken nineteen days to fire. The Emperor Hsuan Tê reduced the number of the kilns devoted to these pieces, and after the reign of Chia Ching they went out of use. They were revived

11

again by T'ang Ying, who tells us that the last of these dragon bowl kilns fell down in the reign of Ch'ien Lung.

At all times articles made in the imperial factory which were not considered by the superintendent to be of sufficient quality for dispatch to the Palace were sold to the dealers as trade porcelain; while anything made by the private kilns of unusual quality or workmanship was liable to be requisitioned for the imperial use. 'After the porcelain has been taken out of the furnace it is arranged into four separate classes, which are known by the names of "first-class colour", "second-class colour", "third-class colour", and "inferior ware", and the price is fixed accordingly at a high or low rate. The porcelain of "third-class colour" and the "inferior ware" are kept back for local sale. The round ware of "first-class colour" and the vases and sacrificial vessels of the "first and second class" are all wrapped up in paper and packed in round cases. ... With regard to the round ware of "second-class colour", the dishes and bowls are tied together in bundles, each composed of ten pieces, which are wrapped round with straw and packed in round cases, for convenience of carriage to distant parts. The coarser porcelain intended for ordinary use, which is distributed throughout the different provinces is not packed in cases with straw, but only tied up in bundles with reeds and matting.'[26]

It was not until the reign of Chêng Tê that the phrase "palace ware factories" occurs. In the same reign the imperial factory was burnt down and a eunuch sent to rebuild it on its present lines. The appointment of eunuchs as superintendents was discontinued subsequent to 1522, and assistant prefects of the circuit were ordered to officiate in annual rotation. In 1565 an Assistant Prefect was appointed to reside at the kilns, but the plan never seems to have been carried out. In the reign of Lung Ch'ing remonstrances were made by the censors at the quality of porcelain demanded by the eunuchs for the palace. This reign witnessed both fire and flood at Ching-tê Chên and the flight of many of its workers. At the beginning of the reign of Wan Li there were further remonstrances and the imperial kilns were purposely fired by the potters in protest against the exactions of the imperial eunuchs. The further history of the kilns will be followed in subsequent chapters. During the Ch'ing dynasty the town was twice burnt down; once in the fourteenth year of K'ang Hsi (1675) during the rebellion of Wu San-kuei; the second time in the year 1855 when Ching-tê Chên was taken by the T'aip'ing rebels and almost depopulated. In 1864 the kilns were rebuilt, and they are still functioning to-day.

Père d'Entrecolles gives a vivid picture of Ching-tê Chên as he saw the town in September 1712.

'King-te-tching only needs to be surrounded by walls to be called a city, and even to be compared with the largest and most populous cities of China. The places called *tching* (*chên*), which are few in number, but distinguished by a large traffic and trade, are not usually walled—perhaps in order that they may grow without hindrance, perhaps to facilitate embarking and disembarking merchandise. King-te-tching is estimated to contain eighteen thousand households, but some of the large merchants have premises of vast extent, lodging a prodigious multitude of workmen, so that the population is said to number over a million souls, who consume daily over ten thousand loads of rice and more than a thousand hogs. It extends for more than a league along the bank of a fine river. It is not, as you might imagine, an indiscriminate mass of houses; the streets are straight as a line and cross at regular intervals; every inch of ground is occupied, so that the houses are too crowded and the streets far too narrow; when passing along you seem to be in the midst of a fair, and hear nothing but the cries of the street porters trying to force their way through.

'Living is much more expensive at King-te-tching than at Jao-tcheou, because everything consumed there has to be brought from elsewhere, even the wood burned in the furnaces. Nevertheless, it is an asylum for numberless poor families, who can not subsist in the neighbouring towns, and employment is found there for the young as well as for the less robust; even the blind and maimed can make a living by grinding colours. In ancient times, according to the history of Feou-leam, there were only three hundred porcelain furnaces at King-te-tching—now there are at least three thousand. Fires are of great occurrence, and the god of fire has many temples, one of which has been recently dedicated by the present mandarin. Not long ago eight hundred houses were burned, but the large profits their owners drew from their rental caused their speedy reconstruction.

'The town is situated in a plain surrounded by high mountains. The hill to the east forms a kind of semi-circle in the background, while from the mountains at the sides issue two rivers, which unite after-ward: one is but small; the other is very large, and forms a splendid strand more than a league long, spreading into a wide basin and losing much of its velocity. This wide space may be seen sometimes filled with two or three long lines of boats, moored close together. The sight with which one is greeted on entering through one of the gorges consists of volumes of smoke and flame rising in different places, so as to define all the outlines of the town; approaching at nightfall, the scene reminds one of a burning city in flames, or of a huge furnace with many vent-holes.

'It is surprising that such a populous place, full of such riches, and

13

with an indefinite number of boats coming and going every day, and which has no walls that can be closed at night, should nevertheless be governed by a single mandarin, without the least disorder. It must be allowed that the policing is admirable; each street has one or more chiefs, according to its length, and each chief has ten subordinates, every one of whom is responsible for ten houses. They must keep order, under pain of the bastinado, which is here administered liberally. The streets have barricades, which are closed at night, and opened by the watchman only to those who have the password. The mandarin of the place makes frequent rounds, and he is accompanied occasionally by mandarins from Feou-leam. Strangers are hardly permitted to sleep there; they must either spend the night in their boats or lodge with acquaintances, who become responsible for their conduct. . . .

'The boats come constantly down the river, laden with *petuntse* and *kaolin* which have to be purified by decantation, leaving an abundant residuum, which gradually accumulates into large heaps. The clay seggars in the three thousand furnaces last only twice or three times, and very often the whole baking is lost. Some of this *débris* is utilized to fill in the walls which surround all the houses, or is carried to the swampy ground adjoining the river, to make it fit for a market-place, and ultimately for building, for which new ground is always wanted. Besides, in the flood time, the river carries down much broken porcelain, so that its bed is, so to speak, entirely packed with it, making a refreshing sight for the eyes.'[27]

1. 'Recent writers have been inclined to belittle Hobson's writings, yet, with the possible exception of *The David Catalogue*, which may be not all Hobson, his writings are more suggestive and often closer to the facts as now known than much more recent publications.' Sherman E. Lee: *Sung Ceramics in the light of recent Japanese Research.* ARTIBUS ASIAE. Vol. XI, 3, p. 172.

2. The work of any scholar, however distinguished, must in time yield some minor mistakes. Hobson, who will be remembered by posterity as the great oriental ceramic historian, who laid down the outline of the subject for all time, in lucid and unimpeachable prose, is no exception to this rule. It must be with the greatest diffidence that a pupil of another generation who owes him so much, dares to join issue with the great master on some of his attributions of minor pieces of the Transitional and Early K'ang Hsi periods. In *The Art of the Chinese Potter* is not the rouleau vase (Plate CXL), with incised decoration beneath an aubergine glaze, late K'ang Hsi and not Ming? Is not the cylindrical vase (Plate CXLII), with pencilled under-glaze blue decoration, transitional, and not, as Hobson appears to suggest, fifteenth century? Is it not possible that the box and cover, illustrated on Plate CXXXV, Fig. 2 as Wan Li, are of the K'ang Hsi period? In *The Wares of the Ming Dynasty* is not the small bowl with a landscape (Plate 14, Fig. 2) with a Yung Lo mark a Ch'ing piece? While the hexagonal box and cover brought to

Denmark in 1622 (Plate 31, Fig. 1) would appear almost certainly to be Japanese. Lastly, the covered jar and vase (Plate 39, Figs. 3 and 4—they also appear in the Museum Guide, Ed. 1937, Figs. 92 and 93), described here as Wan Li, and Chia Ching or Wan Li, respectively, may well be early K'ang Hsi, although the second piece might be transitional. Is it not probable that neither piece is older than the middle of the seventeenth century?

3. Honey, W. B., *The Ceramic Art of China and other countries of the Far East*, p. 1.

4. Although I have shrunk from carrying this plan to its logical conclusion, when it came to the captions to the illustrations!

5. I have attempted to distinguish (*a*) the transitional wares made from 1620 onwards till 1662, from (*b*) the early K'ang Hsi 1662–83, before Ts'ang Ying-hsüan's reorganization of the kilns and both from (*c*) the rest of the K'ang Hsi wares (1683–1722).

6. My original idea was not to reproduce any pieces from the famous David Foundation, which was the most important private collection of Chinese ceramics in this country, as the collection is already so well known in Hobson's famous *Catalogue*. But I have not been able to resist reproducing one or two of the most beautiful pieces in the Chinese taste. Hobson's sumptuous volume has long been out of print, but the David Foundation is producing an illustrated catalogue—alas, in these straightened times, not in colour—of which Section 2, covering the Ch'ing enamelled wares, appeared in 1958.

7. I have to thank Messrs. Sparks, Bluett, Spink, Moss, Norton and Messrs. Sotheby's either for permission to reproduce photographs of pieces which have been through their hands or to photograph pieces in their possession, and the owners of the pieces illustrated for permission to ascribe ownership.

8. The two most important Chinese sources in the literature of Chinese ceramics are the *T'ao Shuo* and the *Ching-tê Chên T'ao Lu*. The *T'ao Shuo—A description of Pottery in six Books* by Chu Yen is still probably considered by native connoisseurs the chief authority on the subject. It was translated under the title *Descriptions of Chinese Pottery and Porcelain* by Bushell in 1910. The author, Chu Yen, also known as Chu T'ung-ch'üan, or by his literary title Li t'ing, was a native of Chekiang. In 1767 he appears to have been engaged by the Governor of Kiangsi. Bushell believes that he was stationed there up until the time of the publication of his book in 1774. During his residence he would have had ample opportunity of investigating the potteries at Ching-tê Chên. He was a voluminous and discursive writer, whose works included *A commentary on the Shuo Wên; Selections from the prose and poetry of the T'ang and other dynasties; Instruction on playing the lyre;* and *On the Art of writing verses.* He was also an amateur poet. The second work, the *Ching-tê Chên T'ao Lu* of which Lan P'u (Lan Pin Wan) was the original author, was not published till after his death by his pupil Chêng T'ing Kuei in 1815. Parts of this work were translated by Stanislas Julien under the title of *Histoire et Fabrication de la Porcelaine Chinoise* in 1856. A fresh and complete translation has now been set before the public by my friend Mr. Geoffrey Sayer, who most generously put his notes at my disposal.

9. The two letters are reproduced in full in the original French in the Appendix to Bushell's *Description of Chinese Pottery and Porcelain* (a translation of the *T'ao Shou*). They are translated by Burton in *Porcelain, its Art and Manufacture*, Ch. IX.

10. D'Entrecolles arrived in China in 1698. He was born either at Lyons or Limoges and served his novitiate at Avignon. The whole of the rest of his life was

spent in China and he died in Peking in 1741. He was responsible for the trans-
lation of a variety of Chinese texts, but perhaps he was most famous for the
descriptions of China he sent to Du Halde, many of which the latter quoted at
length in his *Description de la Chine*. His two letters on Ching-tê Chên appear
in Du Halde's book (*Tome* II, 216–46) and in the Hakluyt editions, (notably the
first and the edition of 1781) of *Lettres Edifiantes et Curieuses*. Among the many
subjects in which he was interested was inoculation for smallpox, botany, natural
history, physics, ethnology, archaeology and astronomy. He seems to have been a
delightful personality in whom enthusiasm, close observation, painstaking accur-
acy and hard work were combined with a charm of style and a grace of diction,
which make his letters so readable. It is not surprising to hear that he had con-
siderable influence at the Chinese Court, and that he was venerated by his native
converts, many of whom existed among the potters of Ching-tê Chên. Throughout
his account of the kilns his vocation is never allowed to drop out of sight, and we
find the last paragraph of his first letter reads, 'Ching-tê-chên owes to the liberality
of M. le Marquis de Broissia a church, which has a numerous congregation, in-
creasing considerably every year. May God pour his benedictions more and more
over these fresh faithful; I recommend them to your prayers. If they were helped
by some assistance to increase the number of catechists the people of China would
be enabled to learn that not only the luxury and cupidity of Europeans make them
send their money as far as Ching-tê-chên, but that there are zealous persons who
have nobler intentions than those who bring such fragile jewels.' (Burton's
translation, p. 110).

11. Burton, *op. cit.*, p. 90.

12. Bushell, *Oriental Ceramic Art*, p. 285.

13. Burton, *op. cit.*, p. 93.

14. Translated in full by Bushell with explanatory comment in *Oriental Ceramic Art*, Ch. XV.

15. Bushell, *Oriental Ceramic Art*, pp. 442–4.

16. The heir-apparent was the fourth son of the Emperor K'ang Hsi, the prince who reigned afterwards as Yung Chêng. It is interesting to find him mentioned as a patron of the kilns as early as 1704 or 1705.

17. Plate XXVII, Fig. 2.

18. Plate CXX, Fig. 2. It is interesting to note in passing that the manufacture of these statuettes was not confined to Tê-hua in Fukien.

19. Bushell, *Oriental Ceramic Art*, pp. 352–5.

20. The name of the town is said to be derived from that of the Southern Sung Emperor, Ching Tê, in whose reign the officials for the first time charged the potters to mark pieces 'made in the reign of Ching Tê'. Previously the name of the town had been Ch'ang-nan-chên from its position on the southern bank of the Ch'ang River.

21. Bushell, *Oriental Ceramic Art*, p. 278–81.

22. A. Brankston, *Early Ming wares of Chingtechen*, Part II, chapter I.

23. Brankston, *op. cit.*, p. 56, quoting the *Fou-liang-hsien-chih*.

24. *ibid.* p. 57.

25. Bushell, *Oriental Ceramic Art*, p. 287.

26. T'ang Ying—quoted by Bushell, *Oriental Ceramic Art*, pp. 458–9

27. Bushell's translation, *Oriental Ceramic Art*, pp. 283–6.

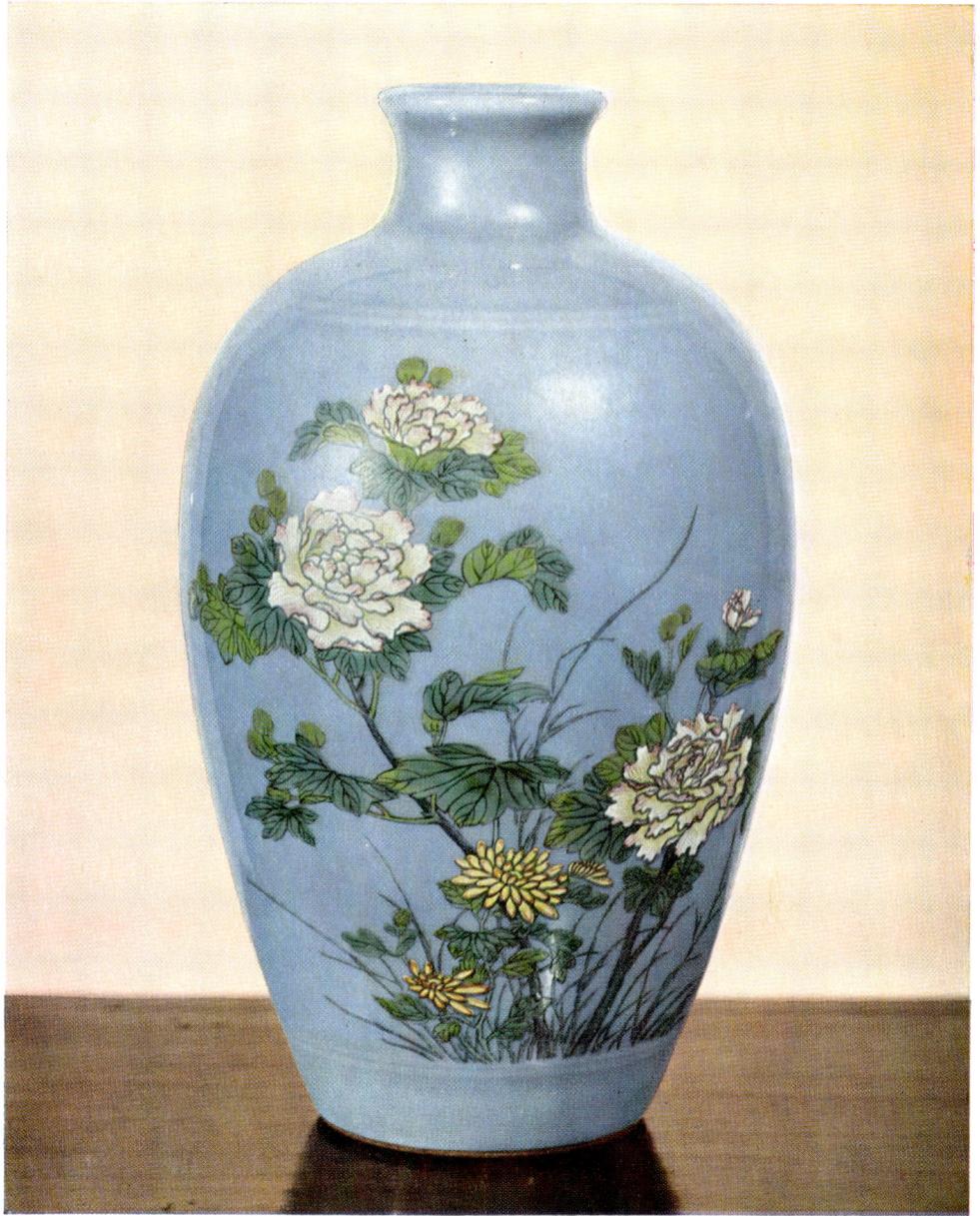

A. *Vase, decorated in enamels with mallow flowers and chrysanthemum;*
on reverse a poem signed Chüeh T'ao (T'ang Ying),
Director of the Imperial Porcelain Factory
Ching-tê Chên 1736–1753, Ht. 7·5 in.
Mount Trust. See page 65

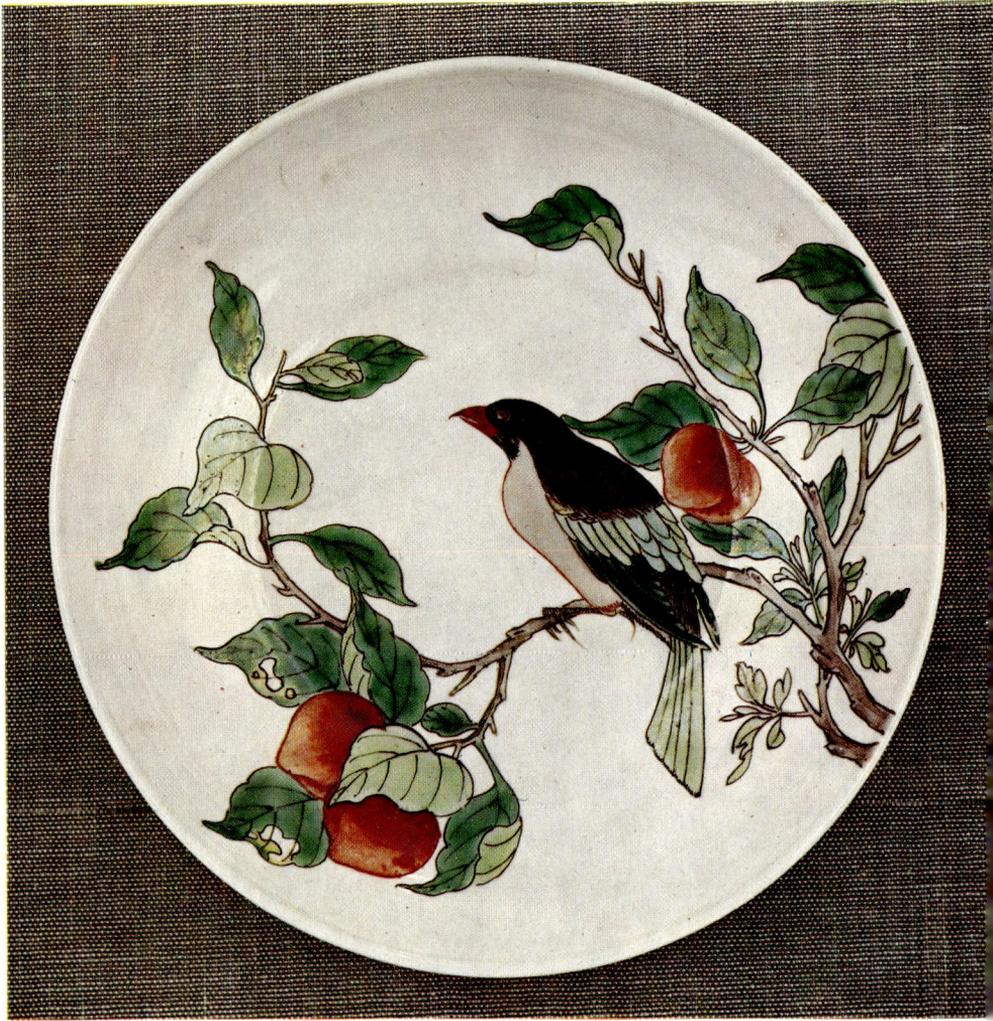

B. 'Birthday' dish with a bird on a fruiting branch in 'famille verte' enamels. The underlip decorated with a gold peony scroll on a tomato-red ground. Mark of Ch'êng Hua but K'ang Hsi period. Reputed to have been made for the 60th birthday of the Emperor in 1713.
Diam. 6·25 in.
British Museum. See pages 32, 41

2

THE PERIOD OF TRANSITION
1620-83

No easy road marked out with visible ceramic signposts bridges the gulf which invariably exists between the fall of one Chinese dynasty and the rise of the next. The fall of the Ming dynasty creates no exception to this rule. It would be a mistake to imagine that there is in the earliest Ch'ing porcelains any direct or immediate break with the past. The same craftsmen must have continued to work on the same materials each side of the watershed which divides the two dynasties. Styles overlap periods and only by slow degrees can new models have replaced the long-established and traditional ones. On account of this it is difficult to assign with any degree of certainty many of these transitional pieces to one dynasty or the other. Numbers of the coarse polychrome pieces at present associated with the Ming[1] may well belong to the years of Shun Chih and early K'ang Hsi, though they are still usually described as Ming. It is safer to label all these pieces seventeenth century. The boundary line, so indistinct between the two dynasties, is even less well defined between the various Ch'ing emperors. Monochromes which by all critical standards should have been made in the reign of K'ang Hsi may be found to possess a Yung Chêng mark; and a typical Yung Chêng piece may reveal a Ch'ien-lung seal mark upon its base, while the Ch'ien Lung *nien hao* in its turn was actively misused by the potters of later reigns.

The period of transition between the Ming and Ch'ing dynasties can be said to run from the death of the Ming Emperor Wan Li in 1619 to the appointment of Ts'ang Ying-hsüan as director of the imperial factory in the twenty-first year of K'ang-hsi in 1682.[2] In those sixty-three years we know very little of what took place at Ching-tê Chên[3]; its history is overshadowed by the dynastic struggle in which the Ming dynasty went down. During the twenty-five years which elapsed between the death of the Emperor Wan Li and the end of the Ming dynasty three emperors occupied the throne. The first of them, T'ai Ch'ang, ruled for one year; the second, T'ien Ch'i, ruled from 1621-7; the last, Ch'ung Chêng, from 1627-44. The reign mark of

T'ai Ch'ang is unknown; that of T'ien Ch'i (1) occurs most often on a number of small saucers, dishes and small plates usually of second-rate quality, but decorated sketchily and not unattractively in green, red, aubergine and yellow enamels and a greyish underglaze blue. These pieces have always found favour in Japanese eyes, and are the source of the Kutani palette. The mark of Ch'ung Chêng is rarer still. Hobson dismisses the reign as 'an undistinguished period, practically unknown to porcelain collectors'. It occurs on a small blue and white cup (2) and on the side of a vase with the date 1639 (3) decorated with sprays of prunus blossom in a greyish blue on a muddy grey ground. This piece is placed among the provincial wares, in deference to Hobson's opinion that the imperial factory was in a state of suspended animation during this period. This vase may have been made either at one of the private kilns in or around Ching-tê Chên or even in another province. It is a heavy piece with a foot burnt brown, not unlike that of the Ming celadons.

But the most characteristic group of the transitional years is the well-known blue and white family 'of a strong build suitable for export and of good material, with a clear white body often left un-glazed on a flat base. The glaze is thick and rather bubbly, and the blue is of a bright violet tone, which seen under the bubbly glaze suggested the graphic simile of "violets in milk". The decoration too has frequently repeated characteristics which seem to indicate the use of a set of stock patterns. A common type is a figure scene set in a land-scape, with a wall of rocks emerging from swirling clouds and grass expressed in a mannered fashion by a series of V-shaped strokes. Borders of stiff leaves,[4] rolling foliage, and a formal plant design suggestive of a tulip (4) are further traits by which this transition ware can be recog-nized.'[5] Another feature common to this late Ming group and to some Wan Li wares is a border of scroll work or other formal design etched with a point under the glaze. (5) Sometimes they bear Chia Ching marks.

In the unique vase of Mr. de la Mare dated 1638 (6) a wash of green is brushed over the blue and white but this may have been applied at a later date. The few pieces in these groups which are dated or datable —more often by European metal mounts than by any other means— fall within the Ming period. There is a tankard of German form of this blue and white type in the Hamburg Museum with a silver cover dated 1642; a vase with tulip decoration at Chantilly with a cyclical date referring to 1639 or 1699. Another piece had a Dutch mount which could be dated between the years 1632 and 1648.[6] A

Plates: (1) I, Fig. 1B; (2) I, Fig. 1C; (3) CXVI, Fig. 1; (4) III, Fig. 1; (5) IV; (6) III, Fig. 2.

vase with 'tulip' decoration on the neck, and another mug with silver mounts, are or were both in the Dresden Collection.[7] The mug mounts are dated 1642. Zimmermann dated both pieces about 1640. It is possible that a mounted piece with a Ch'ing cyclical year date may make its appearance. It would be surprising if some members of this group or something closely allied to them were not made after 1644. (1)

Mr. Perzynski[8] alone has given some attention to this family which has been treated with unmerited contempt by collectors, as a mere export ware, which indeed it was.

During the period of Wan Li and the three succeeding Ming emperors the newly formed East India Companies, especially the Dutch, placed enormous orders for blue and white porcelain at Ch'ing-tê Chên. The convulsions which preceded and accompanied the fall of the dynasty must have made these orders very welcome, as they compensated in part for the loss of imperial patronage and the unsettled state of the home market. Prevailing conditions must have presented the factories, which employed an enormous staff, with the alternative of either dismissing many of their hands or making more porcelain for the foreign market. The forms of many pieces in the transitional groups are modified to suit European taste. Cylindrical tankards with a hole in the handle for a metal mount are a complete innovation, drawn from a Dutch or German original. Pieces of Wan Li and transitional blue and white often appear in the paintings of Snyders and Kalf and other Dutch artists of this period, and it may be possible to throw light on their date from this angle.[9] Monochrome porcelains of the transitional period are not difficult to place. The commonest pieces are decorated in incised patterns, under a white glaze, or a pale celadon glaze resembling 'ying ching'.

The stem cup and saucer (2) belong to a small family, which exhibits a new and distinct hand in porcelain decoration. This group has never previously been given any serious attention in ceramic literature. But the drawing on them provides clearly defined characteristics. They include the famous Cosmo Monkhouse box,[10] which has a Ch'êng Hua mark, and the beautiful little box and cover decorated in underglaze blue and enamels from the Oppenheim Collection (3) reproduced by Hobson as Ch'êng Hua.[11] Although the base and calligraphy of this piece have much in common with the Ming it is, I believe, an early K'ang Hsi box of very fine quality and before 1683, and not even sixteenth century. The trouble is that there is nothing else to compare it with. More distantly related to this group is a

Plates: (1) V, *Fig.* 2, XX, *Fig.* 2; (2) I, *Figs.* 2A and B; (3) XXV, Fig. 1B.

series of 1662 to 1675 wares, often with K'ang Hsi marks, and some marked Shên-tê t'ang, a hallmark which does not occur only on Tao Kuang pieces (see page 99).

Examples from three other groups belong, at least partially, to this period. The first of these is the so-called enamel on biscuit, little plates and figures and ornaments for the writing table. (1) The porcelain was first baked, and then covered with enamel glazes and baked again in the '*demi-grand feu*'. The majority of the pieces are ascribed to the K'ang-hsi period, but some are earlier.[12] In the second group are the round-bellied, heavy-lidded potiches and tall vases with flaring mouths decorated in bright enamels and underglaze blue in the Wan Li colour scheme (2). Most of these are decorated in Ming style, but some of the patterns such as running horses against a sea of waves (3) occur each side of the border line. Most of these pieces may be placed in the last quarter of the seventeenth century.

The third group consists of large dishes, with a curious furrow in the back near the standing rim. These pieces are regularly met with in Indian collections, where they have often been used for eating rice. This ring certainly gives more solidity to the dish and may have fitted into a grooved stand. Such pieces are usually decorated in *famille verte* enamels or underglaze blue in a vigorous free style with dark, deep colours. They been known to carry the K'ang Hsi mark.

In dating all three families and also monochrome pieces of the transitional period, greater boldness and robustness inclines the scale of our judgment to the Ming. Imperfections visible through the glaze, reddish rims left unglazed, muddy greens and yellows, and an impure watery glaze full of air bubbles are all signs of the Ming. According to Nanne Ottema, the most trustworthy criterion in such a judgment is and remains the foot of the article in question. If it is filled out with no rim to stand on and unglazed it has almost certainly to do with a Ming piece.[13] If its foot is turned off sharply and the flow of the glaze completely controlled and is pointed by a sharply defined line from the unglazed part of the rim of the foot then we shall have to assume a Ch'ing origin. These Ch'ing pieces are fashioned underneath in such a way as if designed to be placed in a well-shaped wooden stand. I should not be surprised if the invention of these wooden stands should be ascribed to the Ch'ing period.[14]

Little is known of what took place at Ching-tê Chên during that interval of 39 years which lies between the succession of Shun Chih and the reorganization of the factory under Ts'ang Ying-hsüan. Ferguson goes so far as to say: 'During the turmoil which marked the

Plates: (1) XXVII, *Fig* 1; (2) II, V, *Fig.* 1; (3) II, *Fig.* 1.

downfall of one dynasty and the rise of another the imperial kilns were closed and were not opened till the tenth year of K'ang Hsi, i.e. A.D. 1671. This makes it impossible that any piece of imperial ware marked with the dynastic title of the first emperor of the dynasty, Shun Chih, should be genuine. The factories were not open and there were no wares. It also makes absurd the use of the term "very early K'ang Hsi".[15] This statement is not easy to square with the existence of two imperial decrees of this reign quoted by Bushell and culled from the pages of the T'ao Shuo.[16] The first is in the tenth year of the reign (1653) ordering dragon bowls for the palace gardens.[17] It is true it was found impossible to make these dragon bowls and that a petition had to be presented by Chang Chao-lin, Governor of the Province of Kiangsi, that the order should be withdrawn; but the fact that the order was made supposes the existence of an imperial factory at this date. In 1659 a second order asking for a supply of oblong porcelain plaques for letting into the verandas of the Palace had to be treated in the same way, although the Imperial Commissioner sent down a Commission from the Board of Works to superintend the work.

Specimens of porcelain carrying the Shun Chih mark are as rare as the marked pieces of the last emperor of the Ming. Hobson speaks of them as of insignificant importance, and assumes that they could not be distinguished from those of the last Ming reign on the one hand and those of the early years of K'ang Hsi on the other. He suggests that many of the pieces carrying the mark Ta Ch'ing nien chih (made in the great Ch'ing dynasty) might well belong to this reign, as this mark would be more appropriate to the first emperor of the Ch'ing dynasty than any other. Brinkley says: 'During the first reign, Shun Chih, no marked revival of art industries seems to have taken place. A certain quantity of blue-and-white hard-paste porcelain was however manufactured. Such specimens as survive are of fair quality, heavy, solid, somewhat rudely finished below, and generally having no depression in the under surface; characteristics that render them apt to be confounded with the wares of the Wan Li era, especially as the tone of the blue decoration is virtually alike in both periods. The mark of the era . . . is seldom met with.'[18] Mr Russell Tyson's fine polychrome jar from the beginning of the reign (it bears the nien hao and the cyclical date for 1646—Plate VIII) bears Hobson out, as does the rough blue and white brush pot in the David Foundation dated 1655,[19] while Mr. Norton's small cylindrical incense burner with the mark may be taken for an early example of prunus and cracked ice decoration.[20] A number of dishes which also bear the mark of Shun Chih, decorated with lions and other animals in underglaze blue, are so undistinguished that they can be assigned to the nineteenth

century. It is a pity that it is not possible to establish the identity of some of the blue and white pieces recovered from Table Bay by Henry Adams and his divers in 1853. They form a part of the cargoes of several East Indian merchantmen; and though it is known that one of them was the *Haarlem* (lost in 1648) it is impossible to say to which ship any particular piece belonged.

Apart from the blue and white two or three other examples of marked Shun Chih dishes are known. These are covered with a deep violet blue glaze incised on the interior and exterior with a five-clawed dragon (1). One of these has been described[21] as exhibiting several features denoting the transitional period. 'The colour of the glaze—a blend of indigo and violet blue,—has some resemblance to that of Chia Ching, but is clearly approaching the regular purple-blue of K'ang Hsi. The drawing is good but although the dragons are in the Wan Li convention, they do not possess the Ming vigour. The potting technique and the clay employed follow in the main that of the later Mings.' The six-character mark within a ring would suggest that these plates were Palace products and I find no personal difficulty in accepting them as such despite Ferguson's stricture.

Another Shun Chih piece is the figure of Wên Chang Ti-chün, principal god of literature, seated in yellow and green robes, once in the Lindley Scott Collection.[22] The inscription on its back runs: 'Inscribed by Ch'iao Tzu-huan, tile maker of this district, on the eighteenth day of the third month of the sixteenth year of the Shun Chih period (15th May, 1659).' This piece may be of provincial make. It would certainly have been assigned to a Ming date if it were not for the inscription. As it is, it illustrates most effectively the time lag in taste between the capital and the provincial areas. Mr. Fujio Koyama[23] speaks of another piece, 'a five-storied pagoda green, blue and yellow, and on the back an inscription with an engraved date corresponding to the twelfth year of Shun Chih (1655),' which belongs to Minpo Yokawa of Tokyo.

It is during the reign of Shun Chih that Lang T'ing-tso was appointed Governor of Kiangnan.[24] His name has been associated with the production of the famous red glaze—the *Lang Yao*—but this tradition does not seem to be supported by any documentary evidence. Kuo Pao-'chang links this glaze with another Lang (Lang T'ing-chi) who was appointed Governor of Kiangsi in the forty-third year of the reign of K'ang Hsi (1704) who he says operated his own factory for the manufacture of porcelain—'exercising his own ingenuity he made wares that were highly finished and beautiful. His wares were also pre-

(1) *Plate* VI.

sented to the Imperial Court. They are called *Lang Yao*'.[25] Ferguson, on the other hand, associates it with yet another Lang (Lang T'ing-hsiang). He says: 'In the latter part of 1675 General Pai died and was succeeded (presumably as governor of the province) by Lang T'ing-hsiang who during his term of office, which was cut short after a month by his retiring into mourning for his father, sent the first consignment of imperial ware, yü ch'i, to Peking which had been produced in the Ch'ing dynasty. . . . This is the origin of the long misunderstood term and I have only been able to clear up this mystery since the publication of the Draft of the Ch'ing dynasty history early in 1928. His palace attendants knew that this term would please K'ang Hsi with whom the Lang family stood in high favour. Lang T'ing-tso who had served under the first Ch'ing Emperor, Shun Chih, had been appointed by K'ang Hsi to two viceregal positions. At the same time he had made Lang T'ing-hsiang Governor of Honan and later Viceroy of Fukien. During the latter part of his reign K'ang Hsi appointed a cousin, Lang T'ing-chi, Governor of Kiangsi and later Viceroy at Nanking. It came to be a Palace proverb that K'ang Hsi had the Lang family in his stocking. . . . There is no evidence that any of the three Langs had any particular interest in the porcelain industry, and it was mere chance that the first imperial ware was sent to the palace by Lang T'ing-hsiang. Of course this consignment of ware included not only sang de bœuf, which later came to monopolize the term lang yao, but also all kinds of green, yellow, red, black and polychrome wares.'[26] Other writers have associated the term with the name of Lang Shih-ning (the Jesuit priest Castiglione, who came to China in 1715), who according to at least one source took part in the decoration of some of the fine Ku Yüeh Hsüan pieces. Bushell believed the *Lang Yao* to be apocryphal; Franks for some reason states that it became extinct in 1610 and Grandidier also placed the whole incident in the Wan Li period. Hobson points out that the name *Lang Yao* does not occur in any of the standard Chinese works devoted to the ceramics of Ching-tê Chên, but that it is believed that members of the Lang clan—a common Chinese surname—lived in the neighbourhood of Ching-tê Chên, and that it is possible that a member of the family gave his name to the ware.

This *sang de bœuf* glaze—the *chi hung* (sacrificial red) and *pao-shih hung* (precious stone red) of the Chinese—was not a new invention but a rediscovery of a glaze known and treasured in the Ming period, but lost in the reign of Chia Ching. It is improbable that many of the K'ang Hsi red monochromes appear before 1700. The colour of this *Lang Yao* ranges from a dusky blood red to a brilliant cherry—through all the French fancy names of *sang de bœuf, sang de pigeon* and *sang de poulet* to the Chinese 'mule's liver' (a dull maroon) and

various other shades of pinkish brown. It is finely crackled. In the finest K'ang Hsi pieces the colour drains away from the lip leaving the lip bone white or a pale anæmic green (1). This glaze requires perfect fluidity to be brought to perfection. The modern imitations are superior to the Ch'ien Lung copies, in which the red is either opaque or flambé and the foot is poorly finished. The later eighteenth-century potters lost the secret of controlling this glaze, which ran down over the foot and had to be ground away.

As little is known of the earliest K'ang Hsi wares (i.e. those made between the year of his succession 1662 and 1683, when Ts'ang Ying-hsüan took on the control of the imperial factory) as of the ceramic productions of the last years of the Ming. A rough and heavy blue and white incense bowl (2) with typical brown lip, decorated with two dragons in a misty underglaze blue inscribed: 'The sixth year of K'ang Hsi (1667) the first month of summer presented by the disciple Wang Chih-hsi to the Ching Yin An (the pure secluded monastery)' and a small bowl of the same date (3), give the key to some of the coarser pieces.[27] The former has the brown lip typical of so many transitional pieces. Two other vases, one decorated in blue and white and the other in the Wan Li colour scheme in polychrome enamels and under-glaze blue, by comparison almost certainly belong to this period (4), because of the quality of the blue washes. In both pieces the body is heavy, the glaze greenish and far from faultless, and the form clumsy. Smaller pieces in this characteristic hand exist (5), of better quality.

In 1671 we hear of an order for sets of sacrificial vessels ordered from Ching-tê Chên for the use of the emperor's worship at the imperial ancestral temples in Peking. A deep dish[28] (6) painted in underglaze blue and copper red, with a half-length seated figure bears a cyclical mark of the following year, 1672.[29] Ferguson, who had un-rivalled opportunities of acquiring information from Palace sources, believes that the imperial factory was not opened until 1671, under the directorship of Tung Wei-kao, who took little interest in the factory, which at this period only produced ritual vessels. 'It is now', he says, 'possible for us to date the ritual vessels of the K'ang Hsi period as not earlier than 1671 and imperial ware as not earlier than 1675.'[30] But this statement, if it is true, can only apply to the imperial factory. In 1673 the province of Kiangsi was thrown into confusion by the rebellion of Wu San-kuei, Tung fled or disappeared, and his place was taken by General Pai Sê-ch'an. He died in 1675, and in the same year the factories were pillaged and burnt by the

Plates: (1) VII, *Fig.* 2; (2) IX, *Fig.* 2; (3) I, *Fig.* 1A; (4) XI; (5) I, *Fig.* 2C, IX, *Fig.* 1A, XX, *Fig.* 2; (6) XVIII, *Fig.* 1.

insurgents, so it may be presumed that he was among the victims of the rebellion. According to the Annals of *Fou-liang* the factories were not rebuilt until 1677[31] when Chang Ch'i-chung, a magistrate of Fou-liang, was appointed superintendent. This man seems to have been a conscientious official, and through his pressure or that of the next director the system of supplying the imperial kiln with conscript labour seems to have been abolished.[32] He also succeeded in securing for the support of the imperial factory the land tax of Fou-liang, which was usually remitted to Peking. But he is more famous because in the first years of his directorship he issued a proclamation forbidding the potters to write the *nien hao* of the reign on their pots, or texts from any of the sacred or classical works, lest their sacred character should be profaned.[33] It is not known how long this order was maintained and if it was ever properly enforced. Many of the Ch'ing pieces marked with an empty double ring, an artemisia leaf, a hare, a double fish, a fungus, an incense burner (the spider mark of the old-fashioned English dealer), have been ascribed quite incorrectly to this period. For the greater number of these pieces show far too great elegance and finish (1) to be so early.

A new superintendent who only remained a year was appointed in 1680; his name was Hsü T'ing-pi. The *T'ao Lu* says that this is the year in which the first imperial orders of the reign were received and gives him and his secretary Li T'ing-hsi the credit for putting an end to compulsory labour. He seems to have been resident at the kilns during his office. It was in this year also that a great danger to Ching-tê Chên was averted. For the emperor seems for a moment to have considered transplanting the imperial kiln to Peking, where he set up twenty-seven workshops in the Palace precincts for the manufacture of metal-work, glass, enamels, jade, lacquer and the kindred arts. He planned in addition a porcelain factory and machinery and workmen were both requisitioned from Ching-tê Chên to be sent north; but this enterprise was abandoned. D'Entrecolles' account of the venture runs: 'The reigning emperor (*K'ang Hsi*) who will ignore nothing, also brought workmen in porcelain to Peking, with everything employed by them in the work; they neglected nothing, in order to succeed under his supervision, yet all their labour was wasted. It is possible that interested motives may have contributed to their want of success; however that may be, it is King-te-tching alone which has the honour of furnishing porcelain for all parts of the world. Even Japan comes to buy it in China.'[34] In the ninth month of this same year an imperial decree was issued ordering porcelain for the Palace

(1) *Plate* XXIII, *Fig.* 1.

from Ching-tê Chên. A commission was selected from among personnel of the Nei Wu Fu (The Palace Office of Works) to superintend the work. A second commission was appointed in 1682, headed by Ts'ang Ying-hsüan, Secretary of the Imperial Parks Department, which arrived at Ching-tê Chên in the second month of the twenty-second year of K'ang Hsi (1683)[35]; on his arrival Ts'ang took over the directorship of the imperial factory.

The seventeenth century is associated in the minds of collectors of Chinese porcelain with transition, change of dynasty, decadence of the kilns at Ching-tê Chên, and collapse of the imperial factory (rebuilt in 1683). But for the lover of painting it is one of the most glorious centuries in Chinese art, beginning with Ch'en Hung-shou and Chu Ta, and continuing with Yün Shou-p'ing, Wang Hui, Tao Chi and Kun Tsan. Not all the arts were in abeyance. As in the case of the Yüan dynasty, China was large enough to hold a Mongol invasion and to produce great artists as well. The eclipse of ceramics is only a temporary condition.

1. They are invariably lacking in marks.

2. Transitional style is foreshadowed before the close of the reign of Wan Li, and lingers for the first two decades of K'ang Hsi. It was not until 1644 that the Manchus placed Shun Chih on the Dragon throne, although the last Ming Pretender to the throne did not commit suicide in Burma till 1662.

3. 'During the sixty years between 1620 and 1680 we can take hardly any account of the Imperial Porcelain factories. The only porcelain which during that time can be ascribed with any certainty to Ching-tê Chên is the fine blue and white porcelain, which is exclusively a product manufactured for export in private kilns.' Nanne Ottema, *Handboek Chinesische Ceramiek*, ch. IX, trans.

4. This is probably the most characteristic feature of the whole family. Plate III and Plate IV, Fig. 2.

5. R. L. Hobson, *The Wares of the Ming dynasty*, p. 168.

6. *Country Life*, Jan. 29, 1921, Fig. 10.

7. Ernst Zimmermann, *Chinesische Porzellan*, Plate 54.

8. F. Perzynski, *Towards a grouping of Chinese Porcelain*. Three articles in the *Burlington Magazine*, Oct. 1910–March 1911.

9. Nanne Ottema, *op. cit.*, pp. 179–83 illustrates some of these.

10. Cosmo Monkhouse, *A History and Description of Chinese Porcelain*. Plate II. The box was once in the Bushell Collection and is now in the David Foundation.

11. Hobson, Rackham and King, *Chinese Ceramics in Private Collections*, ch. VI, Fig. 131. Compare the smudgy underglaze blue on this box with similar blue on the bowl dated 1667 (Plate IX, Fig. 2), the vase (Plate XI, Fig. 1) and the stem-cup with K'ang Hsi mark (Plate I, Fig. 2c).

12. An ink palette of this family dated 1692 is illustrated Plate XXVII, Fig. 1.

13. This is not correct. Many transitional Ming-K'ang Hsi pieces have unglazed bases, and this feature does occur in late K'ang Hsi pieces also.

14. Nanne Ottema, *op. cit.*, ch. XIX.

15. John Ferguson, *Survey of Chinese Art*, ch. VI, Ceramics, p. 91.

16. Both these orders appear in the pages of the *T'ao Lu* in Book I, which says 'a factory built for pottery making by the present Royal House (the Ch'ing dynasty) started operation in the tenth year of Shun Chih (1653)'.

17. These bowls are placed in stands in the courtyards of the palace and used for the cultivation of lotus and other water plants and goldfish (Bushell).

18. F. Brinkley, *Japan and China*, vol. 9, pp. 136–7.

19. Jenyns, *Archives of the Chinese Art Society of America*, vol. 9, 1955, *The Wares of the Transitional Period between the Ming and the Ch'ing 1620–1683*, figs. 7*b* and 1*d*.

20. Oriental Ceramic Society, *Catalogue of Loan Exhibition of Chinese Blue and White Porcelain*, Dec. 1953–Jan. 1954, No. 230, Plate 15*a*.

21. Edgar Bluett, *Ming and Ch'ing porcelains*, p. 69.

22. *Sotheby's Catalogue of the Lindley Scott sale on 4th July*, 1945, Lot 67, illustrated.

23. Fujio Koyama, *Oriental Ceramics*, vol. IX, no. 4, '*Dated Ming and Ch'ing pieces.*'

24. He was raised to the Viceroyalty of Kiangsi and Kiangnan in 1654. In the last year of the reign of Shun Chih (1662) the viceroyalty was divided. Lang T'ing-tso remained *tsung-tu* of Kiangnan and Chang Chao-lin was promoted to be *tsung-tu* of Kiangsi. The two provinces were united again in the fourth year of K'ang Hsi (1665) when Lang again became Viceroy, until he was succeeded by a Manchu of the Yellow Banner.

25. Kuo Pao-ch'ang, *A brief description of porcelain* in the preface to Vol. II of the *Illustrated Catalogue of the Chinese Exhibits to the Chinese Exhibition at Burlington House*, 1936, p. 28.

26. Ferguson, *op. cit.*, p. 91.

27. At the OCS Blue and White Exhibition, 1953–4, five cups or small bowls (Nos. 231–5) from the Riesco Collection were dated 1665, 1666, 1666, 1668 and 1669. Decorated with flowers, insects and rocks or with landscapes, they clearly belonged to this group.

28. *Sotheby's Catalogue*, 26th April, 1938. The Stephen Winkworth Sale.

29. I see no reason to doubt either this or the earlier inscriptions.

30. Ferguson, *op. cit.*, p. 91.

31. Honey and Hobson say not until 1681. Honey, *Ceramic Art of China and the Far East*, p. 139.

32. According to the *T'ao Lu*, citing an old source, called the *Old Record of Factory supplies*—certain villages of the Fou-liang district and those of a few villages of the P'u-yang district had originally to supply the manpower for the imperial factory. Later the villages of P'u-yang successfully petitioned against their feudal service. But presumably the Fou-liang district had still to pay their feudal dues until Chang's reorganization.

33. *T'ao Lu*, bk. 8, item 50, Sayer's translation, p. 87.

34. Bushell, *Oriental Ceramic Art*, p. 283.

35. This is from Bushell's account (*Oriental Ceramic Art*, p. 305), but it is also supported by the *T'ao Lu*.

3

THE DIRECTORSHIP OF TS'ANG YING-HSÜAN AND THE YEARS THAT FOLLOWED. 1683-1726

Ts'ang Ying-hsüan is first heard of as head of the Commission which was sent to investigate and superintend the work of the factory at Ching-tê Chên in 1682. With his appointment as Director in 1683[1] a new era opens. K'ang Hsi had by now abandoned the idea of transplanting the imperial factory to Peking, and from now onwards his patronage is given to Ching-tê Chên and the imperial factory enters on the most brilliant period of its existence.

Very little is known about Ts'ang himself beyond that he was Secretary of the Imperial Works Department in Peking before his appointment. Hannover assumes that he was a master potter. T'ang Ying, one of his successors, in his *Life of the God of Furnace Blast* says that when Ts'ang was director of the kilns 'the finger of the god was often seen in the midst of the furnace fire, either painting the designs or shielding them from harm, so that the porcelain came out perfect and beautiful.'[2] Another account says that the porcelain made by him was of fine rich material and thin translucent texture.[3] It is unfortunate that T'ang is not a little more explicit about Ts'ang's life and tastes. It is not known how long he remained superintendent, but there seems to have been a considerable interval between his departure and the appointment of Nien Hsi-yao in 1726. D'Entrecolles makes no mention of his name in his letters of 1712 and 1722, but the exaggerated description in these letters of Ching-tê Chên, as a town four miles round, with over a million population and three thousand kilns, which at night looked as if it was on fire, must have been written during or soon after Ts'ang's term of office.

The *T'ao Lu*[4] after speaking of the rich texture of his clays, the brilliance of the glaze, and the thin bodies of his porcelains, goes on to enumerate the invention of four special glazes associated with the period of his directorship. They are:

(*a*) The eelskin yellow (*Shan yü huang*).

28

(b) The spotted yellow (*Huang pan tien*).

(c) The snakeskin green (*Shê p'i lü*) (1).

(d) The turquoise blue (*Chi ts'ui*).

It also praises his pale yellow, his pale mauve (? aubergine), pale green pieces, and his powder blue (*ch'ui ch'ing*). 'Of the celebrated wares manufactured in the reign of the three emperors, the fresh red vessels of K'ang Hsi Yao were the most eminent, while those of sky blue, kingfisher green, bluish green, lemon, light yellow, *soufflé* red, *soufflé* purple, *soufflé* blue, and *soufflé* green were specially beautiful. Wares of the period decorated in underglaze blue and in variegated enamels, which followed the patterns of the Hsüan Tê and Ch'êng Hua period, compared favourably with them. Porcelains decorated in *cloisonné* enamel style were an innovation of this date. All these wares of K'ang Hsi emanated from Ts'ang Yao.'[5] Hobson suggests that the eelskin yellow was probably a brownish glaze applied to the biscuit, but a piece labelled Ts'ang Yao sent over by the Chinese Government to the Chinese Exhibition at Burlington House possessed a tea-dust glaze of the kind associated with the directorship of Nien Hsi-yao in the Yung Chêng period. Bushell identifies the spotted yellow with the mottled yellow, green, and aubergine pieces known as 'tiger skin' and 'egg and spinach'. (2) Brinkley writes of it as a stoneware covered with green and yellow specks; but (as Hobson says) 'it must be confessed that the term is sufficiently vague as to cover a variety of mottled glazes in which yellow plays a part'. If these glazes are to be fully identified it must be from labels in the Chinese palace collection.

The yellows of the K'ang Hsi period, whether they are primrose, citron, canary, lemon or pale straw are always light and transparent (3). This also applies to the numerous greens, whether they are pea green, *Lang Yao* green, camellia green (4) or the three most famous greens of the period, the cucumber green (*Kua p'i lü*); the apple green (*P'ing kuo ch'ing*) (5), so widely sought after by European collectors and so often reproduced, or the snakeskin green (*Shê p'i lü*). This last was probably a deep iridescent green, which is not uncommon. As the same enamels were usual on polychrome and monochrome pieces it is not surprising that K'ang Hsi greens are almost as dominant among the monochromes as the *famille verte* palette is amongst the polychromes of the period. The kingfisher blue (*Fei ts'ui*) seems difficult to distinguish from the peacock green (*Kung ch'üo lü*) (6). These last two glazes are awkward to date, when shape and paste are no

Plates: (1) CV, *Fig.* 2c; (2) XXVI, *Fig.* 2; (3) XXXVI, *Fig.* 1, XXXVIII; (4) CV, *Fig.* 2B; (5) CV, *Fig.* 2A; (6) CI, *Fig.* 2 for a later example of this colour.

guide, as they were Ming favourites, and both of them continued to be made extensively to the reign of Ch'ien Lung, as did lavender (1).

Both D'Entrecolles and T'ang Ying have left us descriptions of how the powder blue was blown on by a bamboo tube.[6] This technique does not seem to have antedated the K'ang Hsi period. Later pieces treated in this way are never so bright or deep in tone. The powder-blue pieces are usually either painted with arabesques or other designs in gold[7] (2) or with reserves in underglaze blue or *famille verte* enamels. A deep purple blue called Mazarin blue by the French (3) was also decorated in gold. A distinctive pale celadon also appears at this time. This is one of the monochromes so often mounted in France[8] in ormolu by Gouthière or Caffiéri (4). The so-called *clair de lune* is another monochrome credited to Ts'ang's ingenuity.

Among the reds the famous *Lang Yao* has already been mentioned. Yet another of Ts'ang's ceramic masterpieces is said to have been the invention of peach bloom, a brownish red, interspersed with flushes of pink and glints of green and moss brown. It is usually found in small pieces (5); among the larger pieces it is favoured by many of those amphora-shaped vases with hollow bases. It would be interesting to know when this shape originated; the majority of these vases are later imitations. Another colour which according to D'Entrecolles was a novelty in 1722 was the mirror black (*wu chin*); this was also decorated in gold (6). This invention was a development of the famous *café au lait* glazes[9] (*Tzü chin*) which were in use during the Ming period. In K'ang Hsi's reign this colour is often used to decorate the outside of plates, whose inside is decorated in underglaze blue (7) or *famille verte* and later it was used for the outside of bowls combined with *famille rose* panels, made largely for export. The use of silver decoration is given by D'Entrecolles as another invention of the period, but other sources date its origin to T'ang Ying's directorship.

Another discovery of this period was the *hua shih* or soft paste, which D'Entrecolles speaks of as a novelty in 1722. 'Porcelain fabricated with *hua-shih*', he says, 'is rare, and much dearer than the other; it has an extremely fine grain, and with regard to the work of the brush, if it be compared with ordinary porcelain, it is like vellum compared with paper. Moreover, this porcelain is so light as to surprise one accustomed to handle other kinds of porcelain; it is also much more fragile than the common sort, and it is difficult to seize the proper moment of its firing. Some, who do not use the *hua-shih* to make the body, content themselves with making a kind of glue of it, in which they im-

Plates: (1) XL, *Fig.* 2; (2) XLII, *Fig.* 1; (3) XLI, *Fig.* 2; (4) XCVI; (5) VII, *Fig.* 1; (6) XLII, *Fig.* 2; (7) XIII.

merse the porcelain when it is dry, so that it takes up a layer on which to receive the colours and the glaze, by which means it acquires a certain degree of beauty.'[10] Its manufacture was always an expensive process, so that its use was for the most part confined to the small furniture of the writing table—miniature water droppers, brush holders and decorative vases (1). Many of these pieces have an almost eggshell thinness and an orange-skin texture or a finely crackled surface, but the great majority of these were made in the reign of Ch'ien Lung (2) and later. The brush pot (3) has a substantial body, and may be one of the dipped pieces, while bowls with a large crackle seem to belong to the earlier part of the century (4). Very rarely is soft paste associated with enamel decoration (5).

White wares were very popular in K'ang Hsi's reign. They could be decorated with incised designs (6) or perforated (*ling lung*) or modelled in biscuit or cut in low relief (7). Plain white biscuit pieces are sometimes signed by such potters as Chiang Ming-kao or Ch'ên Kuo-chih, and so presumably did not come from the imperial factory. The fine white eggshell porcelain (the *t'o t'ai* or bodiless pieces) made in the reign of Yung Lo were copied at this period, but as they had already been copied in the reigns of Ch'êng Hua, Lung Ch'ing and Wan Li in the Ming period and appear again as copies in the Yung Chêng list and were copied again under Ch'ien Lung, they should be approached warily[11] (8).

There is one family of white porcelain, on which the body and glaze resembles the soft paste pieces. This is the Fên Ting, made in imitation of the classical Ting ware. Some of these pieces have five-clawed dragons, enveloped in clouds etched in the porcelain under an ivory white glaze; others carry embossed designs worked in relief upon the paste. These pieces were copied again in the reigns of Yung Chêng[12] and Ch'ien Lung. Some of these K'ang Hsi pieces carry Sung marks. A great number, which have a soft creamy body that can easily be scratched with a knife, still pass as Sung or Yüan pieces (9).

The crackled pieces moved D'Entrecolles' admiration. He describes them as 'marbled all over, and cut in every direction with an infinity of veins; from a distance it might be taken for a broken piece with the fragments remaining in place; it is like a work in mosaic.'[13] The Chinese use various terms to describe this technique such as *sui ch'i* (shattered pieces); *ping lieh* (fissured ice) and *yü tzŭ* (fish roe). According to the *T'ao Lu* the glaze was prepared from a natural rock found at San-pao-p'êng, from which was prepared *sui ch'i tun* (crackle

Plates: (1) XVII, *Fig.* 1; (2) CX, *Fig.* 1; (3) XX, *Fig.* 1; (4) XVI, *Fig.* 1; (5) XLVIII, c; (6) LXX, *Fig.* 2; (7) LXVII, *Fig.* 1; (8) XLIII, *Figs.* 1A and B; (9) XXXVII, LXX, *Fig.* 1; (10) LXVII, *Fig.* 2.

ware bricklets), which if finely levigated or roughly washed could produce various crackles at will (10).

No attempt will be made here to describe in detail the vast mass of underglaze blue and *famille verte* enamel pieces, which were the most typical product of the period. The thousands of these pieces which reached Europe in the eighteenth century were the production of the private kilns of Ching-tê Chên; many betray by their shape and decoration that they must have been made for export; (1) others which do not show any modification to suit European taste must have been made for the contemporary Chinese market (2) including the well-known 'birthday' cups and plates[14] (3).

It is to be hoped that one day it will be possible to put some chronological order into the vast ranks of these blue and white and *famille verte* pieces. Perzynski alone has made some attempt to classify the blue and white into families. His theory is that the hand of certain artists of strong individuality can be detected in the decoration of these pieces by careful study. He would like to attribute to certain hands the stock designs such as the 'hawthorn pattern' (actually plum blossom); the 'tiger lily' pattern (the ragged leaves suggest they are really chrysanthemums); the slender ladies (the *mei jên*) called by the eighteenth-century Dutch 'Lange Lijsen' and by the English 'Long Elizas'. Working along these groupings[15] he divides the K'ang Hsi motives into five groups. But this line of investigation does not lead to any result. The patterns in the K'ang Hsi stock pieces were copied by the thousand. Some were the work of individuals, while others passed through many hands; and the names of these decorators, who were by Chinese standards merely artisans, will never be known. The style of most of the blue and white is cold, polished and even monotonous because of its mass production, but there are individual pieces of great artistic quality (4). It has lost the spontaneous vigour and freedom of the Ming, but gained a symmetry and balance in decorative effects. The shapes of the best pieces are distinguished, the glaze faultless, the paste of the highest quality. Probably the most striking quality of the best of these pieces is their intense, luminous, pulsating, azure blue; which has never been equalled. The secret of this seems to have been the selection and grinding of the cobalt.[16]

Nanne Ottema believes that the finest of these pieces were made round about 1700. If the piece had not been glazed properly after painting or was over-fired in the kiln, the blue would turn black or run.

Plates: (1) XXX, *Fig.* 2, XXXI; (2) XXVIII, XXX, *Fig.* 1, XXXII, XXXV, *Fig.* 1, LV, *Fig.* 2, LVII, *Fig.* 2; (3) XXV, *Figs.* 1A and c, XXIX; (4) XIX, *Fig.* 1, XXI, *Fig.* 1.

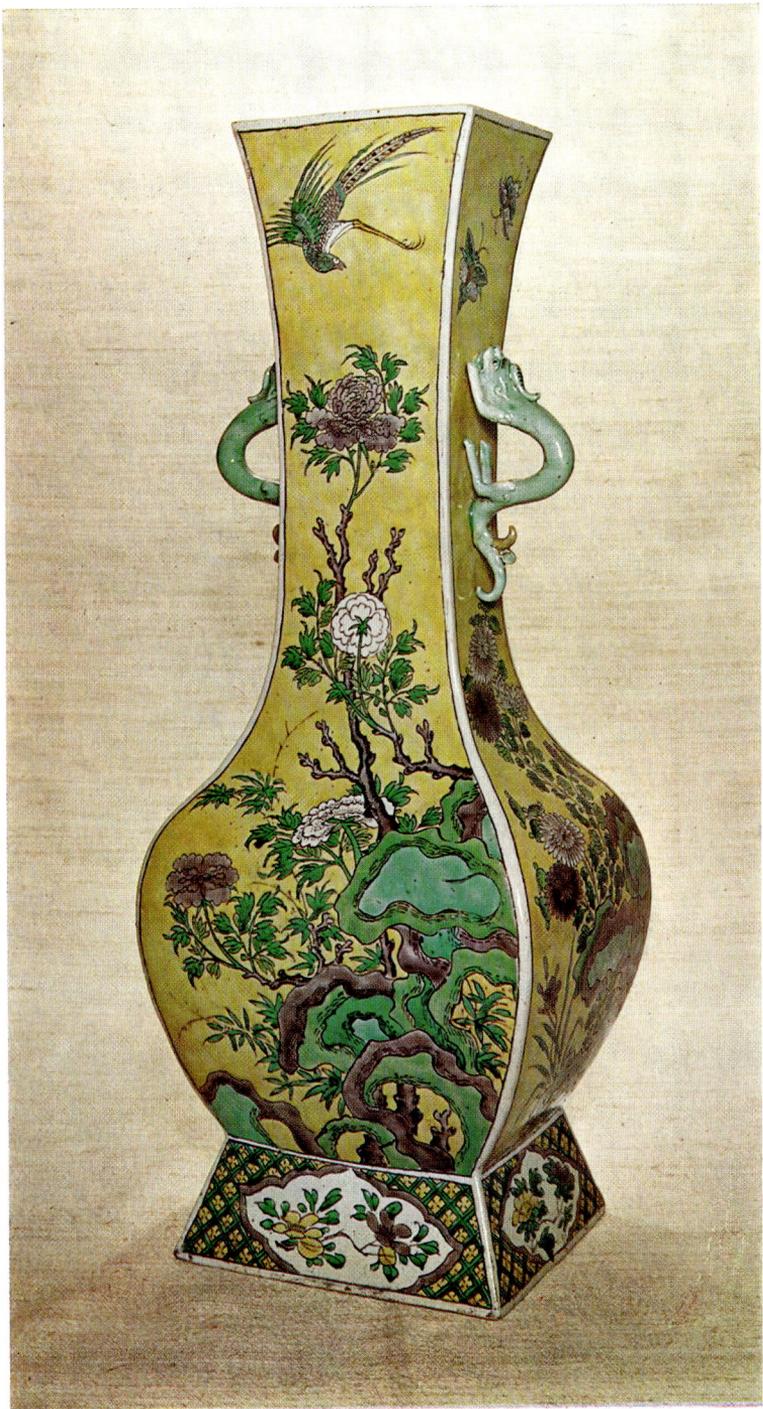

C. *Vase with lizard handles, decorated in green and aubergine enamels.
with areas reserved in white, on a yellow ground. No marks;
K'ang Hsi period. Ht. 20·5 in.
Victoria and Albert Museum. See page xii*

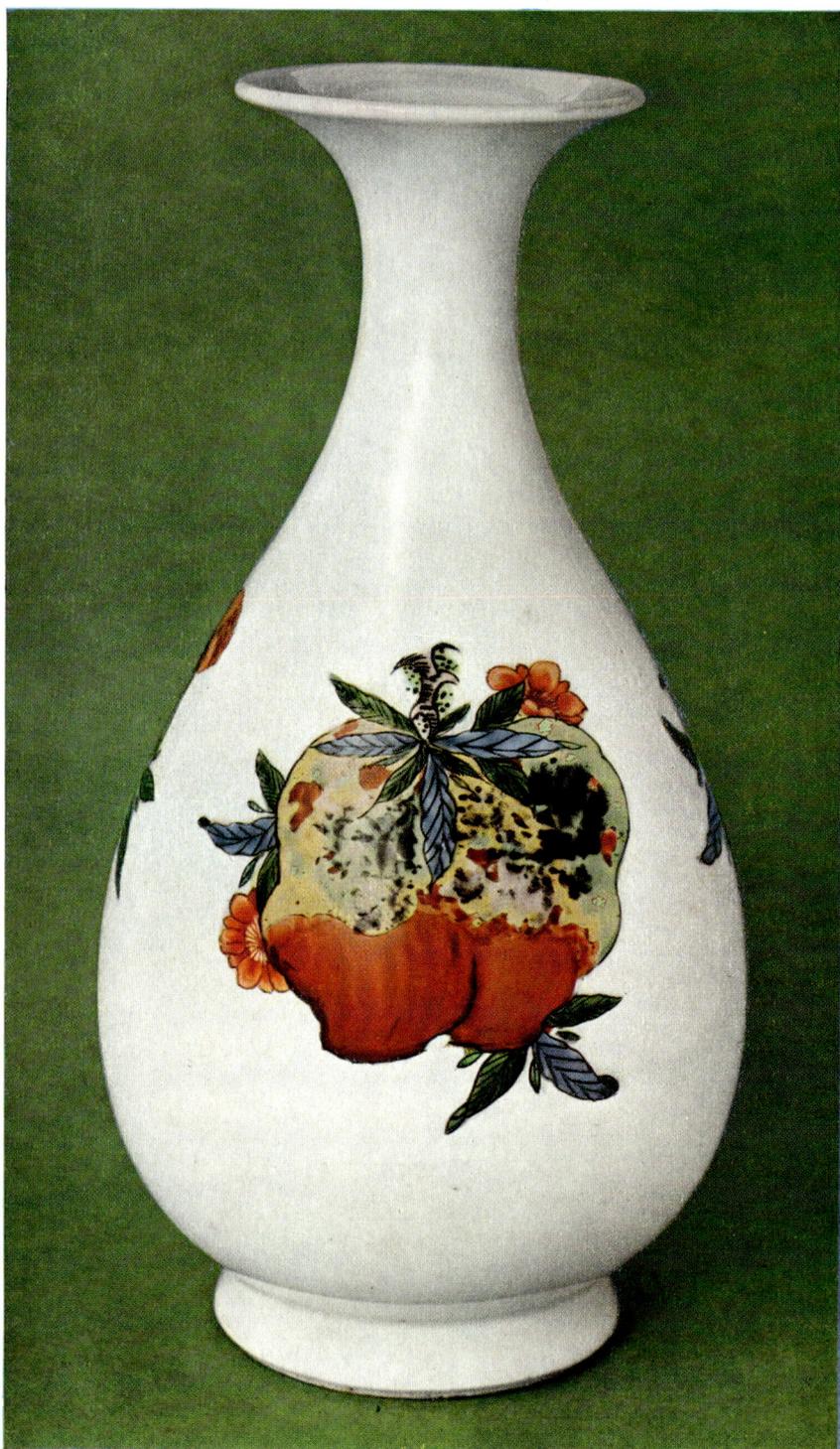

D. *Vase, decorated in enamels with peach, pomegranate, and finger citron. No marks; K'ang Hsi/Yung Chêng transition. Ht. 9·2 in. Ex Stephen Winkworth Collection. See pages 35, 58*

The underglaze copper red was always more difficult to handle. In the Chia Ching and Wan Li periods it was replaced by the overglaze iron red (*fan hung*), which was cheaper and easier to work. In the reign of K'ang Hsi it reappears as the *Yu li hung* (glaze enclosed red) (1). Evidently Louis Le Compte had a poor opinion of its merits, for writing in 1686 he says: 'The painting is not one of the least beauties of the porcelain. For that purpose one may make use of all colours, but commonly they use red and much more blue. I never saw any vessel whose red was lively enough; it is not because the Chinese have not very lovely red but perhaps because the most lively and subtle parts of this colour are imbibed by the roughness of the matter on which it is laid. . . . As for the blue they have it is most excellent. . . . There are some fine ones made at this day and I have seen in some Mandarin houses whole services that were superfine.'[17] Perhaps private kiln ware was the better because the Emperor did not pay enough. This underglaze red is combined most attractively and effectively in the reigns of K'ang Hsi, Yung Chêng and Ch'ien Lung with underglaze blue (2) and a celadon green (3). This to my mind is one of the most attractive familes of the period.

In the coloured enamel wares the Wan Li *wu ts'ai* were the forerunners of the *famille verte* palette. The chief change is that the traditional underglaze blue of the Ming, which evidently suffered in the subsequent refirings which were necessary, was exchanged for the famous overglaze violet blue enamel, also derived from cobalt, which deposits a thin lustre on the surrounding glaze, whose presence is hailed quite rightly as a sure sign of genuineness and is the delight of every amateur.[18] Both the enamels and the glaze on the rougher *famille verte* pieces are apt to chip and scale; particularly the rims of the plates, but this defect seems to have been corrected by the use of a special glaze. The chronology of the *famille verte* family is only sketchily established; the stronger and rougher pieces are in shape, colour and body, the nearer they usually are to the Ming period (4).

Another technique popular in the K'ang Hsi period is the old Wan-Li *san ts'ai* (the three colour enamels of Wan-Li) lead glazes applied to biscuit. The colours were green, yellow and aubergine with a black outline. These pieces were fired in the muffle kiln. This technique was widely used for figures—particularly of Buddhist Divinities, Taoist Immortals (5), children (6) and models of birds (such as parrots and hawks), kylins, and dogs of Fo; in the figures faces and hands are of unglazed biscuit. The raised folds and borders of the clothes of these figures were used to limit the field of individual

Plates: (1) XXII, *Fig.* 1; (2) XXIII; (3) XXI, *Fig.* 2; (4) X; (5) XXXIII, *Fig.* 2; (6) XXXIII, *Fig.* 1.

colours and to prevent them from running together. Later imitations of the biscuit pieces often produce nice problems of connoisseurship.

Another K'ang Hsi innovation was lacquered porcelain inlaid with mother of pearl; the *lac burgauté* of the French and the *Lo tien tz'ŭ* of the Chinese. In view of the Chinese horror of a *mao ping* (hair crack or small defect) in a piece of porcelain and the infinite trouble which is often taken to conceal these deficiencies, probably many of these lacquered pieces have defects, covered by their shell and lacquer coating.

The *famille noire* group has in the past occupied a place entirely out of proportion to its interest or aesthetic value (1). In these pieces the black pigment was covered with a thin transparent green glaze which produced an iridescent sheen. Because these pieces were costly to produce, as repeated firings often destroyed them in the kiln, they have commanded prices in the West which no other Chinese porcelain has been able to secure. Their desirability has produced many imitations, made not only in China and Japan but also in Europe. The best of these are usually blue and white K'ang Hsi pieces, in which the design has been ground away and the vase repainted in the *famille noire* palette. These pieces may deceive those who rely on an inspection of the base of a specimen to form a judgment.

An invention of importance dating from towards the end of the K'ang Hsi period and attributed to Ts'ang is that of the *famille rose* enamels, which in the next reign replaced the admiration for the *famille verte*. These enamels were a European invention, but the exact date of their introduction into China is still unknown. Honey writes: 'The opaque rose-pink colour, which was later to give its name to the *famille rose*, was introduced into China at some undetermined date towards the close of the reign of K'ang Hsi. It was of foreign origin and had in fact been in use in Europe for scarcely half a century before its adoption in Chinese porcelain. Its discovery dates from about 1650, when Andreas Cassius of Leyden produced from gold chloride and tin the rose purple colour named after him. The first use of the colour in pottery was probably made by Nuremberg enamellers such as Wolf Rössler ("the Monogrammist W.R.") about 1680. The rose-pink and other opaque colours associated with it were known as *yang ts'ai* ("foreign colours") or *yüan ts'ai* ("soft colours") to the Chinese, who have obscurely referred to Western enamelling ("*fa lang*"), either *cloisonné* or painted in the Canton manner, as the source from which they were derived. It has recently been argued from the Chinese side that the term "*fa lang*" definitely referred to *cloisonné* enamel and

(1) *Plate* XXVI, *Fig.* 1

that wares with the "foreign colours" were made from the twentieth year of K'ang Hsi (1682). While this date seems impossibly early, it seems certain that the rose-pink and crimson were at the disposal of the Chinese potter for some time before the end of K'ang Hsi's reign.'[19]

These 'foreign colours' can be seen creeping into the *famille verte* decor on such pieces as the big plate (1) decorated in both the *famille verte* and the *famille rose* in a subsidiary capacity. A bowl in the British Museum with ruby sides and a painting of flowers and fruit within (2) bears a cyclical mark corresponding to the year 1721 on the base in underglaze blue, showing that the ruby back technique so closely associated with the next reign, that of Yung Chêng, was fully developed before the closing years of K'ang Hsi.[20] The beautiful vase (Colour Plate D) belongs to this transitional period.

The K'ang Hsi pieces which reached Europe in the eighteenth century were almost without exception the output of the private factories of Ching-tê Chên, although the bulk of them do not seem to have been modified in shape and decoration to meet European tastes. Before the last war, these pieces could be best studied in the great collection brought together by Augustus the Strong, King of Poland and Elector of Saxony, in Dresden. This collection was until 1939 on exhibition in the Johanneum. The inventory dates from 1721. In this inventory numbers with letters and signs indicate the class to which the piece belonged, according to the classification adopted at that time. 'W' is used for 'White Saxon'; 'R' for 'brown Saxon'; a cross for Japanese, an 'H' written sideways for white Chinese (*blanc de Chine*) —usually Tê-hua specimens; a wavy line or lines indicates Chinese blue and white and powder blue; a 'P' for black Indian (this was Chinese). An angle was used for the *krachporzellan* or 'old Indian ware'. This appears on a variety of pieces, but particularly on Kakiemon and Oriental pieces both Chinese and Japanese, decorated in Holland. Honey points out that the divisions were entirely unreliable and that the presence of the Meissen inventory cipher 'W' on a specimen is no proof of Meissen manufacture. Mistakes also took place. There is in the Victoria and Albert Museum a Chinese cup marked with the 'W' and 'R'. An interesting little Chinese cup in the British Museum carries on the base an imitation of the underglaze blue crossed swords of Dresden (3).

Augustus the Strong did not die until 1733; it would be safe to assume that nearly all the Collection mentioned in the inventory was bought by him at the fairs of the Compagnie des Indes in Leipzig.[21]

Plates: (1) XLVI, *Fig.* 2 (*Colour Plate* E); (2) LIX, *Fig.* 2; (3) LIX, *Fig.* 1B.

'It is unlikely that any additions were made after the Yung Chêng period.'[22] Two sales of duplicates in the Dresden Collection which occurred between the two wars, one in 1919 and the other in 1920, have scattered pieces from this collection far and wide (1). Unfortunately the number and cyphers on the Oriental and European specimens, other than those made at Meissen, were roughly cut into the glaze on the base of the pieces. These marks have been forged, as such an origin would give a piece a certain standing on the Continent. But even if this had not occurred it does not seem that the cyphers would lead to the discovery of any definite date at which each piece was acquired. This collection remains (or remained) to students the most important documentary collection of K'ang Hsi porcelain in Europe; although the masterpieces of the imperial kiln were not represented there.[23] Later dedicatory pieces in the reign are known (2).

A large number of blue and white, monochrome and enamel pieces if the K'ang Hsi period are marked with the *nien hao* of the reigns of Hsüan Tê, Ch'êng Hua, and Chia Ching of the Ming period. Some pieces even carry a Yung Lo mark, and there is a series of blue and white saucers marked Hung Wu, which may have originated in the K'ang Hsi period. The *nien hao* of Wan Li apparently never appears on K'ang Hsi pieces, though it is found on Yung Chêng ones.

It seems strange that in a period in which ceramic creation was at its height Chinese potters should have looked back to the Ming period as the classic yet unobtainable model. It is difficult to say how many of their pieces were meant to be imitations of the earlier periods. The mark of Ch'êng Hua even occurs on *famille noire* pieces and *lac burgauté* techniques quite unknown at that time. It is as if the potters were saying 'This vase is so good, that it might have been the production of the Hsüan Tê or Ch'êng Hua period'. This habit is reflected in modern Chinese blue and white, which often carries K'ang Hsi and Ch'ien Lung marks, which could not hope to deceive even the most ignorant amateur. Some of these K'ang Hsi pieces with Ming marks may be accounted for by the legislation of 1677, which forbade the use of the K'ang Hsi *nien hao*, but it is not generally believed that the decree was closely observed or was in force for any length of time.[24] The exact range and quality of the deliberate copies of Ming pieces in the eighteenth century have still to be determined (3).

Of the Yung Lo pieces the white *t'o t'ai* (bodiless pieces) were copied in this reign together with the *ya shou pei* (press hand cups)

Plates: (1) XII, *Fig.* 1, XXX, *Fig.* 2; (2) XII, *Fig.* 2; (3) IX, *Fig.* 1c, XIV, XV, XVI, *Fig.* 2, XVII, *Fig.* 2, XIX, *Fig.* 2, XXII, *Fig.* 2, XXIV, XLVI, *Fig.* 1, LXIII, XCV; (4) XLIII, *Figs.* 1A and B.

of the same reign. 'In later copies (4) the size of the foot is often smaller in proportion, but in the K'ang Hsi period excellent reproductions were made, it is only by the drawing, the glaze on the base and the footrim that some of these can be identified. However, when one compares the K'ang Hsi pieces together with the Yung Lo originals, in sunlight if possible, there can be little doubt which is the finer. The glaze of the K'ang Hsi pieces is smooth and regular; the body is exactly moulded; the shape, and the colour chalk white. . . . The base of the K'ang Hsi piece is of uniform white. The footrim of the Ming piece is almost invariably finished with a knife, that is cut to leave a flat surface, neither wedge-shaped nor rounded. The Ch'ing potters preferred a rounded footrim, which appears to have been smoothed with the finger or a brush while the foot was still soft.'[25]

The K'ang Hsi copies of the *hsien hung* (fresh red) bowls of the Hsüan Tê period are often excellent in glaze and colour. But Brankston believed with some reason that it is possible to recognize most of them either by the writing of the *nien hao*, (in which the characters of the later pieces are less regular and rectangular) and by the pallor or uniformity of the blue in which they are written. He points out that the most striking characteristic of the Hsüan Tê dishes and bowls is that they have slightly undulating convex bases, whereas their Ch'ing copies are perfectly flat underneath. The same features present themselves in the K'ang Hsi imitations of Hsüan Tê and Ch'êng Hua blue and white (1). It would appear that in the Yung Chêng period they were able to copy far more successfully the famous *Su ni p'o*[26] blue of the originals (2). Reproductions in Ming (3) and archaic bronze (4) style continued throughout the century. Decoration in Hsüan Tê style is found also in underglaze red (5), while the use of tomato (iron) red as a ground persisted, in the Ming tradition (6) and later with the new 'foreign' colours well into the nineteenth century (7).

The K'ang Hsi copies of the Ch'êng Hua period provide without question one of the most difficult problems of Chinese ceramics. 'Many of these copies are easily recognizable, but others are so good that if it was not for the K'ang Hsi mark, they would be easy claimants to the Ch'êng Hua period.'[27] In those K'ang Hsi copies carrying a Ch'êng Hua mark, the colours themselves were applied in washes over an outline of underglaze blue so that the drawing is difficult to judge. The

Plates: (1) XIV, *Fig.* 2, XVI, *Fig.* 2, XVII, *Fig.* 2; (2) XIX, *Fig.* 2, LXIII; (3) XIV, *Fig.* 1, XV, XCI, *Fig.* 1, XCV; (4) IX, *Fig.* 1B, XLVI, *Fig.* 1; (5) XXII, *Fig.* 2, XLVI, *Fig.* 1; (6) XVIII, *Fig.* 2; (7) XLV.

most fashionable colours for the period are the *tou ts'ai* (fighting enamels), once improperly but so much more appropriately known as the bean enamels. 'In some ways, the copies are nearly equal to the originals.'[24] (1).

The *T'ao Shuo* describes no less than eight different classes of Ch'êng Hua cups. There are wine cups painted with figure scenes and lotus flowers; wine cups 'painted in blue and white'; small cups 'decorated with flowers and insects' (no colours given); shallow cups decorated with fine sacrificial utensils; wine cups again decorated with 'a high flowering silver candle lighting up beauty', which refer to a damsel holding up a candle to a *hai t'ang* flower; brocade design cups, and others decorated with swings, with dragon boats in procession; with famous scholars, with playing children, with a trellis of grapes; with fragrant plants; with fish and waterweed, with gourds and aubergine fruit, with lotus and Buddhist emblems; with the *Yu po lo* flower and with Indian lotus scrolls.

A great many of these designs have still to be identified. Two of these cups decorated with melons in *tou ts'ai* enamels and with Ch'êng Hua marks, from the Oppenheim Collection are illustrated (2). Between them is another cup in the same enamels decorated with *ju-i* emblems and carrying a K'ang Hsi mark. One of the melon cups is decorated with touches of red only on the melons, and the other with larger bunches of grapes and melons with touches of red on both. There seems to be little to distinguish the right-hand piece from its K'ang Hsi neighbour, either in the colour of the enamels, the calligraphy of the *nien hao* or in the finish of the foot. The real difficulty lies with the second melon cup, which is decorated with a slightly more luminous green enamel. The *nien hao* on this piece is large and clear, as opposed to the *nien hao* on the other melon cup which is small and dark. It (number two) is written in pale blue and according to Brankston who illustrates a similar piece 'in a handwriting distinct from any other Ch'êng Hua pieces'. He refuses to commit himself on the date, contenting himself with the tantalizing comment: 'If this cup is of the Ch'êng-hua period then the cup with red enamel dragons, which was lent to the International Exhibition by the Chinese Government, must also be so, for the marks are identical.'[29] In the case of these two cups can the writing of the *nien hao* be used to draw a distinction in date between the two pieces, and are both pieces K'ang Hsi? It is possible the second cup is sixteenth century but it may be of the period of its mark.

Plates: (1) XLVIII, A, LXXI, *Fig.* 2, LXXII, *Fig.* 1; (2) XXIV, *Figs.* 1A and C; (3) XXIV, *Fig.* 2.

The same difficulty arises in two cups decorated with birds on branches in underglaze blue (3). The right-hand piece is clearly K‘ang Hsi, but is the left-hand piece (despite the pockets of glaze on its foot and different calligraphy) a genuine Ch‘êng Hua piece or also a K‘ang Hsi copy? The drawing of the bird and the colour of the blue is quite different to that on a stem cup from the Wu Lai-hsi collection which seems to me to have far stronger claims.[30] This piece, if it is not K‘ang Hsi, may be sixteenth century or again a genuine Ch‘êng Hua piece. The little cup (1) is not the period of its mark.

How far can we rely on certain characteristics in the writing of the *nien hao* in Ch‘êng Hua, or for that matter in any other pieces, to distinguish the date? Two characteristics of the writing of the character Ming, as distinguishing features of the Ming pieces as opposed to their eighteenth-century copies have been cited.[31] In one there is a tendency to square the sun radical on the left and in the other to produce a curved tail in the moon radical on the right, these characteristics being lacking or less developed in the genuine pieces. There is no doubt that these points are noticeable; the question for the connoisseur to decide is whether there are not so many exceptions to these as to invalidate them.[32]

The mark of the Hsüan Tê calligraphers is usually recognizable, but at least one of the late Ming amateur potters, Hao Shih-chiu, who we have no reason to believe did not copy Hsüan Tê pieces among others, is believed to have been an expert calligrapher.[33] According to Brankston 'the output of the Imperial factory (during the period) cannot have been very large and one man would almost certainly be sufficient to inscribe all the articles manufactured during one day. The handwriting of three or four different persons is recognizable during this period'.[34] Did this statement spring from his own observation or from some Chinese text?

He goes on to say of the Ch‘êng Hua pieces that 'with a very few exceptions the writing on the Imperial wares appears to be the work of one man. This is not as unlikely as it sounds, since the Imperial factory may have produced only a very little during the early years of the reign'.[35] If this is true, there should be no difficulty about dating the Kitchener bowl, which almost certainly is an imperial piece. But Brankston avoids this issue!

Another problem piece is the little covered box with a Ch‘êng Hua mark (2) which I have already referred to as belonging to the same family as the Cosmo Monkhouse box (both K‘ang Hsi before 1683).

The Ch‘êng Hua chicken cups present the greatest variety of all.

Plates: (1) XLIII, *Fig.* 1c; (2) XXV, *Fig.* 1b; (3) CX, *Figs.* 3b and c.

There would appear to be late Ming, K'ang Hsi, Yung Chêng, and Ch'ien Lung copies of these cups besides inferior modern imitations (3). It must not be forgotten in dealing with Ch'êng Hua imitations that Nien Hsi-yao was famous for his copies of Hsüan Tê and Ch'êng Hua pieces in the reign of Yung Chêng. The separation of these from the K'ang Hsi copies of the same subject is a problem still to be undertaken. In addition there is no question that many Ch'êng Hua pieces were copied in the Ming period, and this may provide the solution of several problem pieces.

Another problem arises from the underglaze blue Palace bowls of the Ch'êng Hua period decorated with scrolls of hibiscus or lilies. Brankston says of this family:—'It would appear that in the K'ang Hsi period the potters and draughtsmen were able to imitate Ch'êng Hua pieces so well that little difference is noticeable'.[36] Each of these bowls must be judged on its own merits (1).

Genuine Ch'êng Hua pieces may be much fewer than we like to admit, and conversely a greater proportion are K'ang Hsi copies than we like to allow. Nor can the possibility be ruled out that some of these copies were made later in the Ming period by such gifted amateur potters as Ts'ui Kuo-mou[37] (Old Mr Ts'ui), Chou T'an-ch'üan[38], or Wu Wao, whose pseudonym was Hu yin Tao jên (the Taoist hermit of the teapot). Two of these amateurs lived in the reigns of Hung Chih and Lung Ch'ing. Chinese opinion seems to vary as to the quality of these reproductions, and Europeans have still to identify them. The problem here is to assess the Chinese descriptions of their work.

(1) *Plate* XVII, *Fig.* 2.

1. Kuo Pao-ch'ang records the year as 1682. The *T'ao Lu* gives 1683 and adds that Ts'ang was accompanied by a label writer Ch'ê Erh-tê whose calligraphy it may be possible to identify.

2. Quoted by Bushell, *Oriental Ceramic Art*, p. 306.

3. Bushell, *loc. cit.*

4. Julien's translation of the *T'ao Lu*, p. 107, and Sayer's translation, p. 48.

5. *Illustrated Catalogue of Chinese Government Exhibits for the International Exhibition of Chinese Art in London*, 1935, Kuo Pao-ch'ang, vol. II, p. 28.

6. T'ang Ying says 'The ancient method of applying the glaze was to cover the vase . . . with a goat's hair brush, filled with liquid glaze, but it could hardly be evenly distributed. . . . The round vases were dipped into the large jar which held the glaze, but they became too thickly or too thinly covered, and, besides so many were broken that it was difficult to produce perfect specimens. In the present day the small round pieces are still dipped into the large jar filled with glaze, but the vases and the larger round vessels are glazed by blowing. A bamboo tube is cut one inch thick and some seven inches long, and the mouth is covered with fine gauze, which is dipped into the glaze, and then it is blown through from the other end.

The number of times that the process has to be repeated depends on the size of the piece and on the kind of glaze, varying from a maximum of seventeen to a minimum of three or four.' Bushell's translation from the *T'ao Shuo*, p. 21.

7. Most of which soon wore off!

8. Little interest was taken in Chinese monochrome in eighteenth-century Europe, except in France. Hence the adoption of French descriptions of the glazes.

9. Which exist in a wide range of glazes ranging from chocolate to chestnut; from coffee to dead leaf brown, through old gold to straw.

10. Bushell, *Oriental Ceramic Art*, p. 350. Another translation of this passage is given by Burton, *Porcelain, its Art and Manufacture*, p. 112.

11. A passage in Book IV of the *T'ao Lu* reads—'The *t'o t'ai* or bodiless pieces are thin. They were first made under Yung Lo, but Yung Lo preferred thick pieces (!). To-day these are commonly called "semi-bodiless". In addition to these there is a class of ware as thin as bamboo paper. In order to mark the distinction people call this "true bodiless". These were introduced by the unofficial kilns during the time of Ch'êng (Hua) and also during Lung (Ch'ing) and Wan (Li). But Lung and Wan preferred the eggshell pattern and limited themselves to a single pure white hue, not like the present-day pieces, which are chiefly variegated in colour.' Sayer's translation, p. 32.

12. In the Yung Chêng list of 1732 we are told'Only one kind (of Ting) is copied, *Fên Ting*; the other variety, the *T'u Ting* (the earthy Ting) is not imitated.' (Bushell, *Oriental Ceramic Art*, p. 370.)

13. Bushell, *Oriental Ceramic Art*, p. 349. And cf. Burton, *op. cit.*, p. 96.

14. These birthday plates are painted with miniature-like precision in delicate iron-red and green enamels with figure groups or more commonly with birds on a fruiting bough. They seem confined to dishes of various sizes with flattened rims bearing a brocade border in pale iron-red and gold interrupted by four medallions each with one of the seal characters 'Wan Shou wu chiang' (A myriad longevities without ending). The belief that they were made for K'ang Hsi's sixtieth birthday which occurred in 1713 is well-established among Western collectors at least and has lately been given fresh currency by Lady David in her introduction to Section 2 of the David Foundation Catalogue, which states that this ware, devised for this occasion, was among those which Lang T'ing-chi, then Governor of the Province of Kiangsi, was commanded to have made and sent up to the capital. Hobson, how-ever, scouted the story, writing (*Later Ceramic Wares of China*, p. 36) 'there is no foundation for this picturesque story, and the plates would have done equally well for any other birthday anniversary' as might the so-called 'birthday' cups decorated in underglaze blue and enamels with flowers of the seasons, which belong to quite a different family, though painted in the same delicate style and the best of them being clearly of the same date as the plates. It would be interesting to know the evidence associating either of these groups with K'ang Hsi's sixtieth birthday.

15. Perzynski, *Burlington Magazine*, Oct. 1910–Mar. 1911.

16. T'ang Ying writes: 'The material comes from the province of Chekiang where it is found in several mountains within the prefectures Shao-hsing Fu and Chen-hua Fu. The collectors who go into the hills to dig for it wash away the earth which adheres to it in the water of the mountain streams. The mineral is dark brown in colour. The large round pieces furnish the best blue and are called "best rounds"; distinguished in addition by the name of the place of production. It is brought by merchants to the porcelain manufactory and is buried by them under the floor of the furnace, roasted for three days, and washed after it is taken out,

before it is finally offered for sale, ready for use. This material is also found in different mountains in the provinces of Kuangsi and Kuangtung, but the colour produced by these kinds is comparatively pale and thin and is unable to support the fire, so that they can be used only for painting coarse ware for sale in the market. . . . The blue material, after it has been roasted, must be specially selected, and there is a particular class of workmen whose duty it is to attend to this. The superior kind selected is that which is dark green in colour, of rich translucent tint and brilliant in aspect. This is used in the imitation of antiques, for the monochrome blue glaze and for fine porcelain painted in blue. When of the same dark green colour, but wanting somewhat in richness and lustre, it is used for the decoration of the coarser porcelain made for sale. The remainder, that has neither lustre nor colour, is picked out and thrown away . . . With regard to the preparation of the colour for the artists, it must be ground perfectly fine in a mortar; if coarse, spots of bad colour will appear. Ten ounces of the material are put into each mortar, and it is ground by a special class of workmen for a whole month before it is fit to be used. The mortars used for grinding it are placed upon low benches, and at the sides of the benches are two upright wooden poles supporting cross-pieces of wood, which are pierced to hold the handles of the pestles. The men, seated upon the benches, take hold of the handles of the pestles and keep them revolving. Their monthly wage is only three-tenths of an ounce of silver. Some of them grind two mortars, working with two hands. Those who work till midnight are paid double wages. Aged men and young children, as well as the lame and the sick, get a living by this work.' T'ang Ying, quoted by Bushell, *Oriental Ceramic Art*, pp. 436–8, 440.

17. *Memoirs and Remarks on the Empire of China* by Louis Le Compte, 1686. Translated by Benjamin Tooke, 1698. Published 1737 and 1738, pp. 152–4.

18. The belief that this overglaze enamel does not antedate the Ch'ing dynasty, although an excellent general rule, is untrue. Hobson has noticed and recorded experiments in this glaze on a Wan Li piece. See R. L. Hobson, *Pottery and Porcelain*, vol. II, p. 85.

19. William Bowyer Honey, *The Ceramic Art of China and other countries of the Far East*, pp. 151–2. See also Footnote 20 on page 95.

20. But even cyclical year dates must be treated with some caution, although one would have supposed that they would provide respectable evidence of the period or at least imply an exact copy of an earlier piece. For there is in the Salting Collection a typical *famille verte* vase, inscribed on the base in underglaze with the cyclical year date of the first year of Ch'êng Hua whose style absolutely precludes it being a copy of a Ch'êng Hua specimen, as the shape and type of decoration were entirely unknown in Ming. It can hardly be assumed that the mark was added for purposes of fraud as no informed collector could have been possibly deceived. See Honey, *K'ang Hsi vase with a Ming cyclical date*. Artibus Asiae MCMXXVIII/XXIX, No. 2/3, p. 166.

21. There is a tradition that the Elector obtained the enormous vases—one yard high and more—from the Queen of Holland in barter against a regiment of grenadiers, from which is derived their name 'Grenadiervasen'.

22. Hobson, *BM Handbook*, Ed. 1937, p. 77. The bulk of the Chinese porcelain in the Dresden Collection was, however, unquestionably K'ang Hsi.

23. Its fate is still uncertain, but the Johanneum was destroyed during the Second World War and the collections themselves have disappeared.

24. We do not hear of it ever being officially rescinded.

25. Brankston, *Early Ming wares of Ching-tê Chên*, p. 9. This is a very discerning description.

26. *Su ni-p'o* (sometimes written *Su-ma-ni* and *Su-ma-li*) is generally identified with the Island of Sumatra. By the time of Ch'eng Hua the pigment is said to have been exhausted. It was replaced later by the equally famous *Hui Ch'ing* (Mohammedan blue), which seems to have come from Yunnan. This in its turn was exhausted before the end of the Ming dynasty.

27. Brankston, *op. cit.*, pp. 36, 37.

28. *ibid.*, p. 37. Brankston displays the same dexterity in wisely avoiding the direct issue of date in his description of the famous Kitchener bowl now in the David Foundation, of which he says:'There are some points in it which differ from any other known Ch'êng Hua *t'ou ts'ai* pieces. . . . There are K'ang Hsi pieces of quality equal to this, but yet it is different from most of the K'ang Hsi copies.' *Op. cit.*, p. 42.

29. *ibid.*, p. 42.

30. This piece which has a Ch'êng Hua mark is in the British Museum.

31. 'The Nien hao and period identification,' *O.C.S. Trans.* 1935–6 and 'Second thoughts on dating Ming porcelains', *O.C.S. Trans.*, 1942, by Edgar Bluett.

32. The *nien hao*, for instance, on the plate 20(*b*) illustrated by Brankston in *Early Ming Wares*, which Brankston apparently accepts as Hsüan Tê would appear to me not to conform very happily to these rules.

33. 'In the Ming period there was Hao Shih-chiu a man of Fou-liang, a capable singer and expert calligraphist and draughtsman, who hid himself behind the potter's wheel. He made elegant pots of refined porcelain with superhuman skill and called himself "the old man who hid in a pot".' *T'ao Lu*, bk. 8, Item 24, Sayer's translation, pp. 78–9.

This is the potter who was famous for his 'floating dawn' (*liu hsia*) wine cups and his eggshell (*luan mo*) tea cups.

34. Brankston, *op. cit.*, p. 22.

35. *ibid.*, p. 38.

36. *ibid.*, p. 46.

37. 'Ts'ui Kung was an expert potter in the time of Chia [Ching] and Lung Ch'ing. He chiefly reproduced pieces made in the methods handed down from Hsüan [Tê] and Ch'êng [Hua]. Contemporaries thought them better than the originals and called his creations Ts'ui-Kung ware porcelain. People from all quarters competed to buy them. Of all his pieces the wine cups alone differed in size from Hsüan and Ch'êng models, but they were their equals in quality. As for the rest, both the variegated and the "blue and white" were just the same.' *T'ao Lu*, bk. 5, Sayer's translation, p. 46.

38. 'Chou Tan-ch'üan of Wu-mên was cleverer than his fellows and an intimate of the great officer T'ang. Each time that T'ang visited Ching-tê Chên in Kiangsi he would reproduce an antique pot which would set the gossips talking. Its marks and its glaze would be so exactly like the genuine article that only a real expert could distinguish the "pearl from the fish eyes".' *T'ao Lu*, bk. 8, item 19, Sayer's translation, p. 77.

4

THE DIRECTORSHIP OF NIEN HSI-YAO. 1726-36

It was not until four years after the second letter of D'Entrecolles that a new Commissioner, Nien Hsi-yao, was appointed as Superintendent of the Imperial Factory by the Emperor Yung Chêng, who as heir apparent had taken considerable interest in ceramic production. D'Entrecolles mentions his purchase of porcelain musical instruments and Bushell considers that much of the elaborate work which distinguished the closing years of K'ang Hsi was due to his interest. Throughout his reign of thirteen years, sandwiched between the sixty years of his father and predecessor K'ang Hsi and the sixty years of his son and successor Ch'ien Lung, he continued to send specimen glazes from the palace collections to be reproduced at the imperial kilns at Ching-tê-chên.

The appointment of Nien Hsi-yao was made in the fourth year of Yung Chêng's reign and as he continued in office till the first year of Ch'ien Lung, his directorship almost exactly spans the Yung Chêng period and all its finest ceramic productions are associated with his name. Little is known about his previous official career, except that like his predecessor he was a member of the Nei Wu Fu (The Palace Office of Works), from which all three of the famous directors were recruited. Two years after his appointment as Superintendent he was promoted Commissioner of Customs at Huai-an-fu, where from that date onwards he resided. From these Custom chests he was allowed an annual grant of 5,000 taels for the upkeep of the imperial factory; later this was increased to 20,000. He held these two posts until 1736 when he was promoted again and replaced by T'ang Ying, who in 1728 had been sent to assist him. According to the *T'ao Lu* Nien personally selected the material for the porcelain made at the factory during his period of directorship and personally superintended the process of manufacture. But after he had been promoted to Huai-an-fu he can only have been able to make periodic tours of inspection, because of the distance, and T'ang Ying (though nominally only his deputy), must have exercised considerable control as the resident in charge at Ching-tê Chên and was probably responsible for many of the

44

innovations of this period attributed to his chief. According to the *T'ao Lu* 'the vases made at this time included very many of soft eggshell colour and well-rounded form, the glaze of which shone with the lustre of pure silver. Some were decorated in blue and white, others in colours, and the various processes of painting, engraving, modelling under the glaze, and carving in pierced work, were all practised in turn. The reproduction of ancient wares and the invention of novelties were all undertaken at the factory under his (Nien's) direction.[1] Kuo Pao-ch'ang contents himself with the remark that he (Nien) had an abundance of fine material and experienced workmen to do his bidding.[2] After his transfer the porcelain made for the use of the emperor was sent by boat by his orders twice every month from Ching-tê Chên to be inspected by him at Huai-an-fu and then forwarded by him to Peking.

The worship of the local god of the potters seems to have played an important part in the life of the community. There were three temples inside the factory. One of these was the shrine of the Protector of the potters, and another dedicated to Kuan-ti, the god of war. Of the third temple called the Chên Wu-tien we have no further details. Outside the factory there was the Shih Chu Temple (the Temple of the Head teacher). In 1727 Nien repaired the temple of the local god of the kilns[3] and erected a tablet recording the fact.

It is also recorded that Nien wrote a book the *Shih Hsüeh* ('Visual Learning'[4] published in 1735 on foreign perspective, in which he proclaims himself a pupil of Lang Shih-ning (Castiglione).

The reign of Yung Chêng is famous for its monochromes, many of them copies of the famous Sung wares and also for its use of *clair de lune* (*yüeh pai*) and *soufflé* red glazes. New inventions attributed to Nien include the *cloisonné* blue, also referred to as the sapphire blue (*pao shih lan*) and the tea dust (*ch'a yeh mo*) (1) produced by the insufflation of green enamel upon a yellow brown ground, which owes its colour to iron. This glaze was much prized in the reign of Ch'ien Lung[5] and sumptuary laws were made restricting its use to the emperor. Nien was also famous for his copies of 'hidden designs' (*an hua*)[6] and his openwork (*ling lung*) of earlier reigns. An advance in the control of transmutation glazes (*yao pien*) and the invention of painting porcelain in ink black designs touched with gold (*ts'ai shui mo*) date from this reign (2). D'Entrecolles describes in his last letter written in 1722 how attempts had been made to paint Chinese vases in the finest ink, but in vain, as the ink vanished with the heat and the porcelains came out undecorated! Another novelty was the robin's

Plates: (1) CIV, *Fig.* 2; (2) XLVII, *Fig.* 1, LVIII, LXXVII, *Fig.* 1.

egg glaze (*chün yu*) a greenish blue flecked and dappled with red. It was said to bear a resemblance to the Kuangtung and Yi-hsing copies of Chün ware (1).

The porcelains of this reign have a particular elegance of shape and delicacy of colour which some may find cloying (2). The glaze tends to be whiter than that of K'ang Hsi, the moulding at the foot vanishes and the brim becomes sharper. A bright turquoise blue, reminiscent of Chia Ching, together with an apple green (3), a pale yellow (4), a mauve and various crimsons and pinks provide a delectable palette, which is not difficult to recognize on the finer pieces, in which daintiness makes up for any lack of vigour (5). In the earliest pieces the *famille verte* enamels if not in the ascendancy, are still present (6), but as the reign proceeds the painting becomes sharper and more meticulous and the crimson becomes deeper and more dominant and less transparent until it becomes the muddy crimson pink of the coarser Ch'ien Lung export plates, so common in our country-houses. The fine blue and white pieces of this reign are still underrated (7).

The influence of the West is now more noticeable, even in the pieces made for the Imperial Court. 'New copies of the Western style of painting on enamels (*fa-lang*) the landscapes and figure scenes, the flowering plants and birds, are, without exception, of supernatural beauty and finish'[7] are mentioned. The penetration of the influence must have been largely due to the Jesuits. It is probable that Father Verbiest helped K'ang Hsi to set up the Palace workshops in Peking in 1680 for the production of the minor arts. As early as 1712 D'Entrecolles was approached by the Mandarins of Ching-tê Chên with a demand for European novelties which might be copied for the Court. The two Jesuit painters, Gherardini and Belleville, had arrived in 1699, and later Attiret and Castiglione (who arrived in 1715) attached themselves to the Imperial Court and acquainted the Chinese with the use of shadows and European perspective.

There exists a most important piece of documentation of the wares of the period in a list—now known as the Yung Chêng list—entitled 'An old list of the different colours of the Round and Square porcelain and of the vases made for the Emperor.' first published in 1732 in the *Chiang-hsi T'ung Chih* (The general description of the Province of Kiangsi.) This list, compiled by the orders of Hsieh Min, Governor of the Province, between 1729 and 1732, was the work of T'ang Ying, who succeeded Nien as Superintendent in 1736. For a long time this

Plates: (1) CIV, Fig. 3B; (2) XLIX, A, LV, *Fig.* 1; (3) LXVIII, *Fig.* 2; (4) XXXIX; (5) LVII, *Fig.* 1, LIX, *Fig.* 1A, XC, *Fig.* 2; (6) LV, *Fig.* 2, LVII, *Fig.* 2; (7) LX, LXI, LXII, *Fig.* 1.

list masqueraded as the work of Hsieh Min, because the revised and remodelled edition of the *T'ung Chih* published in 1880 ignored the name of the author. But as Sir Percival David has pointed out, the list forms part of T'ang Ying's inscription on the 'Stone Tablet giving a brief Account of the Ceramic Industry', compiled in 1729.

This list does not pretend to enumerate all the Palace wares, but as the Editors say, 'with respectful reference to the production of the imperial porcelain manufactory, among the ornamental vases and jars, the vessels for sacrificial wine and for meat offerings, the dishes, bowls, cups, and platters for ordinary use, ordered to be sent in annual notation to the palace, there are so many different kind of things, that it would be impossible to attempt to enumerate them all. We will extract from Hsieh's Description. . . . a list of fifty-seven kinds given there, in order to give a general idea of the porcelain of the time.'[8] This list then was not a list of pieces sent down from the Palace to be copied, but a representative, although not inclusive, selection of the pieces made for the Palace. It might be a copy of an annual or half-yearly invoice of porcelain made for the Palace (for such invoices must have existed) or a précis of several of them, which was incorporated as a sample in the pages of the *T'ung Chih*.

It might be expected that the annual indents of the porcelain ordered for the Palace would have been preserved from the founding of the imperial kiln in 1369 or 1398 up to the fall of the Ch'ing dynasty. The *Fou-liang-hsien Chih* according to Bushell gives annual indents from the eighth year of Chia Ching.[9] From the list Bushell extracts the indents of the years 1546 and 1554; but it is not clear from his statement whether the indents for the rest of Chia Ching's reign remain and what happened to the indents of the reigns that followed.

The *Chiang-hsi T'ung Chih* also gave a list of porcelain requisitioned for the Palace in the third year of the reign of T'ung Chih (1864). The list contains fifty pieces and appears in the *T'ung Chih* immediately after the Yung Chêng list. It is difficult to understand why only these odd lists remain. If only either the *Annals of Ching-tê Chên* or the Palace Records could supply such lists from the time of Chia Ching onwards it would go a long way towards establishing a chronology for the imperial wares.

The Yung Chêng period was the period of the finest copies of the monochromes of the Sung period and the underglaze blue of the Hsüan Tê period. The Ch'êng Hua pieces were also extensively copied, but these were probably not as fine as the copies of K'ang Hsi.[10]

'The official factory under the supervision of T'ang Ying during the reigns of the Emperors Yung Chêng and Ch'ien Lung, manufactured

wares after the reputed vessels of the various dynasties. Such objects as the white Ting, the Tung, the Chün, the Ju, the Kuan, the Lung Ch'üan, the Ko, the Ti, and the Hsiang-hu wares of the Sung dynasty and also those manufactured in the periods of Yung Lo, Hsüan Tê, Ch'êng Hua, and Hung Chih of the Ming dynasty, were all followed without exception, all being finely executed.'[11] Actually only seven pieces in the Yung Chêng list are described as copies of pieces sent from the Palace. Others are described as 'copies of the old'; others again as copies of wasters from disused kilns, or merely copies.

The copies of Ju, Kuan, and Ko ware made by Nien or T'ang were evidently very close indeed to their originals. It is often very difficult to distinguish them, and they are in their own way equally admirable. Some of them are of the quality of the Ju bottle (Plate V in the *David Collection Catalogue*), which was accepted as Sung even by the Chinese Palace Authorities, until the impressed mark of Yung Chêng was discovered cunningly concealed under the glaze, and covered by the incised mark of Yung Pao. This piece, but for the mark, would pass as Sung in many quarters to-day.

Most private collections of Sung monochromes contain one or more of these eighteenth-century imitations, but it would be invidious to call attention to unpublished specimens. Mr. W. W. Winkworth in a review[12] of the *David Collection Catalogue* has been bold enough to list a number of these specimens in this collection. I have not handled these pieces for some time, but my inclination is in agreement with his estimates. They include besides the Ju bottle just mentioned, a Kuan type bottle illustrated on Plate VI[13] (regarded by Hobson as doubtful); a Kuan vase, Plate VIII;[13] another Kuan bottle and a vase, Plates X and XI;[13] yet another Kuan bottle, Plate XII;[13] and a bowl Ko or Kuan, Plate XIX.[13] The last piece is catalogued by Hobson as a Ching-tê Chên copy probably of Ming date.[14] Whenever a monochrome piece of this category is found with a mark erased from the base, it is in my experience invariably an eighteenth-century copy, the deletion of the mark enabling it to masquerade as Sung.

There is a marked tendency among Yung Chêng imperial pieces, to find the *nien hao* ground away or otherwise obliterated, particularly on these copies of the Sung monochromes. No doubt many of these pieces have been stolen by eunuchs or concubines, and when sold out of the Palace they were defaced to avoid detection, but when this occurs on imitations of the Sung period it was probably so that the objects might be sold as Sung. It was at one time supposed that eighteenth-century copies were of white porcelain dressed with a dark slip to imitate the iron body of the Sung ware; but a Kuan type vase

THE DIRECTORSHIP OF NIEN HSI-YAO

(1) with the Ch'ien Lung mark given to the British Museum by Sir Harry Garner shows that a special dark body was sometimes used, while still greater confusion and difficulty are caused by the assertion of the Director of the Palace Museum that the Sung Kuan ware was sometimes made of a light coloured clay washed over with a dark ferruginous clay.

The Yung Chêng list includes no less than thirteen copies of Sung glazes.[15] The first group of these is—

'Glazes of the Ta-kuan period (1107–10) of the Sung dynasty with iron paste.' These are assumed by Bushell to be copies of Kuan Yao, which came to be called Ta-kuan Yao after the Ta-kuan period, in which they were made; but in view of the ritual disc of Ju ware in the David Foundation with an inscription of the first year of Ta-kuan, their identity remains uncertain. According to Hannover the eighteenth-century copies of Kuan (2) were produced not only by the smaller factories at Ching-tê-chên, but also at Lung-ch'üan. More modern counterfeits may come from Japan. In the Yung Chêng list these copies are divided into three different colours:

(a) pale blue (*yueh pai*); (b) pale green (*fên ch'ing*); (c) dark green (*ta lü*)—all of which were copied from specimens sent down from the Palace.

'Ko Yao glazes, with iron paste' in two colours, (a) rice colour; (b) pale blue or green. These again were copies of specimens sent down by the Palace Authorities, of the wares originally made by the elder Chang at Liu-t'ien in Lung ch'üan in the Sung period. The 'Taoist hidden in the teapot' who lived in the reign of Wan Li had previously been celebrated for his copies both of Ko and Kuan!

'Uncrackled Ju ware—copied from the colour of the glaze of two pieces of the *Sung* dynasty—a cat's food basin (*mao shih p'ên*) and a mask-shaped dish (*jên mien hsi*)'. The former of these pieces has been identified by the Palace Authorities[16] as a narcissus bowl (*tz'u hsi*) of *tung ch'ing* (Eastern green) ware. The second piece has never been identified. Modern wares from Ju-chou are still sold in Peking under the title of 'Blue as the sky after rain'. In the older Japanese publications the term is invariably used to describe all the ying ch'ing glazed pieces; Harada's excavations at Liu Ju Hsien (old Ju Chou) in 1931 might seem to identify this ware as Northern celadon. But although Northern celadon fragments may be common on Ju sites this does not prove they are Ju.

The copy of another Ju chou glaze; this one with a fish roe crackle. Chekiang celadons vary tremendously in body, shape and crackle.

The White Ting glaze. 'Only one kind is copied, the *Fên Ting*;

Plates: (1) LXIV, *Fig.* 2; (2) LXIV, *Fig.* 1, LXVI.

the other variety, the *T'u Ting*, (earthy Ting) is not imitated.' This statement is supported by the *T'ao Lu*. Koyama locates the original habitat of these wares as Chien-tz'u-ts'un in Central Hopei, where he excavated pieces with both incised and moulded designs. But it is probable that the latter style is more representative of the Ting yao made at Ch'i-chen in the later Sung, after the migration of some of the Ting potters.[17]

The white Ting wares of the Sung period have been imitated at all periods. Copies were made by the goldsmith P'êng Chun-pao in the Yüan dynasty and by Chou Tan-ch'üan of the Wan Li period, long before Nien or T'ang tried their hands at them. The *Po Wu Yao Lan* says 'The new censers modelled in the form of the four legged sacrificial *ting* of the ancient sovereign *Wên Wang* and the bronze bowl-shaped *yi* with mask handles of monsters' heads and halberd shaped "ears" are in no way inferior to the original productions of the Ting-chou potters and they may even be mistaken for genuine old specimens, if the gloss of the furnace has been removed by friction. The best are those made by Chou T'an-ch'üan'.[18] Honey, who does not appear to rank these copies very highly writes: 'What appear to be Ming versions of the Ting ware are usually smooth and lifeless copies of bronze forms, with insignificant incising or moulded low-relief decoration'[19]; but he admits that in the eighteenth century the almost slavish devotion to past styles shown by Yung Chêng and his son Ch'ien Lung, coupled with the skill of T'ang Ying, led to the making of many pieces which can hardly be distinguished from their Sung originals. Three Ting water pots in the *David Catalogue* (Plate XCVI)[13] fall into this class; two of them are already catalogued as eighteenth and seventeenth century respectively. A third piece, a bag shaped vase (Plate XCVII)[13] Winkworth places in the same category,[12] while two clumsy pieces (Plates CIII and CIV)[13] he describes as modern.[20] Later pieces of Ting, usually of the Kiangnan Ting type, usually large and heavy with a yellowish white crackled ostrich-egg appearance and brown stains with little or no decoration, continually turn up in the market. Some of these are eighteenth century and others undoubtedly quite modern, although they are apt to be given early attributions. Many of these pieces I believe came from provincial kilns in Anhui and Fukien. Japan turns out, or did before the war, many counterfeit Ting bowls, which are quite correctly unglazed on the upper rim, though they never in my experience bear a copper ring. Rücker Embden tells us that in order to counteract the excessive shine on modern pieces the Chinese rub their specimens with the worn-out shoe-soles of rickshaw coolies!

The Chün glazes. These were a speciality of T'ang Ying who was

famous for them. Five varieties of them are described, (*a*) rose crimson, (*b*) Pyrus japonica pink, (*c*) aubergine, (*d*) plum-coloured blue, (*e*) mule's liver mingled with horse's lung, as copied from specimens in the Palace Collections; the other four 'taken from new acquisitions' are described as (*f*) dark purple, (*g*) rice coloured, (*h*) sky blue, (*j*) furnace transmutations. Some of the brilliant successes in the originals and in the copies must have been due to hazard. It is noticeable that nearly all Chün pieces are labelled either Sung or modern copies—a few inferior pieces being thrown into the Yüan period—on the principle laid down by Vignier—'When in doubt call it Yüan.' Yet 'It is clearly established that the factories at Chün Chou, near Kaifeng in Honan, so celebrated for their mixed-colour glazes in the Sung dynasty, continued through the Yüan and Ming periods. But how to differentiate the productions of the several centuries is a problem at present practically insoluble. It is customary to relegate the rougher wares of Chün type, those with coarse stoneware bodies of buff, red or brown colour, to the Yüan dynasty, and collectors hitherto have scarcely taken into account the possibility of any of them being Ming'.[21] It is doubtful whether all those Ming copies were confined to the soft Chün pieces, as has hitherto been supposed. To distinguish these copies from those eighteenth-century counterfeits is usually quite easy. The piece reproduced (I) would deceive nobody. But no very clear idea exists of the range of the best of T'ang Ying's copies of Chün. Is it possible that several of those famous Chün bulb bowls with numbers on the base will eventually be numbered among them? But there are immense practical difficulties in copying anything which cannot be mechanically produced, such as moulded shapes and drawn designs. In pottery, the same ingredients should produce the same results. But even two samples of clay from the same site may be different enough to affect the glaze. Modern potters can seldom repeat their effects; and it is surprising how well the Sung potters maintained their glazes. It must be admitted that the best eighteenth-century copies of porcelain which can be at present identified fall by far short of their originals. The Yung Chêng potters appear to have resorted to *soufflé* cobalt to obtain their colour, but they did obtain the shapes.

Lee[17] believes that Chün was closely associated with the Kuan and Ju wares. He even goes so far as to label illustrations of what have hitherto passed as typical Chün pieces as Kuan-Chün Yao. The similarity between green Chün and Northern celadon ware has already been remarked upon by Hetherington.

(I) *Plate* LXV, *Fig.* 1.

Some reference may be made at this point to the stoneware of Tz'ŭ Chou although it was not included in Yung Chêng's list and has never ranked very high in Chinese eyes. Enormous numbers of these pieces which still rank as Sung, Yüan or reluctantly as Ming must have been made in the reigns of K'ang Hsi, Yung Chêng, and Ch'ien Lung. This family, which comes from Tz'ŭ Chou in the southern corner of Chili, is without a rival in age or continuity. Professor Koyama has described a large Sung Tz'ŭ Chou site near Peng-chou-chên in Southern Hopei which he visited in 1941. But this ware was made all over N. China in the Sung period. As Lee says: 'The term Tz'ŭ Chou should become a broad generic classification for the geographically all-pervasive stoneware made for all levels of society in North China during the Sung dynasty. This stoneware can be divided into two basic types; the one covered with white slip and usually decorated and glazed transparently or more rarely glazed in yellow, olive, or green, the other (which is covered with brown to black glazes of the iron family) is often decorated with 'sgraffiato designs. One or more varieties of the type of family occur with only slight variations at nearly all the Northern Sung kiln sites.'[17] This ware seems to have been in existence, without any serious break in tradition, since the Sung period. Rücker Embden says he saw waggon loads delivered at Honan fu in the 1920's. The type in which the decoration is cut through a dark brown glaze is one that has been particularly favoured by copyists. To determine the date we must be in a position to refer to dated and documented Ch'ing pieces and of quite modern times. 'There will always be great difficulty in dating them (these wares) on account of the continuity of the old traditions. If the merchant had his way every Tz'ŭ Chou piece would be Sung, a manifest absurdity. Collectors are more disposed to admit that the Ming dynasty must have furnished a proportion of the existing examples, but even they are slow to allow the very strong probability that a still larger proportion date from the Manchu period.'[22]

In the same way the tradition lingered on among the *temmoku* glazes in Honan and Fukien. Certain provincial types in these glazes must have been made in the Ming and perhaps even in the Ch'ing; they usually show their origin by their shape, but sometimes they might belong to any period.

Two shades of the Lung-ch'üan glaze, pale (*ch'ien*) and deep (*shên*), were also copied. These do not appear to be difficult to distinguish from the Sung specimens. They were 'brighter, neater and more glossy' than their Sung prototypes (1).

(1) *Plates* XL, *Fig.* 1 and XLI, *Fig.* 1; both pieces are K'ang-hsi.

The celadon potteries of Chekiang appear to have been totally destroyed in the so-called Tartar wars, which K'ang IIsi waged at the beginning of his reign. That they never recovered from this blow must be because the taste for Ming blue and white had already conquered the Mohammedan world.

Another group, which were apparently of the celadon type, appear under heading eight as *Tung ch'ing* (Eastern green) glazes. This glaze is also enumerated in the Tung Chih list.

The productions of the rice-coloured glazes of the rubbish heaps at Hsiang hu from the Sung dynasty and imitations of pale blue-green pieces from the same site. The *Fou-liang-hsien Chih* describes this site as twenty *li* East of Ching-tê Chên. 'There are many broken fragments on the ground (there) which are thin bodied and of *mi sê* (the colour of unhusked rice) and *fên ching* (pale blue).' Brankston was unable to visit this place in 1937 because of bandits, but succeeded in obtaining a series of fragments from this kiln site, including pieces with a porcellanous body and a thin dull olive green glaze, which were probably imitations of Yüeh ware of the T'ang dynasty; other shards had a *ying ch'ing* glaze and blue and white decoration.

Reproductions of various Ming porcelains account for twelve other headings in the list. The earliest of these is copies of Yung Lo porcelain, including eggshell (*t'o t'ai*) or bodiless wares (the bodies of these pieces are sometimes so thin that they seem held together by two layers of glaze) of plain white and with engraved or embossed decoration. These specimens are well known to collectors. The Yung Chêng copies were not equal to the K'ang Hsi pieces made in the same vein.

Copies of the porcelain of the reign of Hsüan Tê run into several items. The first of them is headed 'Reproductions of the copper-red of *Hsüan-tê* porcelain. . . . (*a*) the clear red (*Hsien hung*) and (*b*) the ruby red (*Pao shih hung*)' (1). Branston remarks that the *Hsien hung* appears to be less sensitive to the heat of the furnace than the *Pao shih hung*. He adds: 'The seventeenth- and eighteenth-century copies of these are very good; and, so far as glaze and colour are concerned, equal to the originals in many cases. The mark is written differently on the copies, many so badly written that they may be dismissed at once. The best copies err in having marks that have been too carefully written, the characters are too regular and rectangular; in the *hsüan* character in particular the strokes are all either vertical or horizontal. When in blue the mark is too pale and uniform in tone.

(1) *Plate* LXV, *Fig.* 2.

The most striking characteristic of the Hsüan-tê dishes and bowls is that they have slightly undulating convex bases, whereas the Ch'ing copies are perfectly flat inside and underneath.'[23]

Another item runs 'Copies of *Hsüan-(tê)*' porcelain decorated in ruby red, (*a*) with three fishes, (*b*) with three fruits, (*c*) three *ling chih* (the sacred fungus), (*d*) five bats, symbols of happiness. These pieces (1) again are very difficult to distinguish from their originals. A stem cup in the British Museum Collection, previously labelled Hsüan Tê, is more likely to be a Yung Chêng copy on account of shape and glaze (2). The dating of these stem cups is one of the greatest problems of Chinese ceramics, and here we often find Brankston and Winkworth questioning Hobson's attributions. The stem cup with an underglaze red fish on it (Plate CXXXVIII in the *David Catalogue*), accepted by Hobson as Hsüan Tê, is in the opinion of Winkworth either K'ang Hsi or Yung Chêng. Nor would Winkworth accept the honey pot and cover (Plate CXXXVII)[13,24] decorated in underglaze blue and red, with a dragon amid waves and a Hsüan Tê mark on the back, as of the period. It must be admitted that the waves are stiff, the designs badly drawn. Design and glaze are not bad, but the blue is not like an early blue. A similar honey pot is reproduced on Fig. 139, p. 66 of a recent Exhibition of Ming blue and white in America (published in the *Philadelphia Museum Bulletin of* 1949). This piece also has a Hsüan Tê mark, but is described in the catalogue as of the Wan Li period, though I suspect that it is an eighteenth-century copy. The blue and white honey pot from the Oppenheim Collection, without a mark, imitating Hsüan Tê (3) has also been dated sixteenth century, but was more probably made about 1730. It is of the stem cups that Nanne Ottema writes 'These so-called stem cups, decorated with red fish which appear to be swimming in a greenish tinted glaze, were so successfully imitated in the eighteenth century that only when they carry a reliable government mark have they been properly distinguished'.[25] Unfortunately the marks are not reliable![26]

The Hsüan Tê monochrome reds are not easy to distinguish from their copies. In the Monochrome Exhibition of the Oriental Ceramic Society two saucer dishes illustrated this problem.[27] Winkworth, in his review of this Exhibition in *Oriental Art*,[28] is in direct opposition to the committee of the Society over the attribution of both these pieces. Others have questioned the genuineness of the red bowl reproduced by Honey as perhaps Hsüan Tê on Plate 100(*b*) in his *Ceramic Art of China*. There is, among other difficult pieces, an unmarked monochrome red stem-cup in the Victoria and Albert Museum, which

Plates: (1) XLIII, *Fig.* 2; (2) XLIII, *Fig.* 2A; (3) IX, *Fig.* 1C.

does not show enough glaze on the base to be identifiable. But most of these problem pieces betray themselves after study, either from shape or colour, or by comparison with reliable examples. Depth of foot and glaze are two criteria.

'Reproduction of the deep blue of *Hsüan-tê* porcelain. The colour of this glaze is deep and somewhat reddish; it has an orange-peel texture and palm eyes.'[29] These deep violet blue copies of the monochromes of the Hsüan Tê period are quite numerous; usually correctly marked, they sometimes carry a Hsüan Tê *nien hao*. The list also contains reproductions of the pure white pieces of the Hsüan Tê period. (1) Copies of these pieces seem to be rarer than the originals, while in the case of the red and blue monochromes the originals are much harder to come by.

Curiously, the Yung Chêng list makes no mention of copies of Hsüan Tê blue and white, a ware extensively reproduced from 1683 until well into the nineteenth century. The genuine Hsüan Tê blue, as Brankston says, 'seems to be suspended in the glaze and does not cling to the body of the ware.'[30] It displays irregular vibrant pools and splashes of black, because the cobalt was not over-refined. These deep flushes of dark blue merging to black were more difficult for most of the eighteenth-century imitators to reproduce, as the source of the supply of the original blue had been lost. The Hsüan Tê blue and white was far more difficult to copy and far easier to distinguish from its copies than those of the Hsüan Tê monochrome reds. The Ch'ien Lung copies in which the extra blue has been stippled on to imitate the accidental imperfections of the genuine pieces are hopelessly poor. But there are some copies which may be of Yung Chêng manufacture which present the most tempting plausibility.[31] The finer copies are very artistic, but seldom really convincing. The outline may be correct, but the touch of the drawing is rarely so sensitive. Photographs of them may easily deceive.

Another class of Hsüan Tê ware which was imitated is described as 'Copies of porcelain of the reign of *Hsüan-tê* with painted designs on a yellow ground'. This yellow glaze Brankston believes was an invention of the Hsüan Tê period. Unfortunately it is very easy to add this yellow ground to Hsüan Tê blue and white pieces. Pieces redecorated in this way usually disclose the fact when examined for scratches. New about this time are the yellow-ground bowls with green enamel decoration of dragons or boys at play (2).

Two items in the list deal with copies of the Ch'êng Hua period. The first of these is 'Copies of porcelain of the reign of *Ch'eng-hua*

Plates: (1) LXII, *Fig.* 2; (2) LXIX.

decorated in five colours', the second is 'Blue and White Porcelain with the decorations pencilled in pale blue'. The first class evidently refers to the copies in *tou ts'ai* enamels, a palette which was constantly copied from Ch'êng Hua onwards to the end of the Ming (1). It is not easy to distinguish copies in this style from originals. There are also nineteenth-century imitations of quite good quality.

The Chinese have always placed a very high value on the enamelled wares of Ch'êng Hua. Somewhat curiously, a number of fine pieces outlined on pale underglaze blue and clearly intended for enamelling in tou t'sai (2) have come down to us untreated, possibly because the enamelling was done elsewhere. From the time of Ch'êng Hua's reign onwards every man of taste would have liked to put Ch'êng Hua *tou ts'ai* ware cups before his guests, and they must therefore have been copied on a large scale. Their price was very high before the close of the Ming dynasty. The Emperor Wan Li is supposed to have had a pair always on his dinner table, which he valued at 1,000 oz. of silver.[32] The author of the *Po Wu Yao Lan* says: 'In the highest class of porcelain of the reign of *Ch'êng-hua* there is nothing to excel the stemmed wine-cups with the shallow bowls and swelling rims decorated in five colours with grapes; these are more beautiful even than any of the cups of the *Hsüan-tê*. Next to these come the wedding-cups decorated in colours with flowers and insects, or with a hen and chicken, the wine-cups of the shape of a lotus-nut painted with figure scenes, the shallow cups decorated with the five sacrificial utensils, the tiny cups with flowering plants and butterflies, and the blue and white wine-cups that are as thin as paper'.[33] The author of the *Yeh Huo Pien* was struck dumb with astonishment at seeing Ch'êng Hua wine cups sold for no less than a hundred taels of fine silver a pair. While Chu Yi-tsun, the author of the *P'u Shu T'ing Chi (Memories of the Book Sunning Pavilion)* who lived at the beginning of the Ch'ing period is quoted by Bushell as saying: '(I) often went, while staying at Peking, to the fair at the Buddhist Temple Tz'ǔ-ên-ssu, where rich men thronged to look at the old porcelain bowls exhibited on the stalls there. Plain white cups of *Wan Li* porcelain were several taels of silver each, those with the mark of *Hsüan-tê* or *Ch'êng-hua* ranged from twice as much and more, up to the chicken cups, which could not be bought for less than five twenty-tael ingots of fine silver, yet those who had money did not grudge it, estimating the porcelain of this period as more valuable than the finest jade.'[34]

Two other items in the Yung Chêng list are (a) 'Copies of porcelain of the reigns of *Wan-li* and *Chêng-tê* decorated in five colours' and (b) 'Copies of Chia (-ching) Porcelain painted in blue'. The Wan Li five-

Plates: (1) XLVIII, B, LXXI, LXXII, *Fig.* 1; (2) LXXII, *Fig.* 2.

coloured pieces decorated in underglaze blue and enamel colours are not hard to distinguish. Eighteenth-century copies of these pieces in the form of *potiches* with lids are not uncommon. The copies of the Chêng Tê period Bushell describes as 'archaic style. . . . in coloured glazes, which were laid upon the unbaked paste, worked in outline and chiselled'.[35] The blue and white of the Chia Ching period was distinguished by a deep, strong blue, the Mohammedan blue from Yunnan. Satisfactory copies of these pieces do not appear to exist.

The Yung Chêng list goes on to enumerate a large number of copies of the K'ang Hsi glazes, including reproduction of the eelskin yellow; the snakeskin green; the spotted yellow; the turquoise glazes flecked with purple and gold attributed to Ts'ang Ying-hsüan; the oil green glaze; the *clair de lune*; the *soufflé* reds and blues; and copies of the porcelain painted in yellow with chiselled designs. Copies of the K'ang Hsi yellow monochromes (1) and the brown monochromes, both plain and engraved, are recorded. Coral red pieces (*mo hung*) 'reproduced from old pieces' are another item (2). Porcelain painted in silver (*mo yin*) usually on a copper ground, is also mentioned. This silver enamel was so fugitive and so easily erased that little trace of it has survived. Some of the porcelain decorated in underglaze red also appears to have been copied from K'ang Hsi prototypes, and has K'ang Hsi marks. This fact is mentioned in the list. The coffee-coloured glazes (*tzŭ chin*) of the K'ang Hsi period were still popular and the list refers to two shades 'copies of coffee-brown glazes'. Lastly copies of monochrome green with and without engraved designs and copies of mirror black (some with decoration on white reserved on the black ground, and others with the black ground pencilled over in gold), complete the list of K'ang Hsi copies mentioned.

Among the new inventions attributed to Nien is a glaze described as 'the Chün (-chou) glaze of the muffle stove. The colour of this is between that of the Canton pottery ware and that of the enamel of the Yi-hsing "boccaro" stoneware and it excels these in its markings and in the changing tints of its flowing drops.'[36] This must either have been a copy of one of the Chün or Kuangtung glazes (3) or perhaps the robin's egg glaze, so common in the Ch'ien Lung period, but this does not flow. Copies of Lung Ch'üan glazes decorated in ruby red are described as a new process. These pieces were decorated with three fish, three fruits, three sacred fungi or three bats. Pieces decorated with three fruits in copper red, with dark underglaze blue leaves on a celadon ground, are the commonest. The outlines of the leaves are

Plates: (1) XXXVI, *Fig.* 2; (2) XXV, *Fig.* 2c, LXVIII, *Fig.* 1; (3) LXV, *Fig.* 1, CV, *Fig.* 1.

sometimes touched in with cobalt blue. The effect is very decorative.

The European colours, apart from the *famille rose*, included an opaque yellow, purple, red, green and black. Copies of the Japanese (*Tung Yang*) included porcelain painted in gold and porcelain painted in silver. This was a copy of the old Imari porcelain of Arita. Many of these Japanese pieces repeated the patterns of late Wan Li and had been given Ming marks. They were now re-copied by the Chinese, often for the European market. The list tells us that the Kuangtung wares and Yi-hsing wares of the Ming dynasty were copied. Also some unspecified items like porcelain with engraved designs, porcelain with embossed designs executed in undercut relief.

This reign must remain most famous for its *famille rose*, whose soft and delicate tints ranged from the deepest ruby red to the palest pink (1). On a background of the same ruby-red (2) the effect is apt to be excessive, and the fine and airy drawings of birds and flowers (3) or fruit (4) against a white background made for the Chinese market are very much more attractive than the excessively ornamental seven-rimmed ruby-backed plates made for the foreign market. It is also the period *par excellence* of a series of magnificent teapots decorated in Chinese taste (5). Unfortunately the foreign style becomes more and more prominent; the elements of light and shade and European perspective gradually begin to exert their influence. Many of these pieces were painted in Canton on porcelain which had been sent in the white from Ching-tê Chên by artists who were more accustomed to applying enamel colours to copper. Some of the porcelain from the studios of these enameller-painters is so thin that it has been christened eggshell. The style of painting is extremely delicate and often produces the effect of a European miniature on ivory. Representation of pheasants, (6) quail, (7) peacocks (8) and Chinese ladies and children (9) are the commonest themes. The decoration of cocks (10) combined with rocks and peonies is perhaps the commonest of all and it spells a rebus containing good wishes for fame, riches and honours. Even more distinguished than any of these is the imperial Yung Chêng bowl (Colour Plate G) painted on the outside in pale green, yellow and mauve enamels with a design of narcissus and *ling chih* fungus on a pale pink ground with a short poem in black characters on the reverse. This piece slightly resembles another imperial bowl in a pink ground (11) with K'ang Hsi mark in the Chinese National Collection.

Plates: (1) L, LI; (2) LIX, *Fig*. 1c; (3) LII, XCII, *Fig*. 1; (4) Colour Plate D, LVI, LXXVI, *Fig*. 2; (5) XLIV, *Fig*. 2, LXXIII, *Fig*. 2, LXXIV, LXXV; (6) XLIX, c; (7) LII, *Fig*. 2; (8) LIII, *Fig*. 2; (9) XLVII, *Fig*. 2, LXXVI, *Fig*. 1; (10) LIII, *Fig*. 1, LIV, *Fig*. 2; (11) XLIV, *Fig*. 1.

THE DIRECTORSHIP OF NIEN HSI-YAO

1. Quoted by Bushell, *Oriental Ceramic Art*, p. 362. See also Sayer's translation, p. 48.

2. Kuo Pao-ch'ang, Introduction to Vol. 2 of the *Illustrated Catalogue of Chinese Government Exhibits for the International Exhibition of Chinese Art in London*, 1935, p. 28.

3. It is of this god that T'ang Ying writes 'the porcelain industry gives subsistence to an immense number of people whose life hangs on the success or failure of the furnace fires, and they are all devout in worship and sacrifice. Their god, named T'ung, was once himself a potter, a native of the place. Formerly, during the Ming dynasty, when they were making the large dragon fish-bowls, they failed in the firing year after year, although the eunuchs in charge inflicted the most severe punishments, and the potters were in bitter trouble. Then it was that one of them, throwing away his life for the rest, leaped into the midst of the furnace, whereupon the dragon bowls came out perfect. His fellow-workmen, pitying him and marvelling, built a temple within the precincts of the imperial manufactory, and worshipped him under the title of the "Genius of Fire and Blast". Down to the present day the fame of this miracle is cherished, and the potters continue to worship him, not a day passing without reverential sacrificial offerings. Theatrical shows are also instituted in his honour during which crowds of people fill the temple grounds'. Bushell, *Oriental Ceramic Art*, p. 461.

4. A copy of this book is in the Bodleian Library. Mr. Sayer who has handled it tells me that he noticed two passages in it referring to Castiglione. The first ran 'I have recently got my figures from Lang Shih-ning', and the second 'Having had talks with the Western Scholar Lang Shih-ning I can now make Chinese drawings in the foreign style'.

5. When Bushell says quite incorrectly it was invented.

6. A curious feature of the period is the existence of a range of bowls and saucer dishes decorated with dragons *an hua* and also with sprays of flowers over the glaze, the two types of decoration shewing no awareness of each other's existence (Plate XXXV, Fig. 1).

7. Bushell, *op. cit.*, p. 388.

8. Bushell, *op. cit.*, p. 367.

9. Bushell, *op. cit.*, pp. 223–34.

10. The *T'ao Lu* gives the copies of Hsüan Tê and Ch'êng Hua as the speciality of Nien. The best copies of Hung Wu, Yung Lo, Chêng Tê, Chia Ching, and Lung Ch'ing, and Wan Li, and also those of the Hsiang Hu vessels of the Sung dynasty are credited to T'ang Ying. It is interesting to notice that such unlikely reigns as those of Lung Ch'ing and Wan Li seem to have been copied.

11. Kuo Pao-ch'ang, *op. cit.*, p. 30.

12. W. W. Winkworth, *The Burlington Magazine*, Dec. 1934; the *David Collection Catalogue*, p. 93.

13. These references are to the *David Catalogue*.

14. I feel that Hobson had he lived would have revised his opinion on several of the other pieces.

15. I use Bushell's translation from *Oriental Ceramic Art*, pp. 368–90, for the heading extracts from the Yung Chêng list, but not necessarily the order. The complete list is also given in Appendix A to Honey, *Guide to Later Chinese Porcelain*, 1927.

16. Sir P. David, 'A commentary on Ju Ware', *O.C.S. Transactions*, vol. 14 p. 51.

17. Sherman E. Lee, *Sung Ceramics in the light of recent Japanese Research* (1936–7). Artibus Asiae, vol. XI, 3, p. 166.

18. Bushell, *op. cit.*, pp. 273–4.

19. Honey, *Ceramic Art of China and other countries of the Far East*, p. 92.

20. To me, subsequent to his review of the David Catalogue. I am in agreement with this opinion.

21. R. L. Hobson, *The wares of the Ming Dynasty*, pp. 187–8. He continues, 'The pottery section of the K'ang Hsi Encyclopedia quoting from the official Ming records states that a "large supply of vases and wine jars" from Chün Chou and T'zŭ Chou were sent to the palace in the Hsüan Tê period and again in the year 1553 in the Chia Ching period. Further, we are led to suppose that the factory was in receipt of a subsidy up to the year 1563, when the tax hitherto levied on this ware was remitted and the subsidy simultaneously lapsed.'

22. *ibid.* p. 187.

23. Brankston, *Early Ming Wares of Chingtechen*, p. 26. Quite modern copies however may have the undulating convex base.

24. One of the rarest pieces in the whole David Foundation is the Hsüan Tê blue and red bowl reproduced on the same plate.

25. Nanne Ottema, *Handboek Chinesische Ceramick*.

26. There is however a stem-cup with red fruits on it in the Ashmolean Museum (Oxford) with a reliable Wan Li mark.

27. *Exhibition of Monochrome Porcelain of the Ming and Manchu Dynasties.* 27th Oct.–18th Dec., 1948, Nos. 129 and 130. O.C.S., Cat. pl. IV.

28. W. W. Winkworth, *Oriental Art.*, Vol. I, p. 186.

29. Bushell, *op. cit.*, p. 372. The orange skin refers to the undulating surface of this glaze, while the palm eyes are due to production of tiny bubbles in the glaze.

30. Brankston, *op. cit.*, p. 23.

31. It is usually assumed that Yung Chêng copies of Hsüan Tê blue and white are quite easy to detect. Certainly there is not much difficulty attached to detecting the difference between the Yung Chêng dish reproduced by Bluett on p. 57, *Oriental Art*, vol. 1, No. 2, 1948, and the original Hsüan Tê piece reproduced on the same page. The trouble arises over such pieces as the blue and white pilgrim bottle formerly in the Wu Lai-hsi Collection and now in the possession of Mrs. Walter Sedgwick, which would appear to be the bottle illustrated by Honey on Plate 87b of the *Ceramic Art of China*. If this piece is a Yung Chêng copy, as I believe it is, one cannot lightly dismiss the ability of the copyists!

Another bottle of this description but of not just the same quality is in the collection of Mr. de la Mare. Another piece, which from the illustration would appear to me to be of fine quality, is the *Yu shou fu* bowl illustrated by Brankston as a later copy, on Plate XI of his *Early Ming Wares*. It is difficult to detect the great difference in the drawing of the flowers and the attachment of their bases to the stems, which Brankston has pointed out as the distinguishing features between the two. But perhaps both these pieces are genuine.

32. Brankston, *op. cit.*, p. 40.

33. Bushell's translation, *Oriental Ceramic Art*, p. 207. Copies of the blue and white pieces are not uncommon, usually small wine or stem cups, miniature seal boxes or vases or tiny saucers, pencilled in a delicate grey blue. It is the originals which are rare.

34. Bushell, *op. cit.*, p. 209.

35. *ibid.* pp. 378–9.

36. *ibid.* p. 374.

5

THE DIRECTORSHIP OF
T'ANG YING (1736-1749 or 1753)

More is known about T'ang Ying than about any of his predecessors or successors. Not only was he the most famous of all the Directors of the imperial factory, but he was a profuse writer, who has left us his autobiography written in a highflown literary style. Among his many works, in addition to the Yung Chêng list compiled in 1729, are the *T'ao Ch'êng Shih Yu Kao* (Draft Instructions for the manufacture of porcelain) published in 1735[1] and the *T'ao Yeh T'ou Shuo* (a description with twenty illustrations on the manufacture of porcelain) undertaken by imperial command and published in 1743. He was also responsible for the *T'ang Ying Lung Kang Chi* (the Record of a dragon bowl); the *T'ao Ch'êng Chi Shih* (Records of completed pots), and the *T'ao Jên Hsiu Yü* (A potter's heartfelt words), besides some flowery poetic effusions.[2] And in 1915 a stone tablet was excavated at Ching-tê Chên, inscribed with the title 'Orders and Memoranda on Porcelain', in which he discusses his efforts to counterfeit bronze vessels.

T'ang Ying succeeded Nien Hsi-yao as Commissioner at Huai An and Superintendent of the Imperial Factories in 1736. He had already worked as an assistant to Nien since 1728[3] and he had been in charge of the imperial factory since Nien's transfer to Huai An in 1729. His post must have been a responsible one, for T'ang himself admits that on his own transfer to Huai An he was only able to find time to visit Ching-tê Chên once in the years between 1736 and 1739 on account of the great distance. Fortunately in 1739 the Commissionership of the Customs (which included the control of the Customs of Kiangsi, Kiangnan, and Anwhei) was transferred to Kiukiang and T'ang remained in charge and retained his directorship of the potteries. Kiukiang was much nearer to Ching-tê Chên than Huai-an-fu, and the situation permitted the Director to stay at the imperial factory for part of the year at least, and to superintend much of the work in person. T'ang remained at this post till 1749 when, according to Bushell, he was succeeded by Ch'in Yung-chün.[4] Kuo Pao-ch'ang, says he was not relieved until 1753.

T'ang was a native of Manchuria, of Chinese Bannerman extraction, who as a youth had been selected by the Emperor K'ang Hsi to be in charge of the seals on the imperial writing desk. Later he became a junior secretary in the Palace. The Emperor Yung Chêng seems to have encouraged his studies and to have offered him promotion. It was at his own request apparently that he was sent as assistant to Nien in 1728. By all accounts he was a most conscientious administrator, who won the confidence and affection of the potters, and a familiarity with their problems, by living, eating, and resting with his workers.[5]

The following extract comes from his own pen:

'I (Ying), a native of Shêng-yang, in the province of Kuantung (Chinese Manchuria), whose family has for generations shared in the imperial favour, since they followed the dragon standard to Peking, had my name enrolled at my birth in the Nei-wu-fu, the "Imperial Household". In my youth I was employed in the palace in the Yang-hsin-tien, and worked there for more than twenty years. In the year that the emperor now reigning came to the throne (1723) I prostrated myself to heaven and earth in acknowledgment of the imperial grace in promoting me to be secretary and only feared my inability to deserve such honours. Later, in the autumn of the sixth year (1728) of the reign of *Yung-chêng*, in the eighth month, the late Prince of Yi conveyed to me, by word of mouth, the celestial orders, appointing me (Ying) to superintend the porcelain manufacture in the province of Kiangsi, and instructing me to relieve the workmen in cases of disease and trouble, and to encourage the trade among the merchants. The imperial words were truly grand; the emperor's grace is all-pervading, and his thoughts are unfathomable. In reverent obedience to the order, I (Ying) started at once from the capital, and, in the tenth month of the same year, arrived at the manufactory at Ching-tê-chên, and hastened to regulate the work of the potters and the trade of the merchants, in obedience to the decree. With care and trembling, without wasting a "cash" of the funds entrusted to me, I had the porcelain made according to the indents. A list of the things sent, and a statement of accounts, have been forwarded by me each month to the superintendency of the imperial household. Up to now, the cyclical year *yi-mao* (1735), I have been seven years engaged in the work. Although but "a broken-down horse", I put forth all my strength. My ability is poor, and my faults many, and it is only by the emperor's grace that I have escaped punishment. An annual allowance (in addition to salary) of five hundred taels has been granted me for fuel and water, so my family subsists on the imperial bounty, which a life's poor work could ill requite. The potter's work is a humble one,

yet my own life, as well as that of the craftsmen, depend on the favour of the emperor, and I cannot but proclaim the imperial grace. The ritual wine-vessels (*tsun*) and the sacrificial bowls (*kuai*) are now all made of clay, so as not to waste the national resources, and the daily wants of the people are also supplied by the potter's craft, so that the work must continue to be carried on by our successors. If the rules of the art be preserved, the labour will be halved, and the gain two-fold; if the rules be forgotten, money will be wasted, and the artisans' labour lost, so, for the use of after times, I have compiled the present epitome. Although I (Ying) dare not profess a complete knowledge of all the minute details of the ceramic art, yet I have practised it diligently for a long time, and am familiar with the official lists of the articles produced, with the composition of the glazes used in their decoration, with the designs and dimensions of the pieces, as well as with the wages and food of the workmen, their rewards for diligence, and their fines for negligence. Although naturally stupid, I have learned one or two of these things, which I have collected and written down, and had them cut upon stone tablets, erected on the south side of the Jewel Hill, so that my successors in the directorship may have some materials for further researches, and be encouraged in their careful zeal; to put on record also the emperor's compassion for the people, and his instructions that the funds should not be wasted nor the workman's labour unrecompensed. What I have carefully written, I know personally, and I submit it with deference to the officials that shall succeed me. "The farmer may learn something from his bondman, and the weaver from the handmaid who holds the thread for her mistress" '6

According to the *Ching-tê Chên T'ao Lu*, 'The Honourable T'ang, in the cyclical year *hsü-shên* (1728) of the reign of *Yung-chêng*, first came to reside at the imperial manufactory as assistant to the director Nien, and he acquired a great reputation for his work. In the first year (1736) of the reign of Ch'ien Lung he was placed in charge of the customs at Huai-an-fu. In the eighth year[7] (1743) he was transferred to be commissioner of customs at Kiukiang-fu. In both these posts he retained the directorship of the porcelain manufacture. He had a profound knowledge of the properties of the different kinds of earth and of the action of fire upon them, and took every care in the proper selection of the materials, so that his productions were all highly finished and perfectly translucent. In the reproductions which he made of the celebrated porcelains of ancient times every piece was perfectly successful; in his copies of famous glazes there was not one that he could not cleverly imitate. His genius and ability were so great that he succeeded in everything he attempted. He also made porcelain

decorated with the various coloured glazes newly invented—viz., foreign purple (*yang tz'ŭ*), cloisonné blue (*fa ch'ing*), enamelled silver (*mo yin*), painted in sepia (*ts'ai shui-mo*) (1) foreign black (*yang wu-chin*), painted in the style of *cloisonné* enamels (*fa lang hua fa*) painted with foreign enamel colours on a black ground (*yang ts'ai wu-chin*), with white designs reserved on the black ground (*hei ti pai hua*), with the black ground pencilled over in gold (*hei ti miao chin*), the new sky-blue monochrome (*t'ien-lan*), and the transmutation glazes (*yao-pien*). The paste of the pieces was white, rich, and compact; the fabric, whether thick or thin, was brilliant and lustrous; and the imperial porcelain attained at this period its greatest perfection. (2)

'He also, in obedience to an imperial decree, respectfully described the "Twenty Illustrations of the Manufacture of Porcelain", arranged them in order, and wrote detailed descriptions of the illustrations, which were presented by him to the emperor.

'The learned Li chü-lai of Lin-ch'üan in his preface to the Collected Works of the Honourable T'ang, says: "As results of his genius alone, flowering and producing fruit in his mind, the ancient manufacture of the large dragon fish-bowls and of the Chün-chou porcelain, which had long been lost, was re-established; and turquoise (*fei-ts'ui*) and rose-red (*mei-kuei*) glazes were produced by him of new tints and rare beauty. T'ang was thoroughly devoted to his work, and the brilliancy of his genius is reflected in the beautiful porcelain made by him."

'When T'ang Ying was appointed to his new post at Huai-an-fu in 1736, he left behind, for the instruction of his successors, a collection of memoranda entitled *T'ao Ch'êng Shih Yu K'ao* "Draughts of Instruction on the Manufacture of Porcelain" which are often quoted in official books. The author writes in his preface to these drafts, which is quoted in the Fou-liang-hsien Annals: "When I was sent by imperial decree in the sixth year of the reign of *Yung-chêng* (1728) to undertake the superintendence of the porcelain manufactory, I was unacquainted with the finer details of the porcelain works of the province of Chiang-yu (Kiangsi), where I had never been before. But the materials are the same as those employed in other art-work and are changed in the fire in accordance with the chemical laws of the five elements, and they are combined after old prescriptions, as well as by new experiments. I worked hard with heart and strength, and for three years shared with the workmen their meals and hours of rest,

Plates: (1) LXXVII, *Fig.* 1; (2) LVI, *Fig.* 2, LXXXI, XCII, *Fig.* 2, XCIII, *Fig.* 1.

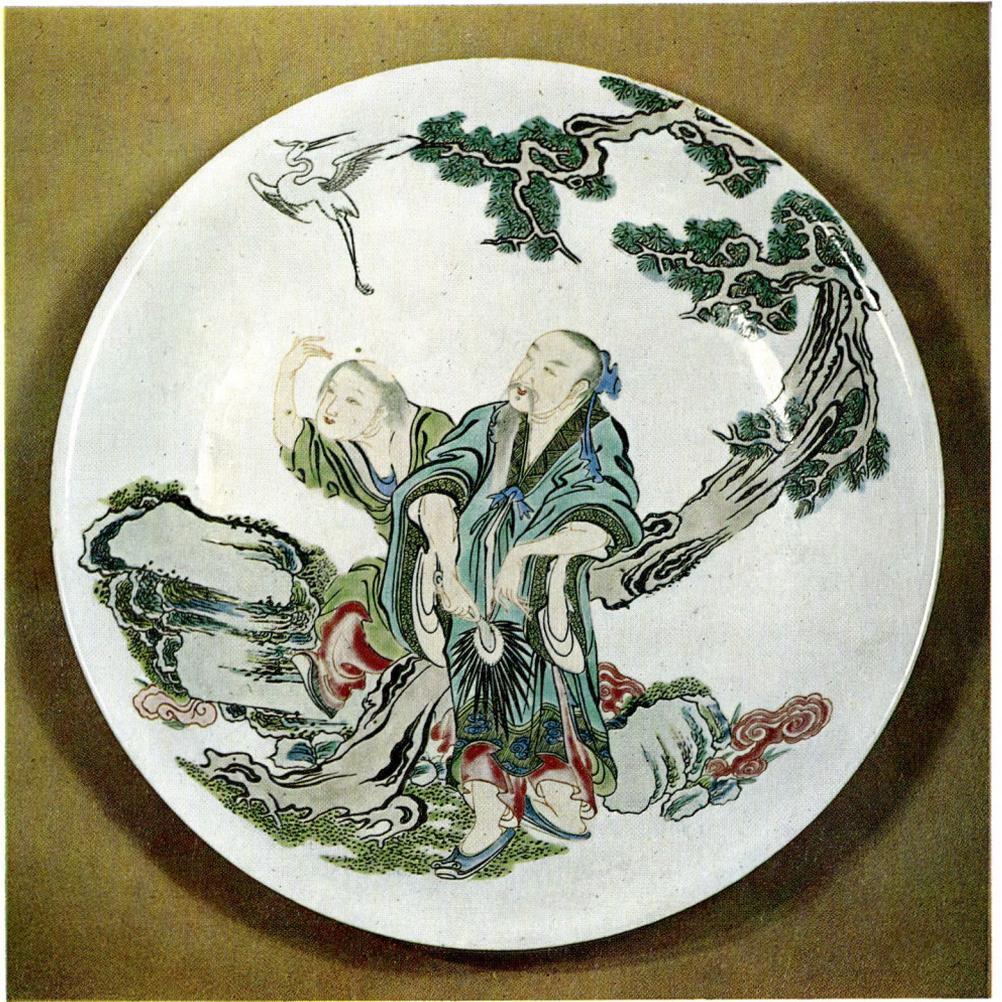

E. *Plate decorated in 'famille verte' enamels, with touches of 'famille rose'. No mark; K'ang Hsi/Yung Chêng transition*
Diam. 14 in.
Gerald Reitlinger
See page 35

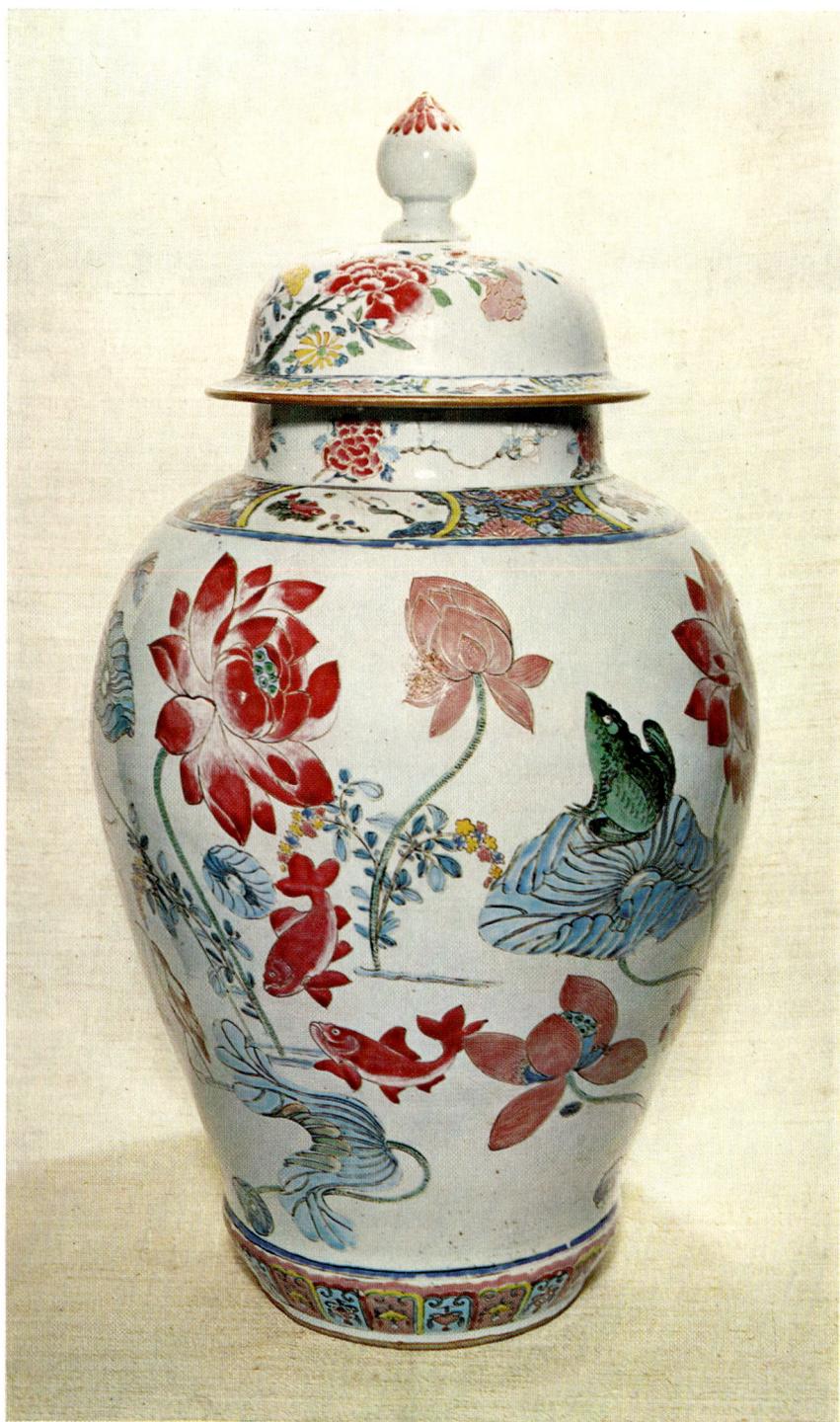

F. *Potiche with cover, decorated in 'famille rose' enamels with a design of lotus, fishes and frog. No mark; Yung Chêng period. Ht. 25·5 in. Gerald Reitlinger. See page xii*

until in the ninth year, *hsin-hai*, of the cycle (1731) I had conquered my ignorance of the materials and processes of firing, and, although I dared not claim familiarity with all the laws of transformation, my knowledge was much increased. After five more hot and cold seasons had passed by, during which 'his pottery vessels were not imperfect and the potter had not asked for sick-leave', the accounts were made up to the thirteenth year of Yung Chêng (1735), and it was found that, for an expenditure of several tens of thousands of taels of treasury silver, no less than between 300,000 and 400,000 pieces of porcelain, comprising all kinds of vases and round ware, had been sent up to the palace at Peking for the use of the emperor. After the sovereign had flown up to heaven on a dragon, in the first year of his successor Ch'ien Lung (1736) I received the appointment of Commissioner of Customs at Huai-an and had to leave the immediate superintendence of the porcelain works. For this reason I have collected the drafts of the instructions of these years, and as many of the scattered leaflets as have been preserved, and arranged them in order, adding some notes of the progress of the work during the nine years in which I have been director." '[8]

Some extracts from his descriptive text to the *Twenty Illustrations on the Manufacture of Porcelain* have already been quoted.[9]

To T'ang more than Nien the perfection of the later Yung Chêng wares is probably due. Most of the new glazes placed to T'ang's credit were invented during the reign of Yung Chêng. Others like the tea dust glaze (*ch'a yeh mo*), though a Yung Chêng invention, is more commonly associated with the reign of Ch'ien Lung. But the ancient bronze colouring (*ku t'ung ts'ai*) (1) and the iron rust glaze (*t'ieh hsiu hua*) were almost certainly invented by T'ang Ying during the reign of Ch'ien Lung. A mustard yellow, a sulphur yellow, an opaque lavender blue (2) and a coral red were also part of his palette, while the *T'ao Lu* speaks of 'His (T'ang's) dragon jars and his Chün ware vessels which, reverting to the methods of the past, recovered their old perfection, while his "cock kingfisher" and his "rose" excelled the marvels of the present. The reason is His Excellency's heart was in his pottery'.[10]

A few pieces of porcelain of very fine quality, chiefly in delicate enamels, carry T'ang's name upon them, together with a poem, written either by himself or on his instructions. The famous lavender vase, once in the Russell Collection, is one of these[11] (Colour Plate A). This vase is inscribed with a poem:

Plates: (1) CI, *Fig.* 1; (2) LXXXVII, *Fig.* 1.

'The hibiscus flowers of Ssŭ-ch'üan are famous for their two colours;
They are all over the branches in October.
In full bloom they are a wonderful sight in the Autumn.
But soon the wind will blow down the leaves.'

which is probably of T'ang's own composition.

The oval seal before the inscription reads 'Crescent Moon', and the other two 'Chüeh-t'ao' and 'Brush and ink'.

Bushell records the existence of an inscribed pricket candlestick painted in underglaze blue with conventional scrolls, made in 1741 and presented by T'ang to a Taoist temple at Tungpa.[12] The inscription runs—

'Reverently made by T'ang Ying of Shên-yang, a Junior Secretary of the Imperial Household, and Captain of the Banner, promoted four honorary grades, Chief Superintendent of the Works of the Palace Yang-hsin-Tien, Imperial Commissioner in Charge of the three Customs Stations of Huai, Su, and Hai, in the province of Kiangnan, also Director of the Porcelain Manufactory and Commissioner of Customs at Kiukiang, in the province of Kiangsi; and presented by him to the Temple of the Holy Mother of the God of Heaven at Tungpa to remain there through time everlasting for offering sacrifices before the altar; on a fortunate day in the spring of the sixth year of the Emperor Ch'ien-lung.[13]

It is, alas, impossible to distinguish the pieces made by T'ang during his directorate from those which he sponsored while he was still Deputy Director, unless the imperial orders for these years should come to light. But I would suggest that the lovely bottle decorated with pomegranates and birds in Chinese taste once in the Bruce Collection (Colour Plate H) might well be one of the transitional Yung Chêng/ Ch'ien Lung pieces. It must be an imperial piece; it might almost have been made under T'ang's supervision at the end of the reign of Yung Chêng, but for the *nien hao* and the use of iron red in the mark. I know of no instance in Ch'ing porcelain before Ch'ien Lung of the use of overglaze iron red[14] for the *nien hao*. Marks in overglaze enamel (blue, pink, lavender, black) started, in my view, with K'ang Hsi, although not everyone accepts pieces with these marks.

All the old Sung glazes seem to have been copied by T'ang, with the exception of the mythical Ch'ai ware; he was particularly celebrated for his copies of Chün. The *T'ao Lu* lists him as reproducing besides the wares of the Ming Emperors Hung Wu, Yung Lo, Chêng Tê, Chia Ching, Lung Ch'ing and Wan Li, imitations of the Hsiang-hu wares of the Sung dynasty, the Ou vessels of Yi-hsing, and the Kuang-tung wares. He also specialized in the *flambé* glazes (the *pien yao*)

which he could control at will[15] (1). The colours of the Ch'ien Lung transmutation pieces usually run from turquoise and purple splashes and splotches to tomato red and deep crimson, but there are other and subtler combinations. The glaze is lightly crackled and has usually run down over the foot and had to be ground away.

The T'ao Lu also particularly mentions T'ang's copies of Lung-ch'üan celadons as remarkably fine. They are referred to as 'jewel fired' (pao shao). His elegant and smooth copies of Kuangtung wares were continually referred to as an improvement on these models.

One of the most remarkable features of the ceramics of the Ch'ien Lung period was the virtuosity of their copies of other materials. Imitations of chiselled gold (2), embossed silver, carved jade and other hard stones, lacquer ware, mother of pearl inlay, cloisonné (3) carvings in rhinoceros horn, bamboo (4) and wood, gourd and shell were all executed in porcelain. 'The texture of the ivory, shell, or bamboo is carefully indicated in the porcelain, and the surface colours are reproduced so as to bring out the tints of the variegated marble and pudding stone, the mottled jade, the striped carnelian and agate, the veined walnut-wood, and the carved cinnabar lac, with such exactitude that it is necessary to handle the piece to convince one's-self that it is really made of porcelain. The aspect of gold and silver was given by enamels prepared from the metals themselves; the surface tints of copper and bronze, the rust of iron, and the play of colours upon ancient patinated bronze-red in which the Chinese antiquarian takes so much delight, were produced by combinations of different glazes applied either with the brush or by sprinkling over the first ground colour'.[16] Foreign countries were ransacked for novelties as models. Pieces of 'old Imari' from Japan, Venetian glass, Italian drug pots, Dutch Delft and Limoges enamels were all copied.

Perhaps it is better for T'ang's reputation, that from 1739 onwards till his retirement in 1749 or 1753 he was only able to reside at the imperial factory for short periods and had to delegate much of the work to assistants; for the bulk of the wares of the Ch'ien Lung period are mechanical in appearance and monotonous in design. Though they may show great powers of invention they lack artistic originality. Their brocaded surfaces are overdone; their gilt is too heavy; the exuberance of such patterns as the mille fleurs blowsy and vulgar. Inside the rim and outside the foot many of them are covered with a sickly turquoise green enamel (the European green), which appears about 1750 and which on the base scarcely leaves room for the mark (5),

Plates: (1) C, Fig. 1; (2) CX, Fig. 2; (3) CII; (4) XXV, Fig. 2B; (5) LXXXV, Fig. 2, CXI, Fig. 1.

though it is occasionally used with delicacy as a ground for *famille rose* decoration, as in a Chien Lung bottle in Mr Donnelly's collection. The dominant colour of the period is still the *famille rose* enamel, but this has lost its early translucency. The so-called 'foreign enamels', a thick white, a muddy pink, an opaque mustard yellow, a lime green, a jujube red, are all characteristic enamels of the later part of the reign. There is still a large range of monochromes including the turquoise blue, a deep purple, apple and cucumber greens. The coral red comes into great prominence (1) and also a new sapphire blue (*pao shih lan*). Most of the Ch'ien Lung monochromes are distinguished by a fine crackled glaze. Their shapes tend to archaic bronze forms with elephant head (2) and *t'ao t'ieh* mask handles. The surface is often undulating and pitted. This last characteristic—the *chü p'i* of the Chinese ceramic authors—is the famous orange skin glaze.

The reign of Ch'ien Lung[17] was a continuation of his grandfather's. Under his wise administration the Chinese Empire reached its furthest national boundaries since the T'ang dynasty, but even before the end of his lifetime signs of decay were visible; and when he abdicated at the age of eighty-five in 1795[18] disintegration hastened by European intervention soon set in.

Like his two predecessors, Ch'ien Lung was interested in the arts, and many European artists and architects were employed at his Court. He took a lively interest in Sung ceramics, which he collected, and many of which he caused to be inscribed with his own poems, though not usually, as in the case of his paintings, in his own 'pork and wine' hand.

During this reign blue and white went out of fashion, except for soft paste, and the *famille verte* was entirely superseded. Later a new *verte* palette came in, combining with a rather hard green enamel—sometimes used alone (3)—the 'foreign colours' and an iron red of pale tone as well as the tomato red of the previous century (4). This palette persisted well into the 19th century (5). Overglaze decoration is popular for figures (6) including the harlequin figures decorated with large patches of coloured enamel, interspersed with black. As the reign proceeds all kinds of European designs appear on the porcelain, but not all of them were made for export. This was also the great period for the imported dinner, breakfast and dessert services in all kinds of shapes and sizes including soup tureens, sauce boats, vegetable dishes with lids, salad bowls, hot water plates, fruit dishes as well as

Plates: (1) CIV, *Fig*. 3A; (2) XCIX, *Fig*. 2, C, *Fig*. 2, CIV, *Figs*. 2 and 3B; (3) XCI, *Fig*. 2; (4) LXXXVI, *Fig*, 2A, LXXXVIII, XCIV, *Fig*. 3; (5) CXIII, *Fig*. 2A; (6) CIII.

receptacles for oil, salt, vinegar, pepper and mustard, and even egg cups, often decorated with European coats of arms. Imitations of Sung monochomes were extended to include red, turquoise, yellow and aubergine monochromes of both the Ming and the K'ang Hsi periods. White enamel derived from arsenic (1) was an eighteenth-century invention. It is often used in double enamel decoration in which one colour was blown over another. In some of these pieces, not even the white glaze of the foot is visible. Most of these glazes were thick and opaque and their dull surface was often finely engraved in so-called *graviata* designs (2). A superb range of these pieces is in the collection of Mr. John Morrison (3). The *famille rose* enamel was so much abused that it was even used as a monochrome (4), and it was also used in imitation of underglaze red (5). Decoration in underglaze red itself continued, sometimes alone on a white ground—the *ts'ai hung* of the Yung Chêng list (6)—more often combined with underglaze blue (7). The *lac burgauté* of K'ang Hsi's reign regained its popularity. Notwithstanding the general falling-off in standards to which reference has been made, individual pieces of fine quality, delicately enamelled, were produced (8). Also bowls with coloured grounds (9).

But perhaps the most interesting and by far the most mysterious of all the ceramic products of this reign is a small choice family of Palace porcelains, which go under the name of Ku Yüeh Hsüan. These pieces are decorated entirely in the Chinese taste, but often show European perspective and traces of light and shadow in the painting. Poems with red seals occur upon them and their *nien hao* are usually in embossed enamel. Chinese sources tell us that these pieces reached their perfection under the directorship of T'ang Ying, although we do not know how far he was involved in their production. None of them, as far as I know, bears his name. But the story which surrounds this family is so complicated that I have confined it to an Appendix.[19]

Plates: (1) XC, *Fig.* 1; (2) CIX, *Fig.* 2. (3) CVI, CVII, CVIII; (4) XCIX, *Fig.* 1; (5) LXXXVI, *Fig.* 1B; (6) LXXXVI, *Fig.* 1A; (7) LXXXVI, *Fig.* 2B, XCIV, *Fig.* 1; (8) LXXXIV, *Figs.* 1C, 2B and C, LXXXVII, *Fig.* 2. (9) CXII, *Fig.* 2.

1. The preface of this was published separately as the *T'ao Ch'êng Shih Yü Kao Hsü.*

2. Among these poems is one entitled *A parting gift on leaving the pottery*, which must have been prompted by his departure to Huai An in 1736. It contains the passage—

'Half peasant, half official, I stayed here eight years . . .
The West River for eight years bestowed its Royal favours.
Now again with the coming of the spring I launch my craft on the seas of Huai.

LATER CHINESE PORCELAIN

In the ancient Hs'üan Tsui pavilion I search my heart and cull a sentence.
On the jewelled mount so fragrant I linger to plant a flower.'

<div align="right">Sayer's Translation.</div>

3. Nien evidently thought well of him as the *T'ao Lu* quotes Nien from the *Feng Huo Shen Pei Chi* as saying—'After the Ting-mi year of Yung Chêng I ceased to visit the town, and the following year the Marquis T'ang, as assistant secretary of the Board, came and shared the control with me. The labour expanded and the workmanship improved so I extended his engagement.'

T'ang was well connected, as his autobiography reveals.

4. Bushell, *Oriental Ceramic Art*, p. 279.

5. 'He was profound in his learning, as well as mellow in his experiences. He was able to eat and rest with his workmen and he conducted his investigations with great concentration of mind. In the end he thoroughly mastered the intricacies of his subject, and applying his ingenuity he set to work to imitate old types and introduce new forms with extraordinary understanding. The development of the imperial kilns attained its zenith during T'ang's term of office.' (Kuo Pao-ch'ang, *Illustrated Catalogue of Chinese Government Exhibits for the International Exhibition of Chinese Art in London*, 1935, vol. II, p. 28.)

6. Bushell's translation, *Oriental Ceramic Art*, pp. 393–5.

7. Bushell says that he was transferred to Kiukiang in 1739, and quotes an inscription which he says proves that he was commissioner at Kiukiang in 1741.

8. Bushell's translation. *Oriental Ceramic Art*, pp. 397–9.

9. In Chapter 1, pp. 7–8. The last but one of these Illustrations, No. 19, is entitled 'Wrapping in straw and packing in cases'. T'ang Ying's comment on this runs—

'After the porcelain made in the imperial manufactory has been finished, every year at the two seasons of autumn and winter, a number of broad flat-bottomed boats and a gang of porters are hired to convey to the capital the six hundred and more casks packed with round pieces and vases. The annual supply required for the Palace of round ware of the highest class, including round dishes, bowls, cups, and saucer-plates, ranging from between one and two inches up to two and three feet in diameter, amounts to between 16,000 and 17,000 pieces, in addition to 6,000 or 7,000 pieces selected from the best of the second class. These are all packed together in casks and conveyed to Peking, to be ready for imperial presents, and for the emperor's own use. The vases of all kinds intended for ornamental and sacrificial use of the highest class, including ovoid vases with tall, narrow necks, sacrificial vases with scrolled designs, beaker-shaped vases and urns for burning incense, etc. ranging from three and four inches up to three and four feet in height, require a yearly supply of over 2,000 or 3,000 vases selected from the best of the second class. These also are all packed together in casks and conveyed at the same time to Peking.' Bushell's translation, *Oriental Ceramic Art*, pp. 459–60.

10. Sayer's translation, p. 49.

11. Another vase signed *Chüeh t'ao* decorated with landscape in enamel colours also from the Russell Collection is illustrated, Plate XLIXB.

12. A town situated on the northern bank of the canal which connects T'ung Chai with Peking.

13. Bushell's translation, *Oriental Ceramic Art*, p. 93.

14. Except for a small group of non-imperial porcelains decorated with dragons and bearing the mark of K'ang Hsi. Other pieces that seem to me to belong to the Yung Chêng/Ch'ien Lung transition are the two bottles in Plate XCVIII.

15. In 1722 D'Entrecolles had written prophetically 'There has just been brought to me one of those pieces of porcelain that are called *yao-pien*, or "transmutation". This transmutation occurs in the furnace, and is caused either by some defect or excess in the firing, or perhaps by some other causes which are not easy to conjecture. This piece, which was a failure, according to the workman, and which was the effect of pure chance, was none the less beautiful, or the less highly prized. The workman had designed to make vases of red *soufflé*. A hundred pieces had been entirely lost; this one alone of which I am speaking had come out of the furnace resembling a kind of agate. If one were willing to run the risk and expense of repeated trials, one might discover, as the result, the art of making with certainty what chance had produced a single time'. Bushell's translation, *Oriental Ceramic Art*, p. 516.

16. *ibid.* p. 406. Cf. also the *T'ao Shou* 'The work in jade by Lu Tzu-kang, in gold by Li Ai-shan, in silver by Chu Pi-shan, in rhinoceros horn by Pao T'ien-ch'eng, in tin by Chao Liang-pi, in carnelian by Wang Hsiao-hsi, in copper by Chiang Pao-yun, in carved bamboo by P'u Chung-ch'ien, in mother-of-pearl by Chiang Ch'ien-li, and in Japanese lacquer by Yang Hsun, is merged in the one work of porcelain.' Bushell's translation, *Chinese Pottery and Porcelain*, p. 6.

17. He was not twenty-five years old when he came to the throne.

18. He was to die three years later.

19. See Appendix 1.

6

THE PERIOD OF DECLINE,
1749 (or 1753) to 1912

The date at which T'ang Ying ceased to control the destinies of the imperial factories is not known. The year 1749 and the year 1753 have been mentioned by two different authorities. Whether he was retired, promoted or removed by death may be recorded somewhere in the annals of Ching-tê Chên. Authorities also differ as to the name of his successor. Bushell states that he was replaced by Ch'in Yung-chün in 1749.[1] The *T'ao Lu* gives the name of his successor as Liu Pau-yüan, who must have been an old man at the time of his appointment, as he is described as serving under both Nien and T'ang. He is said to have painted admirable landscapes and to have been an expert calligrapher.[2]

According to Bushell the directors of the imperial factory continued to be appointed from the imperial household until 1778, after which the control was left to the provincial authorities. But the *T'ao Lu* says the system of resident Commissioners was abolished in 1787 when the District officer of Jao chou was left in control, with the magistrate of the Ching-tê Chên Department responsible for the packing.

The prosperity of the imperial factory, and that of Ching-tê Chên itself, was practically dependent on imperial patronage. Under the Sung, Yüan and Ming dynasties the disturbances preceding the downfall of the reigning house correspond in date with the decay of the potter's art. This also holds good for the Ch'ing dynasty. The latter half of the eighteenth century was a period of enormous prosperity, internal tranquillity, and external expansion.[3] Risings of the Triad Societies and of Mohammedan minorities were ruthlessly put down. The clear judgment and iron will of Ch'ien Lung enabled the Government to remit the local taxes for several years in succession.

The element hostile to the dynasty, held in check by Ch'ien Lung, eluded the grasp of his son and successor Chia Ch'ing, who was both stupid and cruel. In Hupeh a rebellion fermented by the Water Lily Triad Society broke out in the year of his succession and was not put down till 1804, when he barely escaped assassination in the streets of

72

Peking; while the Miao Tzu revolted at Kweichow. By the beginning of the nineteenth century the Manchu dynasty was doomed, its authority challenged from without and within. From 1820 onwards in an attempt to preserve its isolation it was embroiled in a series of wars with the European powers. The first of these ended with the Treaty of Nanking in 1842, with the opening up of the country to foreign trade and missionary influence, the establishment of foreign extra-territorial rights and the loss of Hongkong. Internally the régime was increasingly sapped by the anti-dynastic secret societies, whose agitation culminated in the T'aip'ing rebellion, which lasted from 1850 to 1854, devastated the whole of Central China, completely destroyed Ching-tê Chên, and but for foreign interference and the stupidity of the T'aip'ing leaders would have brought down the dynasty. Contemporary writers like Chang Hsüeh-chêng testify to the military incompetence, the inefficiency and corruption of the bureaucracy; the breakdown of the irrigation system; and a series of national calamities which fanned the popular resentment. The dynasty itself was saved for half a century longer until further disastrous wars and foreign encroachments led to rebellion and its overthrow in 1911. It is against this background that the subsequent history of Ching-tê Chên must be viewed.

There is no visible break in the ceramic tradition after 1749, although the industry after T'ang Ying's departure enters on a slow decline. The same monochromes, the same polychrome pieces, decorated in heavy opaque European colours, modelled on bronze forms, with *t'ao t'ieh* mask or elephant head handles continue to be made. Iron red, coral, mirror black, peacock green, and tea dust are some of the commoner monochromes. The enamelled pieces were often decorated in gold arabesques (1) and further elaborated. To this period belong openwork lanterns, perforated perfume boxes (complete in some instances with porcelain chains), vases with moulded or encrusted flowers (2) and probably the many famous openwork revolving vases. 'Miracles of misapplied skill' Honey calls them (3).

More attractive than these are the 'lacework' and 'rice pattern' bowls and vases, in which particles of the body have been cut away and filled in with semi-transparent glaze (4). The *famille rose* palette is still in favour, but it is diluted by the increasing use of iron red enamel, which combines unhappily with the rose pink. Among the new types are the so-called 'medallion' bowls, carrying medallions containing flowers, landscapes or figures against a coloured background

Plates (1) LXXXV, *Fig.* 1, CIX, *Fig.* 1; (2) XCIX, *Fig.* 1; (3) CVII, *Fig.* 1; (4) CIV, *Fig.* 1.

engraved with scrolls. They can be found in a variety of colours including pink, yellow, green, blue, and lavender grey (1). The influence of Ku Yüeh Hsüan lasted throughout this period and continued to be repeated in the twentieth century.

Another group is formed by the porcelain snuff bottles, upon which much care was lavished from the reign of Ch'ien Lung onwards. They are often chiselled and always elaborately enamelled. Many of them bear the mark of Ku Yüeh Hsüan, as well as their glass contemporaries. Others again are in biscuit. Many of the Ch'ien Lung underglaze blue pieces in this *genre* are in soft paste. There are some quite good blue and white pieces (2). Tao Kuang snuff bottles often favour underglaze red.

The reign of Chia Ch'ing (1796–1821) was a prolongation of the reign of his father from the ceramic point of view. Like his father he was fond of inscribing pieces of porcelain with his verses (3). The porcelain of the reign is little inferior to the later Ch'ien Lung wares and difficult to distinguish from it when the mark is lacking. (4) The *T'ao Lu* tells us that at this time the crackle specialists made imitations of Ju, Kuan and Ko, which had each their own specialists to make them. (5) Copies of Lung-ch'üan and Ting wares were apparently still made by experts, as well as by the crackle-ware specialists. There is no swift deterioration, but as the century advances the drawing becomes more and more perfunctory and mechanical, and the body itself begins to degenerate. The medallion bowls[4] increase in numbers.

By the reign of Tao Kuang (1821–50) there is a marked deterioration in both body and glaze. The body becomes a chalky white and thin, and the glaze of an oily sheen and muslin tone. (6) The mixed enamels of this reign combining the *famille rose* and *famille verte* are swamped by the iron red, which from the reign of Chia Ch'ing onwards dominates the rose pink and now becomes a purplish red. There was yet another revival of the *tou ts'ai* enamel pieces in this reign.

Imitation of K'ang Hsi underglaze blue (7) and of the traditional *wu ts'ai* enamel palette made in the reign can be excellent. The bowl (8) is one of a set made at the imperial factories to celebrate the marriage of one of Tao Kuang's daughters to a Mongol Prince. It is inscribed in Mongol with his banner. The popularity of monochromes in *graviata* design was maintained, and there is a predilection for white and blue enamels. Soup bowls decorated with reserves in white,

Plates: (1) CXIII, *Figs.* 1 and 2B, CXIV, *Figs.* 1 and 2A; (2) XCIV, *Fig.* 2, XCV; (3) CXI, *Fig.* 2; (4) LXXXIX, XCIII, *Fig.* 2, CIV, *Fig.* 3C; (5) LXVII, *Fig.* 2; (6) XXV, *Fig.* 2A; (7) CX, *Fig.* 3A; (8) CXII, *Fig.* 1.

usually of bamboo or cherry blossom on a coral red ground, make their appearance, also covered bowls with decoration on a graviata ground (1). Both these and the 'Palace' bowls can be of fine quality (2).

Tao Kuang had many good qualities, but in contrast to his four immediate ancestors he was not an avowed patron of the Arts. Administratively he had a task laid upon his shoulders which was too heavy for him to bear.

The disorders of the next reign, that of Hsien Fêng, a man of little culture (1851–61), were overwhelming. In 1851 the whole of central China rose under the T'ai p'ings against the Manchus. In 1853 Ching-tê Chên was sacked by the rebels and its potter population either was massacred or fled. It was not until 1854 that this rebellion was put down by Li Hung-chang, but the kilns were not rebuilt till the third year of the next reign, in 1864. Meanwhile, in 1856 the second Foreign War broke out. It is not surprising that pieces of porcelain with the Hsien Fêng mark are uncommon and of negligible quality (3). From this reign onwards the custom of pencilling the *nien hao* in iron red on the bottom of pieces is not confined to the imperial factory.

When the imperial factories were rebuilt in the third year of the next reign, T'ung Chih (1862–74) seventy-two buildings were erected more or less on the site of the old kilns by the new director Ts'ai Chin-ch'ing. A list which comes immediately after the Yung-chêng list in the *Annals of the Province of Kiangsi*[5] and which is dated 1864, gives us a picture of the porcelains requisitioned for the Palace at the beginning of this reign. It is arranged under two headings—

(*a*) Vases and larger pieces (*cho ch'i*)

(*b*) Round ware (*yüan ch'i*)

and numbers fifty-five items in all. Items one to nine belong to the first category and items ten to fifty-five to the second. The list is headed 'Vases to be sent to Peking to the Emperor'. The first three items are imitations of Sung glazes, but none of them are likely to be mistaken for Sung in the flesh. Very little of interest emerges from their descriptions.[6]

Actual examples of T'ung Chih porcelain are not as inspiring as the list would make them appear (4). This reign was also shaken by Mohammedan rebellions in Yunnan, Shensi, and Kansu between 1862 and 1878. Further inroads into Chinese sovereignty were made by the Europeans; and Indo-China, Formosa, and the Pescadores grad-ually slipped out of Chinese control.

Some of the imperial pieces of this reign may be without a *nien hao*

Plates: (1) LXXIII, *Fig.* 1; (2) CXIII; (3) CXIV, *Fig.* 1; (4) CXIV, *Fig.* 2A.

if the *Chung Kuo T'ao Tz'ŭ Shih* can be believed. 'Among the Ch'ing dynasty porcelain some is marked only "made in the reign of the Great Ch'ing", omitting the *nien hao*. This is porcelain made during the time of T'ung Chih and Kuang Hsü when Su Shun was running the country. At that time Su Shun's influence blazed to heaven, for he had inordinate ambition and the supervisors of the official kiln daily feared a dynastic change. Consequently they omitted the reign mark in order to flatter him. Here again is a little story in the history of porcelain, which should certainly be known.'[7]

'The chief interest that collectors take in the last two reigns of the Ch'ing dynasty,' according to Hobson, 'that of Kuang Hsü (who reigned from 1875–1908) and Hsüan Tung (who reigned from 1909 until he was deposed in 1912) is to avoid them. This is usually a simple task, for despite their apocryphal K'ang Hsi and Ch'ien Lung marks they are for the most part betrayed by their poor material and weak designs'[8] (1). *Famille noire*, biscuit enamel, *sang de bœuf*, peach bloom and apple green glazes all continued to be made in this reign. Scherzer, who visited Ching-tê Chên in 1882, evidently did not share Hobson's crushing opinion of their merits. For he writes: 'Every piece which leaves the Imperial factory is made exactly according to the design sent from the Imperial household and I believe that it would tax the most practised expert to discover the smallest difference between two pieces—as for example two bowls with green or aubergine dragons in a yellow ground, the one made two hundred years ago, and the other fresh from the kilns, if there was no reign-mark to help him.'[9] He mentions a family of potters, Ho, who made imitations of *sang de bœuf* in the period 'but the glazes were generally too thick, and the colour uneven'.[9] It was during Kuang Hsü's reign that the Empress Dowager Tz'ŭ Hsi, who dominated the throne, took some interest in the imperial factory and sent down Ch'ien Lung pieces from the Palace to be copied there (2). The reign of Hsüan Tung is in no way memorable for any ceramic revival.

Hsüan Tung was compelled to abdicate in 1912 in favour of a Republic, which in 1916 Yüan Shih-kai attempted to overthrow in order to form his own dynasty. He appointed Kuo Shih-wu[10] director of the ex-imperial factory, who made for him vases painted in black, grey and red with landscapes in a weak version of the Ku Yüeh Hsüan style marked '*Hung Hsien nien chih*' his stillborn reign-mark. He also ordered small boxes painted in the *mille fleurs* style and marked '*Chu fên t'ang chih*' (made for the hall where benevolence abounds) (3) and there are some pierced porcelain lanterns decorated in enamels of

Plates: (1) CXIV, *Fig.* 2B, CXV; (2) CXV, *Fig.* 1; (3) CXV, *Fig.* 2A.

remarkably good quality dating from this period. Many of the Yüan Shih-k'ai pieces are in the Ku Yüeh style. With this last flicker the imperial factory as such comes to an end.

The last European who has left us an account of Ching-tê Chên is Brankston, who saw the kilns in 1937.[11]

The Chinese potter of to-day has not lost his skill, his traditional craftsmanship, his good sense and his natural good taste (1). The deceptive forgeries of older pieces, which are still turned out, are evidence of his skill. The many country wares, which find their way to provincial market towns for the public use, although they may be of coarse grey porcelain usually show admirable painting and considerable vitality.[12] What the industry lacks is a body to take the place of their past royal patrons.

Unfortunately a new danger is appearing on the horizon. There was a tendency previous to the Second World War to import cheap crockery from Japan. To-day the importation of plastic rice bowls from Europe has supplanted this source. Their cheapness, lightness, and comparative durability, will present a new problem to the modern Chinese potter.

(1) *Plate* CXV, *Fig.* 2B.

1. Bushell, *Oriental Ceramic Art*, p. 279.

2. It is possible that Ch'in succeeded T'ang as Custom Commissioner at Kiukiang, while Liu became the resident inspector at Ching-tê Chên. But this is pure supposition.

3. In 1765 by order of Ch'ien Lung a series of engravings on copper was commissioned to illustrate his victories over the Dzungars and Mussulmans. These were engraved in Paris under the direction of Cochin from the drawings of Castiglione, Attiret, Sichelbart, and Damascene. They were followed by several later Chinese editors in the same vein, illustrating victorious Chinese campaigns against Tibet, Formosa, Nepal, Annam, Yunnan, and the Mussulmans of Chinese Turkestan. Tibet was occupied, the Gurkhas defeated, Burma was invaded and paid tribute, Annam submitted and the indigenous tribes of South West China were pushed back up the slopes of their inhospitable mountains.

4. Most of these have Chia Ch'ing or Tao Kuang marks.

5. The *Chiang Hsi Tung Chih*, bk. XCIII, ff. 13–16.

6. The T'ung-chih list is recorded in full in Bushell's *Oriental Ceramic Art* pp. 471–83.

7. Wu Jen-ching and Hsen An-ch'ao, *Chung Kuo T'ao Tz'u Shih*, Canton, 1926 (trans.). But see p. 21 for a very different theory advanced by Hobson.

8. Hobson, *The Later Ceramic Wares of China*, p. 93.

9. Quoted by Hobson, *Later Ceramic Wares of China*, p. 93.

10. Who is, I believe, still living.

11. In his *Early Ming Wares*, published in 1938, he devotes a chapter to the district and the kilns.

12. Honey, *Ceramic Art of China*, p. 156, makes this point with customary felicity.

7

THE PORCELAIN OF THE
PROVINCIAL KILNS

The number of provincial potteries throughout China must be immense. The poverty of communications made it essential for each district to produce its own roof tiles, storage jars, and cooking utensils. But unless these local potteries were situated on a highway or near a port, or celebrated for their quality or decoration, their wares were unlikely to travel beyond the local market towns because of the cost of freight. The great majority of these local kilns made little but earthenware, of which the red-pottery teapots of Yi-hsing are a famous example. Others like Shekwan in Kuangtung made stoneware in addition, but few[1] produced porcelain of any quality, although some coarse provincial porcelains are often broadly and attractively decorated. Almost nothing is known about the production of the provincial factories in the Ch'ing period. In the lists of these provincial kilns compiled by Chinese authorities there is seldom any attempt to distinguish between earthenware, stoneware and porcelain, while kiln sites long extinct or of entirely problematical or literary interest are included. One of these lists of contemporary porcelain kilns was published by the *T'ien Kung K'ai Wu* at the end of the seventeenth century and the account was incorporated in the *K'ang Hsi Encyclopedia*. It is difficult to assess its reliability, but Bushell has used it, and Hobson quotes it with approval. This work states that the 'white earth' from which porcelain was made was only found at that date in five or six different places in China. The passage runs—

'The white plastic clay called *ê-t'u* is required for the fabrication of porcelain, and the finest and most beautiful pieces cannot be made without it. Throughout the whole of China there are only a very few places in which it is found—viz. in the north: (1) at Ting-chou, in the prefecture of Chên-ting-fu (province of Chihli); (2) at Hua-t'ing-hsien, in the prefecture of P'ing-liang-fu (province of Shensi); (3) at P'ing-ting-chou, in the prefecture of T'ai-yüan-fu (province of Shansi); (4) at Yu-chou in the prefecture of K'ai-fêng-fu (province of Honan). In the south it is produced (1) at Tê-hua-hsien, in the pre-

78

fecture of Ch'üan-chou-fu (province of Fuchien); (2) at Wu-Yuan-hsien and at Ch'i-mên-hsien—both situated in the prefecture of Hui-chou-fu (province of Anhui).

'In the potteries of Tê-hua there are fabricated only the figures of divinities and statuettes of famous persons artistically modelled and various ornamental objects of fantastic form not intended for actual use. The porcelain which comes from the districts of Chên-ting-fu and K'ai-fêng-fu is occasionally of yellowish shade. The productions of all the other districts are far from equalling that of Jao-chou-fu (in the province of Kiangsi).

'The two kinds of porcelain that were made at Li-shui and at Lung-ch'üan, in the prefecture of Ch'u-chou-fu, in the province of Che-kiang, had the enamel(?) applied after the pieces had been fired. The cups and bowls (from these two districts) which range from sea-green, or celadon, up to a dark-green colour approaching that of lacquer, are called Ch'u Yao—i.e. "Ch'u Ware", after the name of the prefecture.

'With regard to the porcelain which is so eagerly sought after by foreigners from all the four quarters of the world, this is all fabricated at Ching-tê-chên, in the district of Fou-liang-hsien, and the prefecture of Jao-chou-fu. Porcelain has been constantly produced there from the period of Ching-tê (1004–7), when the imperial manufactory was founded, down to our own days, although neither of the two materials of which the paste is made is produced in the district.'[2]

Fujio Koyama gives a list of as many as forty-five kiln sites for the Ch'ing dynasty[3]; another list of kilns operating in Ch'ing times is given in the *Chung Kuo T'ao T'zǔ Shih*.[4] This list divides the kilns into large and small. Under the heading 'Large Kilns' are placed:

(1) Ching-tê Chên
(2) Fatshan in Kuantung
(3) Paoshan in Shantung
(4) Yi-hsing in Kiangsu
(5) Tê-hua in Fukien.

Of these we know that Fatshan concentrated on stonewares in imitation of the Chün glaze and on figures; Yi hsing developed skill in the production of red pottery teapots and other wares approaching a stoneware, while the *blanc de Chine* porcelain of Tê-hua is well known. The products of Paoshan which produced a pottery with white glaze have been identified. A long list of small furnaced kilns follows.[5]

This list cannot be regarded as wholly accurate; for instance the Shekwan kilns, situated near Fatshan, not far from Canton, are recorded twice under different headings. Probably this list does not record anything like the number of kilns which existed during the

Ch'ing dynasty in Fukien alone.[6] But it does illustrate the task of describing the products of the provincial kilns. It is probable that nearly all the kilns in the longer list confined themselves to pottery.

The *T'ao Lu*[7] speaks of modern productions of Ting ware being made at the Ch'ang Nan potteries (no district given); while false pieces of Kuan ware were made at Lung Ch'üan. Reproductions of Ting ware, it records, were made at Kai fêng-fu, while Chün Chou wares were reproduced at Chün Chou in Honan. Among the kilns working 'to-day' (1815) are mentioned[8] Huai Hsing; I Yang; T'êng Fêng and Shen Chou in Honan; Yên Chou in Yên Chou-fu; P'ing Ting Chou in Tai-yuan-fu, Shansi; but no descriptions are given of the wares produced by any of these kilns.

From the account given in the *T'ien Kung K'ai Wu* it would appear that the Ting chou factories famous in Sung times were still extant in the Ch'ing period, although they had lost all their importance. Bushell believes they ceased work towards the end of the Ming dynasty when Chou Tan-ch'üan was making at Ching-tê Chên reproductions of the finely crackled ivory white four-legged Ting censers, astonishing his contempories by his imitative skill. Throughout the Ch'ing dynasty the Fên Ting appears to have been copied at Ching-tê Chên. It is mentioned in the Yung Chêng list. On the other hand, it is probable that the coarse T'u Ting (which is specifically stated as not having been copied in the time of Yung Chêng) continued to be turned out at Ting Chou in the eighteenth century, for the later products of this kiln are stated to have been yellow and dull.

Hobson, writing in 1915, said that he had no information about the ceramic products of Hua-ting Chou, P'ing-t'ing Chou and Yu Chou. This information is still lacking. Two sites,[9] Wu-yüan Hsien and Ch'i mên Hsien, in Anhui, supplied the Ching-tê Chên kilns with materials.

The Ch'u ware of Li-shui, mentioned by the *T'ien Kung Kai Wu*, which would appear from the description to have had enamels fired on a celadon ground, has still to be investigated. When Ch'ien Lung visited the province of Chekiang in 1780 he is said to have been given a copy of a series of illustrations of local handicrafts published under the title of the *T'ai P'ing Huan Lo T'ou* (Illustrations of the vocations of peaceful times) which included the passage: 'Potteries have been recently established in Chekiang at Chapu (a port on the northern shore of Hangchou Bay) where they make vases, basins, wine-cups, rice-bowls, and the like. The porcelain is white, with designs painted in blue, and the potters strive to emulate their rivals of Jao-chou-fu (Ching-tê Chên).'[10] Unfortunately their pieces cannot at the moment be identified.[11]

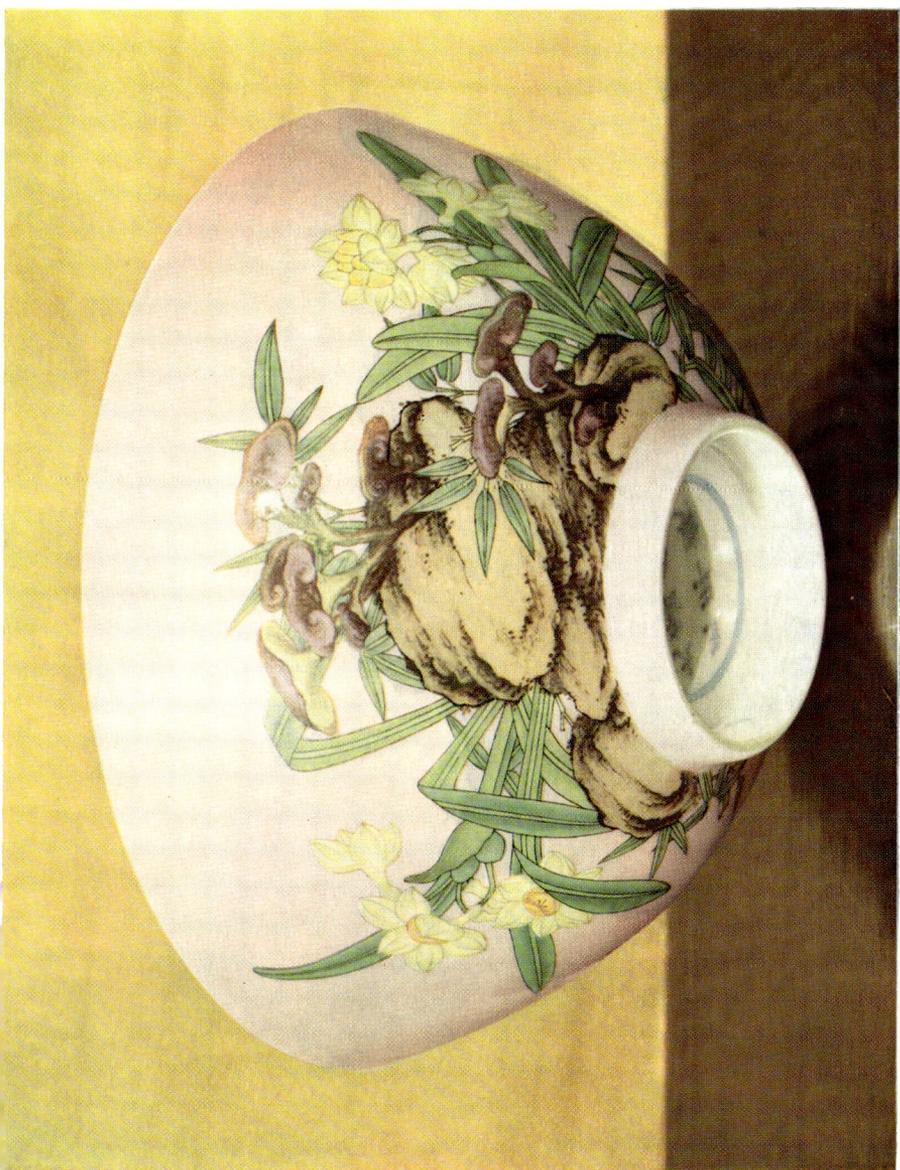

G. Bowl, decorated in enamels with narcissus, ling chih and bamboo; on reverse a poem. Mark and period of Yung Chêng. Diam. 5·5 in. R. H. R. Palmer. See page 58

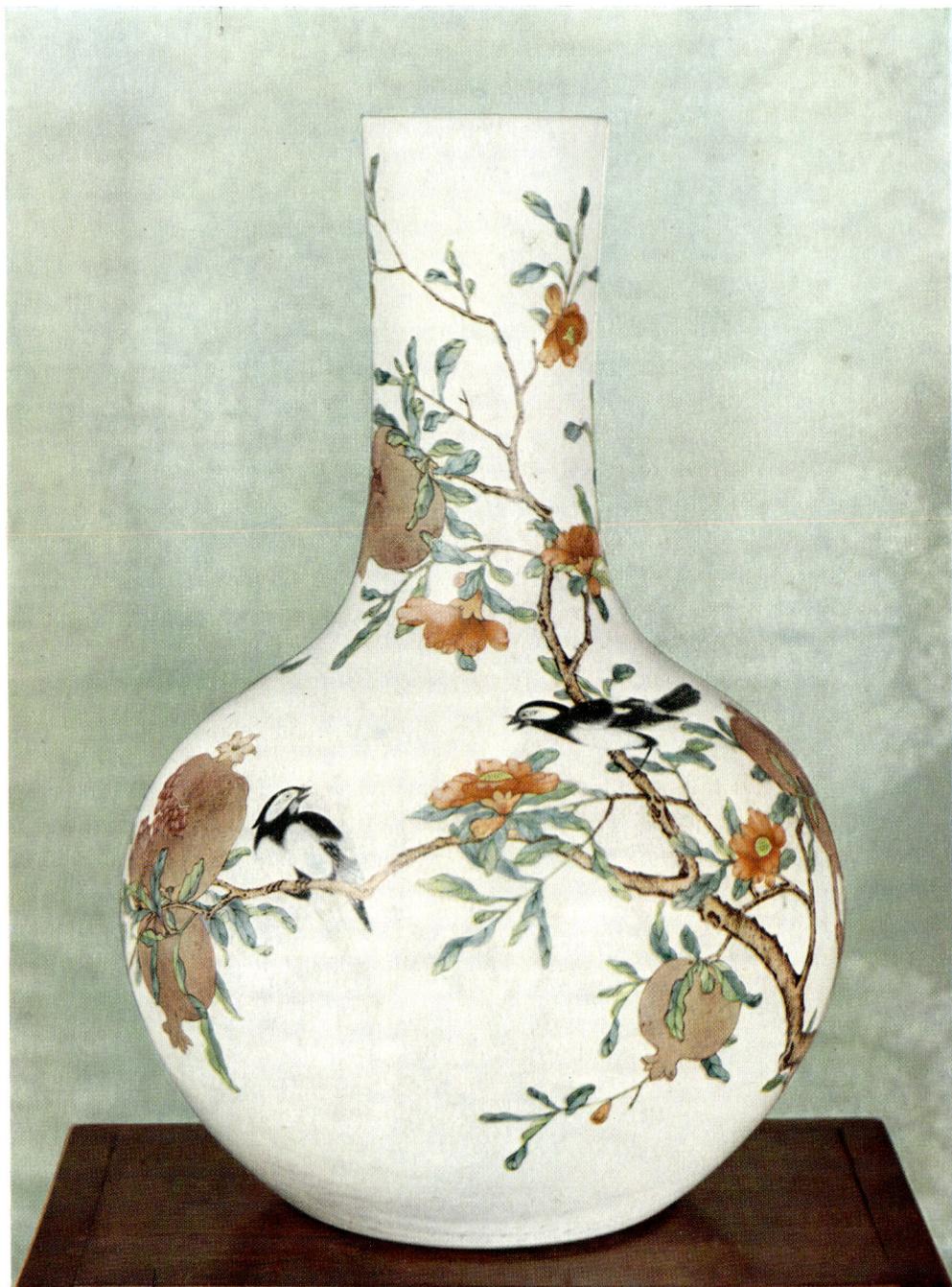

H. *Bottle decorated in enamels with sprays of pomegranate and birds. Mark and period of Ch'ien Lung. Ht. 13 in. Ex Bruce Collection. See page 66*

Ningpo in Chekiang still figured in Consular Reports in the 1920's as exporting 'Chinaware', but it was not clear where the porcelain was made—probably at Tê-hua. The Yangtze ports Kiukiang, Wu Hu, and Nanking traded heavily in the porcelains of Ching-tê Chên, but the mention in a Consular Report of Changsha[12] in Hunan as a distributing centre for 'fine porcelain' seems to point to the existence of a porcelain industry in Hunan.[13]

There remain the potteries of Fukien, of which Tê-hua was and is still the most important. This province was without doubt the home of a great many of our unidentified pieces of provincial porcelain, besides some of the export wares still credited to Annam. Its kiln sites have still to be investigated. The late Malcolm Farley, who was for many years resident in the province and who investigated some kiln sites at Chang Chou, near Amoy, as well as visiting Tê-hua itself, claimed that he had evidence to show that Fukien, besides making the Chien tea bowls, manufactured *ying ch'ing*, blue and white, cream coloured wares, some painted in red and green dating back to the Sung period. He believed that the so-called Kiangnan Ting wares were made both in this province and on the borders of Anhui. Many pieces of this last ware date from the Ming and Ch'ing periods, but it is not easy to distinguish them. In fact it is possible that Fukien may be the original home of the technique of coloured enamels.[14]

The *Annals of Ch'üan Chou Fu* (celebrated as a trading port in the Middle Ages) are often quoted with reference to porcelain (tz'ŭ ch'i) manufactured at Tz'ŭ tsao in the Chu Chiang district; and three other places in the district of An'chi are named as producers of white porcelain inferior to that of Jao chou. Similarly the *Annals of Shao Wu Fu*, on the north-east border of the province, allude to white porcelain made in these places, the factory at Tai ming in Anpin being the best (the others being the Ch'ing Yün factory at Ssŭ-tu; and the Lan ch'i Factory in the Chien nung district) but all were far from equal to the Jao Chou ware.[15]

The district of Wên Chou Fu (formerly in Fukien but now transferred to Chekiang) was noted as early as Chin times for its pottery, the bowls of 'Eastern Ou' are famous. Two pieces in the British Museum Collection come from the neighbourhood, the first an incense burner in the form of the figure of the god of longevity seated on a bull, which arrived in a box, with a label which described it as 'Wên Chou Ware'. The second is a bottle painted a greyish blue with a medley of flowers, fruit, symbols and insects and inscribed on the base '*Fu fan chih ts'ao*'.[16] Hobson rendered this 'made on the borders of Fukien' or 'made for the Prince of Fu'.

The existence of kilns at Fung Kai between Swatow and Chao Chou

fu (where there are beds of kaolin as well as commoner clays) is not known. An old Consular Report describes the objects made here as 'pottery of every description, from common earthenware to finely finished articles with coloured glazes or enamels, cups for tea and wine, bowls, dishes, plates, stores of red terra cotta, pierced plaques for windows, and immense stone jars holding 100 to 150 litres'[17] and also coarse porcelain. Can this be the home of the so-called Swatow wares which were distributed over India, the Malay Archipelago, and the Near East in the sixteenth century? Where these are made is still to be considered; Japanese authorities believe it was at Shih Ma in Fukien.

' "Dishes, rice bowls, wine cups, saucers, spoons, preserve jars, wine bottles, etc. in common porcelain have long been an object of trade between Amoy, in Fukien, and Indo China, the East Indies and India." Shih-ma and Tang-an Hsien in the immediate neighbourhood may have supplied the goods; and we may look to the factories of Swatow and Amoy for the origin of much of the coarse and archaic-looking blue and white, and coloured ware, which is picked up to-day in India and the Eastern Archipelago and not infrequently passed off as antique.'[18] This material is difficult to date, but although some of it goes back to the Ming period, much of it must be late seventeenth century, eighteenth century and later (1).

The white porcelain made at Tê-hua about seventy-five miles due north of Amoy, on the other hand, is easy to identify. This is the *blanc de Chine* of the French. It is expressly stated in the *T'ao Lu* that this factory started to make porcelain in the Ming period, when their white figures of Maitreya and Kuan Yin became famous. But it is not generally believed that the factory dates back to the early years of the dynasty. Hobson treats the Ch'êng Hua and Hsüan Tê marks, which occasionally appear in some pieces, as apocryphal, but they are accepted by most Chinese antique dealers.[19] Wan Li marks, although not common, he treats with more respect. The British Museum possesses a bowl or mortar dated 1511, and a figure of the god of wealth dated 1610.

The bowl at Venice reputed to have been brought back by Marco Polo from Zayton in 1292 is no longer believed in, nor the so-called flute of Yoshitsune—the twelfth-century hero of Japan; while the plate once at Dresden, with a jewelled ornament, supposed to have been brought back by a Crusader from Syria in the twelfth century, is not a Fukien piece at all.[20]

The nature of the material seems to have changed little during the centuries. Even Hobson admits that the dating of Fukien pieces was

Plate (1) CXVI, *Fig.* 2

one of the most difficult problems of Chinese ceramics. The bulk of the pieces which reached Europe are without doubt from the K'ang Hsi period and later. Here the pieces in the Dresden Collection were probably the safest guide. By the eighteenth century these wares were widely distributed in Europe and no longer dear. Many became the models of French, English, and German ceramic factories.

The variety both in quality and colour of the pieces exported to Europe was very wide. They range from coarsely modelled, roughly finished figures, with detachable heads, to elaborately modelled and delicately finished specimens, with fragile fingers and flowing garments with beautifully chiselled folds (1). Many of these elaborate pieces are probably later than is usually believed. The colours range from a dead chalky white to a cold bluish 'skimmed milk', through various yellowish tints to a pinkish white, but these differences do not help to establish criteria to date these wares.

This Fukien porcelain was probably the finest porcelain ever made in the sense of the perfect marriage between the glaze and the body. 'At its best it is of a luminous warm white colour, and of a grain so fine as to give the appearance of translucent congealed fat or milk-white jelly; the dense glassy glaze melts into the body as if they were one substance.'[21] But the author of the *T'ao Lu* complains that it was as a rule too thick, though rich and lustrous. 'Rich and lustrous' says Hobson, 'it has a white, glassy body and a soft, mellow-looking glaze which blends so closely with the body that it is difficult to see where the one ends and the other begins. The colour varies from milk white to cream white, sometimes suffused with a rosy tinge, and the texture of the glaze has been aptly compared with milk jelly or blancmange.'[22]

D'Entrecolles states, quite incorrectly, that the Tê-hua pieces were never coloured in China, and Honey would appear to accept the view that all the decorated pieces were painted in Europe[23] on the white.

A large number of pieces, chiefly small cups, were undoubtedly imported and decorated in this way, usually in Holland. There are also, without question, other pieces decorated in China in red or green enamels (2) to which yellow and aubergine are sometimes added. Dukes, on a visit to the kiln in 1880,[24] speaks of children painting cups in the open air and the *Li-t'a k'an k'ao-ku ou-pien* published in 1877 remarks of this kiln 'when the glaze (of the Chien yao) is white like jade, glossy and lustrous, rich and thick, with a reddish tinge, and the biscuit heavy, the ware is of the first quality; enamelled specimens (wu t'sai) are second rate.'[25] This is probably true. There also exist a number of pieces decorated in underglaze blue (3). Some of the incense

Plates: (1) CXX, *Fig.* 2; (2) CXIX, *Fig.* 1B; (3) CXVII.

bowls, covered with a deep, rich brown glaze have been christened 'Red Fukien' by Farley. They probably were in imitation of bronze. Others again, chiefly figures, have been lacquered red or covered with a red gold and black oil gilding, probably in China, but the majority of the pieces are untouched by colours.

Among the exported pieces in the late seventeenth and early eighteenth century there were many European forms like the porringers with flat handles copied from English silver and datable to about 1675, and mugs and tankards copied from German and English stoneware of the seventeenth century (1). Besides the statues of Buddha, Kuan-yin, and Kuan-ti, for which the kiln became famous in the Ming dynasty, there are figures of Bodhidharma and the Taoist Immortals, and in a less serious vein caricatures of foreigners. The statues of Kuan-yin, goddess of mercy, are innumerable and of great diversity and quality. This is not surprising, as her chief shrine is nearby at Ningpo on the island of Pu-to Shan. She can be represented either as goddess of the Sea, standing on a fish, in which form she was worshipped by the pirates of the Fukien coast; as goddess of fertility and childbirth in which guise she carries a child, or as goddess of compassion carrying a willow wand and pouring from her vase balm upon the troubled world. Grotesque Buddhist lions—the dogs of Fo— mounted on pedestals with brocade balls, and a hollow holder for joss sticks at the side are another common product of this factory. From their open jaws project formidable teeth and they have elaborately curled tails. Pieces made for the Chinese market include teapots, incense vases, and libation cups copied from rhinoceros horn originals. Vases are often moulded in relief with sprays of plum blossom or dragons (2), decorated with sunk panels (3) or with incised ornament, often with verses in the grass or running script. A fret, whorl or swastika is occasionally seen under cups and libation bowls belonging to the early Ch'ing period.

Names of potters do occur in some of the eighteenth-century pieces, generally in seal form, and like the place-names and date-marks when they occur, are usually so obscured by the glaze as to be unidentifiable. But some of the names of potters like Lai Kuan and Ho Chaotsung have been read, although at present nothing is known of their bearers.

The whole history of this kiln awaits investigation. Brinkley was of the belief that it began production *circa* 1400, under the early Ming Emperors, and continued until the latter half of the eighteenth century, when it appears to have been virtually discontinued, 'to be revived in later years.' He gives no documentation for this statement

Plates: (1) CXIX, *Figs.* 1A and C; (2) CXX, *Fig.* 1; (3) CXIX, *Fig.* 2.

and adds: 'a considerable number of specimens are now produced and palmed off on unwary collectors. But the amateur can easily avoid such deception if he remembers that in the genuine pieces of ivory white the ware is always translucent when held up to the light, which quality if not entirely absent, is only possessed in a comparatively slight degree by the modern product.'[26]

There is little doubt that this kiln was at one time a dangerous rival to Ching-tê Chên, as an alternative source of supply for the foreign market. Both T'ang Ying and D'Entrecolles (writing in 1712) tell us that certain Ching-tê Chên potters transported their plant to Fukien in the hope of making more profits out of the foreign trade through Amoy, but these ventures do not appear to have been successful.

The study of the Tê-hua wares has been revolutionized by Mr. P. J. Donnelly's recently published book *Blanc de Chine* (Faber & Faber, 1969). This work should be consulted by anyone needing further information on these wares.

1. Tê-hua was the exception.
2. Bushell, *Oriental Ceramic Art*, p. 623–4.
3. Fujio Koyama, *The Story of old Chinese Ceramics*, Tokyo, 1949.
4. Published 1926.
5. I. Shensi (a) Ching Ts'un Chên, (b) Ch'en Lo
 II. Hupeh Wu Ch'ing
 III. Shansi Ta Ku
 IV. Kansu Lung Shan
 V. Szechuan Ch'êng Tu (this must cover several provincial kiln sites)
 VI. Honan (a) P'ang Ch'êng, (b) Shên Chou, (c) Ju Ning, (d) Wei Ning, (e) I Yang, (f) Tang Fêng
 VII. Hunan (a) Lung Shan, (b) Li Ling
 VIII. Anhui (a) Ch'i Mên, (b) P'ai T'u, (c) Su
 IX. Kiangsu (a) Ou, (b) Ting Shan, (c) Shu Shan, (d) Hsiang Shan
 X. Shantung (a) Tzu Ch'uan, (b) Lin Ch'ing, (c) Yen Chou, (d) Yih, (e) Tsou
 XI. Fukien (a) Shih Ma, (b) Hsia Men (Amoy), (c) T'ang An, (d) An Ch'ing
 XII. Kuangtung (a) Ch'in Chou, (b) Ch'ao Chou, (c) Shekwan
 XIII. Kiangsi (a) Heng Feng, (b) Shiu Wu, (c) T'ai
6. A Japanese kiln map once in the possession of the late Sir Herbert Ingram attempts to plot the kilns of the T'ang, Sung, and Ming dynasties and records over 90 kiln sites, yet it is incomplete. The provincial sites of the Ch'ing period are even less known and studied.
7. Ch. VI.
8. Ch. VII.
9. There seems to be no record of what they made for the local market. There may have been pieces of the Kiangnan Ting type.
10. Bushell, *Oriental Ceramic Art*, p. 624.

11. But it might resemble something like the plate on Plate CXVIII, Fig. 1. The bowl on the same Plate (Fig. 2) seems to be earlier, but on the other hand my friend Mr. Pope writes to me that he came across in Saigon in 1956 a type of underglaze blue known locally as 'blue d'Hue' many of which pieces were marked with the characters for sun and moon respectively. He was told that these were for the use of the king (sun) and queen (moon). This began about 1802 when the Yuan family took over the throne of Annam. This bowl has a moon mark.

12. On a tributary of the Yangtze beyond Hankow.

13. Hobson, *Later Ceramic Wares of China*, p. 111.

14. The mysterious bowl, once in the Winkworth Collection and now in the David Foundation (*David Cat.*, Plate XXX) decorated in thick green, red, and brownish yellow, and turquoise blue enamels and marked Hsüan Tê with the cyclical year mark for 1433 may possibly be a product of the province. It is decorated with prunus boughs and birds—two sprays outside and one within. It is a difficult piece to place. Could this be Swatow ware of a superior quality? Many of the potters of Ching-tê Chên seem to have been recruited from Fukien.

15. Hobson, *Wares of the Ming Dynasty*, p. 177.

16. Baron Ozaki says this is the *nien hao* of one of the Emperor Wan Li's grandsons—a son of his third son, who became King of Fukien in 1601 and was killed in 1640. His son in turn became king in 1643 and emperor in 1644; he was assassinated a few months later.

17. Quoted by Hobson, *Later Ceramic Wares of China*, pp. 110–11.

18. *ibid.* p. 111.

19. Hobson, *op. cit.*, p. 117.

20. 'The search for the primitive Tê-hua ware is made the more necessary since what appear to be the earliest specimens show a perfection of material and workmanship which cannot have been achieved without a long period of experiment. Wares that can be called primitive *blanc-de-Chine* are rare enough, and even these often prove to be late and degenerate rather than early. . . . Reign marks were apparently never used, or are so completely obscured by the thick glaze as to be illegible. Attempts have been made to establish criteria for dating the ware within the period of the 17th, 18th, and 19th centuries to which so much of it obviously belongs; but these have generally failed.' (Honey, *Ceramic Wares of China and the Far East*, p. 133.)

21. *ibid.*

22. Hobson, *Wares of the Ming Dynasty*, p. 174.

23. Honey, *op. cit.*, p. 135.

24. E. J. Dukes, *Everyday Life in China, or Scenes in Fukien*, London, 1885.

25. Hobson, *Chinese Pottery and Porcelain*, Vol. 2, p. 115. I do not understand the reference to Chien yao, a Sung ware of quite different character, though emanating from Fukien. Hobson is clearly writing of Tê-hua ware.

26. It is doubtful whether this statement is of much value. Heaviness of build would seem to be a safer criterion.

APPENDIX I

KU YÜEH HSÜAN (ANCIENT MOON TERRACE)

The designation Ku Yüeh Hsüan[1] to describe a small group of imperial porcelains of the finest quality is probably a misnomer. The term also covers a much larger group of small pieces of glass and porcelain, chiefly snuff bottles, inscribed with these characters but of inferior quality and later date (1). Mr. Yang Hsiao-ku, the author of the standard work[2] on this subject, writes that the imperial Ku Yüeh Hsüan pieces, which were on view in the Ch'ien Ch'ing Palace in a small treasury to the north-east of the Tuang Ning Tien in Peking, used to possess Ch'ien Lung labels describing them as—'porcelain with the body painted in *fa-lang* enamels' (*Tz'u t'ai hua fa-lang*).[3] And this is probably the correct term to use when describing this small family.

'This type (Ku Yüeh Hsüan) of enamelled porcelain originated with the régime of Ts'ang Ying-hsüan, who was superintendent of the imperial factory in the twentieth year of K'ang Hsi. The style of the painting on the porcelain, which was in coloured enamel, was suitably adapted from the technique of manufacturing *cloisonné* ware on a bronze body for the use of the emperor. The colouring materials in use were also imported from the West. . . . During the period between the sixth year of Yung Chêng (1727) and the eighteenth year of Ch'ien Lung (1753), when T'ang Ying was superintendent of the imperial works, this kind of enamelled ware reached its highest stage of development. T'ang improved upon the method in use and put vivacity into what had been dull and stereotyped. He even employed such popular Chinese colours as brown and black to make up for the deficiency in variety of pigment, thus adding freshness and brilliancy to the composition. This art perished with the death of T'ang Ying.'[4]

The finest Ku Yüeh Hsüan pieces are rare, costly and obviously Palace productions. Mr. Yang in his exhaustive study lists only 103 pieces known to him, of which 50, when he wrote in 1934, were in the

Plate: (1) LXXXIV, *Fig.* 1B.

Palace Collections. There are, he thinks, less than 20 genuine pieces in Europe and America together, and not more than 6 pieces in Japan. They appear to be limited in size and shape, ranging from small vases, bowls, dishes and water vessels of usually not more than six or seven inches high to bowls five or six inches in diameter. According to the *Shuo Tz'ǔ*[5] they were the finest of all the ceramic productions of the Ch'ing dynasty and as their price was astounding 'many contemporary imitations were made, which were correspondingly costly. . . . At the time of their production there was not a large output and so of necessity there arose contemporary imitations, but those that came after the time of Ch'ien Lung were not at all expensive in comparison; if they bear these characters Ku Yüeh Hsüan they belong to the spurious type. The genuine specimens seem to have been made between the closing years of the reign of K'ang Hsi and the opening years of Chia Ch'ing'.[2] The late K'ang Hsi pieces are according to the *T'ao Ya*, mostly with a yellow ground, some being decorated with four branches of lotus blossom, with seal characters inlaid, (1). This type has little in common with the elegant and sparsely decorated Yung Chêng and Ch'ien Lung pieces of the same family. Other pieces belonging to this family are the two bowls illustrated on Plate XXXIV.

The fine Ch'ien Lung pieces have a dead-white glossy body of close texture with a sheen on them, akin to that of well-polished jade. The decoration is in keeping with their quality and it is never overloaded. In their delicacy and restraint they are characteristic of decoration in the Chinese taste; some pieces are decorated with European motives and posies of flowers, birds, more rarely landscape and very occasionally figure motives as their subjects.[6] Of the hundred and thirty-eight pieces listed by Mr. Yang, ninety-nine were decorated with floral subjects, (2) twenty-one with birds (3), fifteen with landscape (4) and only three with figures[7] (5).

The fine pieces are invariably inscribed with a poem—often from the imperial pen—in black enamel imitating ink with red seals preceding and succeeding it and one or two other seals to the side. It is probable that these seals do not usually cover a painter's name or *nom de plume*; since quotations from imperial poems could not on grounds of reverence carry the imperial seals, these may have been inoffensive substitutes for them. There is a great variety of these seals, which usually carry meanings of a felicitous nature, but the same ones

Plates: (1) XXXV, *Fig.* 2; (2) LXXX, LXXXII, LXXXIII; (3) LIV, *Fig.* 1, LXXVIII, LXXIX, *Fig.* 1, LXXXIV, *Figs.* 1A and 2A; (4) LXXVII, *Fig.* 2; (5) LXXIX, *Fig.* 2.

frequently occur. A small vase[8] in the David Foundation decorated with orchids and wild roses has a poem preceded by the seal *chia li* (beautiful) and succeeded by two other seals *ssŭ shih* (four seasons) and *ch'ang ch'un* (enduring spring) and underneath is the Ch'ien Lung mark in pale blue enamel (Plate CLXX, Fig. 2 *David Catalogue*).

A saucer dish[9] in the same collection decorated with sprays of magnolia and peach bears the poem, 'Moving shadows follow the morn. A gentle breeze bears fragrance,' preceded again by the seal *chia li*, with two other seals *hsia* (clouds) and *ying* (reflection) after the poem (Plate CLXXIII *David Catalogue*). This piece also carries the Ch'ien Lung mark in pale blue enamel. The poem on this dish with similar seals is repeated on a Yung Chêng saucer dish in the Palace painted in Ku Yüeh style. Two bowls[10] in the David Foundation, are delicately painted with plum blossom in sepia and are inscribed with a longer poem in the same vein—'The student sees the sharp outline of the plum blossom on the window blinds and breathes the scent of unseen flowers wafted past'.[11] This is preceded by the seal *hsien ch'un* (early spring) and followed by the seals *yüeh ku* (ancient moon) and *hsiang ch'ing* (pure fragrance). Underneath they have the Yung Chêng mark in blue. The paste, shape and decoration of these bowls is all of the highest quality. The inscriptions and seals have been chosen with care. They could be nothing else than imperial pieces.

Three bottles[12] in the *David Catalogue* (two a pair), are decorated in Ku Yüeh style with poems and seals, flowers, birds and bamboo growing from rocks. But each poem only carries two seals, the single bottle being inscribed *chia li* (beautiful) followed by *ch'ang chun* (enduring spring) and the pair inscribed *kao chih* (lofty demeanour) and *ch'un shih* (autumn scholar). On the next page is the reproduction of a glass bottle[13] decorated in enamels with a poem and the seals *chia li* (beautiful) and following the poem two others *ssŭ shih* (four seasons) and *chang ch'un* (long spring). All these bottles carry a Ch'ien-lung mark; in the case of the three porcelain pieces in raised blue enamel, but on the glass piece it is incised.

Attempts have been made to identify the seals on Ku Yüeh Hsüan with the *noms de plume* of painters, but consisting as they do of pairs of ideographs making antithetical literary phrases, marked by the parallelism of contrasted words, it seems unlikely that they conceal any such meaning. The *T'ao Ya* says that 'in the K'ang Hsi porcelains they read *Yüeh Ku* (old moon) and *Hsiang Ching* (fragrant purity), and in the Ch'ien Lung period the seals are *Chin Shêng* (golden completeness) and *Tang Ying* (red brightness); all have square seals. The inscriptions below them which are drawn long and square read *Chia li* (beauty), and those of the same nature alone are common to the period

of Yung Chêng and Ch'ien Lung'.[14] It would be dangerous however to attempt to classify these wares on this information.

On the base of the imperial Ku Yüeh Hsüan pieces is inscribed the *nien hao* usually in raised blue enamel, enclosed within a double lined square, with rounded edges. The characters which are meticulously drawn are usually in blue, but sometimes in mauve or yellow. Some of these pieces are marked 'made from imperial order'. It is only the inferior pieces that carry the mark Ku Yüeh Hsüan.

Available information on Ku Yüeh Hsüan is very meagre. None of the early European writers on Chinese ceramics, Jacquemart, Julien, du Sartel, Gulland and Brinkley, mention it at all, nor does any reference to it occur in the pages of the *T'ao Lu* and *T'ao Shuo*. Mr. Yang Hsiao-ku's work is the most authoritative treatment of this subject.[15]

One of the earliest references by any European to this ware occurs in the works of Mr. Hippisley[16], of the Maritime Customs. It was he who was first responsible for the theory that the inscription the 'Old Moon terrace' first appeared on small objects in opaque white glass, delicately painted in enamels which so appealed to the taste of Ch'ien Lung that he ordered T'ang Ying to copy them in porcelain.

Four explanations of the origin of the term Ku Yüeh Hsüan (none of them entirely satisfactory) have been put forward:

(1) Ku Yüeh Hsüan was called after a Mr. Hu (or Ku) a well-known painter on glass, whom the emperor ordered his potters to copy.

(2) Ku Yüeh Hsüan was connected with a pavilion or studio in the Palace belonging to Ch'ien Lung, where the famous painter Chin Chêng—pen name Hsü Ying—painted these wares.

(3) Ku Yüeh Hsüan was a famous hall in the Palace of the Ch'ing emperors, not especially connected with the Emperor Ch'ien Lung, in which the finest porcelain was stored.

(4) Ku Yüeh Hsüan was the auspicious appellation for the 'fox Hsüan chamber' of the Yamen of some high ranking mandarin.

It has been suggested by Hippisley that the name was taken from a Palace glassmaker, Hu, who first used the mark on his products. Bushell believed in his existence, and calls him a glassmaker of Peking, who manufactured under Jesuit influence. In favour of this theory is the fact that some of the porcelain snuff bottles are marked 'Fang Ku Yüeh Hsüan' (in imitation of Ku Yüeh Hsüan), but these pieces are late and of inferior quality and do not necessarily refer to glass originals. Okuda after mentioning this theory says: 'If this man Ku went by the name of Ku Yüeh Hsüan mention must be made of him in some book or other. Whereas there is no such reference we know of. Again, to call wares from the imperial factories by the name of their artists, as it is alleged, is contradictory to Chinese

tradition and much more to the practice of the imperial household.'[17]

Actually in the supplementary edition[18] of the *Tz'u Yuan Hsu Pien*, the *Chinese Encyclopaedic Dictionary* there is a note to the effect that during the reign of Ch'ien Lung a native of Swatow, named Hu Hsüeh-chou, set up a private kiln, which made porcelain snuff bottles, etc., decorated in fine colours with floral patterns and short verses, and marked with Ku Yüeh Hsüan on the base as *nom d'atelier*. The Emperor Ch'ien Lung during a trip to the Southern provinces is said to have admired his work and ordered him to take charge of the imperial kiln in Peking. But this account associating Hu with porcelain manufacture is a recent addition to the *Encyclopaedia* and does not appear in the earlier editions. Hu's name appears to be completely missing from any of the local gazetteers or books of biographical reference in which the names of noted craftsmen,[19] who had attracted the attention of the vermilion pencil, would be found. Both Ferguson[20] and Wu Lai-hsi dismiss the Hu theory as improbable. Yang writes with the greatest contempt: 'With regard to the second explanation that Ku Yüeh Hsüan is the surname of a person: (i.e. Hu) who specialized in painting vessels, which were imitated by the followers of Ch'ien Lung, there is no basis for it and at the beginning of the Ch'ing dynasty all the distinguished people's diaries in the capital never say anything in connection with this, but one hundred years afterwards the baseless rumour has arisen, caused by street hawkers; take such a rumour and put it in a book, and a hundred years afterwards there are people who will take the rumour as a serious fact.'[2] Kuo takes up the position that the Ku Yüeh style of enamel painting was first employed in porcelain and only later on glass. According to him, 'Among the vessels used by the Emperor Ch'ien Lung there are to be found small articles such as snuff-bottles which were made under an imperial decree by the Tsao-pan Ch'u (a department of the imperial household, charged with the duties of making and furnishing vessels for use of the emperor). Upon these articles was applied the method of painting upon porcelain with enamel that is *cloisonné* enamelled porcelain.[21] The technique employed upon porcelain was thus extended to glass ware. The date marks at the base were invariably the four characters *Ch'ien Lung nien chih* written in the *K'ai shu* style, exceedingly formal and trim. Those written in blue enamel are raised and those in "oil red" flush with the base. . . . Porcelain in *cloisonné* enamels is represented by many examples in the Imperial Collection at the Palace. Glass wares of the same kind are mostly represented by snuff-bottles. . . . There are none of these with the mark of Ku-yüeh Hsüan. . . . Nevertheless there was actually the mark of Ku-yüeh Hsüan in the time of Ch'ien Lung, but it was inscribed on glass and not on porcelain wares. Moreover, it

was the mark of a private individual, and was not affixed on vessels for the imperial palaces . . . they were also made by the Tsao-pan C'hu at the time, apparently for a member of the imperial family or an official of high authority in the Imperial Household, to be used by himself.'[22]

With regard to the second theory which is adopted by the author of the *Shuo Tz'ŭ* that the Ku Yüeh Hsüan pieces were decorated by a painter Chin Chêng [tzu Hsü Ying], whose name occurs among the seals, Yang's comment runs,[2] 'By mistake this seal is taken as the name of a painter. This book (the *Shuo Tz'u*) is not acquainted with the facts, because according to the custom of the Ch'ing dynasty every official who specialized in writing must submit their seals to be preceded by the word Kuan (servant), but there is no Kuan before Chin Chêng. . . . Furthermore when I was in Chêng Chun I checked the *Fa-lang* porcelain and found that all the pictures of autumn flowers of a yellow colour were sealed Chin Chêng, just as those of bamboos were sealed Pin Jan Chün Tzu; while the paintings of mountains and water had the seals Shan Kao Shui Chang. All these are inscribed on the porcelains, but they are not the names of painters at all.'

Theories have been put forward that Ku Yüeh Hsüan was the name of a storehouse for this ware, after which it was named; a studio where the ware was decorated, or a pavilion where the ware was used, and from which it derived its name. Wu Lai-shi suggests it was a room where the ware was used. Omura Seiga[23] believed that it was a pavilion in the Palace. But both Yang and Kuo dismiss these suggestions, and both of them claim to have searched the palaces and palace records in vain for mention of such a place. 'With regard to the Hsüan (or pavilion) that is named Ku-yüeh,' writes Kuo, 'visits have been made to all the palaces which are in existence, such as those in the Forbidden City, known as Ku Kung, those in the parks enclosing the three lakes known as San Hai, those in the Summer Palace called I-ho Yüan and those at Jehol, but the search has been in vain. Researches have also been made into books and records that deal with palaces that were destroyed by fire, such as Ch'ang-ch'un Yüan, and Yuan-ming Yüan, but the effort again has been fruitless. Collections of poems and other great literary works by the various emperors have been thoroughly examined, with no more encouragement. In the Collection of the Emperor Kao Tsung (Ch'ien Lung) practically every building in the palaces in and out of Peking has formed the subject for his poetical effusion. Among these so treated there are Mei-yüeh Hsuan and Tai-yüeh Hsuan but no Ku-yüeh Hsuan.' It is obvious then that there is no pavilion of that name within the Palace Precincts or Imperial Parks, for otherwise Emperor Kao Tsung would not have singled it out for neglect.[24]

The fourth theory originates from Lady David.[25] She says Ku Yueh is an ancient and well-recognised etymological 'split' for the patronymic, which is itself a homophone for *hu*, fox. In the same way the characted *hsien* (or *hsüan*)—chamber—might be used in this context for the character *hsien*, which means a fairy. Now the fox genius was by tradition the guardian of seals of office to the high mandarins' Yamens. In some parts of China it was customary for mandarins to keep their seals of office in what was called a 'fox chamber', but the character for fox was never written, so as to avoid the slightest risk of offence to the real animal!

Lady David believes that Ku Yüeh Hsüan was not the hallmark of a glassmaker, nor the name of an imperial pavilion in the Palace, but the auspicious appellation for the 'fox chamber'[26] of a great mandarin who in the last decade of the eighteenth century or in the first half of the nineteenth century commissioned a number of glass snuff bottles and waterholders painted in enamel colours for his private use. These glass objects marked Ku Yüeh Hsüan were well known in the antique market before 1860, when the much finer porcelain pieces decorated in the same vein began to leak out of the Palace, so that these porcelains were given the 'misleading, anachronistic and utterly unworthy name of Ku Yüeh Hsüan, which it is now too late, alas, for us to delete from our ceramic glossary'.

Kuo Pao-ch'ang agrees that the glass articles marked Ku Yüeh Hsüan were in public circulation long before the porcelain pieces associated with them at a later date were known outside the Palace, that for want of an appropriate name these glass pieces were called by their basemark Ku Yüeh Hsüan, and that when about 1860 *cloisonné* enamelled porcelain pieces leaked out of the Palace and those who saw them for the first time, observing their similarity to the glass ware marked Ku Yüeh Hsüan, extended the latter's name to cover them. But this still leaves the origin of the name Ku Yüeh Hsüan a mystery.

Kuo does not attempt to discuss where the Ku Yüeh Hsüan porcelain was made and who provided their decoration, inscriptions and seals. The suggestion put forward by Omura Seiga is that the bodies of these pieces were especially ordered by the Tsao-pan Ch'u from Ching-tê Chên. They were sent up to the Palace in the white, where they were decorated and refired in a small enamel kiln, which is known to have existed in the imperial grounds.

As to the decorators of these pieces it has been suggested that special porcelain painters were sent up to the Palace to be trained by the Tai Kuan (the Imperial Art Bureau) to do this work; but owing to the very small number of pieces which have survived and the superb quality of the painting it is very likely that the painters were members

of the Tai Kuan itself. The *Shuo T'zŭ* says: 'At that time all the porcelain was made at Ching-tê Chên and transported to the capital and all the painters of the ordinary porcelain kilns were ordered to paint these models. In the Palace a pottery kiln was set up. Some say they know that Tung Pang-ta painted them, but from the style of painting it is more probable that many were painted by Chiang T'ing-hsi and Ts'ai Kung and Chiao Ping-cheng.'[14] Yang believes[2] that 'the distinguished people, who sealed and painted them, were the products of the Court and the Han Lin Academy; among them foreigners like Lang Shih Ning (Castiglione), although he was not afterwards in the same position as the resident painters. These distinguished people were not employed in painting common pottery and given a monthly wage of a few taels. There is no comparison between the two'. He adds, 'Lang was good at Chinese and Western technique. All the figures in *cloisonné* enamel porcelain (Ku Yüeh Hsüan in this context) came from him . . . all the pupils who were trained by him were very good at using pink in the face, especially with children and young ladies.'

1. The characters literally translated mean 'Ancient Moon Terrace'.

2. Yang Hsiao-ku, *Ku Yüeh Hsüan tz'ŭ k'ao* (On the Ku Yueh Hsuan porcelain), Peking, 1934. I have translated the passages quoted in this Appendix.

3. He adds: '*Fa-lang* porcelain is the porcelain of France, because French porcelain was imported very early and its imitations called the foreign porcelain and its colour the foreign colour.' The term *fa-lang* was also used to describe *cloisonné* enamels.

4. Kuo Pao-ch'ang, *Illustrated Catalogue of Chinese Government Exhibits for the International Exhibition of Chinese Art in London*, 1935, preface to Vol. II, p. 30. Yang Hsiao-ku agrees that the ware ended with the death of T'ang Ying in 1754 and puts its zenith between 1727 and 1753 (Introduction to Section 2 of David Foundation Catalogue, 1958).

5. Both the *Shuo Tz'ŭ* and the *T'ao Ya* are quoted at length by Yang Hsiao-ku, often with disapproval.

6. In *Old Furniture*, vol. II, p. 175, a Ch'ien Lung vase which belonged to Messrs. Yamanaka is illustrated in colour; in vol. III, p. 83, a bottle, with landscape decoration, which belonged to Messrs. Tonying. Another vase decorated with golden pheasants is reproduced in colour in *Chinese Ceramics in Private Collections* on Plate 28. This piece was in the Russell Collection and has a Yung Chêng mark. Several other pieces are illustrated in colour in the *David Catalogue*. Two vases decorated with women and children are known to me. One of them formerly in the Martin Hurst Collection is illustrated on Plate XL in G. C. Williamson's *Book of Famille Rose* and again in an article in the Magazine *Antiques* of Oct., 1937, in Fig. 4 illustrating an article entitled 'The Ancient Moon Painters' by Homer Eaton Keyes. The second vase now in the Freer Gallery, Boston, is illustrated by Seichi Okuda. (Plate LXXIX, *Fig.* 2).

7. Yang Hsiao-ku, *op. cit.* Lady David, however, quoting from the same source, gives the figures as 84 with flowers and birds, 15 with landscapes and four with figures (Introduction to Section 2 of David Foundation Catalogue, 1958).

Yang's totals are in any case too low, for Lady David was told in T'ai-chung that over 400 pieces of this ware had been removed to Formosa and were in store there.

8. R. L. Hobson, *Pottery and Porcelain in the David Collection* (Plate CLXX).

9. *ibid.*, Plate CLXXI.

10. *ibid.*, Plate CLXXII.

11. Compare Plate LVIII.

12. *David Catalogue*, Plate CLXXIII.

13. *ibid.*, Plate CLXXIV.

14. Quoted by Yang Hsiao-ku, *op. cit.* (trans.).

15. His references to the *T'ao Ya* by Mr. Chên Kang lin, the *Hsi Wang Ts'un Yu Chi* and the *Heng Chih Yin Lu Chi Shuo Tz'ŭ* of Mr. Hsü Shuo-tz'u, which he says are the only other Chinese works on this subject, are not flattering. Of Mr. Chên and Mr. Hsü, who are both his contemporaries, he says: 'What Mr. Chên wrote about Ku Yüeh is wrong, and Mr. Hsü only repeated his mistakes.'

16. A. E. Hippisley, *A sketch of the History of Ceramic Art in China*, Smithsonian Institution, Washington, 1902.

17. Seichi Okuda, *Ku Yüeh Hsüan*, 1936.

18. B. A. de Vere Bailey, 'The Old Moon Terrace,' *Burlington Magazine*, Dce. 1935.

19. Famous craftsmen upon whom imperial favour was bestowed enhanced the communities from which they sprang and their names were consistently recorded in local annals.

20. See B. A. de Vere Bailey, *op. cit.*

21. This is a hideous phrase and very confusing as *cloisonné* is quite a different technique, properly applied to the *san ts'ai* group of the Ming dynasty, where the fields are separated by raised threads of clay (cf. Plate CII). But according to Kuo Pao-ch'ang (*op. cit.*, p. 30) the term 'porcelain body painted in cloisonné enamel' was used in the palace inventory for porcelain decorated in Ku Yüeh Hsüan style from K'ang Hsi onwards, and he uses the description 'cloisonne enamel' for such pieces throughout the catalogue prepared by him for the Chinese Government for the Burlington House Exhibition of 1935. But he also tells us that the palace appellation was changed in 1743 to 'porcelain bodied foreign enamel' which is surely more correct. The term 'foreign enamels' is chiefly associated with Cantonese enamelling on copper. It is probable that it is the *famille rose* which is referred to in the palace inventories in this context, and it is possible that this enamel was first introduced by the Jesuits in the decoration of the so-called 'Cantonese enamels' on copper (which we know were of European origin) and from this translated to porcelain.

22. Kuo Pao-ch'ang, *op. cit.*, pp. 32-3.

23. Omura Seiga, *History of Chinese Art*.

24. Kuo Pao-ch'ang, *op. cit.*, p. 32.

25. S. Yorke Hardy, 'Ku Yüeh Hsüan—a new hypothesis. *Oriental Art*, 1949–1950.

26. or 'fox fairy'?

APPENDIX II

THE *NIEN HAO*, HALL-MARKS, AND MARKS OF COMMENDATION

Whoever wishes to be a connoisseur of Chinese porcelain must take into account the dynastic marks or *nien hao*.

Besides the *nien hao*, hall-marks, marks of commendation and description, Taoist and Buddhist symbols and signatures of potters[1] all appear on Ch'ing porcelain. The *nien hao*, which is usually written in cobalt blue under the glaze, within a double ring on the base, generally consists of six characters written either in two columns of three words or in three columns of two words, or occasionally in one line taken vertically or horizontally.[2] The first character is invariably the word *Ta* (Great), followed by the character giving the ruling house, which is followed again by two characters giving the reign name of the ruling monarch. The last two characters convey respectively the word *nien* (year) and *chih* or *tsao*[3] (made) the first of these two being occasionally replaced by the word *Yü* (imperial) in the case of pieces made for the Palace. A Chinese emperor on his succeeding to the throne loses his personal name and receives an honorific title (the *nien hao*), by which he continues to be known for the rest of his reign unless he wishes to change it.[4]

It has been suggested by early writers on Chinese ceramics that the use of the *nien hao* was limited to the imperial factory, but the excavation of coarse Chinese export porcelain wares in Egypt, the West Coast of Africa, and in the Gulf of the Red Sea and in various sites in India, marked with a *nien hao* makes it impossible to declare that none of those pieces came from provincial kilns, while there are distinguished pieces like the famous enamel bowl with a Hsüan Tê mark in the David Foundation,[5] which are unlikely to belong to the output of any of the kilns at Ching-tê Chên. It is not at present possible to distinguish the work of all the pieces made in the private kilns of Ching-tê Chên either from the work of the imperial kilns or from the output of some of the provincial kilns. The author of the *T'ao Lu* says that at the time of writing (1815) the bulk of the imperial wares were contracted out to private kilns, as in the time of the reigns of Lung Ch'ing and Wan Li of the Ming dynasty. Kuo, writing of the output

of the private factories of Ching-tê Chên, says vaguely: 'Wares made in the private factories of the Ch'ing dynasty, all following the rule of thumb prevailing at the time in the official factory, had a good number of choice pieces among them. During the time of K'ang Hsi, wares in three colours on a lemon or light green ground, and those in five or three colours on a ground of mirror black glaze, were manufactured after the Ming practice, but were finer and more beautiful than the Ming specimens. Such wares are not common among the ceramic vessels from the imperial factory.'[6]

The calligraphic interest of the *nien hao* has already been referred to. It is generally believed that it was only in the imperial factory that special artists were attached to the staff to write the *nien hao*. In private kilns they may sometimes have been written by gifted amateurs, but the bulk of them, as in the case of the provincial kilns, were more probably written by the decorators. In consequence the *nien hao* (other than those on the products of the imperial factory) tend to be badly or carelessly written.[7] The seal marks on provincial pieces—commonly called 'shop marks' by Europeans and *ch'in k'uan* (private marks) by Chinese connoisseurs—are generally impossible to decipher. Most of these illegible scribbles arc almost certainly varieties of the felicitous characters *fu* (happiness) and *shou* (long life).

In Ming pieces the *nien hao* may appear on the neck or lip, but it is not until the Ch'ing dynasty that it often appears in red, black or gold over the glaze. It may either be written in the *k'ai shu* or modern script or in the *chüan* or seal character, which from the reign of Yung Chêng onwards begins to oust the *k'ai shu* in popular favour. The running hand hardly ever appears on a Chinese piece; if it does it is certainly provincial, although it is a common feature of the later Japanese wares. Apart from the *nien hao* cyclical year marks sometimes appear; when the two marks combine they date the piece to an exact year.

Owing to the Chinese veneration for the past and the ceramic greatness of some of the earlier reigns, the marks of such emperors as Ch'êng Hua and Hsüan Tê were as consistently copied in the Ch'ing period as the reign marks of K'ang Hsi and Ch'ien Lung are copied on modern Chinese porcelain. The seal marks of K'ang Hsi on Chinese porcelain are rare, but symbols such as the artemisia leaf, lotus flower, a *ling chih* fungus, a hare, a *ting* (the four-legged incense burner, which is called the spider mark by the Dutch), a pair of fishes or an empty double ring are all found instead of the *nien hao*. Some of these pieces are said to have been made in 1677 and the immediately succeeding years, when the use of the K'ang Hsi *nien hao* was forbidden by decree;[8]

but most of these do not appear to be sufficiently near to the transitional period in style to be so dated. These pieces may be the production of private kilns. Whether this decree was enforced or stillborn we do not know, nor how soon it became a dead letter nor whether it was ever rescinded. Ch'ing pieces with the Tien (Heaven) mark on the base are also found.[9]

The hall-marks are so numerous that it is impossible to attempt to give a complete list. A comprehensive one appears in Burton & Hobson,[10] but this could be very much enlarged to-day. These marks may carry the character t'ang (hall), ko (palace pavilion); t'ing (summerhouse); chai (studio); hsüan (pavilion with a balcony); or shan fang (mountain retreat). The fashion of inscribing on Palace pieces the particular room in the Palace for which it was destined, though known under the reign of K'ang Hsi, does not become general till that of Yung Chêng. But these hall-marks 'reach from the Palace or pavilion of the emperor down to the shed of the potter, so as to include the reception hall of the noble, the balcony of the scholar, the studio of the artist and the shop of the dealer'. It would be a useful contribution towards the dating of the later Chinese porcelains if it were possible to arrange them in chronological order. These hall-marks may equally well signify the place where, or the place for which, the ware was made.

A recent Chinese book on ceramics[11] arranges them under five headings:
(1) Those made for the emperor.
(2) Those made for the royal family and nobility.
(3) Those made for scholars and successful officials.
(4) Those made for artists and craftsmen. (This class should presumably include merchants and shopkeepers.)
(5) Those that are unidentified.

At various times special services must have been made for the Palace to mark some particular occasion, or for the use of some particular person. Among them are the bowls decorated with wistaria and roses and a single magpie on a soft grey background marked on the outer surface near the rim with the hall-mark *Ta Ya Chai* (Hall of Great Culture) and near it a small oval panel framed by dragons with the motto *T'ien ti yi chia ch'un* (Springtime in heaven and earth as one family). Underneath there is yet another mark pencilled in red, which runs *Yung ch'ing ch'ang ch'un* (Eternal prosperity and Enduring Spring) (1). These bowls were part of a service made especially for the Empress Dowager Tz'ŭ Hsi, the *Ta Ya chai*, being the name of

one of the pavilions in the Ch'un Kung, where she at one time resided.

Another hall-mark runs 'made for the Shu-chang Kuan', which was part of the famous Han Lin Academy. It is strange that so few of these imperial pieces carry Mongol or Manchu inscriptions. But bowls do exist inscribed inside 'Baragon Tumed', which were made to celebrate the marriage of one of the daughters of the Emperor Tao Kuang to the hereditary Prince of the Mongols (1).

Another of these hall-marks reads *Shên-tê t'ang*, of which Hobson writes: 'A specimen with this mark in the Hippisley Collection is inscribed with a poem by the Emperor Tao Kuang, definitely fixing the date of the hall-mark, which is found in choice porcelains made for imperial use.'[12] This statement is supported by the *Chung Kuo Tao Tz'u*,[13] which places the Shên tê t'ang hall-mark as appearing during the reigns of Chia Ch'ing and Tao Kuang, with the note that these pieces were of especially fine work. But several pieces[14] which carry this mark exist both in blue and white and in enamel colours of rather coarse quality dating from the early years of K'ang Hsi.

Many of these hall-marks must record the halls of the private houses of officials and the premises of rich merchants, for which they were especially ordered from the private factories of Ching-tê Chên. There is the mark 'for the public use of the general's hall' (probably a present) and a gallipot inscribed 'Cloudy Fragrance Hall, a shop for scented wares and perfumed drugs at the west end of the Ta Shan-Lan on the north side of the street outside the Great South Gate of the Capital (Peking).'[15] Lastly there are a number of pieces often made by provincial kilns, which have been dedicated to Taoist or Buddhist temples, monasteries, or nunneries, usually in the form of incense bowls, pricket candlesticks or vases for the altar. These pieces are sometimes of great interest to the student, particularly if they bear beside the name of the donor and the temple, a date containing both the reign mark and the cyclical year, the month, and the 'lucky day' on which they were presented. They are not usually of fine quality (2).

Marks of commendation and felicitation are as common as the hall-marks, but it is seldom possible to use them for purposes of dating. It is quite usual to meet pieces marked with such expressions as *pao shêng* (of unique value); *ku chên* (ancient trinket); or *chi yü pao ting chih chên* (a gem among precious vessels of rare stones). Marks of this nature were particularly popular in the Ming period.

Marks of felicitation were widely used on presents. The four Chinese characters *Fu* (Happiness); *Lu* (honour); *Shou* (long life); *Kuei* (riches)

Plates: (1) CXII, *Fig.* 1; (2) IX, *Fig.* 2.

are among the most prominent. Among those commonly recorded are 'kuei chang ch'un' (riches, honour and enduring spring) and 'fu kuei chia ch'i' (a perfect vessel of wealth and honour) and 'shuang hsi' or twofold joy, a special emblem of wedded bliss in the form of two hsi (joy) characters placed side by side.

1. These tend to be confined to provincial pieces, but there are probably exceptions.

2. But in exceptional cases they are of four characters and in red or raised enamels.

3. During the Ch'ing period the character tsao appears to have been confined to articles for the people and only chih was used for imperial wares. But both characters are used on imperial wares of the 15th century.

4. No change of this nature occurred during the Ch'ing dynasty.

5. David Catalogue, Plate CXXX.

6. Kuo Pao ch'ang, Illustrated Catalogue of Chinese Government Exhibits for the International Exhibition of Chinese Art in London, 1935, preface to Vol. II, p. 30.

7. I have even seen a cup marked 'Ta Ming Tao Kuang', which appears to be a genuine specimen of the reign of Tao Kuang. Was the Ming mark a deliberate perpetration or an accident made by a copyist?

8. One theory is that this decree was issued by a tactful and resourceful official in order to save the private kilns of Ching-tê Chên during the Wu San-kuei rebellion.

9. These pieces are usually copies of the Ch'êng Hua period, when the mark was first used.

10. Burton and Hobson, Marks on pottery and porcelain.

11. Chung Kuo Tao Tz'u (History of Chinese pottery) by Wu Jên Ching and Hsiu An Ch'ao. Canton, 1926.

12. Hobson, Later Ceramic Wares of China, p. 42.

13. History of Chinese Pottery. See attached list.

14. One of these is in the British Museum (No. 387, Franks Bequest, Fig. 181, B.M. Guide, 1937) while another belongs to Mr. P. J. Donnelly. Both are famille verte dishes, with no blue (apart from the marks) and have grooved bases. Mr. Donnelly also has a blue and white bowl with this mark, of typical early K'ang Hsi decoration and heavy construction.

15. Bushell, Oriental Ceramic Art, p. 94.

NOTE TO APPENDIX III

'There is one small point to be noted in Chinese chronology, an ignorance of which has constantly led to miscalculation of dates in foreign books: the whole of the year in which an emperor dies is always reckoned as belonging to his reign, and the reign of his successor does not begin officially until the first day of the first month of the next year, when a new nien hao is inaugurated.' Bushell, Oriental Ceramic Art, p. 62.

APPENDIX III
CH'ING DYNASTY REIGN MARKS AND DATES

(See note on opposite page)

Shun Chih, 1644–1661

K'ang Hsi, 1662–1722

Yung Chêng, 1723–1735

Ch'ien Lung, 1736–1795

Chia Ch'ing, 1796–1820

Tao Kuang, 1821–1850

Hsien Fêng, 1851–1861

T'ung Chih, 1862–1873

Kuang Hsü, 1874–1908

Hsüan T'ung, 1909–1912

Hung Hsien (1916) (Yüan Shih-kai)

BIBLIOGRAPHY

Bluett, Edgar E. *Ming and Ch'ing Porcelains*. London, 1933.

Brankston, A. *Early Ming Ware of Ching-tê-chên*. Peking, 1938.

Brinkley, P. *China, its History, Art, and Literature*. Vol. IX. Ceramic Art. London and Edinburgh, 1904.

Burton, W., *Porcelain, its Art and Manufacture*, London, 1906.

Burton, W. and Hobson, R. L. *Handbook of Marks on Pottery and Porcelain*. London, 1928.

Bushell, S. W. *Oriental Ceramic Art*. (Text and notes of the Walters Collection. New York, 1899.)

 Description of Chinese Pottery and Porcelain (being a translation of the *T'ao Shuo*) bound up with the two letters of Père D'Entrecolles from Ching-tê-chên 1st September, 1712 and 25th January, 1722. London and Oxford, 1910.

Ferguson, J. C. *Survey of Chinese Art*. Ch. VI. Ceramics. Shanghai, 1939.

Hannover, Emil. *Pottery and Porcelain*. Vol. II. The Far East. Translated from the Danish. London, 1925.

Hobson, R. L. *Chinese Pottery and Porcelain*. Vol. II. London, New York, Toronto, Melbourne, 1915.

 The Wares of the Ming Dynasty. London, 1923.

 The later Ceramic wares of China. London, 1925.

 Handbook of the pottery and porcelain of the Far East in the British Museum. London, 1st edition, 1924. 2nd edition, 1937. 3rd edition, 1949.

 The Chinese Pottery and Porcelain in the David Collection. 1934.

Hobson, R. L., Rackham, B., King, W. *Chinese Ceramics in private Collections*. London, 1931.

Honey, W. B. *Guide to the later Chinese Porcelain in the Victoria and Albert Museum*. London, 1927.

 The Ceramic Art of China and other countries of the Far East. London, 1944.

Julien, Stanislas. *Histoire et Fabrication de la Porcelaine Chinoise* (A translation of parts of the *T'aoLu*). Paris, 1856.

Koyama, Fujio. *Oriental Ceramics*. Vol. 1X. No. 4. Tokyo, 1937.

 The story of old Chinese Ceramics. Tokyo, 1949.

Kuo Pao-Ch'ang. *Illustrated Catalogue of the Chinese Government*

BIBLIOGRAPHY

Exhibits for the International Exhibition of Chinese Art in London.
Vol. II. Ceramics. London, 1935.

Monkhouse, Cosmo. *A history and description of Chinese Porcelain.*
(With notes by S. Bushell.) London, Paris, New York and Melbourne, 1901.

Ottema, Nanne. *Handboek Chineesche Ceramiek.* Amsterdam, 1946.

Okuda, Seichi. *Ku Yüeh Hsüan.* 1936.

Oriental Ceramics, volume 4, 1934–35, (English Edition), Tokyo, 1936.

Sayer, Geoffrey R. *Ching-tê-Chên T'ao Lu.* (Account of Ching-tê-Chên pottery.) London, 1951.

T'ao Ya (Pottery refinements.) London, 1959.

Williamson, G. C. *The book of famille rose.* London, 1927.

Wu Jên-Ching and Hsin An-Ch'ao. *Chung Kuo Tao T'zŭ Shih.* Canton, 1926.

Yang Hsiao-Ku. *Ku Yüeh Hsüan Tz'ŭ K'ao.* (As to Ku Yüeh Hsüan porcelain.) Peking, 1934.

Zimmermann, Ernst. *Chinesisches Porzellan.* Leipzig, 1913.

PERIODICALS

Artibus Asiae

Burlington Magazine, London.
October, 1910—March, 1911. F. Perzynzki: *Towards a grouping of Chinese Porcelain.*
December, 1934. W. W. Winkworth: *The David Catalogue.*
December, 1935. de Vere Bailey: 'The Old Moon Terrace'.

Old Furniture (The Collector). London, 1927–30.

Transactions of the Oriental Ceramic Society. London, 1921—

Oriental Ceramics. Tokyo, 1931—

INDEX

INDEX

INDEX

Imitations of types,
 Ch'ien Lung, 76
 Japanese, 58
 K'ang Hsi, 57, 69, 74
 Ming, 3, 4, 7, 11, 29, 31, 36–40, 43,
 47, 53, 55–60, 66, 69
 Sung, 4, 8, 45–52, 57, 59, 60, 64, 66,
 68, 69, 74, 75, 80
Imperial Factory (*yu ch'i ch'ang*), 5, 11,
 28, 44, 61
Imperial Works Department, 28, 44
Incised decoration, 18
Ingram, Sir Herbert, 85
Ink, painting in, 45
Inscriptions on porcelain, 22, 24, 66, 74
Iron-rust glaze (*t'ieh hsiu hua*), 65

Jesuits, 46, 90, 93, 95
Jewel Hill, 5, 11, 63
Jewel fired (*pao shao*), 67
Johanneum collection, *see* Collections,
 Dresden
Ju ware, 48, 49, 59
Ju-chou, 49
Julien, S., 40, 90

K'ai shu (modern script), 97
K'ang Hsi, viii, x–xi, xiii, 4, 6, 12, 14–
 17, 19, 21–6, 29–40, 42–4, 46, 47,
 52–4, 57, 60, 62, 66, 69–70, 74,
 78, 83, 87–9, 95, 97–9
Kaolin, 6, 14, 82
Keyes, H. E., 94
Kiln sites, 5, 11, 50, 52, 79–81, 85
Kilns, destruction of, 12
Kilns, provincial, list of, 85
Ko ware copies, 49
Koyama Fujio, 22, 27, 50, 52, 79, 102
Kuang Hsü, 76, 101
Kuangtung ware, 46, 57, 58, 67
Kuan-ti (god of war), 45, 84
Kuan ware copies, 49
Kuan-yin (goddess of mercy), 9, 84
Kua p'i lu, *see* Green, cucumber
Kung chiao lü, *see* Green, peacock
Kuo Pao-chang, 27, 40, 45, 59, 93, 94,
 100, 102
Kuo Pao ch'ang, quoted, 22–3, 29, 70,
 87, 91, 92, 97
Kuo Shih-wu (superintendent), 76
Ku t'ung ts'ai, *see* Bronze glaze
Ku Yüeh Hsüan, 23, 69, 74, 76, 77,
 87–95

Lac burgauté, 34, 36, 69

Lace-work decoration, 73
Lacquer, imitation of, 67, 71
Lai Kuan (potter), 84
Lange Lijsen, *see* 'Long Elizas'
Lang Shih-ning, *see* Castiglione, *Père*
Lang T'ing-chi (Governor of Kiangsi),
 22–3
Lang T'ing-hsiang (governor), 23
Lang, T'ing-tso (Governor of Kiang-
 nan), 22–3, 27
Lang yao, 22–3, 29–30
Lang yao green, 29
Lee, Sherman E., 14, 51, 60
Libation cups, 84
Ling chih fungus, 58
Ling lung, *see* Pierced decoration
Li-t'a k'an k'ao-ku ou-pien, *see* Chinese
 texts
Liu Pau-Yüan (superintendent), 72
Lo tien tz'ŭ, *see* Lac burgauté
'Long Elizas', 32
Lung Ch'ing, 12, 31, 40, 41, 43, 59, 66,
 96
Lung-ch'üan, 49, 57, 67, 80

Maitreya, 82
Manganese, 33
Mao ping (small defect), 34
Medallion bowls, 73, 74
Mei jên (slender ladies), 32
Mei kuei, *see* Rose colour
Metal mounts, 18, 19, 50
Mille fleurs, 67, 76
Ming blue-and-white, *see* Imitations
Ming style, 20
Ming types, imitated, *see* Imitations
Mirror black (*wu chin*), 30, 57, 73, 97
Mo hung, *see* Red, coral
Mongolian script, 74, 99
Monkhouse Collection, *see* Collections
Monkhouse, Cosmo, 26
Monochromes, 4, 17, 73, 74
 Ch'ien Lung, 65, 68, 69
 K'ang Hsi, 22–4, 29–31
 Transitional, 19, 22
 Yung Chêng, 45, 48–55, 57, 64, 65
Morrison Collection, *see* Collections
Mo yin, *see* Silver decoration
Mugs, 84
Mule's-liver glaze, 23
Muslin tone, 74

Nien hao, *see* Reign mark
Nien Hsi-yao (superintendent), 2, 3, 28,
 40, 44–6, 48, 57, 61–3, 65, 70, 72

108

INDEX

INDEX

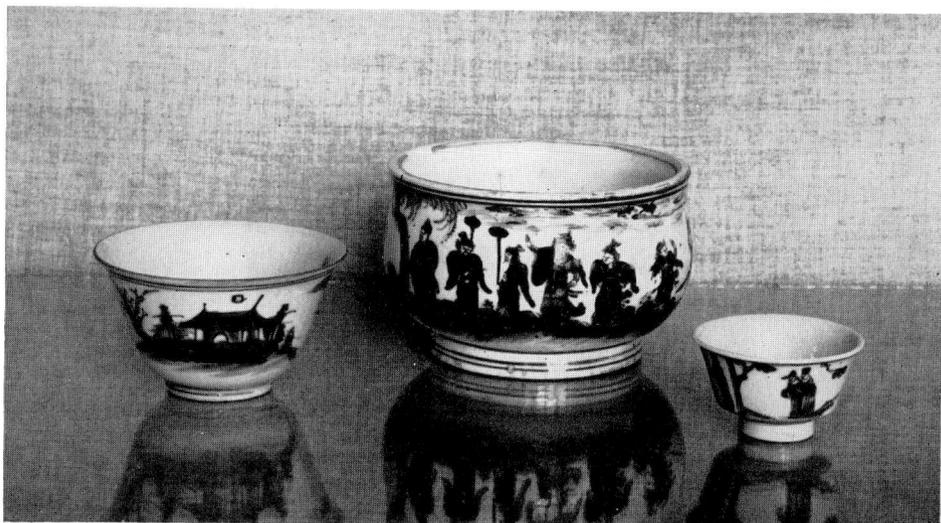

1A. *Bowl, decorated in underglaze blue with cyclical year mark corresponding to the 6th year of K'ang Hsi. (1667). Diam. 4·5 in. See page 24*

1B. *Incense burner, decorated in underglaze blue. Unglazed base with cyclical year mark of the T'ien Chi period corresponding to 1626. Diam. 5·4 in. Ht. 3·5 in. See page 18*

1C. *Cup, decorated in underglaze blue. Mark and period of Ch'ung Ch'êng (1628–1643). Diam. 2·7 in. See page 18*

All from R. H. R. Palmer

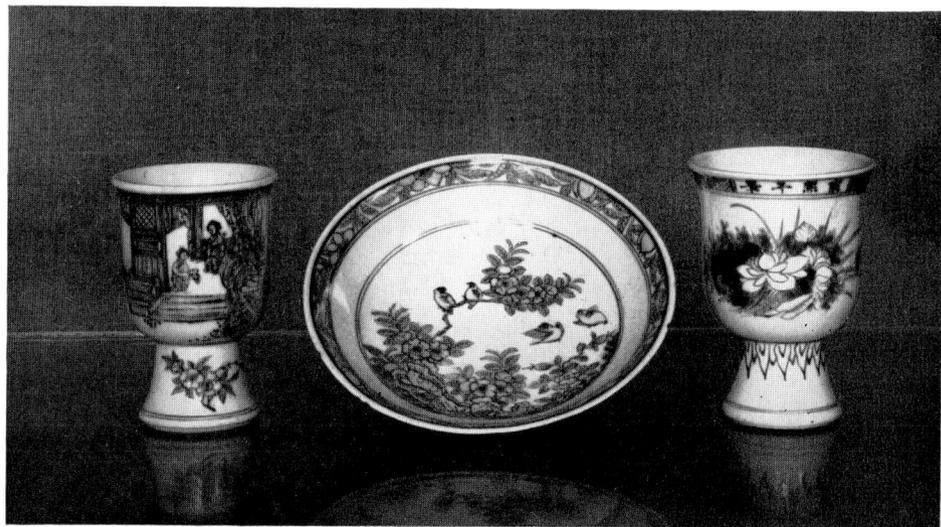

2A. *Stem cup, decorated in underglaze blue. No mark. K'ang Hsi. Before 1683. Ht. 4·6 in. W. W. Winkworth. See page 19*

2B. *Saucer dish, decorated in underglaze blue. No mark. Transitional, 17th century (probably early K'ang Hsi). Diam. 6 in. W. W. Winkworth. See page 19*

2C. *Stem cup, decorated in underglaze blue. Mark and period of K'ang Hsi. Before 1683. Ht. 4 in. P. J. Donnelly. See pages 24, 26 (footnote 11)*

PLATE I

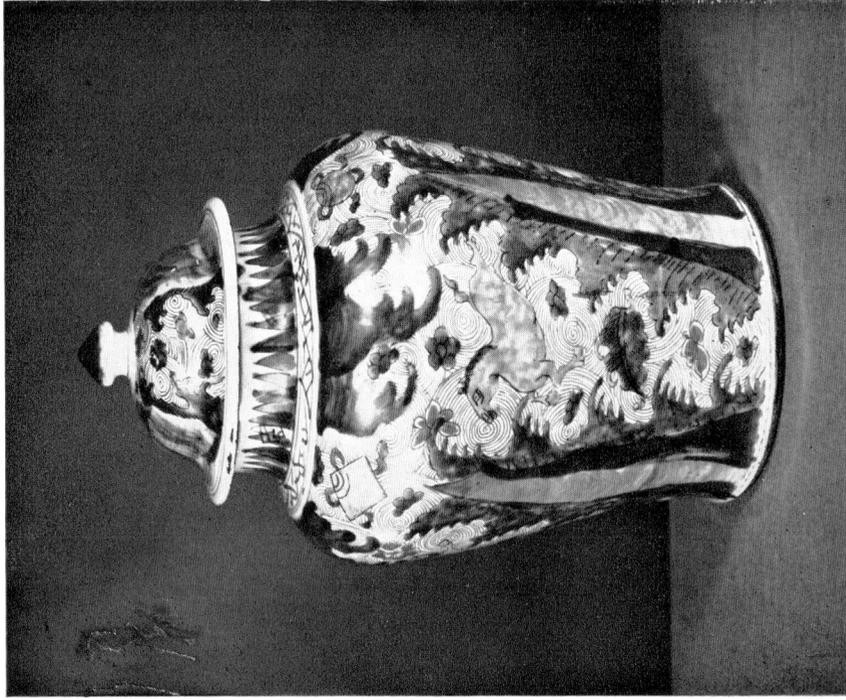

1. Jar and cover, decorated in coloured enamels and
underglaze blue. No mark. Transitional, 17th century.
Ht. 15 in.
Ex Messrs. Sparks. See page 20

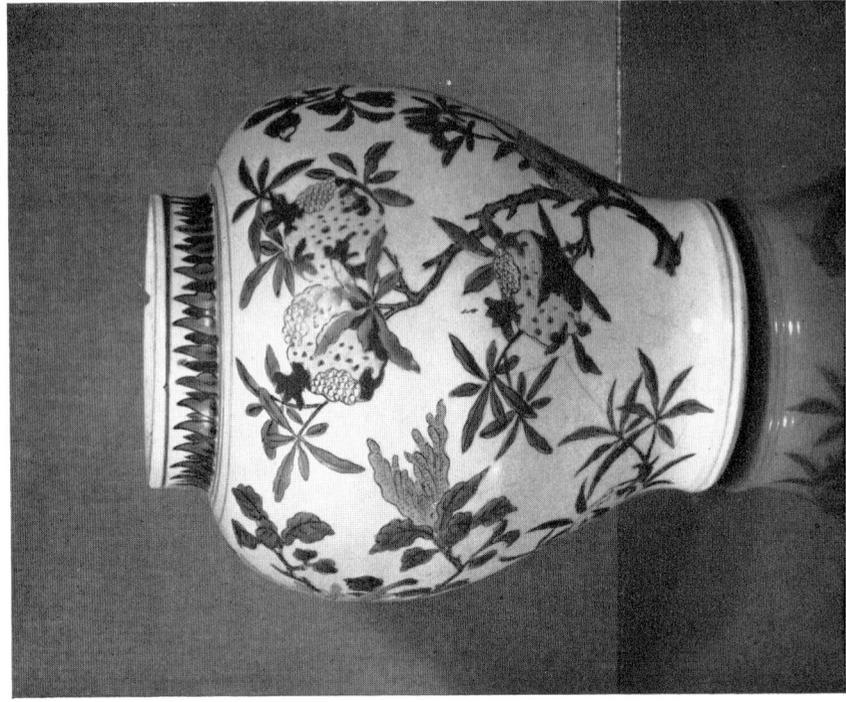

2. Jar, decorated in coloured enamels and underglaze
blue. No mark. Transitional, 17th century. Ht. 11.25 in.
Ex Mrs. Seligman. See page 20

PLATE II

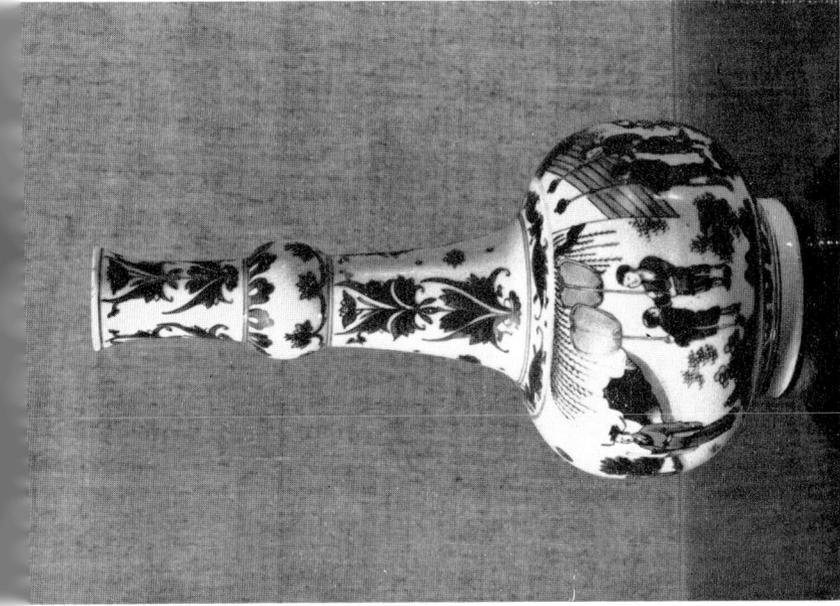

1. *Vase, decorated in underglaze blue. No mark. Transitional, 17th century. Ht. 15 in. British Museum. See page 18*

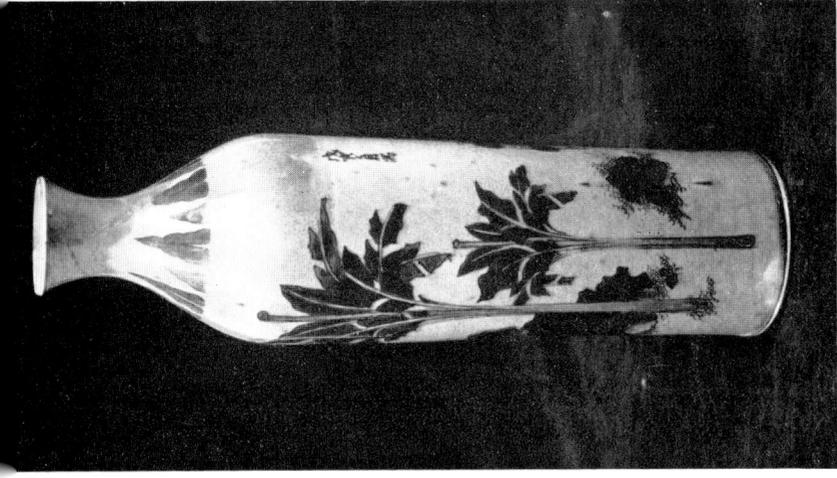

2. *Vase, decorated in underglaze blue, covered with green enamel. Dated 1658. Ht. 12 in. Richard de la Mare. See page 18*

PLATE III

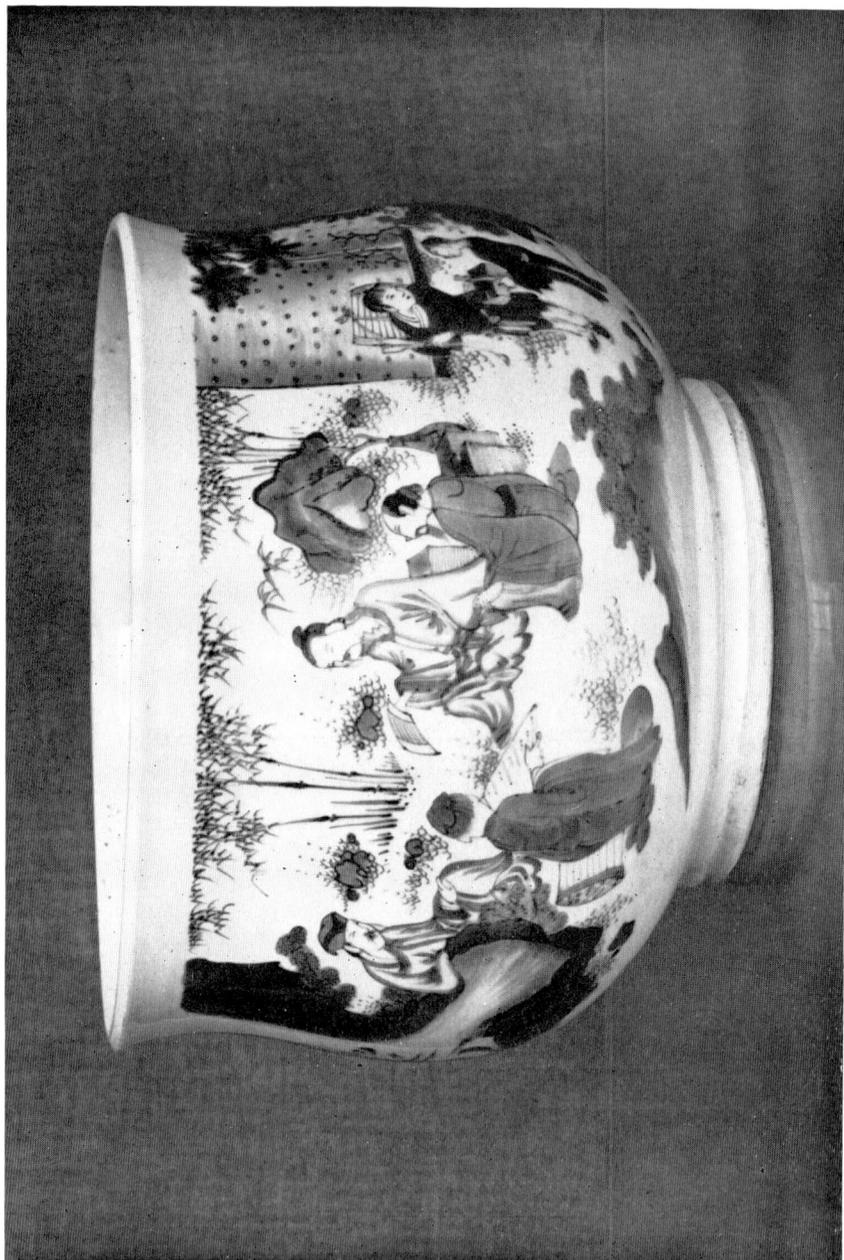

Bowl, decorated in underglaze blue. No mark. Transitional, 17th century. Diam. 10·5 in. Soame Jenyns. See page 18

PLATE IV

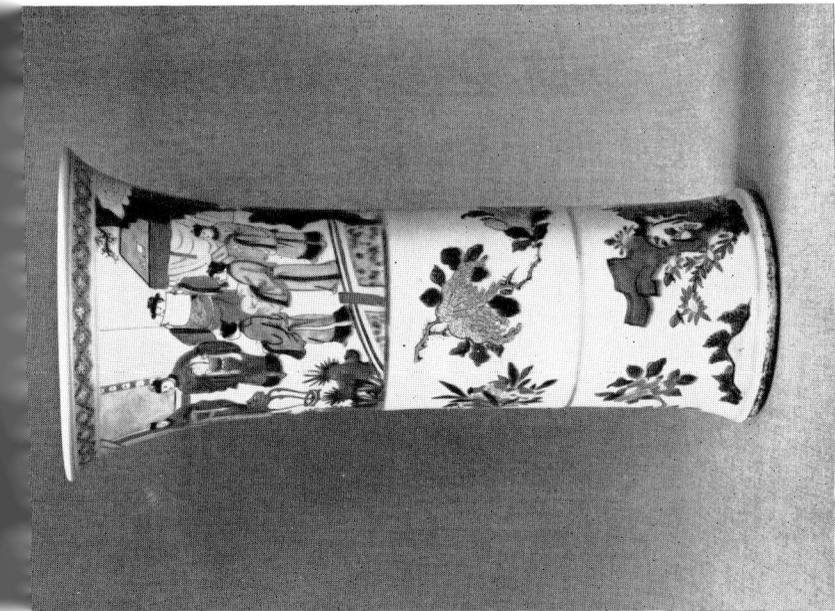

1. Vase, decorated in underglaze blue and coloured enamels. No mark. Transitional, 17th century. Ht. 18.5 in. British Museum (Franks Bequest). See page 20

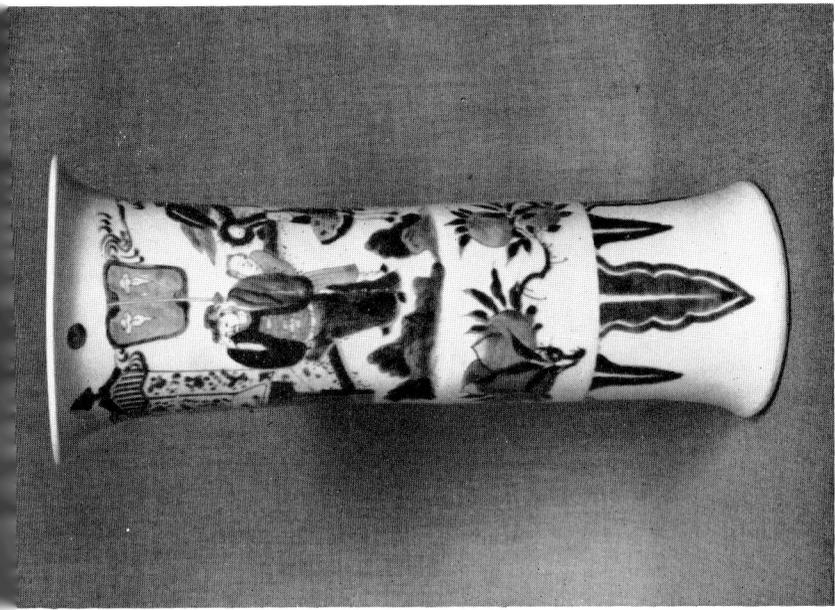

2. Vase, decorated in underglaze blue. No mark. Transitional, 17th century. Ht. 16.8 in. Soame Jenyns. See page 19

PLATE V

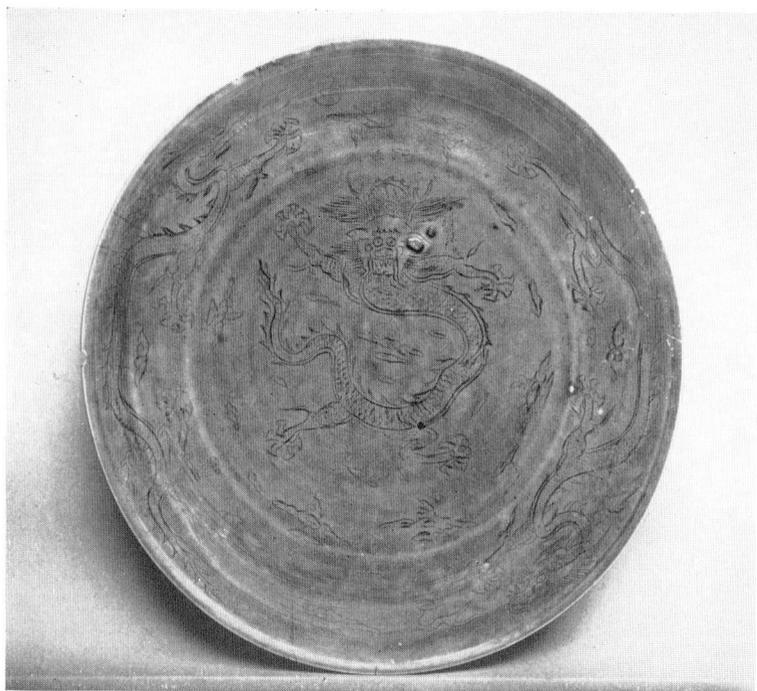

Saucer dish, with incised decoration without and within, under a deep violet blue glaze. Mark and period of Shun Chih (1644–1661). Diam. 9·5 in. See page 22
1. Interior. 2. Reverse
British Museum

PLATE VI

1. Brushwasher, with peach bloom glaze. Mark and period of K'ang Hsi. Diam. 4·8 in. See page 30
Ex Swettenham Collection

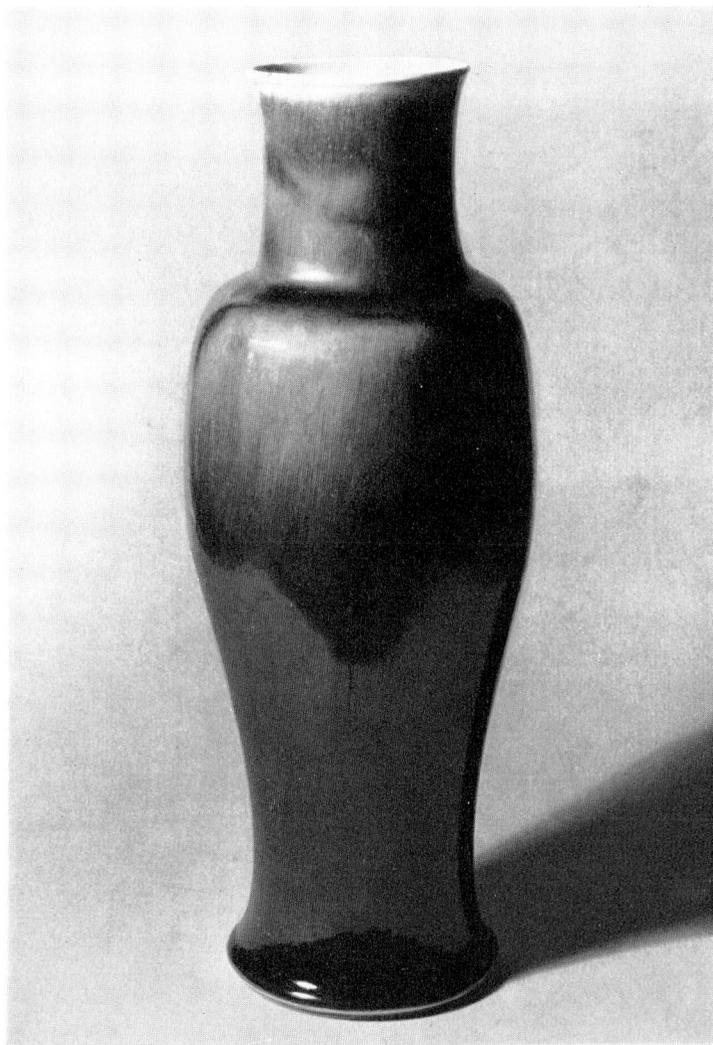

2. Vase, with 'Lang Yao' glaze. No mark. K'ang Hsi period. Ht. 16·8 in. See page 24
British Museum

PLATE VII

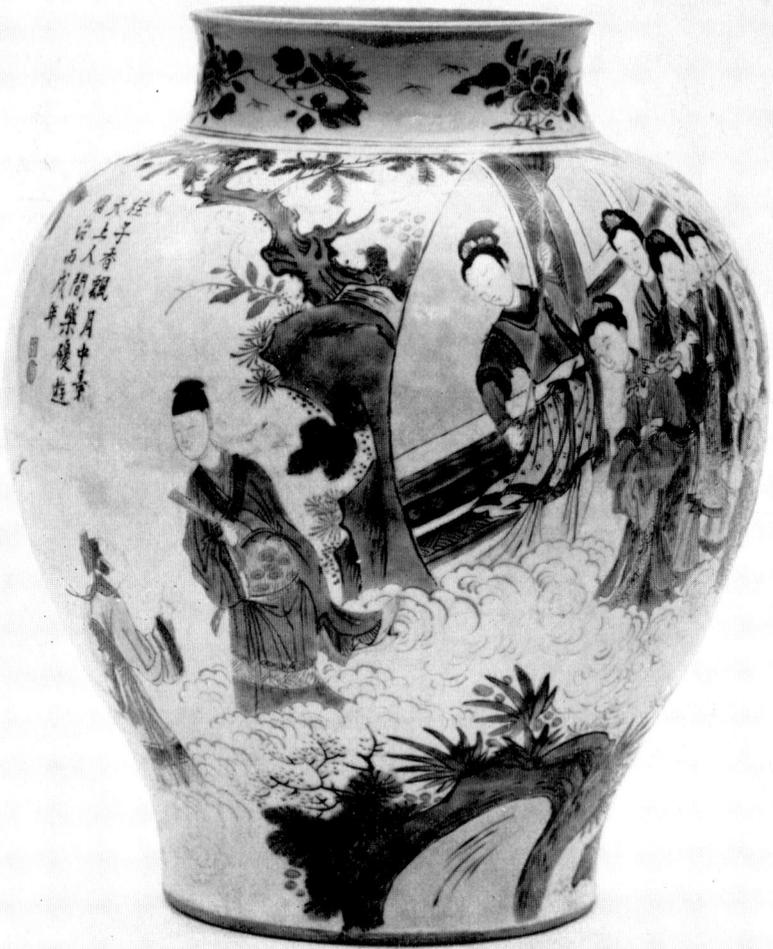

*Vase, decorated with coloured enamels and underglaze blue. Mark of
Shun Chih and cyclical year corresponding to* 1646. *Ht.* 10·6 *in.
Russell Tyson Collection. See page* 21

PLATE VIII

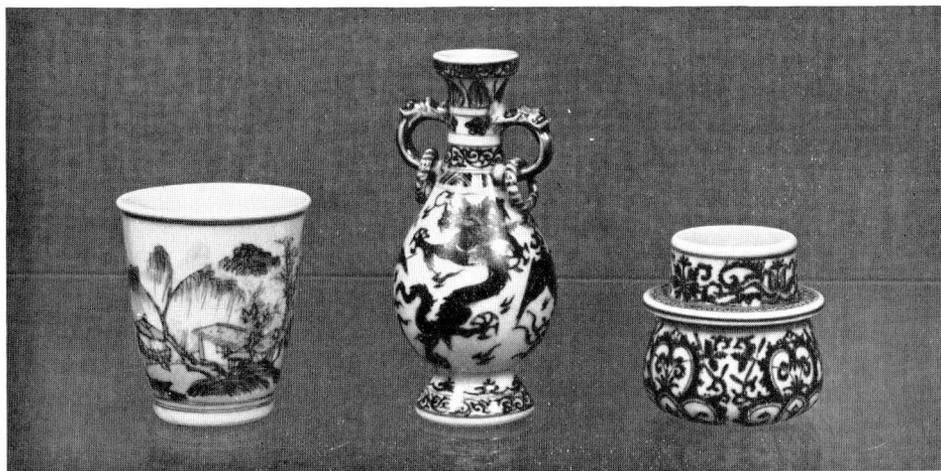

1A. *Cup, decorated in underglaze blue. K'ang Hsi. Before* 1683.
Ht. 2·6 *in. See page* 24
British Museum (Oppenheim Bequest)

1B. *Vase, decorated in underglaze blue. Restored mark of Chêng-Tê.
K'angHsi period. Ht.* 4·2 *in. See page* 37
British Museum (Oppenheim Bequest)

1C. *Honey pot, decorated in underglaze blue, in imitation Hsüan Tê
style. No mark. Early* 18th *century. Ht.* 2 *in. See pages* 36, 54
British Museum (Oppenheim Bequest)

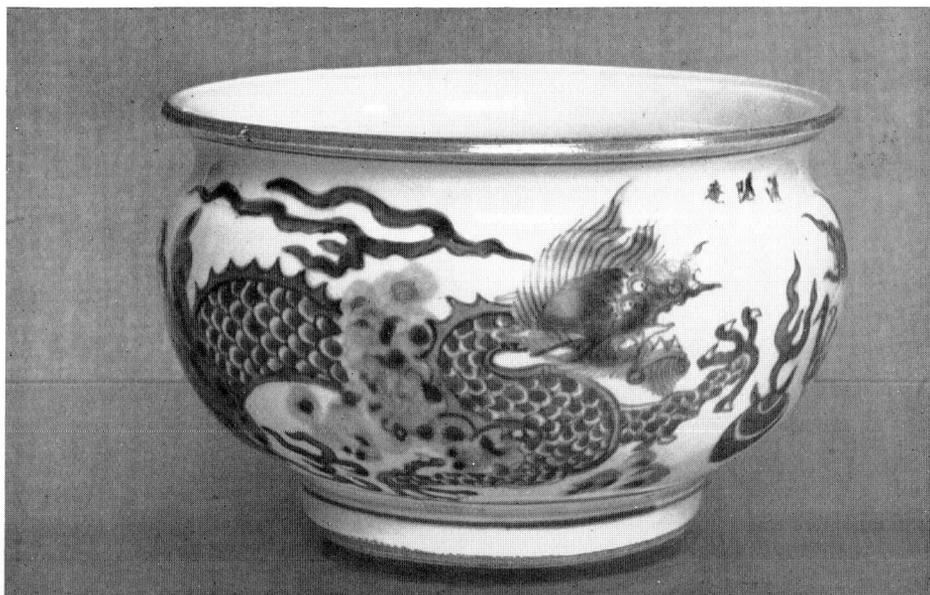

2. *A bowl, decorated in underglaze blue and inscribed in a cartouche
'(In) the sixth year of K'ang Hsi (*1667*) the first month of summer
presented by the disciple Wang Chih-hsi' and on the neck 'Ching
Yin An' (The pure secluded monastery). Diam.* 9 *in.
British Museum. See pages* 24, 26 (*footnote* 11), 100

PLATE IX

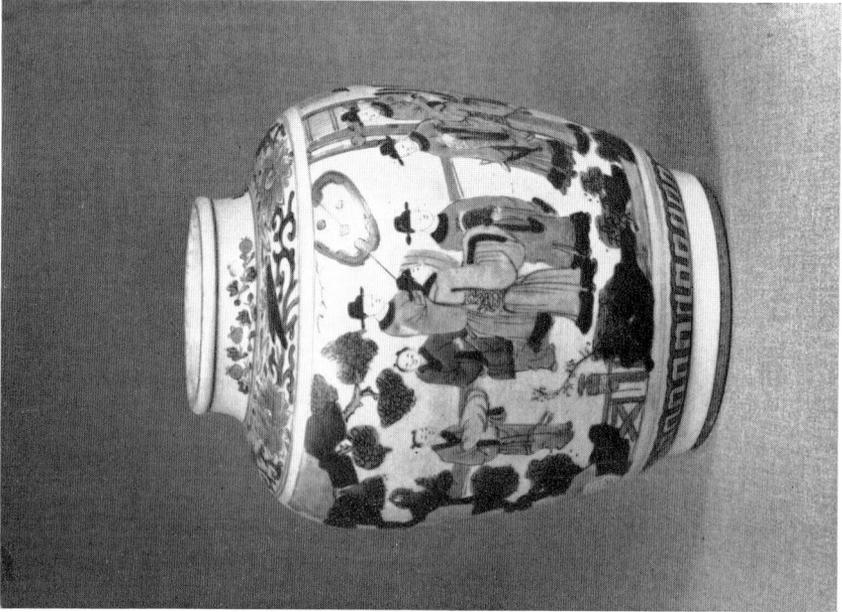

1. Vase, decorated with coloured enamels and underglaze blue. Hare mark on base. Middle 17th century. Ht. 9.5 in.

2. Vase, decorated in 'famille verte' enamels. No mark. Early 18th century. Ht. 15 in. Soame Jenyns. See page 55

2. *Vase, decorated in coloured enamels and underglaze blue. No mark. K'ang Hsi. Before 1685. Ht. 14·5 in.*

P. J. Donnelly. See page 24

(This kylin appears also on some large blue and white dishes and beakers of the period)

1. *Vase, decorated in underglaze blue. No mark. Circa 1667. (Compare Plate VIII.) Ht. 15·5 in. Soame Jenyns. See pages 24, 26 (footnote 11)*

PLATE XI

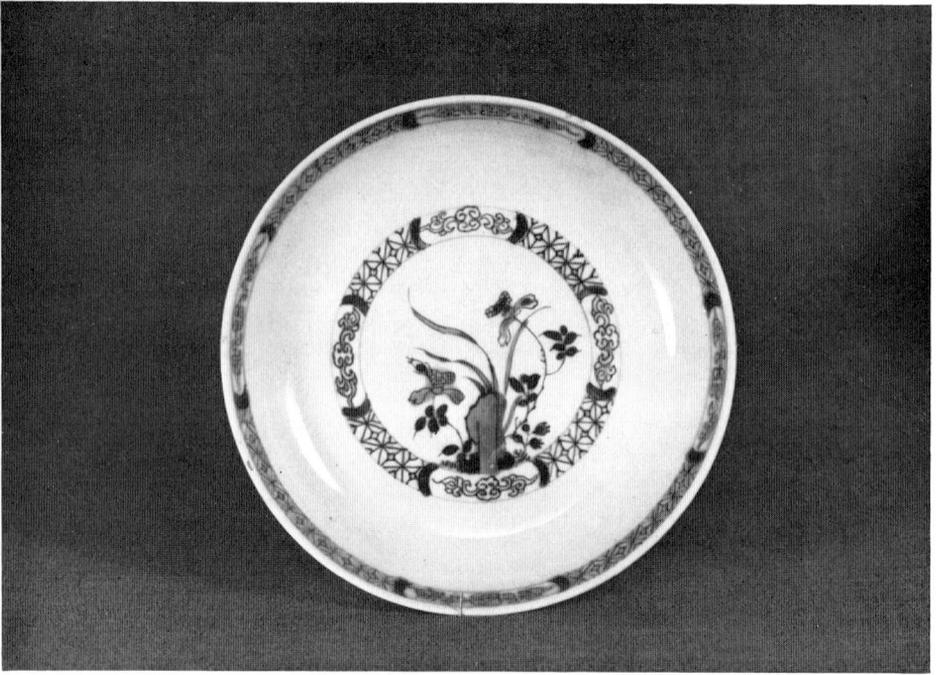

1. *Saucer, decorated in underglaze blue with the mark of the Dresden Collection (K'ang Hsi period). Diam. 6·8 in. John Pope. See page 36*

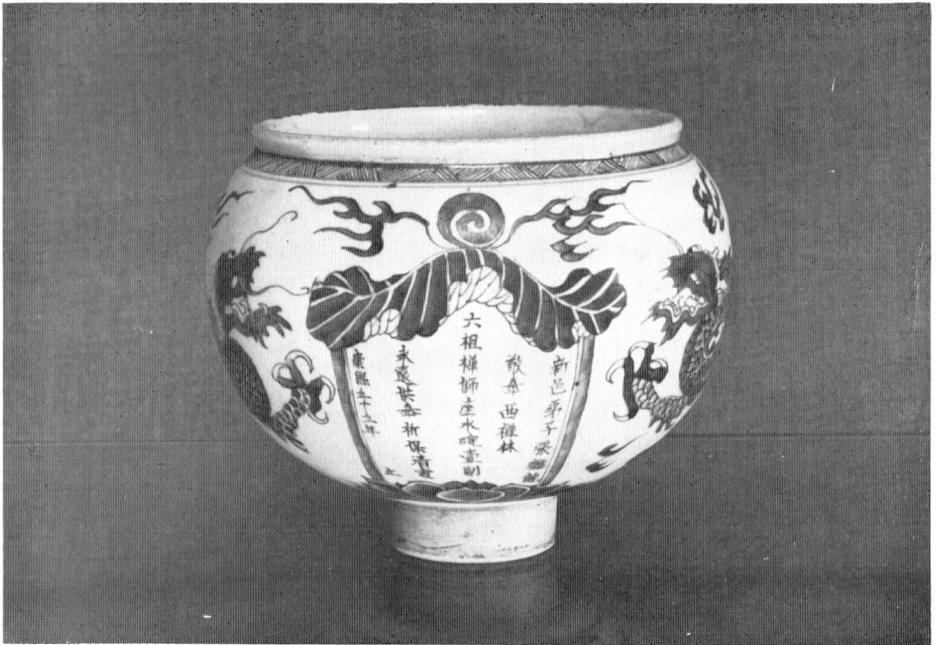

2. *Bowl decorated in underglaze blue and made to fit a stand, presented by a disciple to a monastery and dated the 55th year of K'ang Hsi (1717). Diam. 5·5 in.*
Ex Messrs. Norton. See page 36

PLATE XII

1. *Saucer dish, decorated in underglaze blue on a coffee ground. Mark and period of K'ang Hsi. Diam. 8 in.*
British Museum. See page 30

大
清
康
熙
年
製

1924
10·19
1

2. *Reverse.*

PLATE XIII

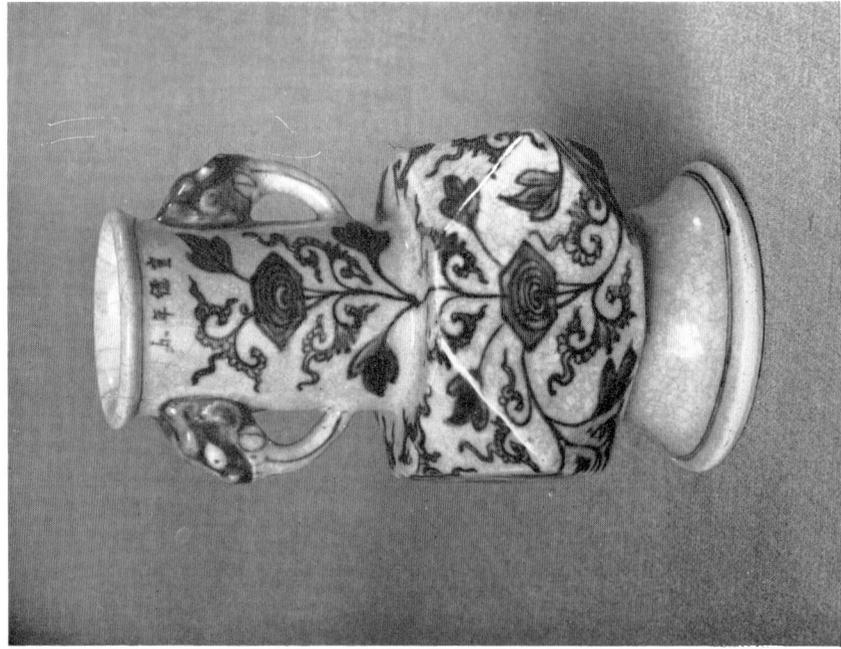

1. Vase, decorated in underglaze blue. Mark of
Hsüan Té (1426–35). Probably Ch'ien Lung.
Ht. 7·6 in. See page 57
David Saunders

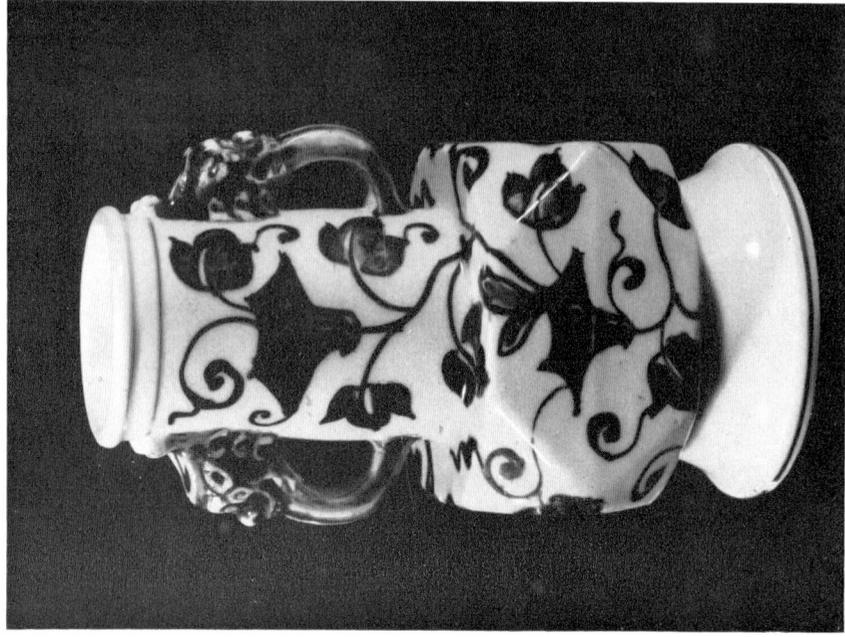

2. Vase, decorated in underglaze blue. Mark of
Hsüan Té (1426–35). K'ang Hsi period. Ht. 4·5 in.
Sir H. Garner. See page 57

PLATE XIV

For comparison see coloured reproduction of original Hsüan Té piece in this style. David Catalogue. Plate CXVI

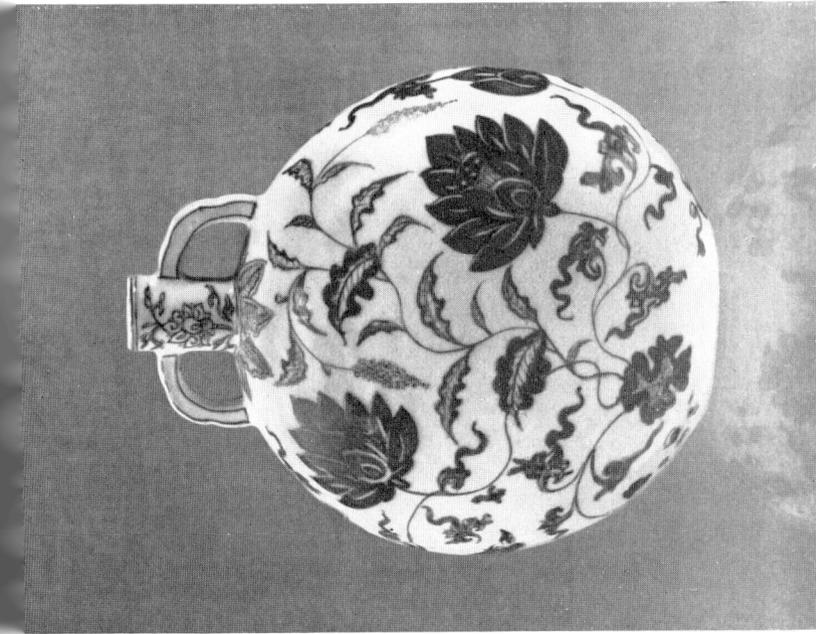

1. Pilgrim bottle, decorated in under-glaze blue in
Hsüan Tê style. Early 18th century. Ht. 8·6 in.
British Museum (Oppenheim Collection)
See page 57

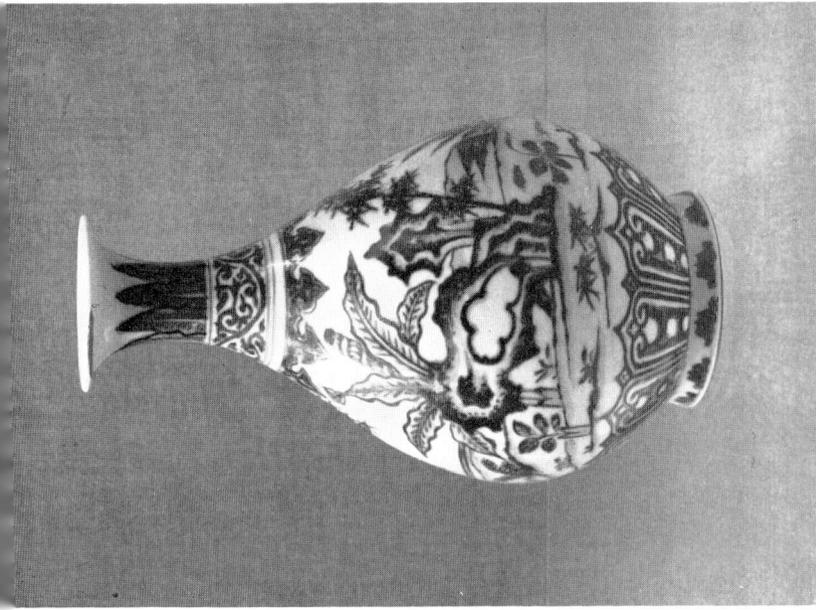

2. Vase, decorated in under-glaze blue in imitation
of Hsüan Tê. No mark. Ch'ien Lung period. Ht. 9 in.
Soame Jenyns. See page 57
(An original bottle in this style is illustrated in the
David Catalogue, Plate CXVIII.)

PLATE XV

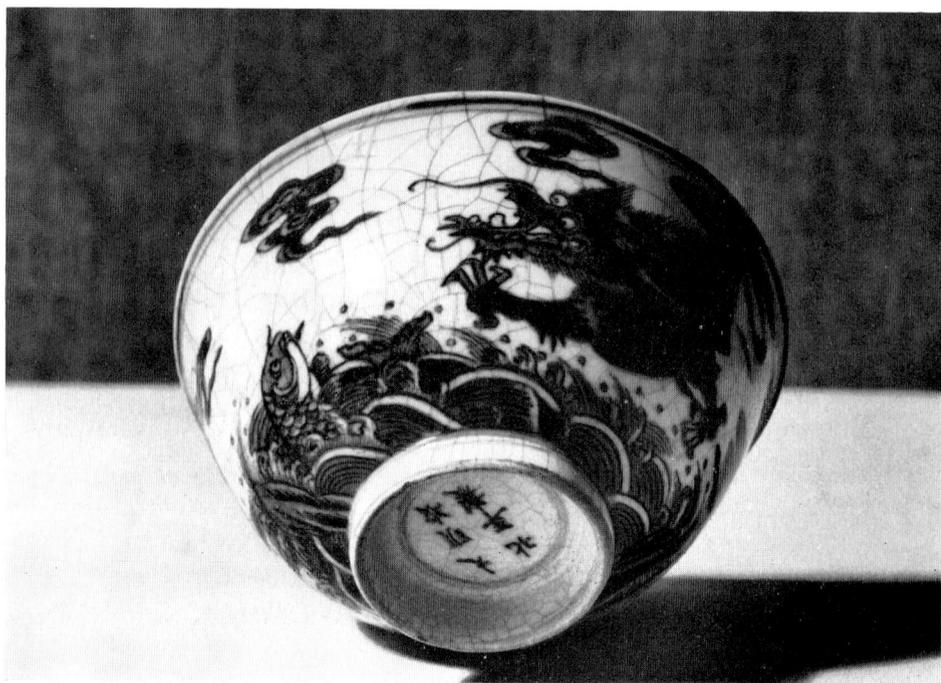

1. *Bowl, soft paste, decorated in underglaze blue. Mark of Ch'êng Hua. K'ang Hsi period. Diam. 4 in.*
Soame Jenyns. See page 31

2. *Bowl, decorated in underglaze blue in Hsüan Tê style. Mark of Ch'êng Hua. K'ang Hsi period. Diam. 4 in.*
Mrs. Walter Sedgwick. See page 37

PLATE XVI

1. *Cup, soft paste, decorated in underglaze blue. Ch'êng Hua mark.*
Yung Ch'êng period. Ht. 4 in.
P. J. Donnelly. See page 31

2. *Bowl, decorated in underglaze blue. Mark of Ch'êng Hua. K'ang*
Hsi period. Diam. 6 in.
Mrs. Walter Sedgwick. See page 40

PLATE XVII

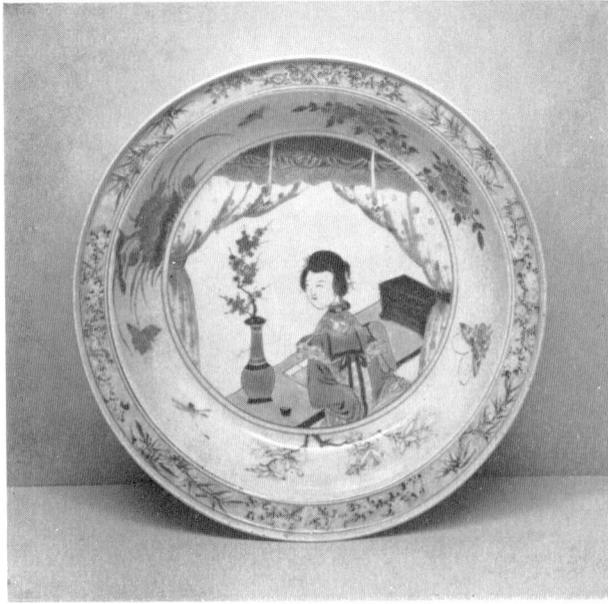

1. *Deep dish, painted in underglaze blue and copper red. Cyclical date 1672 and hall mark. Diam. 14·5 in. Ex S. Winkworth Collection. See page 24*

2. *Stem cup, decorated in underglaze blue, red enamel ground. Hsüan Tê mark. Early 18th century. Diam. 6 in. W. W. Winkworth. See page 37*

PLATE XVIII

1. *Plate, decorated in underglaze blue. Mark and period of K'ang Hsi.*
Diam. 8·5 in. See page 32
Victoria and Albert Museum

2. *Plate, decorated in underglaze blue in imitation of Hsüan Tê. Mark*
and period of Yung Chêng. Diam. 13·7 in.
Miss Honor Frost. See page 37

PLATE XIX

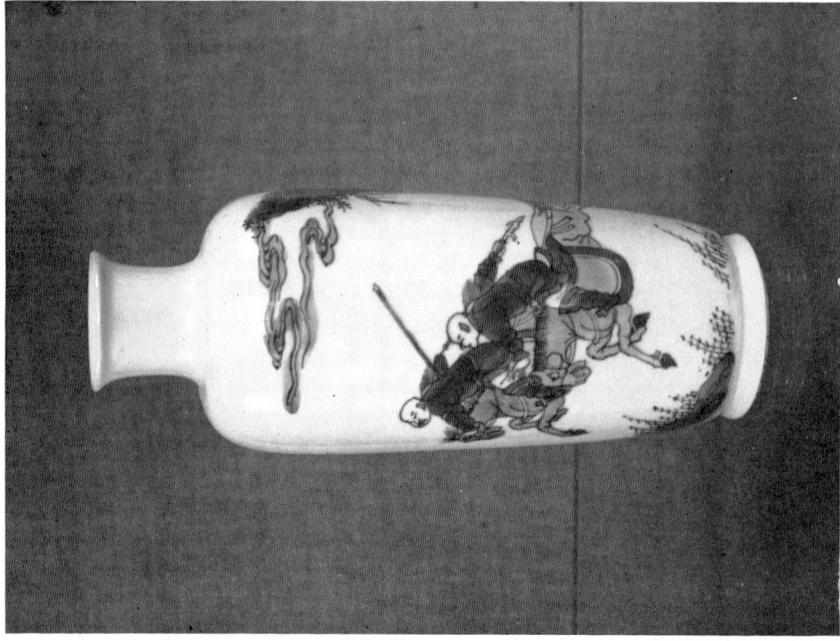

2. *Vase, decorated in underglaze blue. Mark of Chia Ching (1522–66). Early K'ang Hsi; almost in transitional style. Ht. 8 in. British Museum (Franks Coll.). See page 19*

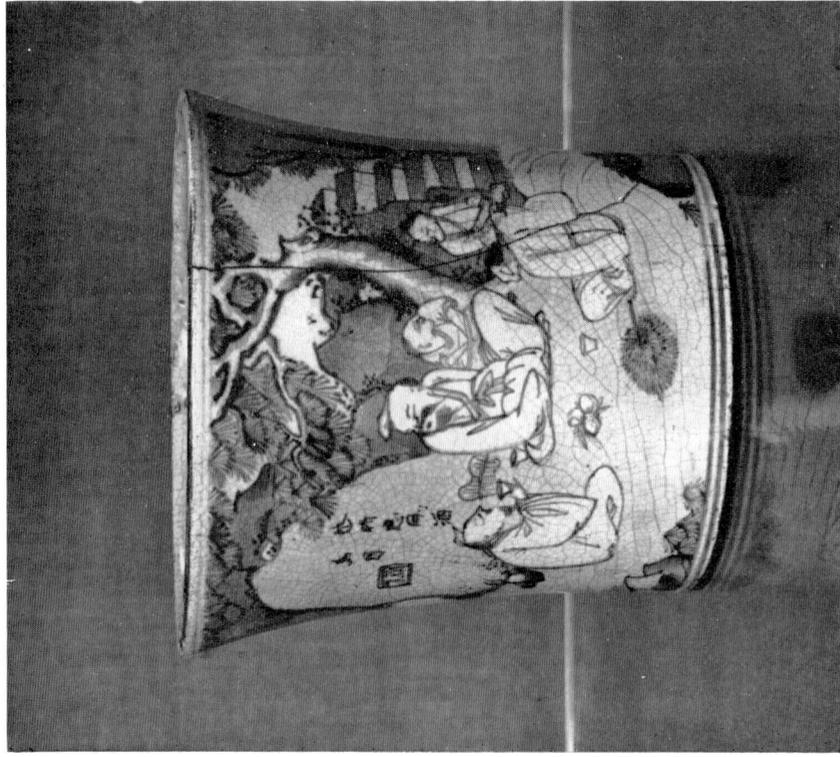

1. *Brush pot, 'soft paste', decorated in underglaze blue. No mark. K'ang Hsi period. Ht. 5·5 in. W. W. Winkworth. See page 51*

PLATE XX

2. *Vase, decorated with white slip, underglaze blue and copper-red on a celadon ground. K'ang Hsi period. Ht. 15·5 in.*
Ex Alexander Collection. See page 55

1. *Vase, decorated in underglaze blue. No mark. K'ang Hsi period. Ht. 16·7 in. British Museum. See page 52*

PLATE XXI

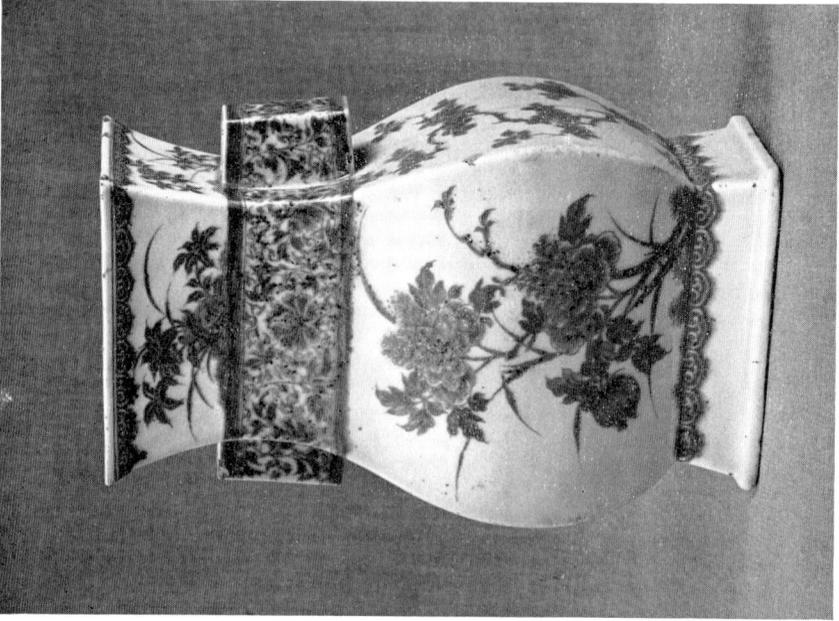

2. *Vase, decorated in underglaze red in Hsüan
Tê style. Mark and period of Ch'ien Lung. Ht.
11·8 in.*

1. *Vase, decorated in underglaze red. Hsüan Tê
mark. K'ang Hsi period. Ht. 13 in.
Soame Jenyns. See page 33*

1. *Vase decorated in under-glaze red and blue.*
Fungus mark. K'ang Hsi period. Ht. 18 in.
British Museum. See pages 25, 55

2. *Bottle decorated in under-glaze red and blue. No*
mark. Ch'ien Lung period. Ht. 14 in.
Mrs. W. Winkworth. See page 55

PLATE XXIII

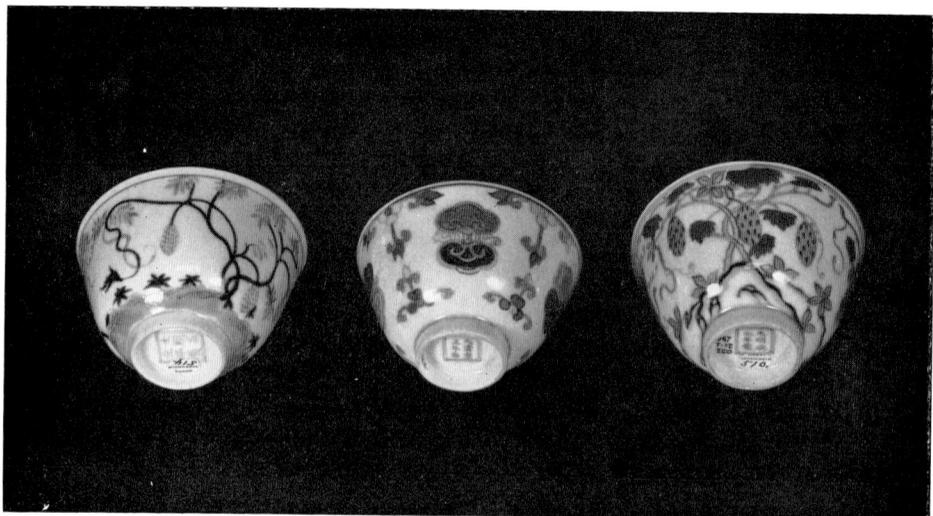

1A. *Wine cup, decorated in 'tou ts'ai' enamels. Mark of Ch'êng Hua.*
Diam. 2·7 in. See page 38
1B. *Wine cup, decorated in 'tou ts'ai' enamels. Mark and period of*
K'ang Hsi. Diam. 2·7 in. See page 38
1C. *Wine cup, decorated in 'tou ts'ai' enamels. Mark of Ch'êng Hua.*
K'ang Hsi period. Diam. 2·9 in. See page 38
All from the British Museum (Nos. A and C, Oppenheim Bequest)

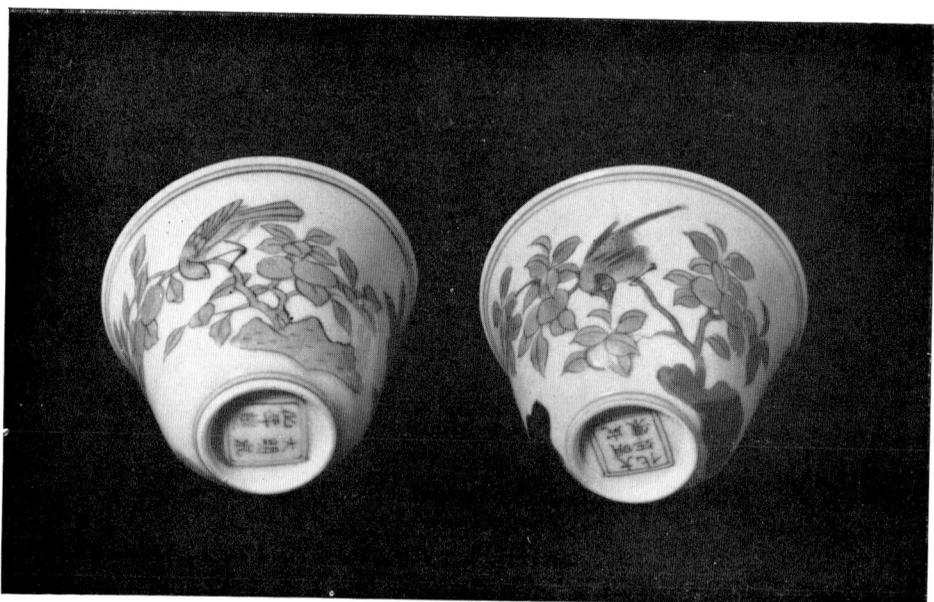

2A. *Wine cup, decorated in underglaze blue. Mark of Ch'êng Hua.*
Ht. 2 in. See page 38
British Museum (Oppenheim Bequest)
2B. *Wine cup, decorated in underglaze blue. Mark of Ch'êng Hua.*
K'ang Hsi period. Ht. 2 in. See page 38
Ex Messrs. Norton

PLATE XXIV

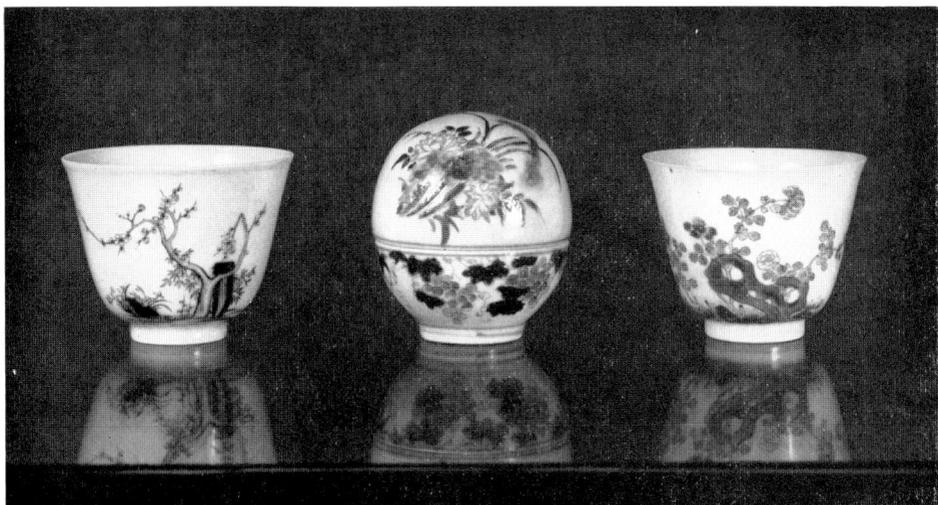

1A. *'Birthday' cup, decorated in coloured enamels and underglaze blue. Mark and period of K'ang Hsi. Ht. 2 in. See page 32*
1B. *Covered box, decorated in coloured enamels and underglaze blue. Ch'êng Hua mark, Transitional. Ht. 2·4 in. (Oppenheim Bequest). See pages 19, 59*
1C. *'Birthday' cup, decorated in coloured enamels and underglaze blue. Mark and period of K'ang Hsi. Ht. 2 in. See page 32*
All from the British Museum

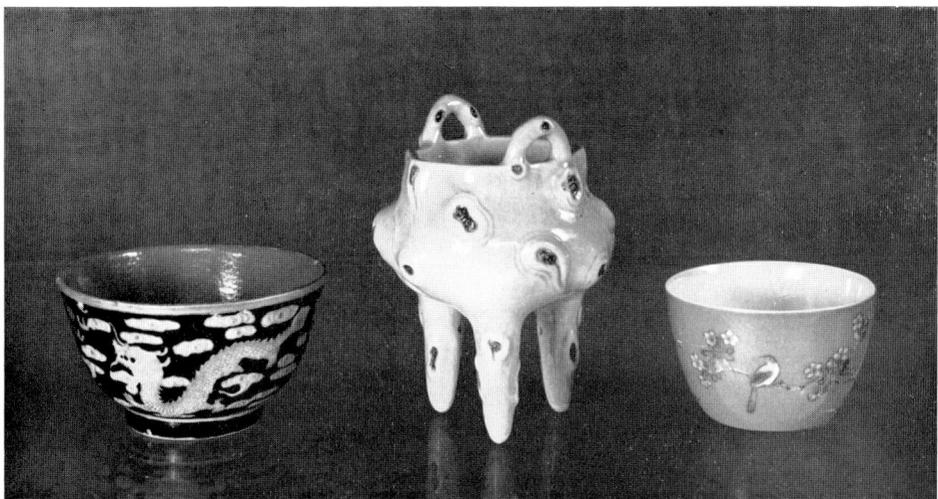

2A. *Wine cup, decorated in coloured enamels on a black ground. Mark in imitation of Ch'êng Hua; 19th century. Diam. 3 in. See page 74*
2B. *Tripod vase, decorated in yellow enamel. In the style of Hsiang's Album. 18th century or later. Ht. 3·5 in. (Oppenheim Bequest). See page 67*
2C. *Wine cup, decorated in underglaze blue on the red ground. Mark and period of K'ang Hsi. Diam. 2·4 in. (Oppenheim Bequest). See page 57*
All from the British Museum

PLATE XXV

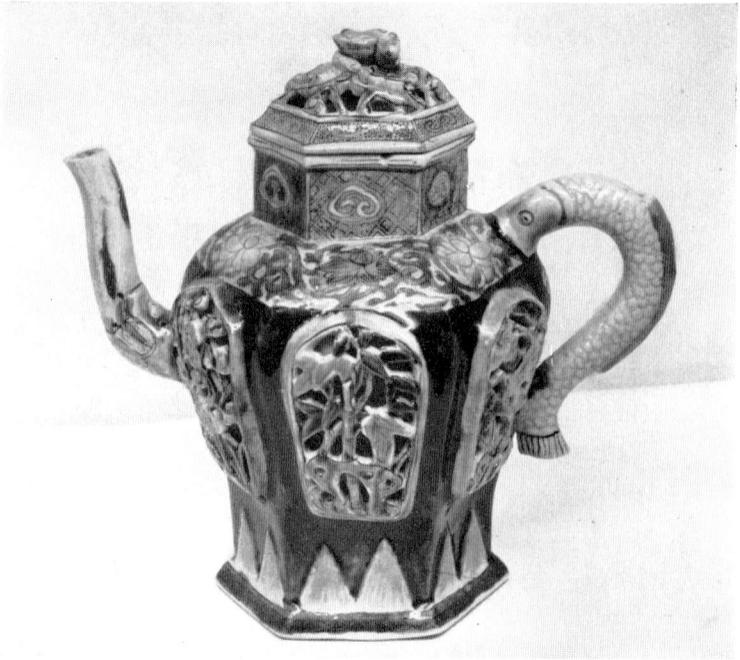

1. *Hexagonal wine pot, in 'famille noire' enamels with openwork panels and perforated cover. K'ang Hsi period. Ht. 6·5 in. Ex C. L. Paget Collection. See page 34*

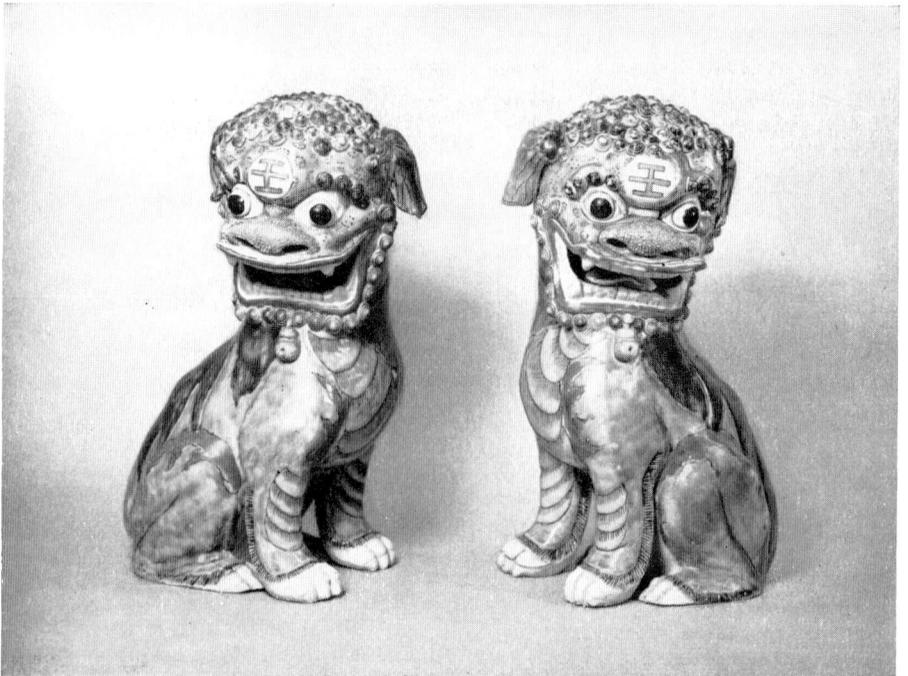

2. *Pair of seated Dogs of Fo, with imperial seal on their foreheads. Green and yellow glaze. K'ang Hsi period. Ht. 12·5 in. Ex Messrs. Sparks. See page 29*

PLATE XXVI

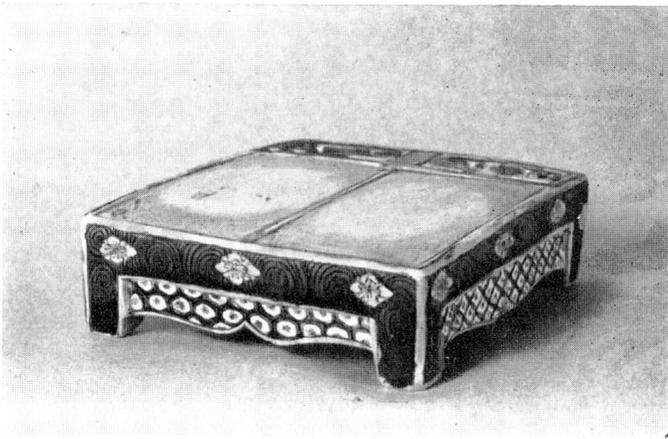

1. Ink palette, enamelled green and black on biscuit. Dated 1692.
L. 5·2 *in. See page* 20
British Museum

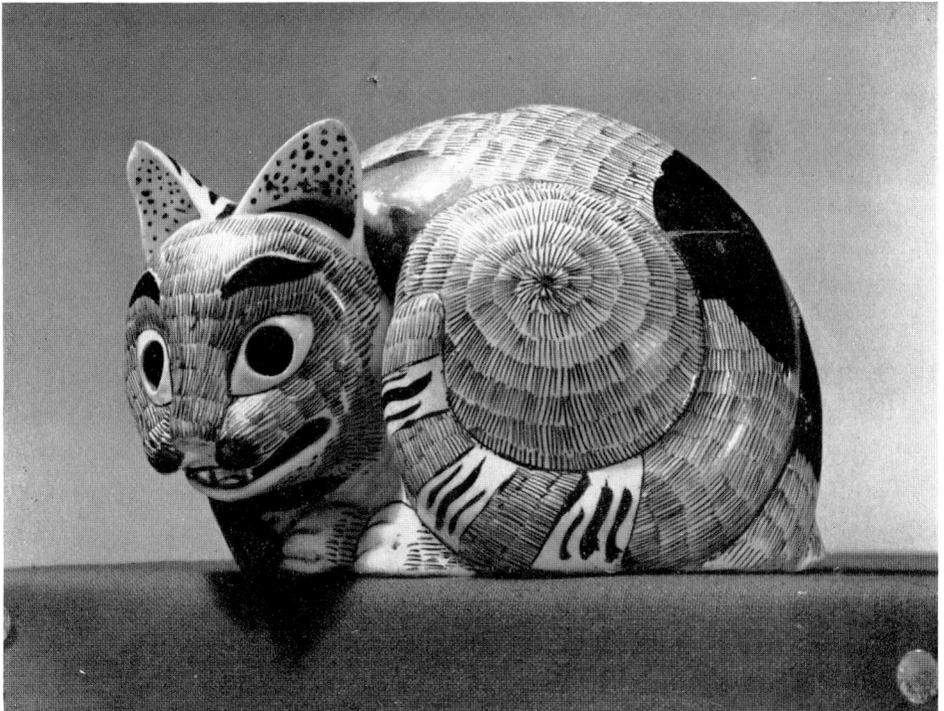

2. Nightlight holder, in the form of a cat decorated in black enamels.
K'ang Hsi period. L. 5·5 *in.*
British Museum. See page 9 (*footnote* 17)

PLATE XXVII

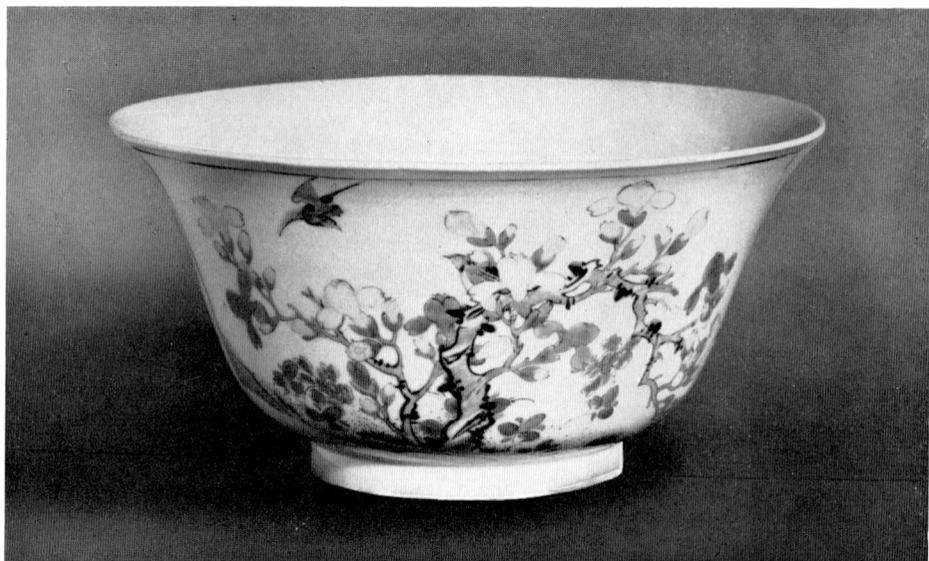

1. *Bowl, decorated in 'famille verte' enamels, poem on reverse side. No mark. K'ang Hsi period. Diam. 7·7 in. Ex Messrs. Sydney Moss. See page 32*

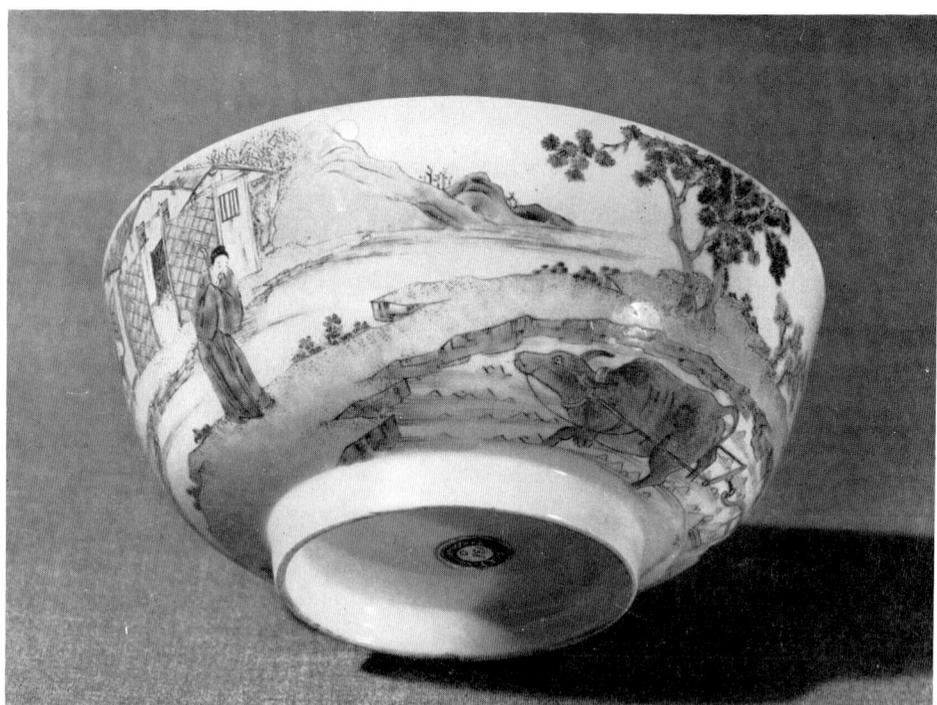

2. *Bowl decorated in 'famille verte' enamels; poem on reverse side. No mark. K'ang Hsi period. Diam. 7·1 in. Gerald Reitlinger. See page 32*

PLATE XXVIII

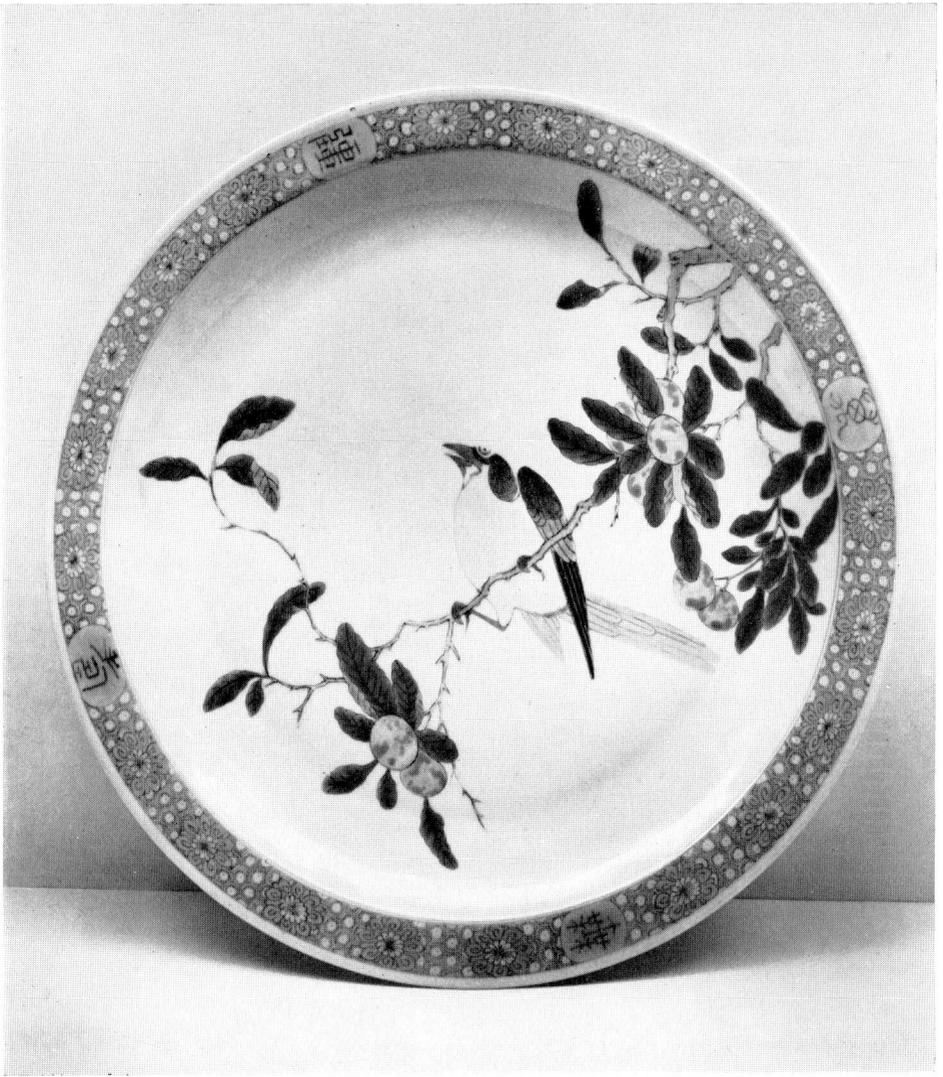

Imperial Birthday Plate decorated in 'famille verte' enamels. Rim broken with four medallions in seal characters—'Wan shou wu chiang' (A myriad longevities without ending). Mark of K'ang Hsi. Diam. 10 in. David Foundation. See page 32*

PLATE XXIX

*Reputed to have been made for the 60th birthday of the Emperor, which fell in 1713.

1. *Plate, decorated in 'famille verte' enamels. Ch'êng Hua mark,*
K'ang Hsi period. Diam. 10·3 in.
Gerald Reitlinger. See page 32

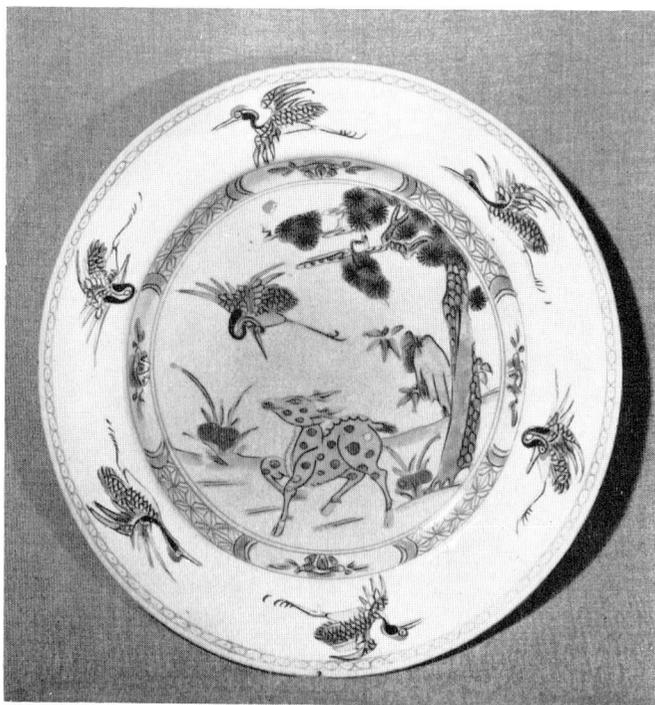

2. *Plate, decorated in 'famille verte' enamels. Mark of the Dresden*
Collection (N—179.I) K'ang Hsi period. Diam. 10 in.
Ex Messrs. Sydney Moss. See pages 32, 36

PLATE XXX

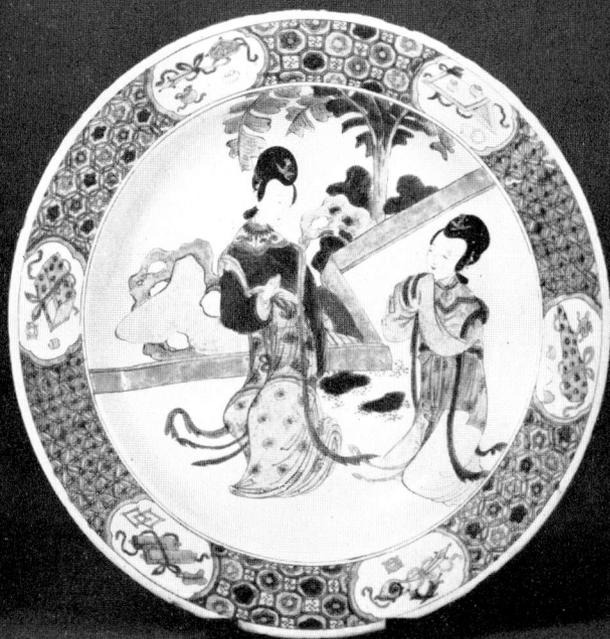

1. *Dish, decorated in 'famille verte' enamels. No mark. K'ang Hsi period. Diam. 15 in. See page 32*
Glasgow Art Gallery and Museum (Burrell Bequest)

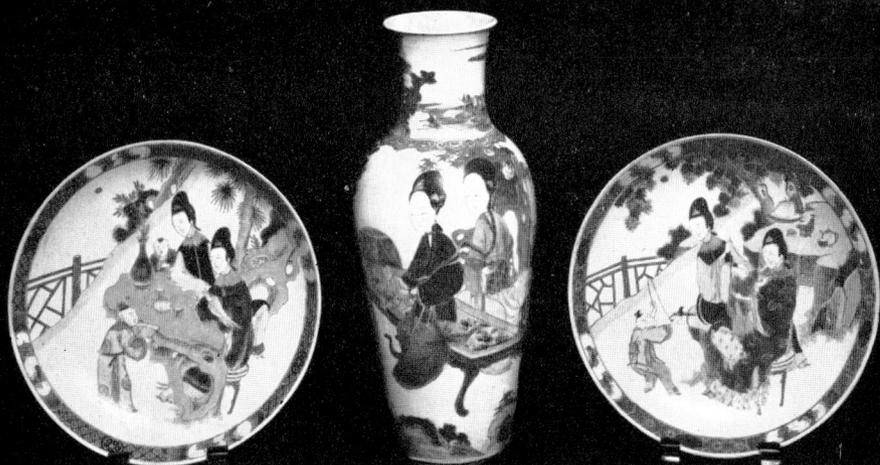

2. *Pair of plates and a vase, decorated in 'famille verte' enamels. Mark and period of K'ang Hsi. Plates, diam. 10·2 in. Vase, Ht. 14·5 in. See page 32. Vase, ex Messrs. Bluett.*
Plates, Glasgow Art Gallery and Museum (Burrell Bequest)

PLATE XXXI

2. *Vase, decorated in 'famille verte' enamels. No mark. K'ang Hsi period. Ht. 8 in. Gerald Reitlinger. See page 52*

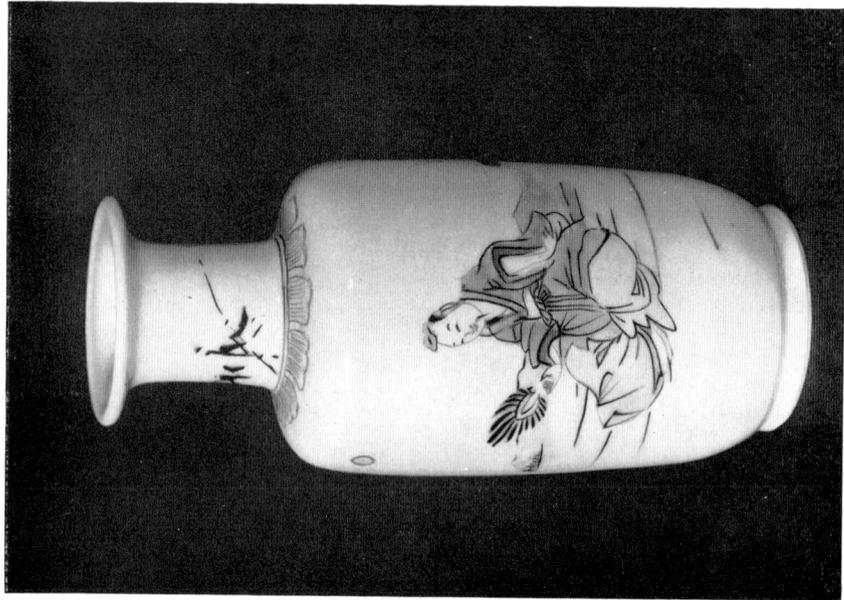

1. *Vase, decorated in 'famille verte' enamels. No mark. K'ang Hsi period. Ht. 6 in. British Museum (Oppenheim Collection) See page 52*

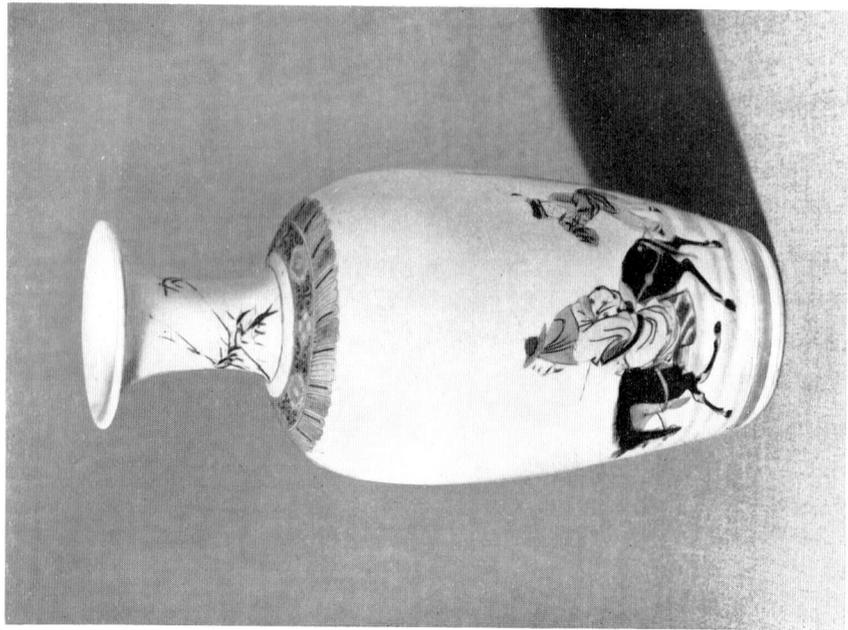

PLATE XXXII

2. Biscuit figure of the Immortal Chung-Li-Ch'uan, wearing a green robe; the base splashed green and yellow. K'ang Hsi period. Ht. 6·5 in. Ex Messrs. Sparks. See page 35

1. Biscuit figure. 'Famille verte' enamels on a green ground. K'ang Hsi period. Ht. 8·7 in. A Conti. See page 35

PLATE XXXIII

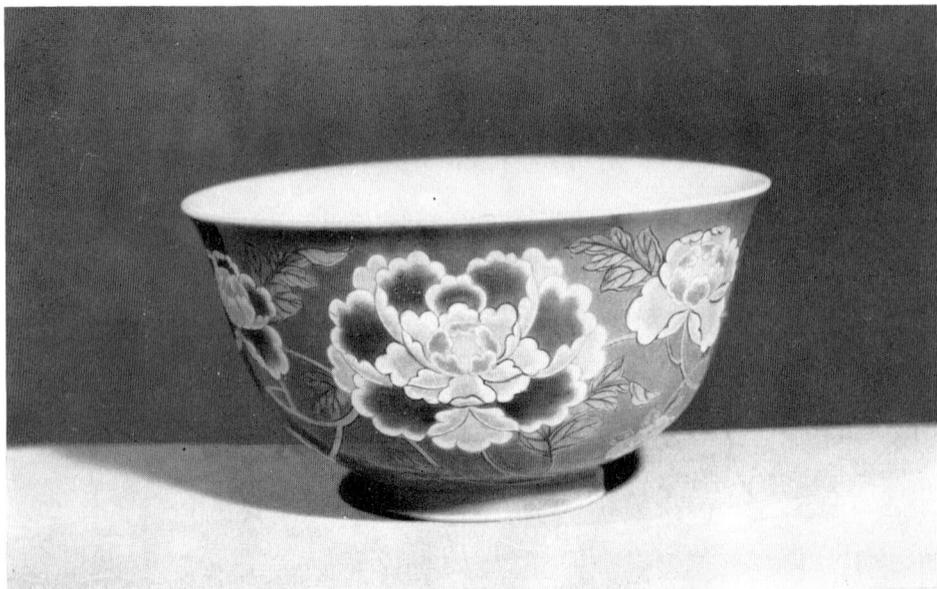

1. *One of a pair of bowls, decorated in enamel colours on a deep pink ground. Mauve enamel Imperial mark and period of K'ang Hsi. Diam. 4·4 in.*
Chinese National Collection. See page 88

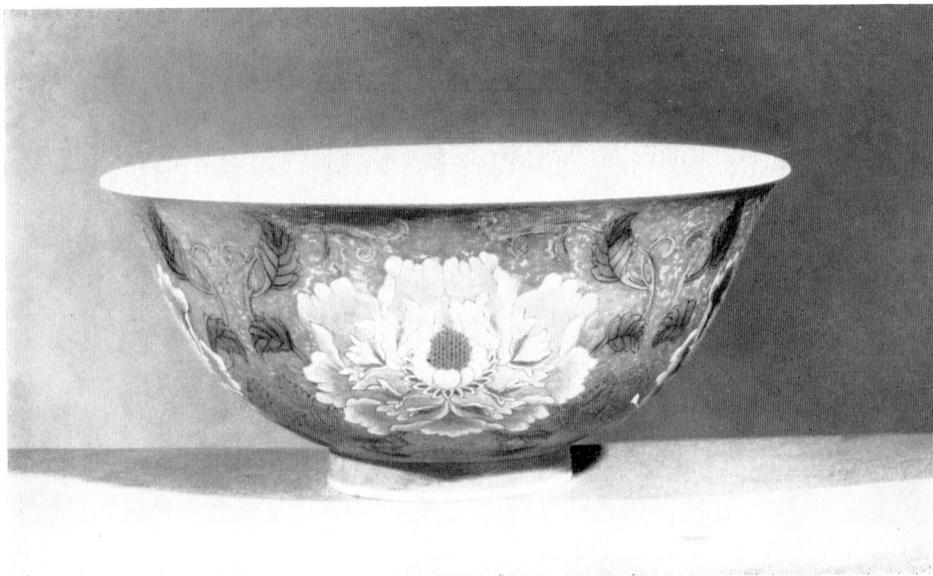

2. *Bowl, decorated in enamel colours on a dappled ruby ground. Blue enamel mark and period of K'ang Hsi. Diam. 6 in.*
Chinese National Collection. See page 88

PLATE XXXIV

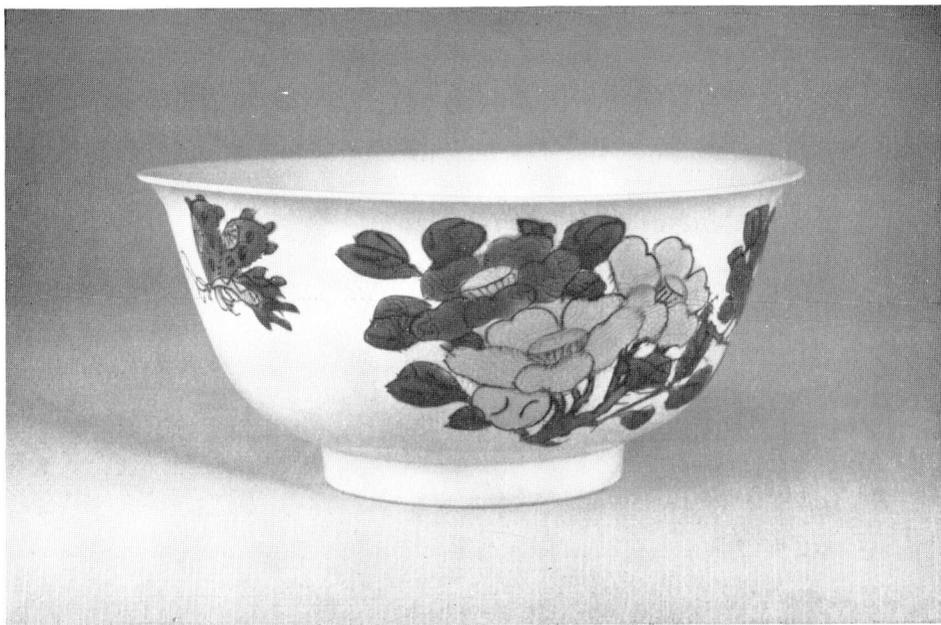

1. *Bowl, with Imperial dragons etched in the paste and covered with decoration in green, yellow and aubergine enamels. Mark and period of K'ang Hsi. Diam. 6 in. See page 45 (footnote 6)*
Ex Messrs. Bluett

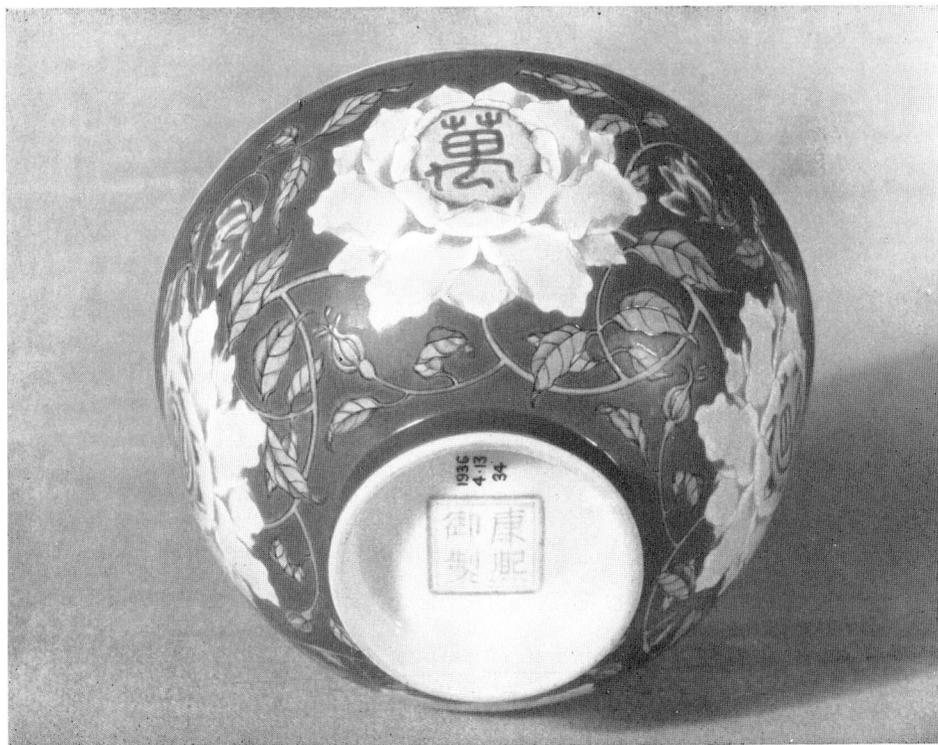

2. *Bowl, decorated in coloured enamels on a blue enamel ground. Mark (in raised pink enamel) and period of K'ang Hsi. Early Ku Yüeh Hsüan? Diam. 6 in.*
British Museum. See page 88

PLATE XXXV

1. *Wine pot, decorated with incised design under a yellow glaze. No mark. K'ang Hsi/Yung Chêng period. Ht. 5·5 in. Ex Swettenham Collection. See page 29*

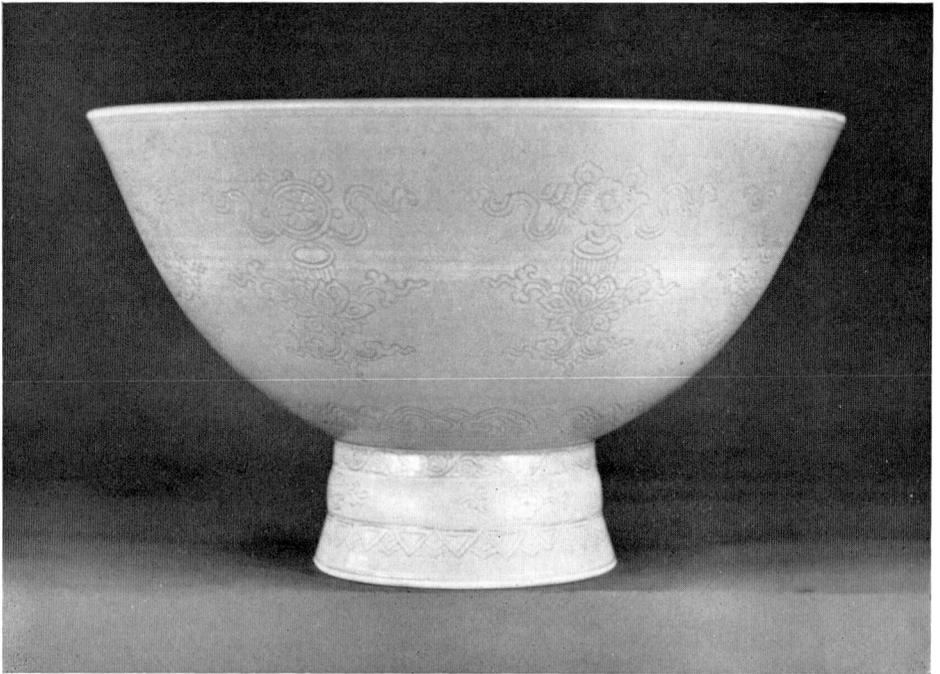

2. *Bowl on stem, decorated with incised design under a yellow glaze. Mark and period of Yung Chêng. Ht. 7·5 in. W. A. Younger. See page 57*

PLATE XXXVI

1A. *Vase, Ting type, steatitic with moulded designs under a white glaze.
17th century. Ht. 8·5 in. British Museum. See page 31*
1B. *Bottle, Ting type, steatitic, with designs in relief under a white
glaze. K'ang Hsi period. Ht. 7·4 in. British Museum. See page 31*
1C. *Bottle, Ting type, design carved under a white glaze. K'ang Hsi
period. Ht. 8·3 in. British Museum. See page 31*

2A. *Vase, with design etched under a white glaze, metal rim. K'ang
Hsi period. Ht. 4·6 in. British Museum. See page 31*
2B. *Bottle, steatitic, with incised ornament under a white glaze. Ch'ien
Lung period. Ht. 5·6 in. British Museum. See page 31*
2C. *Bottle, raised design under a white glaze. No mark. K'ang Hsi
period. Ht. 4·1 in. British Museum. See page 31*

PLATE XXXVII

Saucer dish, engraved with sprays of fruit under a yellow glaze. Mark and period of K'ang Hsi. Diam. 10·5 in.
Glasgow Art Gallery & Museum (Burrell Bequest). See page 29

PLATE XXXVIII

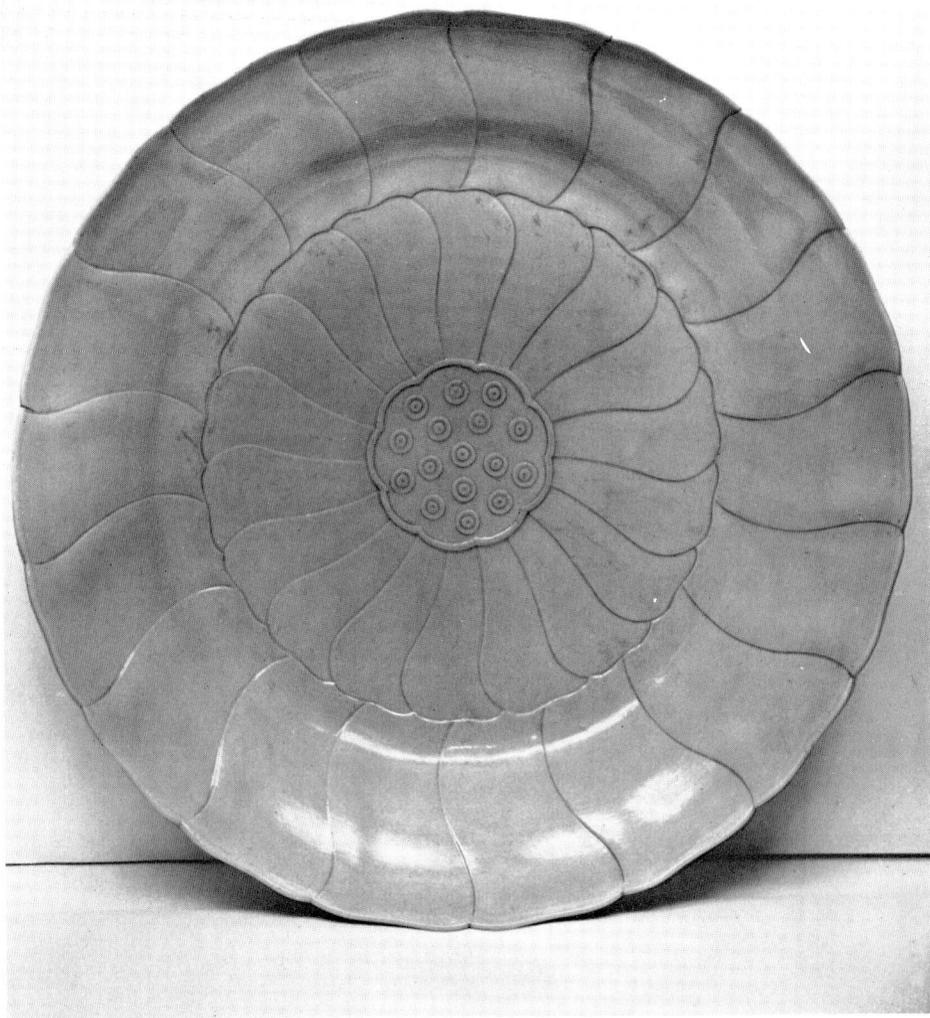

Dish, moulded in Lotus petal whorls with seed pod in the centre. Light yellow glaze. Mark and period of Yung Chêng. Diam. 11·6 in. Fitzwilliam Museum. See page 46

PLATE XXXIX

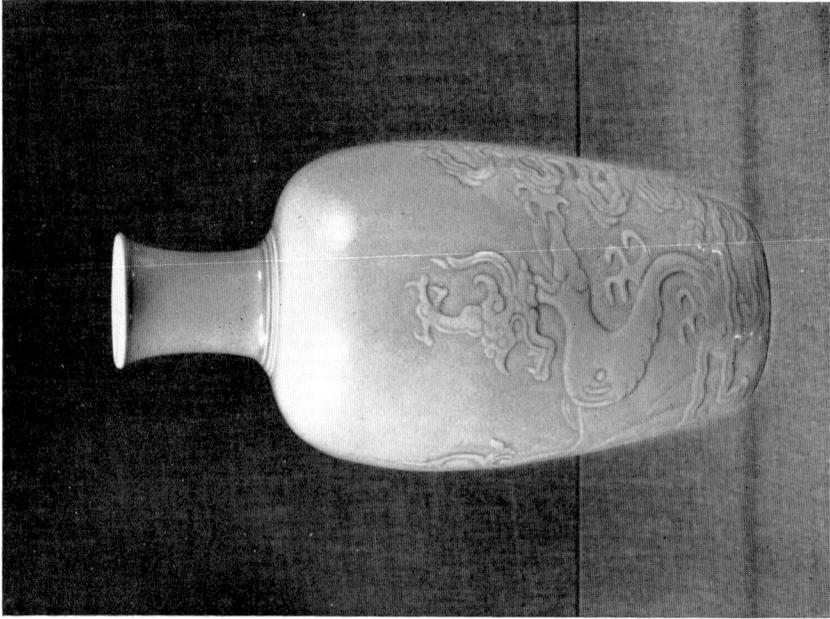

1. Bottle, decorated with a raised and incised design under a celadon glaze. Ch'êng Hua mark; K'ang Hsi period. Ht. 9 in. British Museum. See page 52

2. Vase, covered with a lavender blue glaze. Raised mark and period of K'ang Hsi. Ht. 6·5 in. Ex W. W. Winkworth. See page 50

PLATE XL

1. *Vase, decorated with incised design under a celadon glaze. K'ang Hsi period. Ht. 24 in. Ex Leslie Bibby Coll. See page 52*

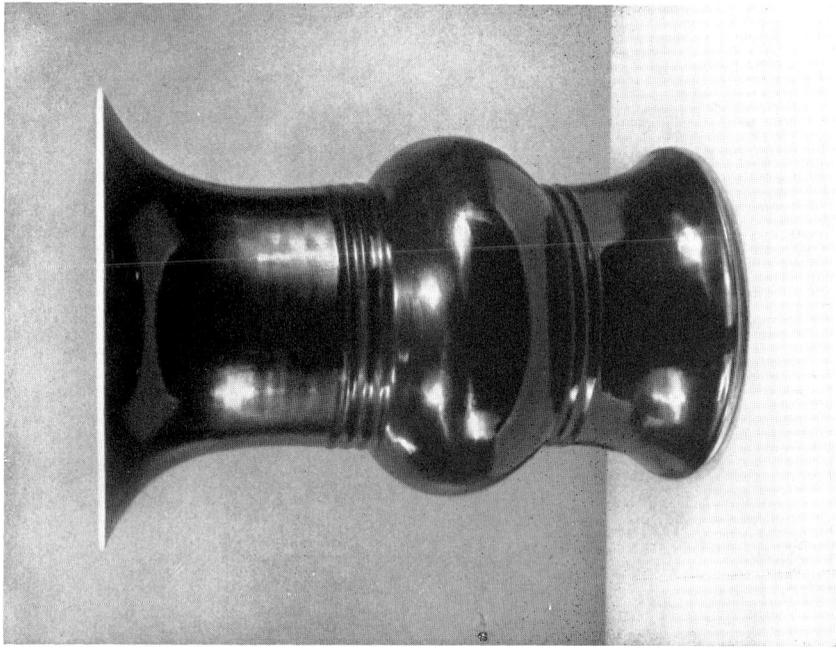

2. *Vase, covered with a deep blue glaze; the interior white. K'ang Hsi period. Ht. approx. 24 in. Ex Messrs. Sparks. See page 50*

PLATE XLI

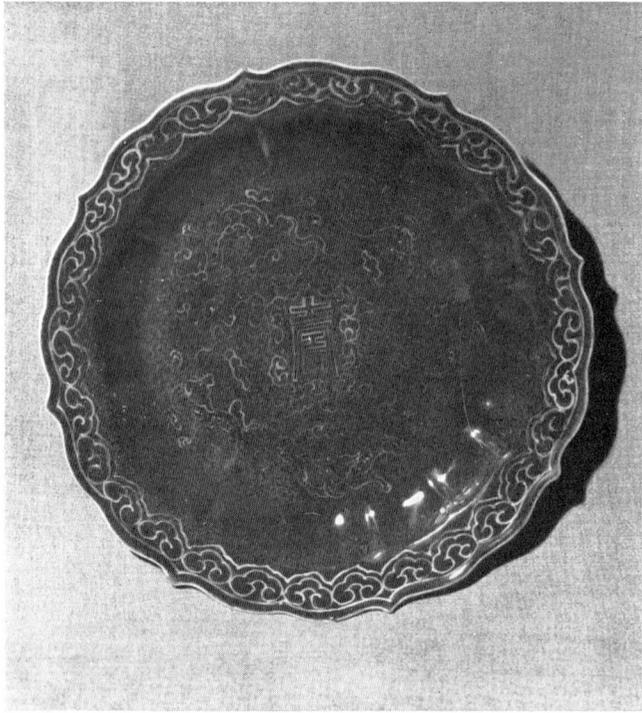

1. *Plate, with powder blue glaze pencilled in gold. Hall mark; Lu i-tang (Hall of green ripples), K'ang Hsi period. Diam. 8·5 in. British Museum. See page 30*

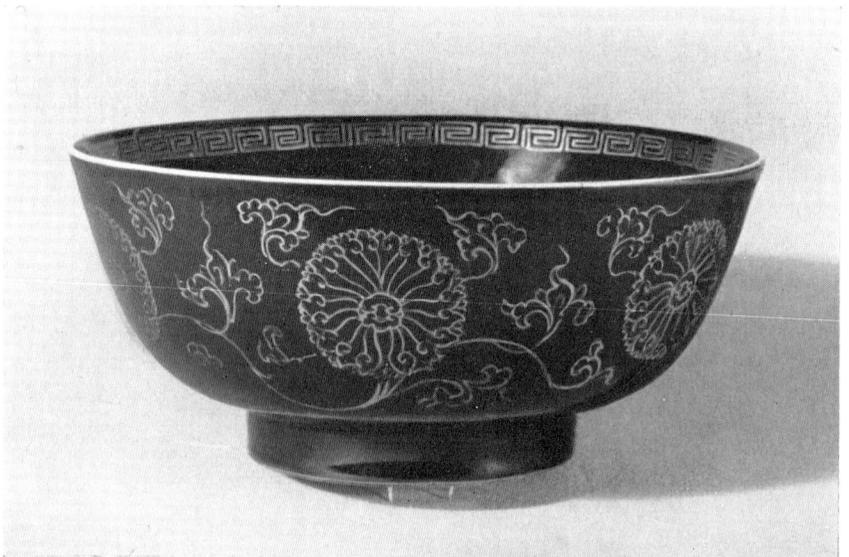

2. *Bowl, with mirror black glaze pencilled in gold. Precious symbol mark. K'ang Hsi period. Diam. 6·8 in. British Museum. See page 30*

PLATE XLII

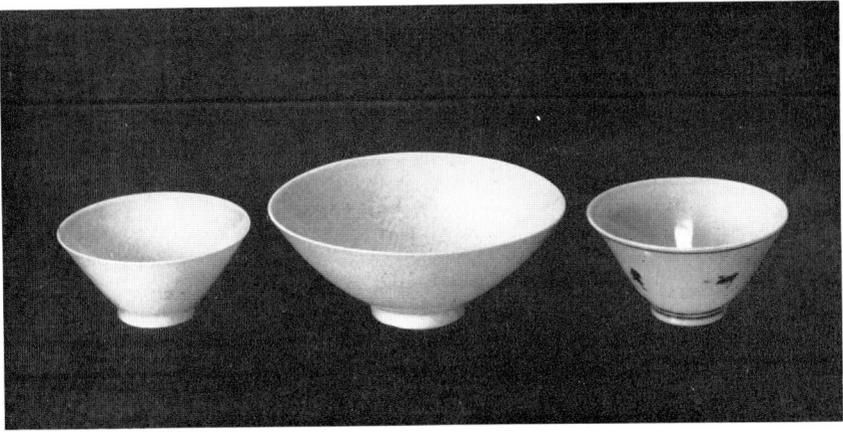

1A. *Wine cup with 'an hua' decoration under a white glaze. Yung Lo mark. 18th century. Diam. 2·3 in. See pages 31, 36*
British Museum (Oppenheim Bequest)
1B. *Bowl, with 'an hua' decoration under a white glaze. No mark. 18th century. Diam. 3·5 in. See pages 31, 36*
British Museum (Oppenheim Bequest)
1C. *Wine cup, decorated in underglaze blue. Ch'êng Hua mark. 16th century or later. Diam. 2·5 in. See page 39*
British Museum (Oppenheim Bequest)

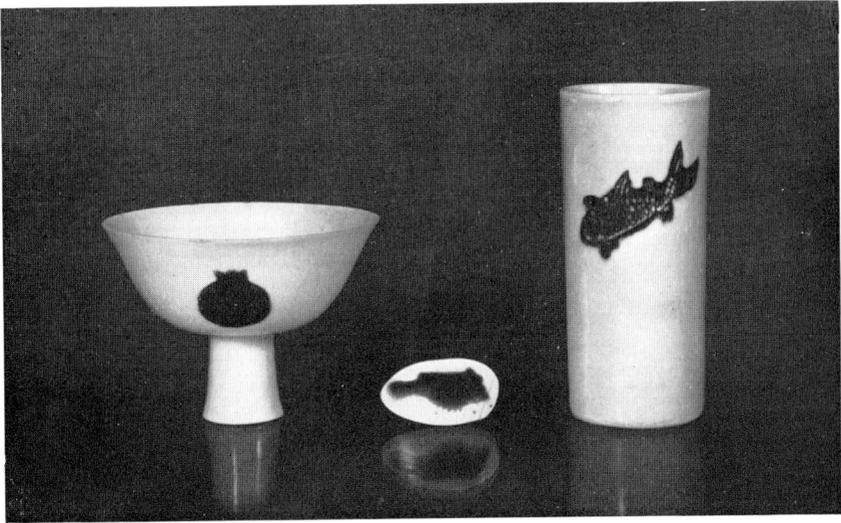

2A. *Stem cup, with underglaze red and 'an hua' decoration. No mark. Yung Chêng period. Diam. 5·9 in. See page 54*
British Museum
2B. *Fragment decorated in underglaze red. Probably 18th century. Length 2·5 in. See page 54*
British Museum
2C. *Brush pot, decorated in underglaze red. Mark of Hsüan Tê 18th century. Ht. 6·7 in. See page 54*
British Museum

PLATE XLIII

1. *Bowl, decorated in coloured enamels on a pink ground. Mark in mauve enamel and period of K'ang Hsi. Diam. 6 in. Chinese National Collection. See page 58*

2. *Teapot, with landscape in blue enamel on a coloured enamel ground. Mark in blue enamel and period of Yung Chêng. Ht. 3.5 in. Chinese National Collection. See page 58*

PLATE XLIV

1. *Bowl, decorated in coloured enamels on a tomato red ground. Mark and (?) period of Yung Chêng. Diam. 5·3 in.*
Gerald Reitlinger. See page 37

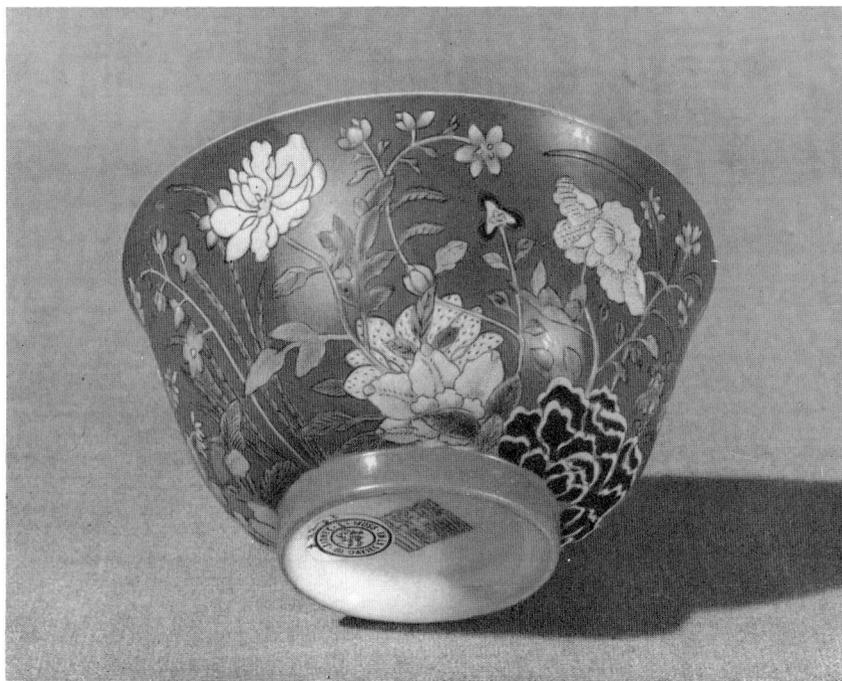

2. *Bowl, decorated in coloured enamels on a tomato red ground. Mark and period of T'ao Kuang. Diam. 5·3 in.*
Ex Messrs. Sydney Moss. See page 37

PLATE XLV

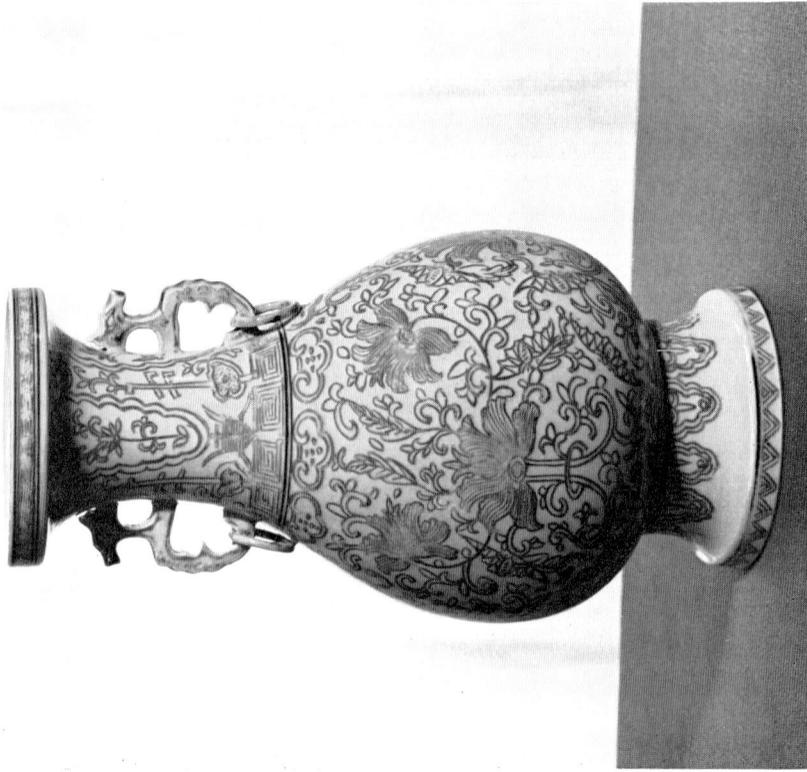

1. *Vase in archaic form, decorated in underglaze red in Hsüan Tê style. Seal mark and period of Yung Chêng. Ht. 14·5 in.*

P. J. Donnelly. See page 37

2. *Plate, decorated in 'famille verte' enamels, with touches of 'famille rose'. No mark. K'ang Hsi/Yung Chêng transition. Diam. 14 in.*

Gerald Reitlinger. See page 55 and Colour Plate E

PLATE XLVI

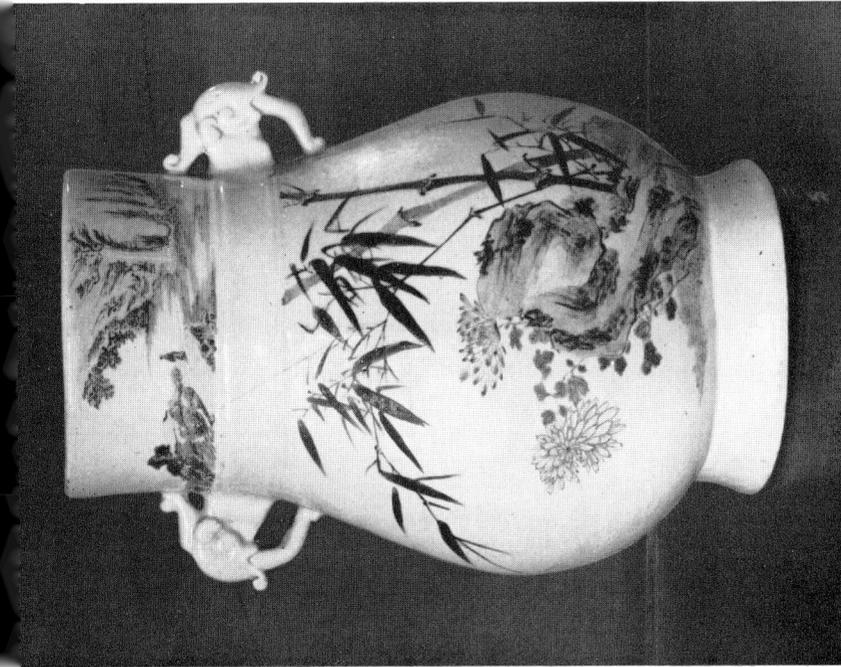

1. *Vase, decorated in 'famille rose' and black enamels. No mark. Yung Chêng period. Ht. 12·5 in. W. W. Winkworth. See page 45*

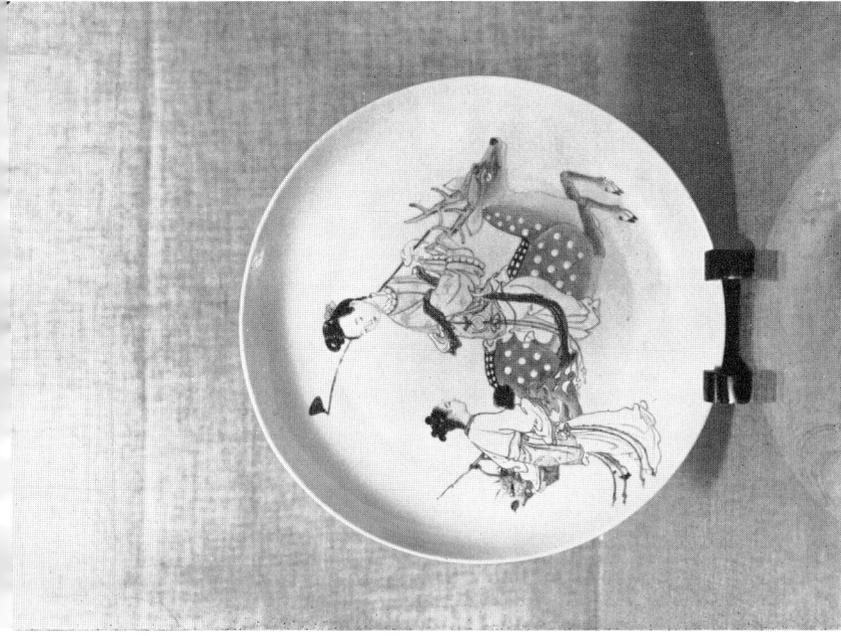

2. *Plate, eggshell porcelain decorated in 'famille rose' enamels. Ruby back. No mark. Yung Chêng period. Diam. 8 in. R. H. R. Palmer. See page 58*

PLATE XLVII

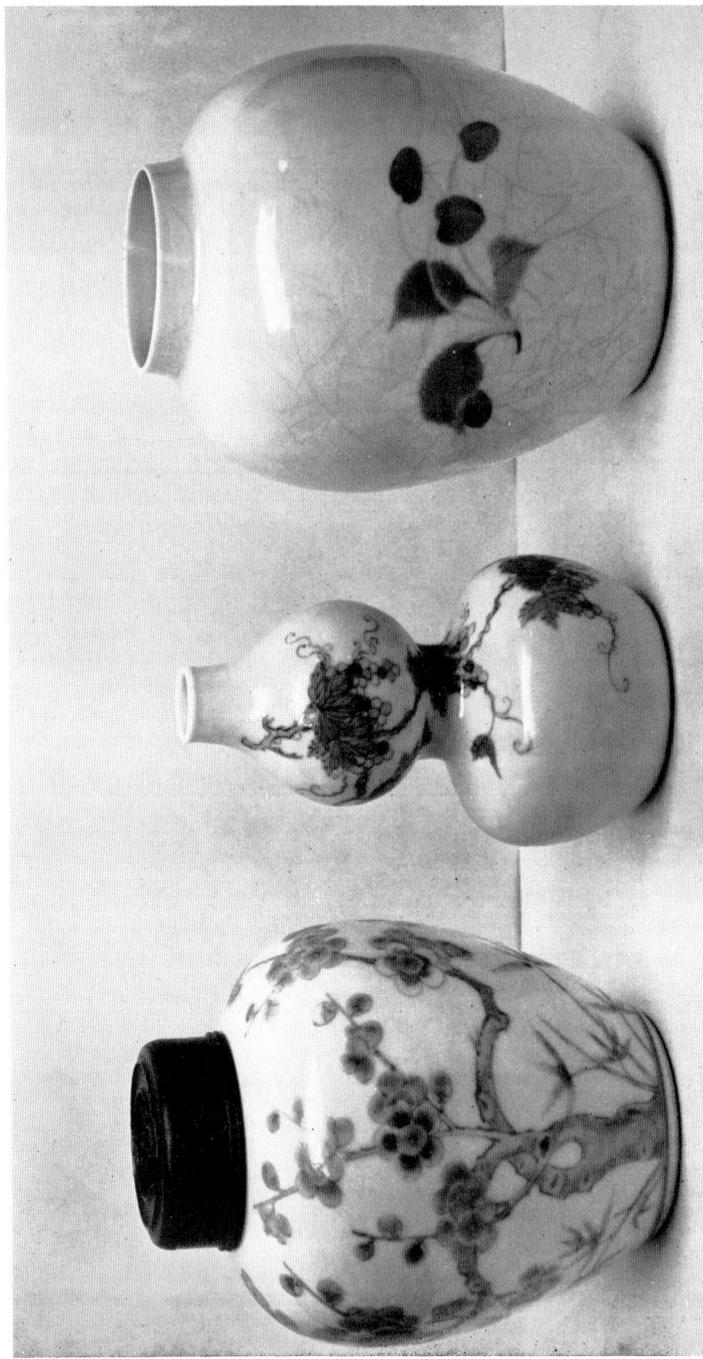

A. *Jar painted in 'tou ts'ai' enamels. K'ang Hsi mark. K'ang Hsi/Yung Chêng transition. Ht. 5 in. Ex Russell Collection. See page 38*

B. *Double gourd vase, painted in 'tou ts'ai' enamels, with fruiting vine and squirrel eating fruit on reverse. Mark and period of Yung Chêng. Ht. 4.9 in. David Foundation. See page 56*

C. *Semi-eggshell jar, painted in 'tou ts'ai' enamels on a crackled soft paste body; three butterflies on reverse. Ch'êng Hua mark, late K'ang Hsi period. Ht. 5.3 in. David Foundation. See page 51*

PLATE XLVIII

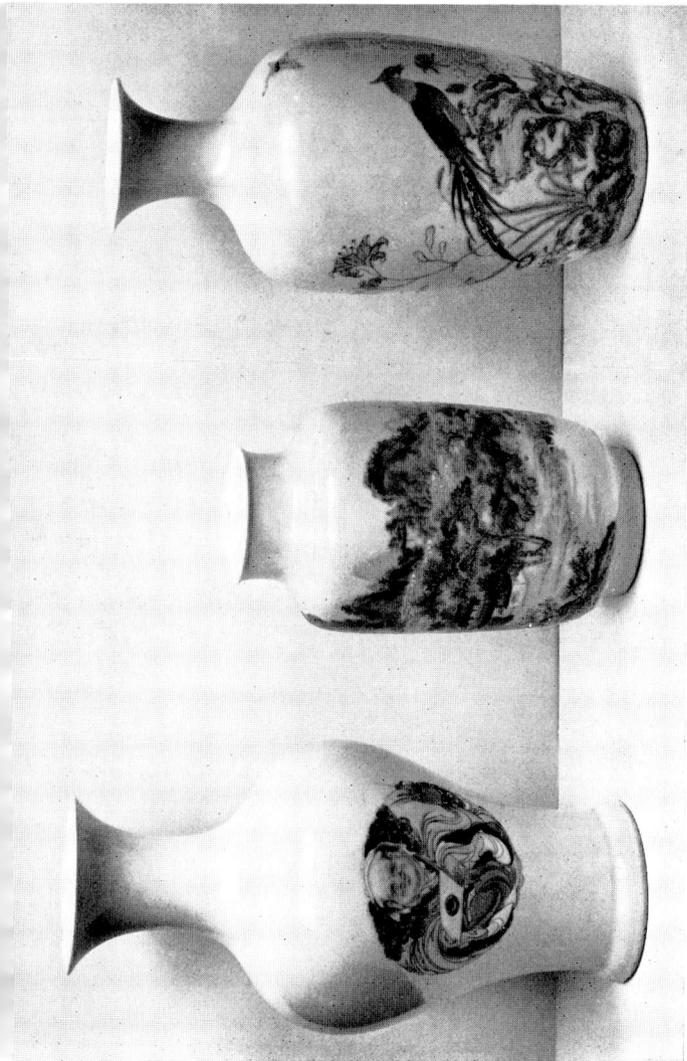

A. *Vase, decorated in 'famille rose' enamels; on reverse, medallion of fungus and bamboo shoots. Mark and period of Yung Chêng. Ht. 9.7 in. Sir A. Simms. See page 46*

B. *Vase, painted in coloured enamels and inscribed with a poem with the seals of Chüeh T'ao; (T'ang Ying, Director of the Imperial Factory 1728–49) and a reference to the Hsüan-tsui Pavilion, i.e. The Imperial Factory at Chêng-tê-chên on the Jewel hill. Ch'ien Lung period. Ht. 7 in. Ex Russell Collection. See page 66 (footnote 11)*

C. *Vase, painted in coloured enamels with golden pheasant and quail in a rockery amid peonies and lilies. Mark and period of Yung Chêng. Ht. 9.2 in. Ex Russell Collection. See page 58*

PLATE XLIX

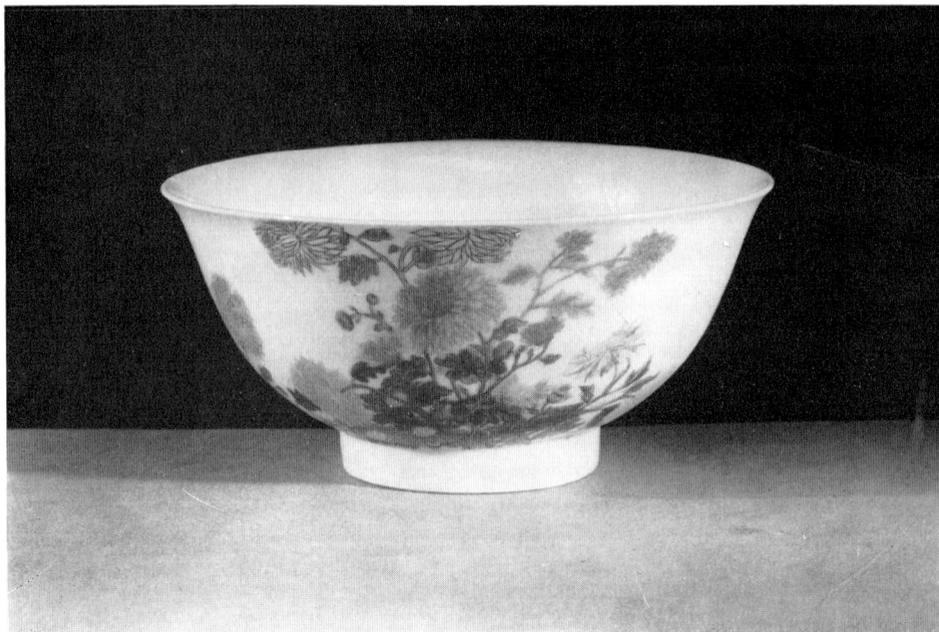

1. *One of a pair of bowls, decorated with chrysanthemums and roses in coloured enamels. Blue enamel mark and period of Yung Chêng. Diam. 6 in.*
Chinese National Collection. See page 58

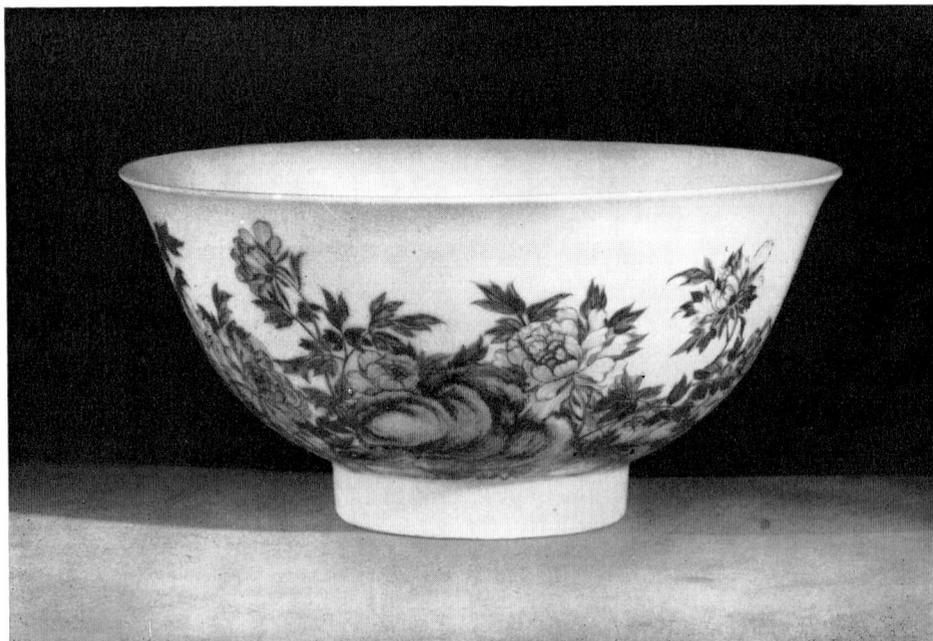

2. *One of a pair of bowls, decorated in sepia with flowers and verses. Blue enamel mark and period of Yung Chêng. Diam. 6 in.*
Chinese National Collection. See page 58

PLATE L

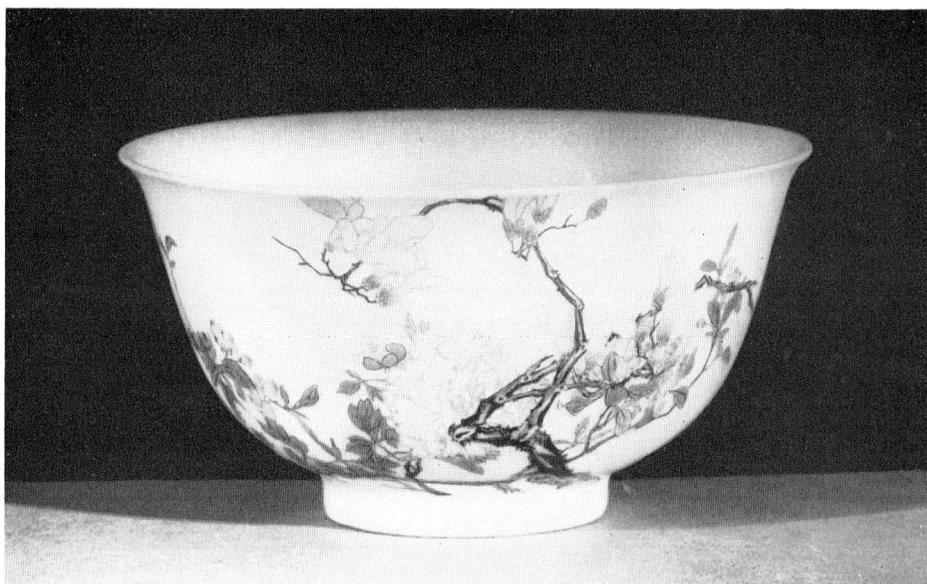

1. *One of a pair of bowls, decorated in enamel colours, with flowers and a poem. Blue enamel mark and period of Yung Chêng. Diam. 4·1 in. Chinese National Collection. See page 58*

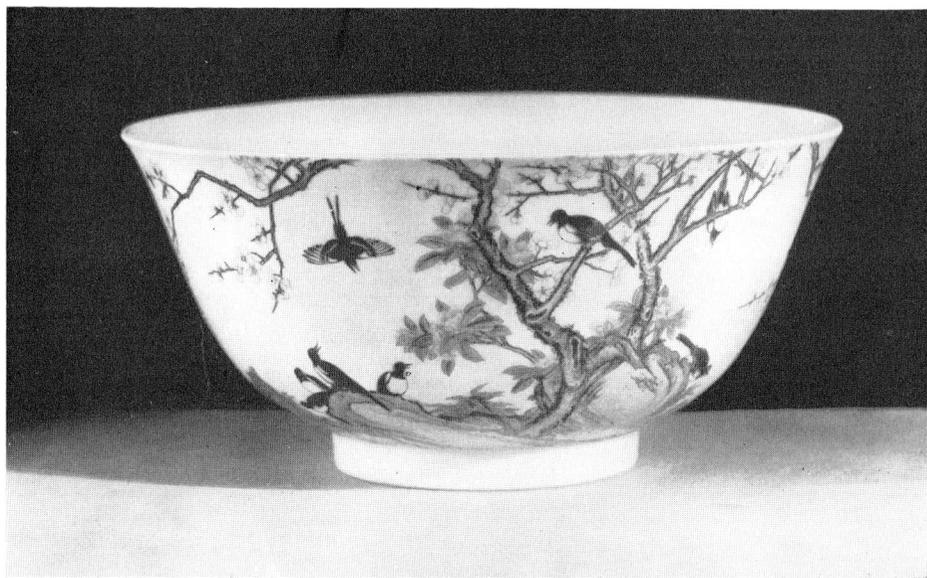

2. *Bowl, decorated in enamel colours. Blue enamel mark and period of Yung Chêng. Diam. 6·3 in. Chinese National Collection. See page 58*

PLATE LI

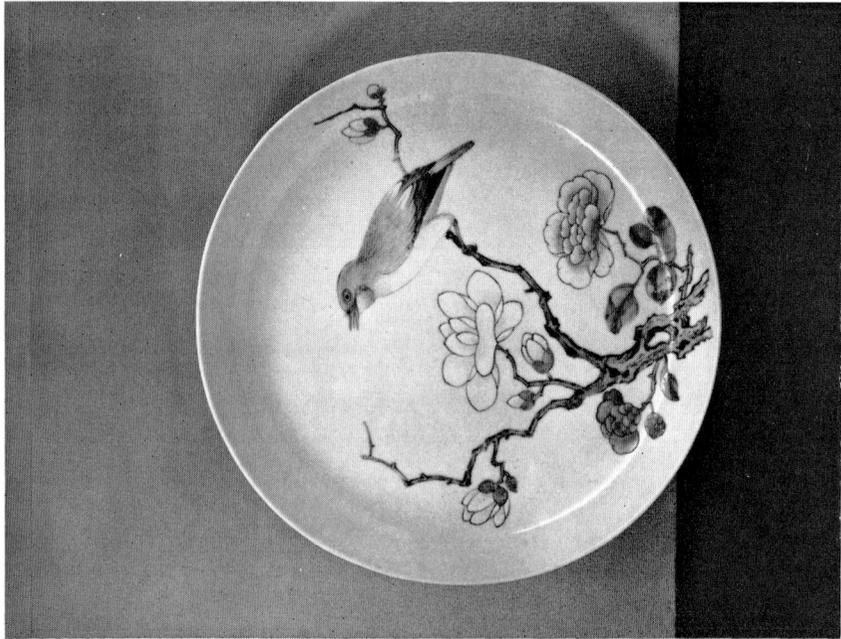

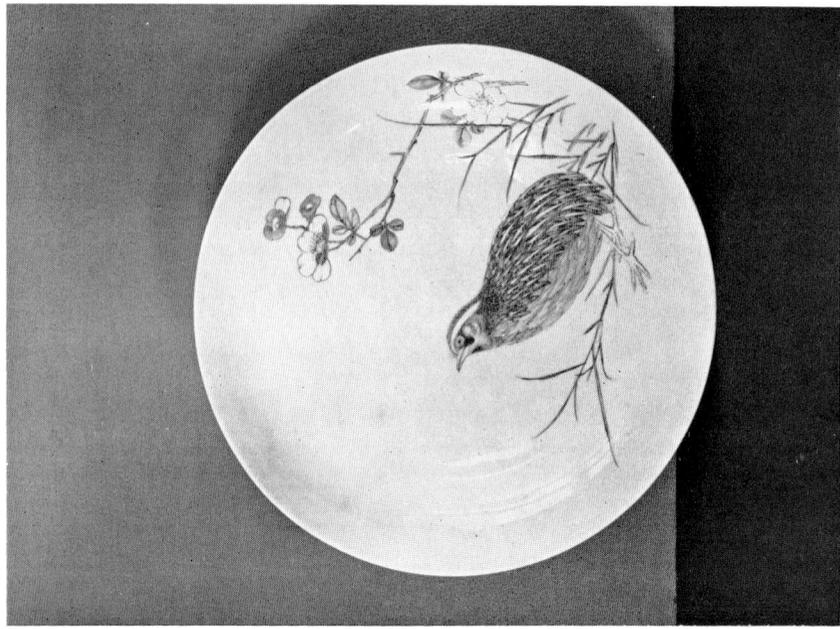

2. Saucer dish, decorated in 'famille rose' enamels. No mark. Yung Chêng period. Diam. 8 in. Victoria and Albert Museum. See page 58

1. Eggshell saucer dish, decorated in 'famille rose' enamels. Ruby back. No mark. Yung Chêng period. Diam. 8 in. David Foundation. See page 58

PLATE LII

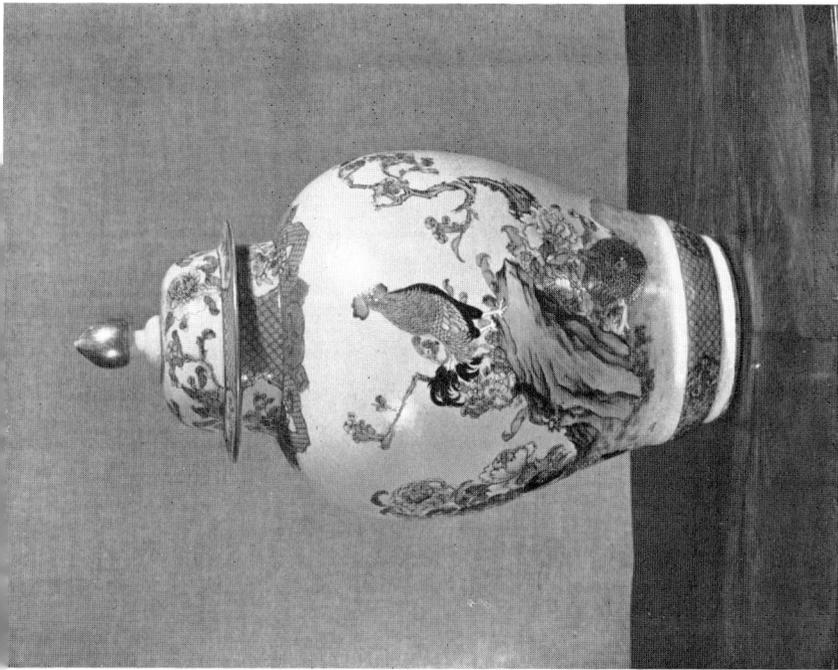

1. Potiche, part of a garniture of three, decorated in 'famille rose' enamels. No mark. Yung Chêng period.
Ht. 24 in. See page 58
John Morrison

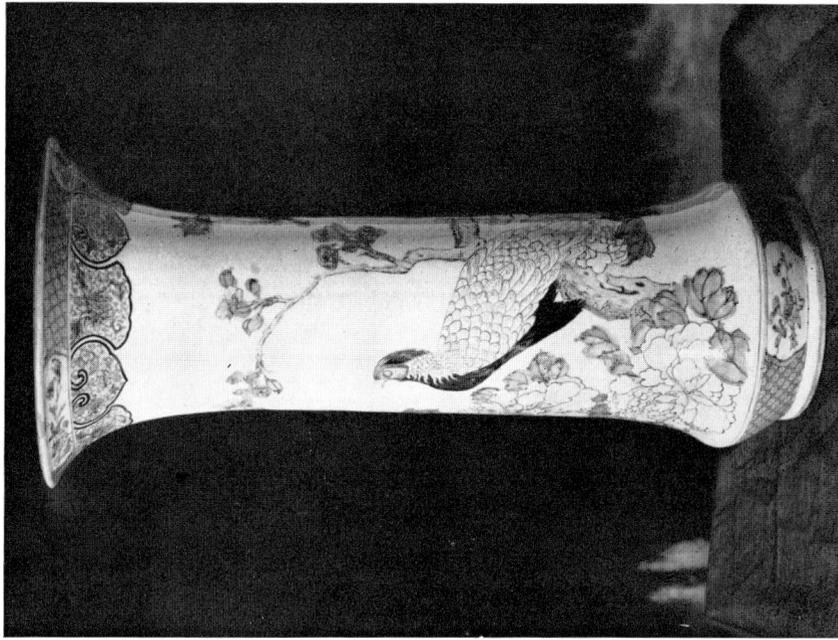

2. Vase, part of a garniture, decorated in 'famille rose' enamels. No mark. Yung Chêng period.
Ht. 19 in. See page 58
Col. Evans Lombe

PLATE LIII

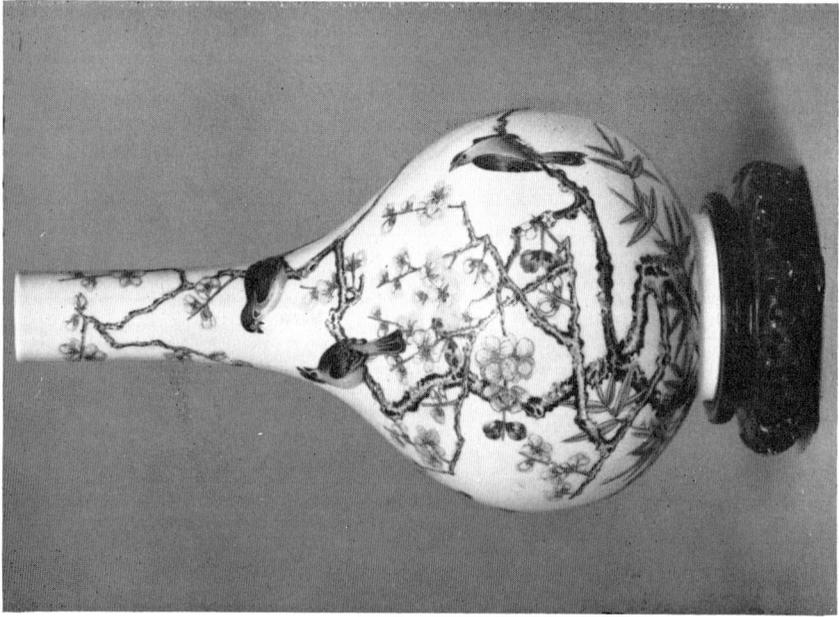

1. *Vase, decorated in coloured enamels. Ku Yüeh Hsüan style. Ch'ien Lung period. Owner and dimensions unknown. See page 88*

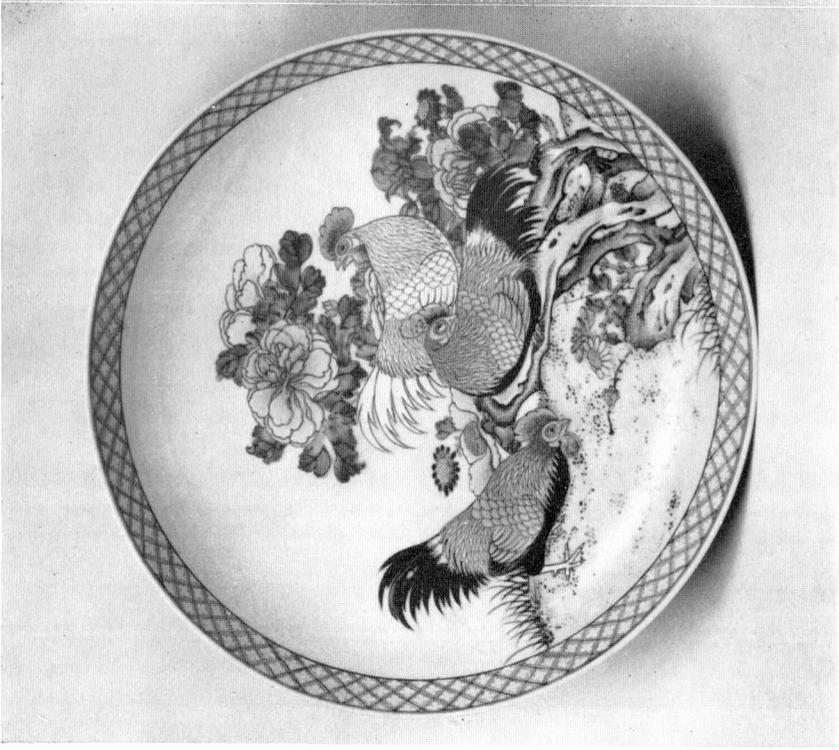

2. *Ruby-backed saucer dish, decorated in 'famille rose' enamels. Yung Chêng period. Diam. 7·7 in. Ex Morrison Collection. See page 58*

PLATE LIV

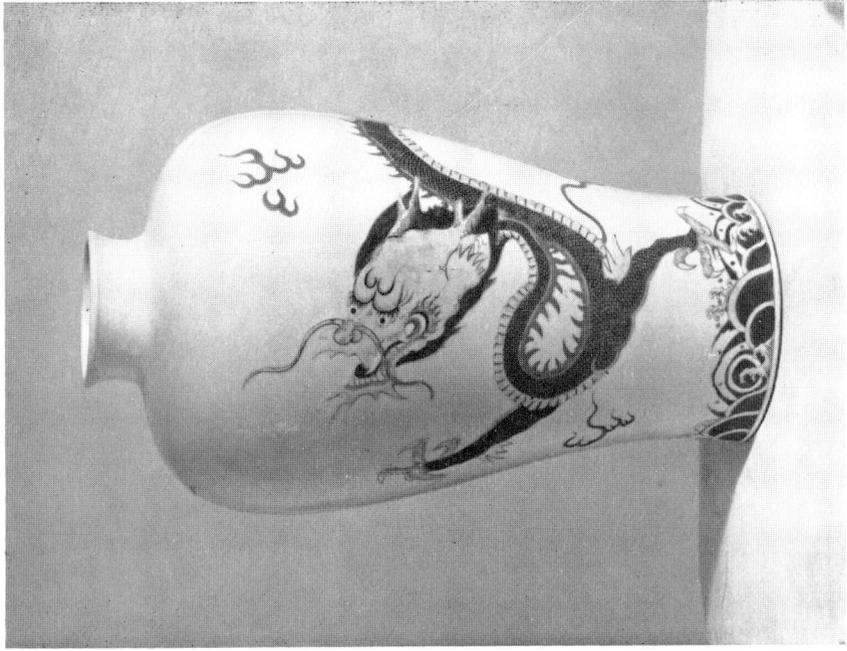

2. *Vase, decorated in 'famille verte' enamels. No mark. K'ang Hsi/Yung Chêng transition. Ht. 15·5 in. Ex Messrs. Sparks. See page 46*

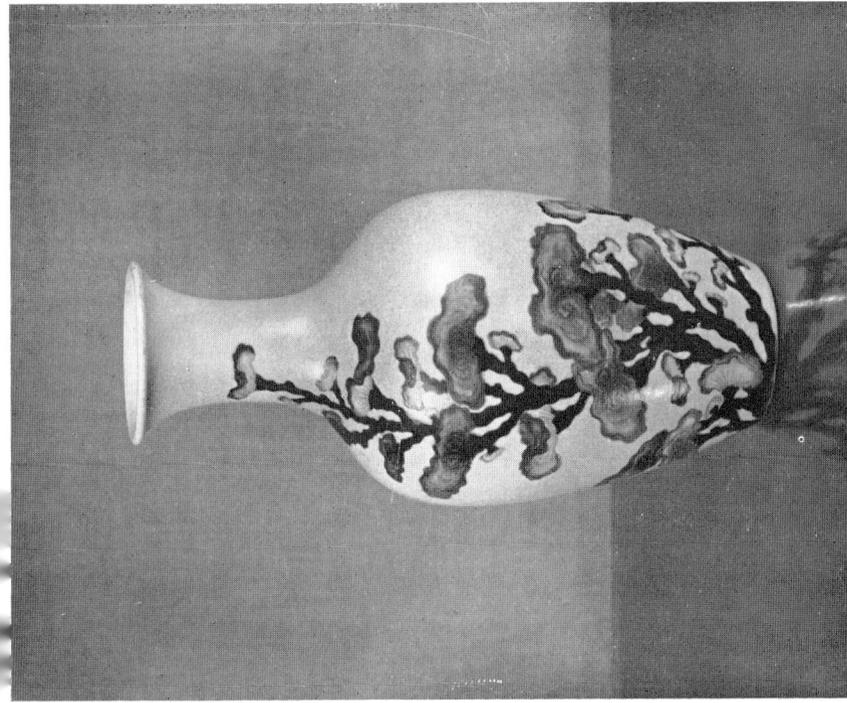

1. *Vase, decorated in purple enamel on a turquoise blue ground. Mark and period of Yung Chêng. Ht. 10·5 in. Ex Bruce Collection. See page 46*

PLATE LV

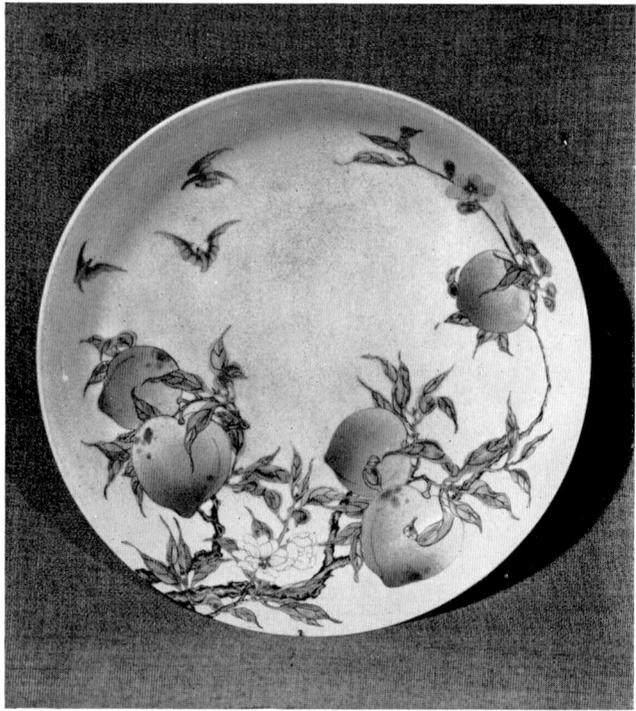

1. *Plate, decorated in 'famille rose' enamels with fruiting peach. Mark and period of Yung Chêng. Diam. 8·3 in. British Museum. See page 58*

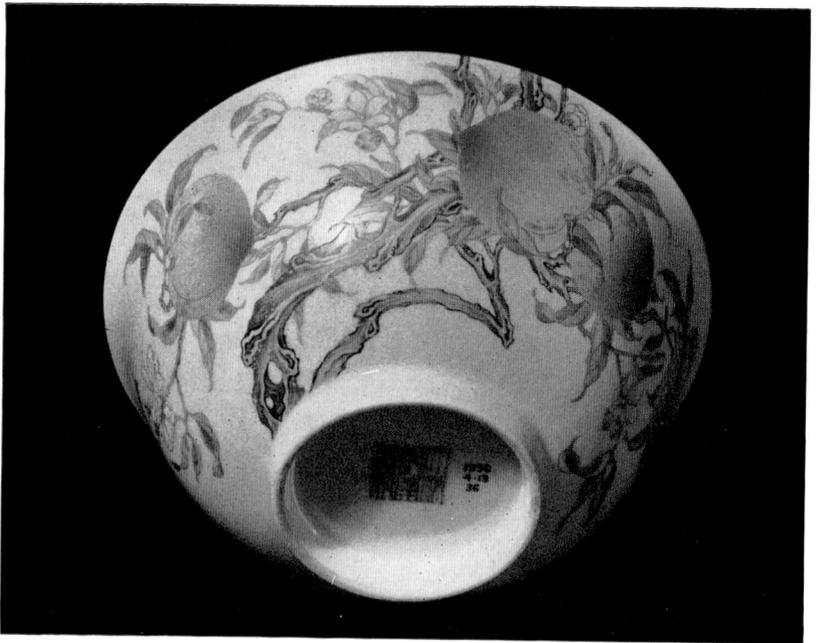

2. *Bowl, decorated in 'famille rose' enamels with fruiting peach. Mark and period of Ch'ien Lung. Diam. 7·3 in. British Museum. See page 58*

PLATE LVI

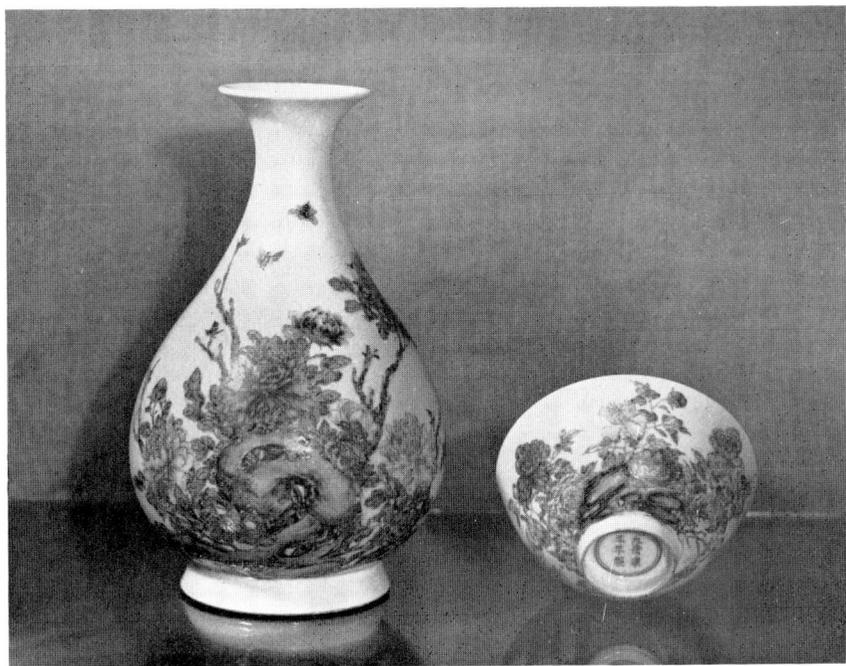

1A. *Vase, decorated in 'famille rose' enamels and iron red. Mark and period of Yung Chêng. Ht. 10·8 in.*

1B. *Bowl, decorated in 'famille rose' enamels and iron red. Mark and period of Yung Chêng. Diam. 5 in.*
Both from the Bristol City Art Gallery. See page 46

2. *Bowl, decorated in coloured enamels. No mark. K'ang Hsi/Yung Chêng transition. Diam. 6·8 in.*
Victoria and Albert Museum. See page 46

PLATE LVII

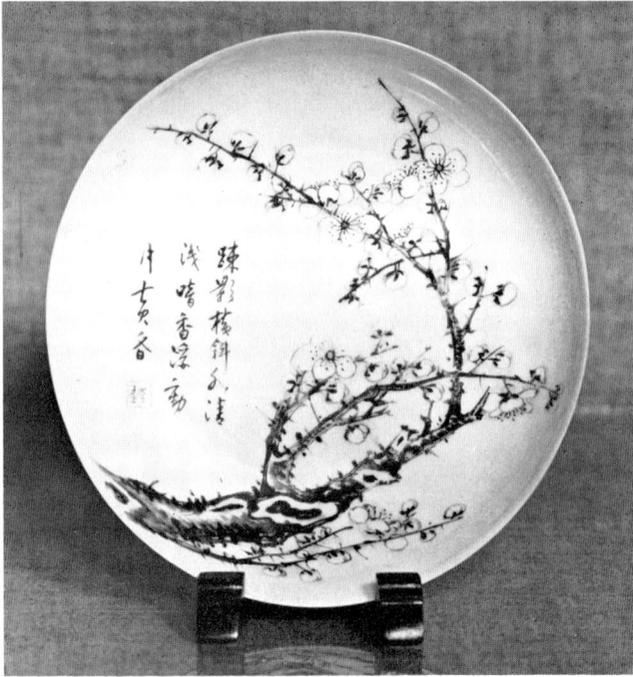

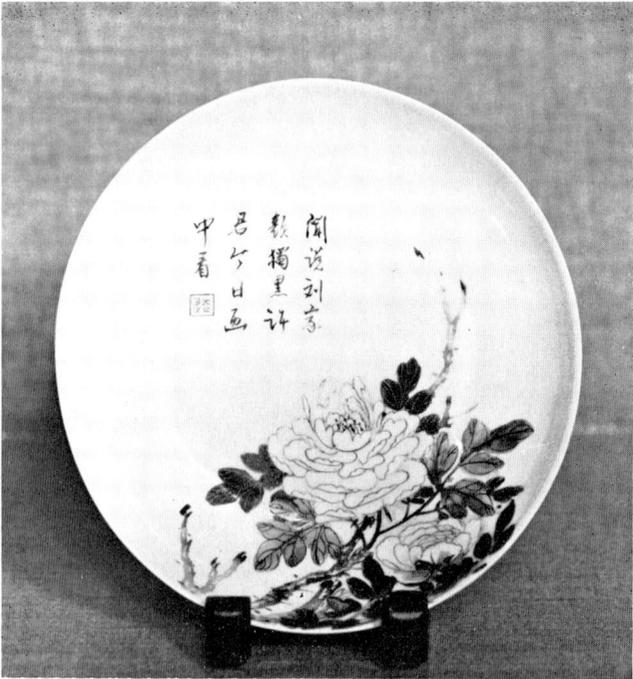

1 & 2. *Pair of semi-eggshell saucers decorated in sepia. Mark, a flower on the base in underglaze blue. Yung Chêng period. Diam. 6 in.*
R. H. R. Palmer. See page 45

PLATE LVIII

1A. *Bowl, decorated in 'famille rose' enamels. Mark and period of Yung Chêng. Diam. 3·7 in. See page 46*
British Museum
1B. *Cup, decorated in 'famille rose' enamels. Mark in imitation of Dresden in underglaze blue. Yung Chêng period. Diam. 2·9 in.*
British Museum. See page 35
1C. *Bowl, decorated in 'famille rose' enamels. On a ruby ground. Mark and period of Yung Chêng. Diam. 3·5 in.*
British Museum. See page 58

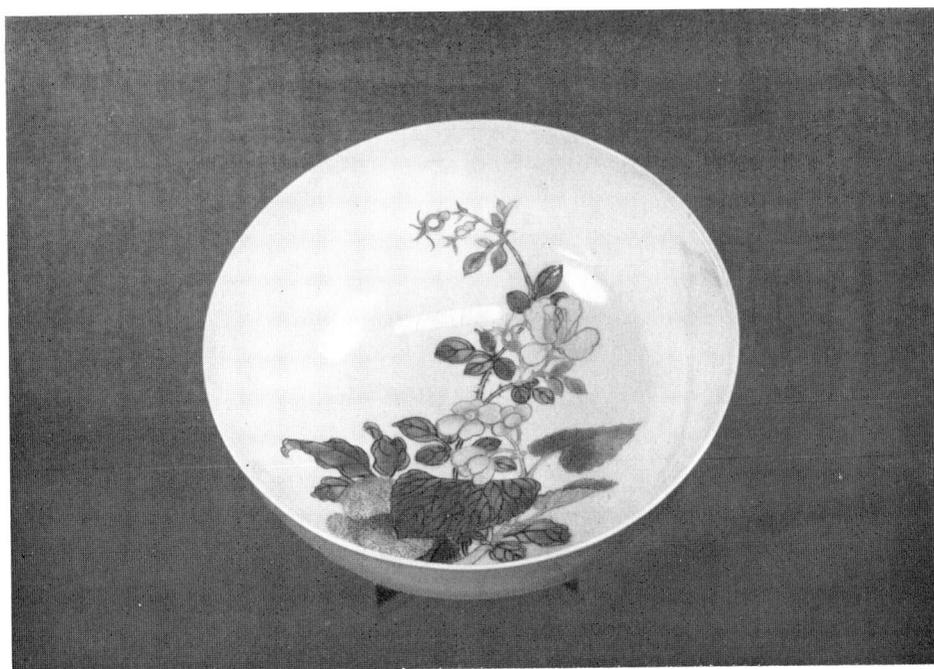

2. *Bowl, decorated in 'famille rose' enamels. Ruby sides. Cyclical date corresponding to the year 1721. Diam. 5 in.*
British Museum. See page 35

PLATE LIX

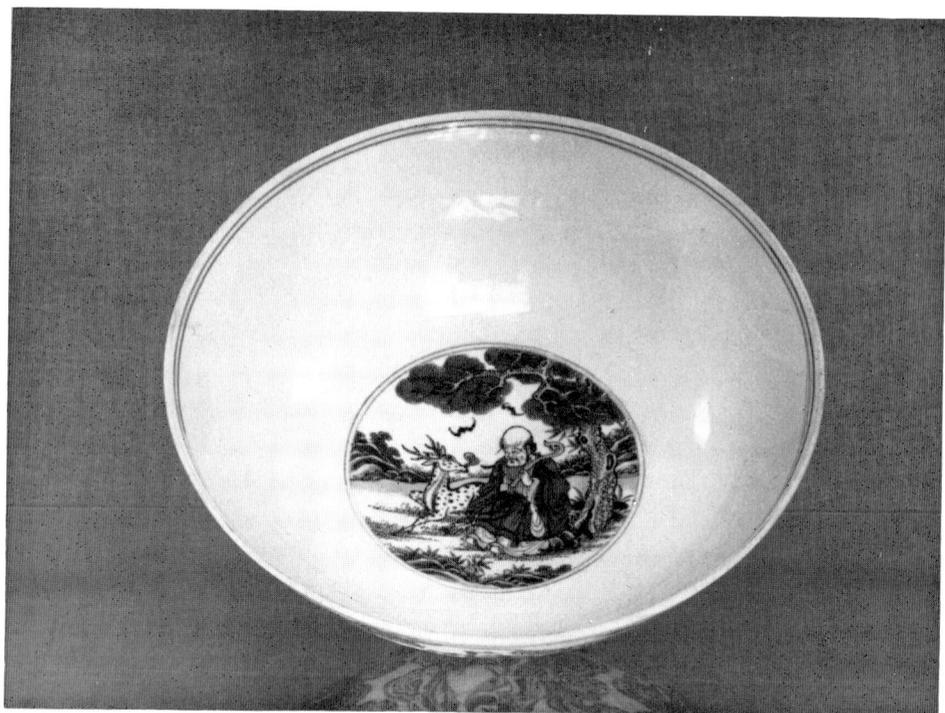

1. *Interior of bowl, decorated in underglaze blue. Mark and period of Yung Chêng. Diam. 10 in.*
Sir H. Garner. See page 46

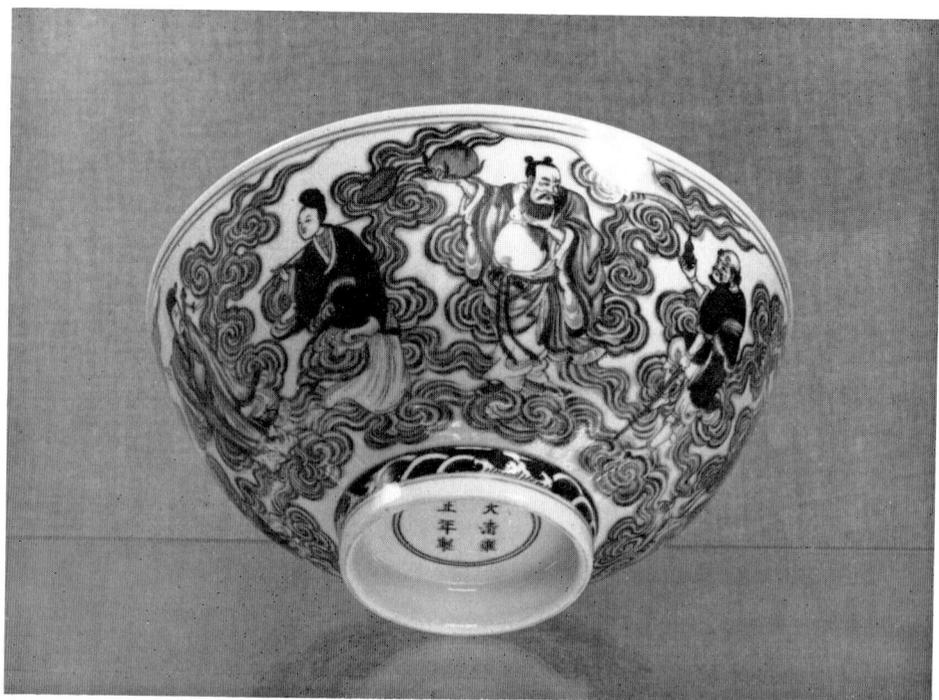

2. *Reverse*

PLATE LX

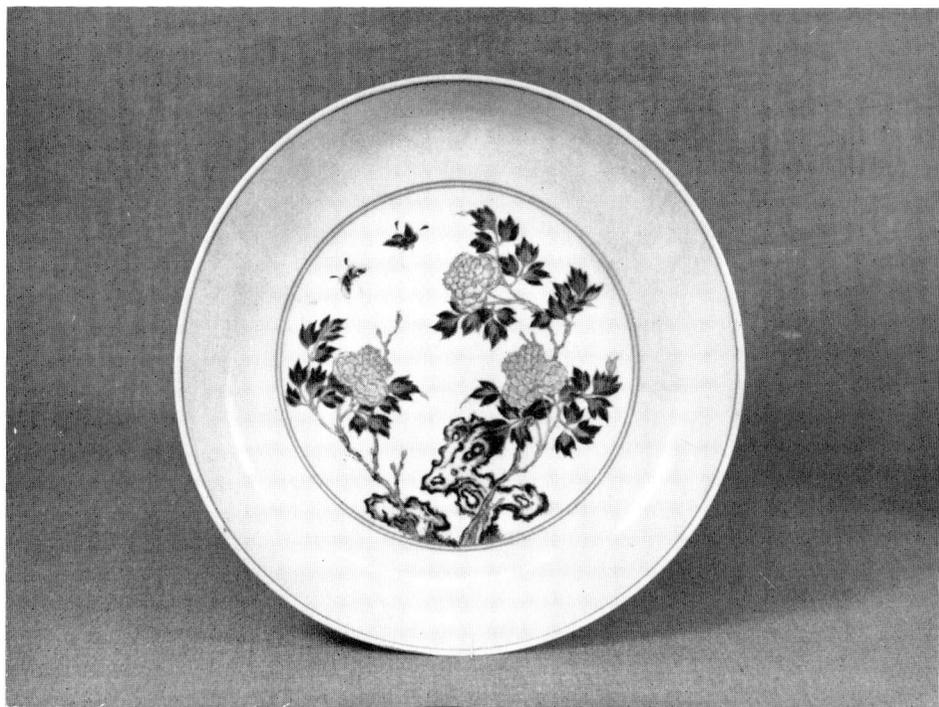

1. *Interior of saucer dish, decorated in underglaze blue. Mark and period of Yung Chêng. Diam. 8·3 in.*
Soame Jenyns. See page 46

2. *Reverse*

PLATE LXI

1. *Bowl, decorated in underglaze blue. Yung Chêng mark and period.*
Diam. 4·7 in.
S. C. Coles. See page 46

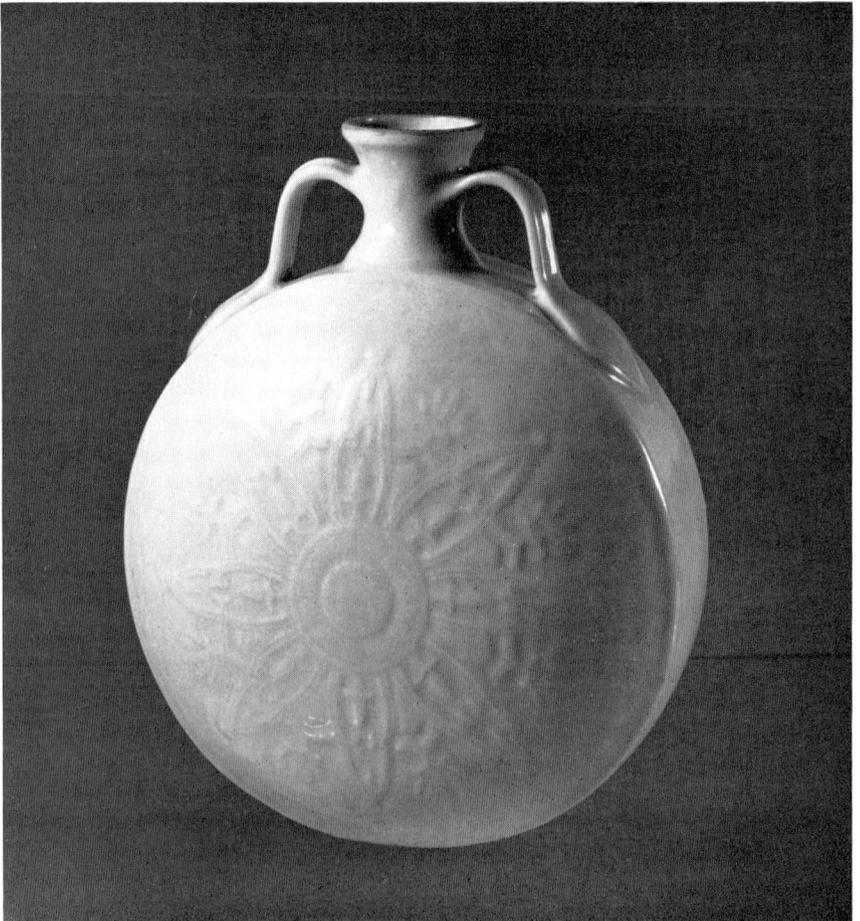

2. *Pilgrim bottle, decorated with an incised design under a white glaze*
in Hsüan Tê style. No mark. K'ang Hsi/Yung Chêng transition?
Ht. 9·9 in. See page 55
British Museum (Manuk Bequest)

PLATE LXII

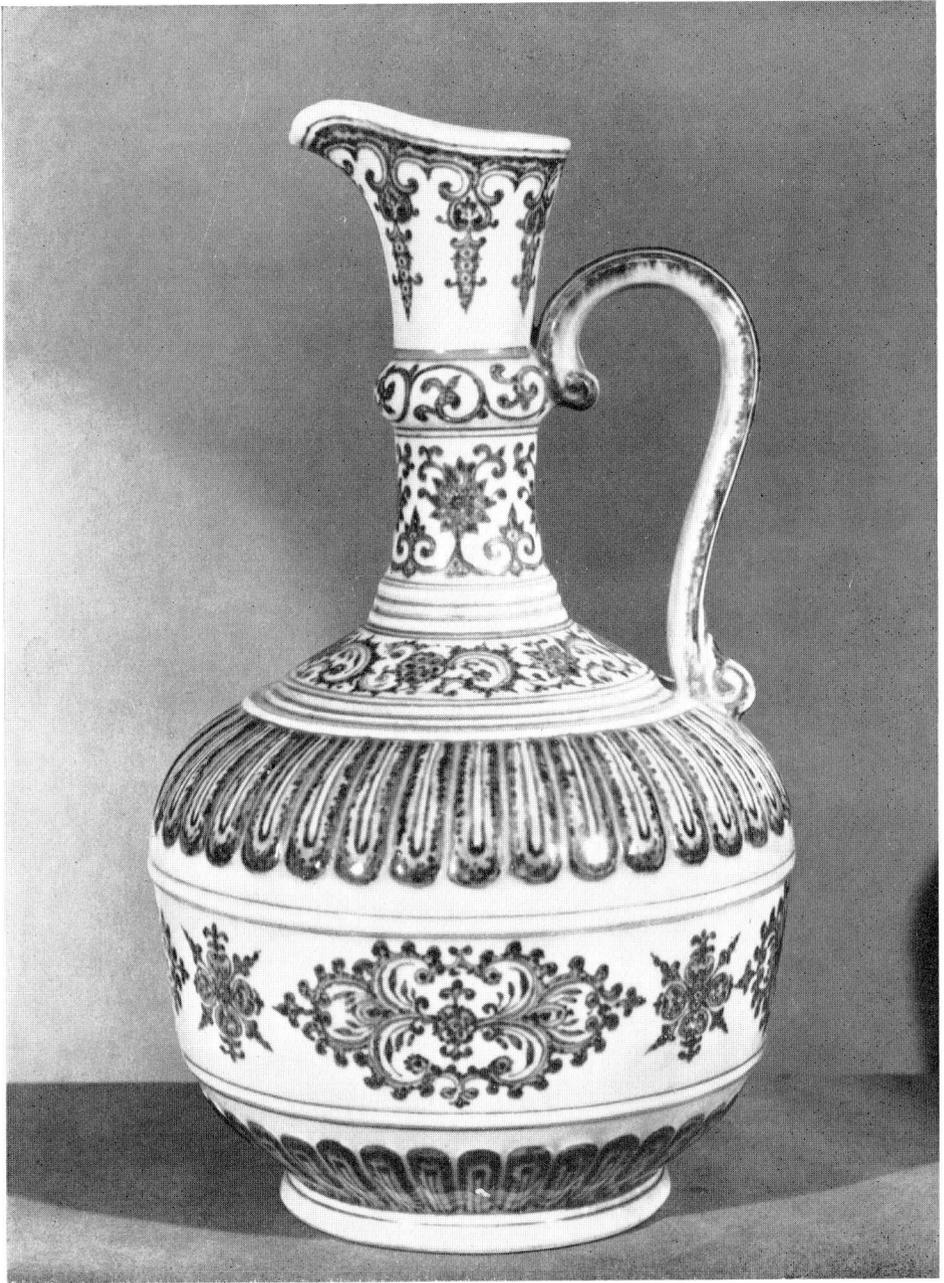

Ewer, decorated in underglaze blue in the Hsüan Tê style. Mark and period of Yung Chêng. Ht. 12 in.
Chinese National Collection. See page 37

PLATE LXIII

1. *Vase, imitating the glaze of Ko or Kuan ware of the Sung period. Mark and period of Yung Chêng. Ht. 9·9 in. British Museum. See page 49*

2. *Vase, imitating the glaze of Ko or Kuan ware of the Sung period. Black body. Mark and period of Ch'ien Lung. Ht. 9·6 in. See page 49 British Museum (Garner Gift)*

PLATE LXIV

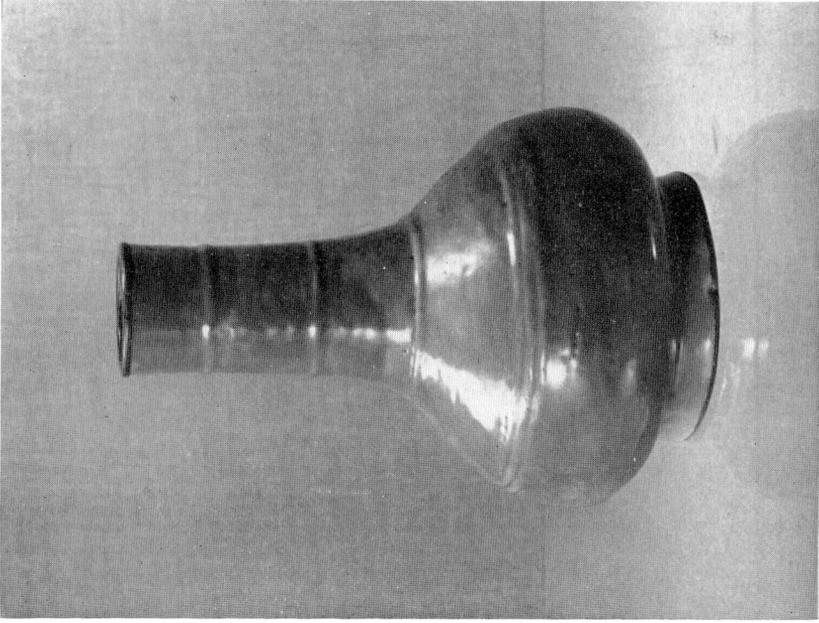

1. Vase, imitating the glaze of Chün ware of the Sung dynasty. No mark. 18th century. Ht. 8·4 in. See page 57
British Museum

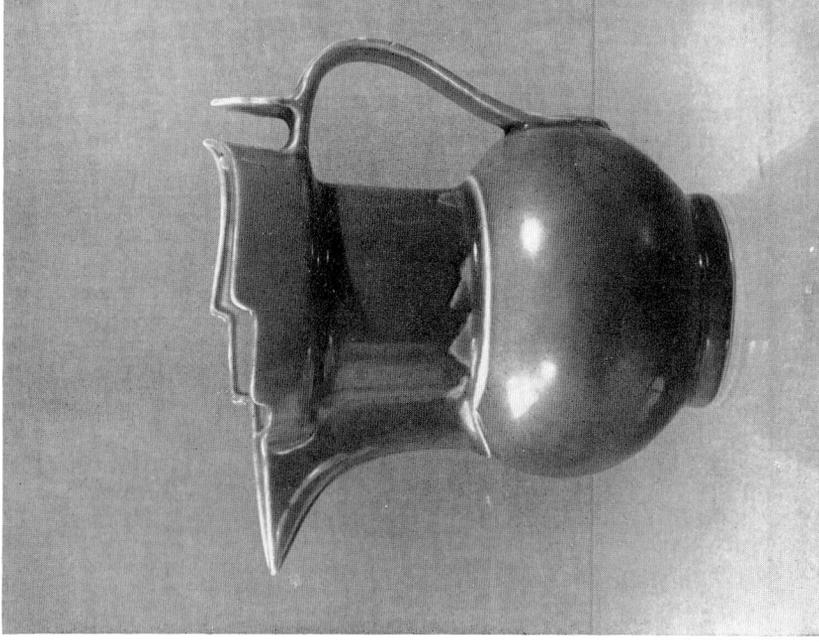

2. Monk's Cap jug, imitating the 'Sacrificial red' glaze of the Ming dynasty. Mark of Hsüan Tê. 18th century. Ht. 8·1 in. See page 55
British Museum

PLATE LXV

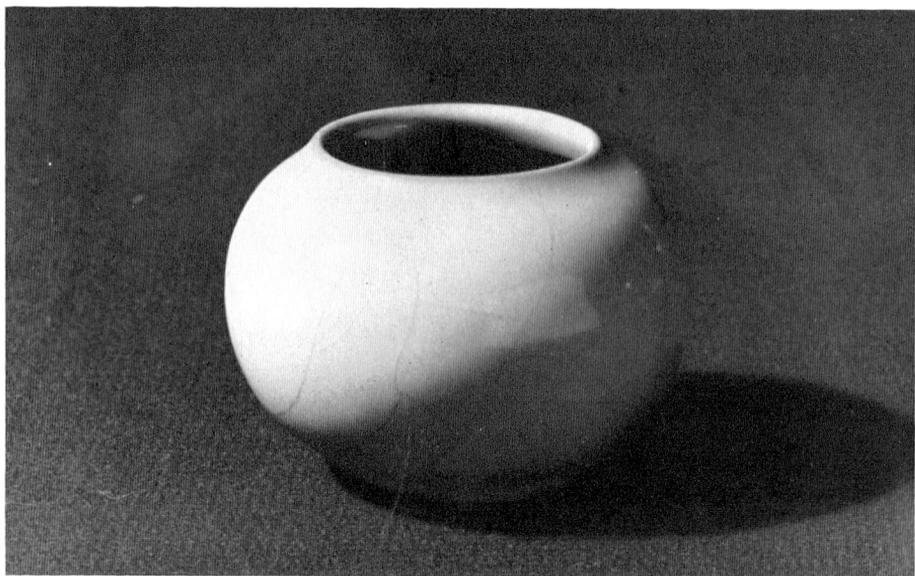

1. *Bowl, imitating the Kuan glaze of the Sung period. No mark. 18th century. Diam. (at middle) 3·5 in. See page 49*
British Museum (Oppenheim Bequest)

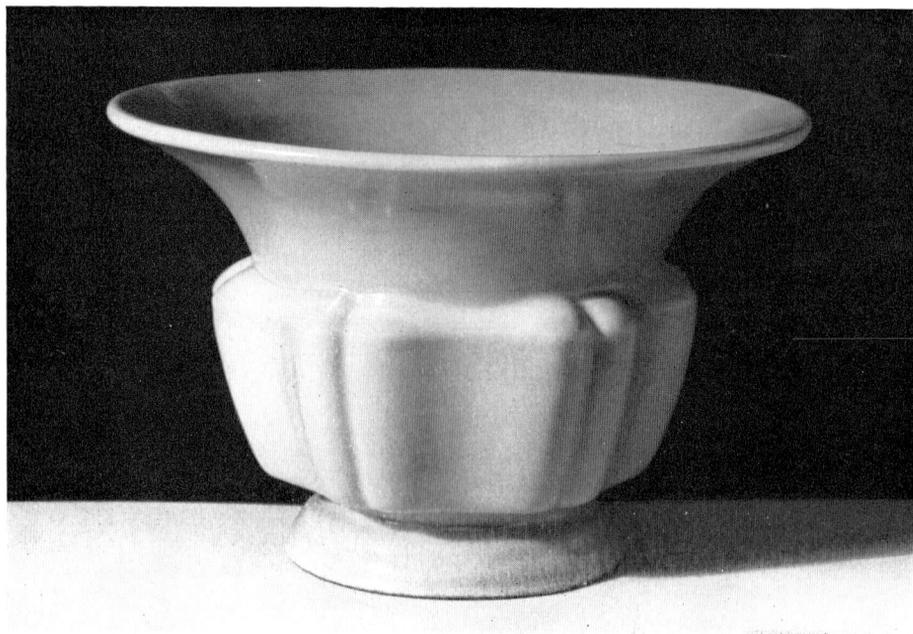

2. *Vase, imitating the Kuan glaze of the Sung period. Diam. 8·5 in. Mark and period of Yung Chêng. See page 49*
Ashmolean Museum (Ingram Gift)

PLATE LXVI

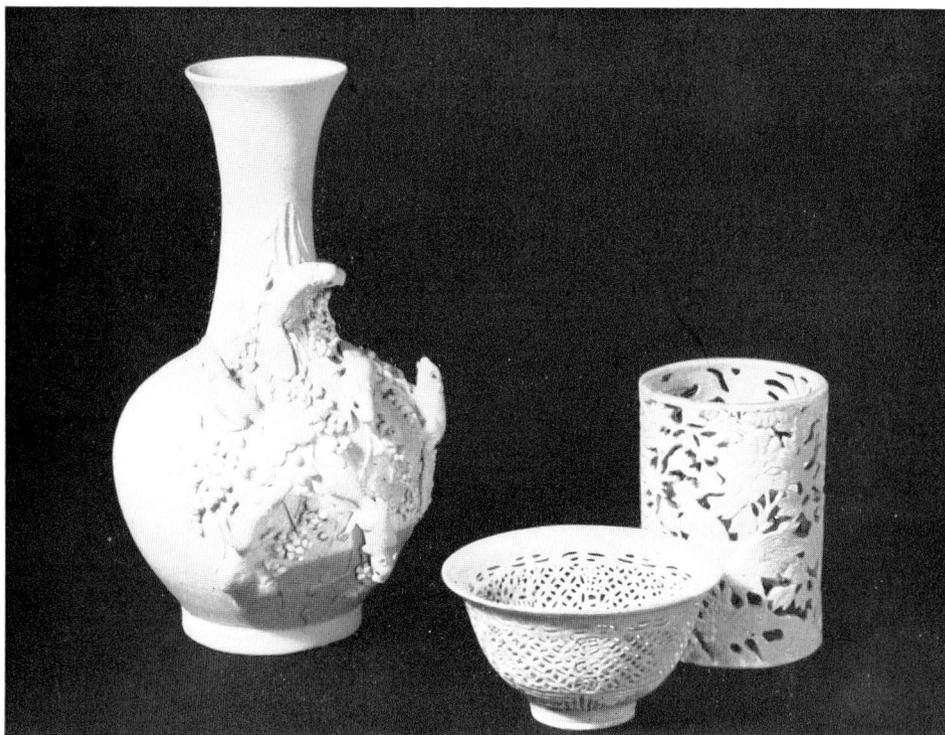

1A. *Vase, underglazed biscuit with decoration moulded in relief. Leaf mark. 18th century. Ht. 8·1 in. See page 31*
British Museum

1B. *Perforated cup, with white glaze. No mark. Transitional or slightly earlier. Diam. 3·7 in. See page 31*
British Museum

1C. *Perforated brush pot with white glaze. No mark. Early 18th century. Ht. 3·7 in. See page 31*
British Museum

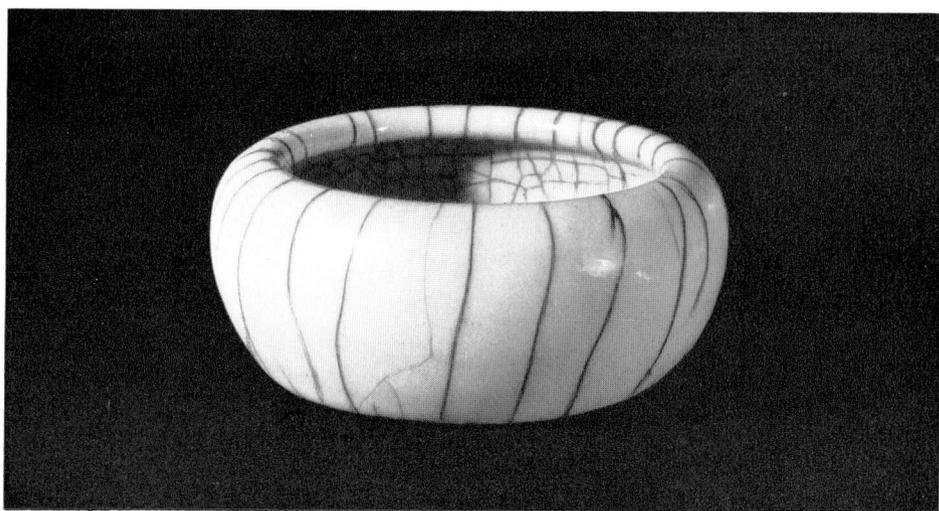

2. *Brushwasher, crackled white glaze. Ch'êng Hua mark; about 1800. Diam. 4·1 in. See page 74*
British Museum

PLATE LXVII

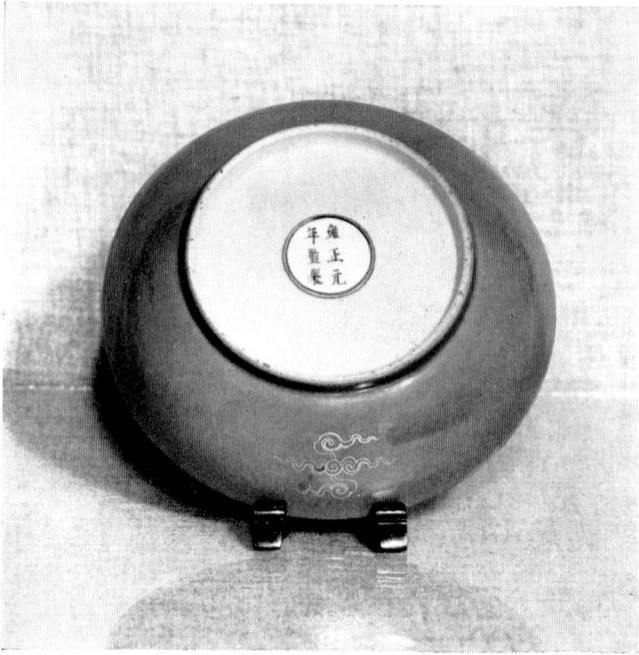

1. *Back of saucer dish, covered with a coral red glaze pencilled in gold; on reverse, with dragon amid clouds. Inscribed 'supervised by Chien in the 1st year of the reign of Yung Chêng' (1723). Diam. 8 in. R. H. R. Palmer. See page 57*

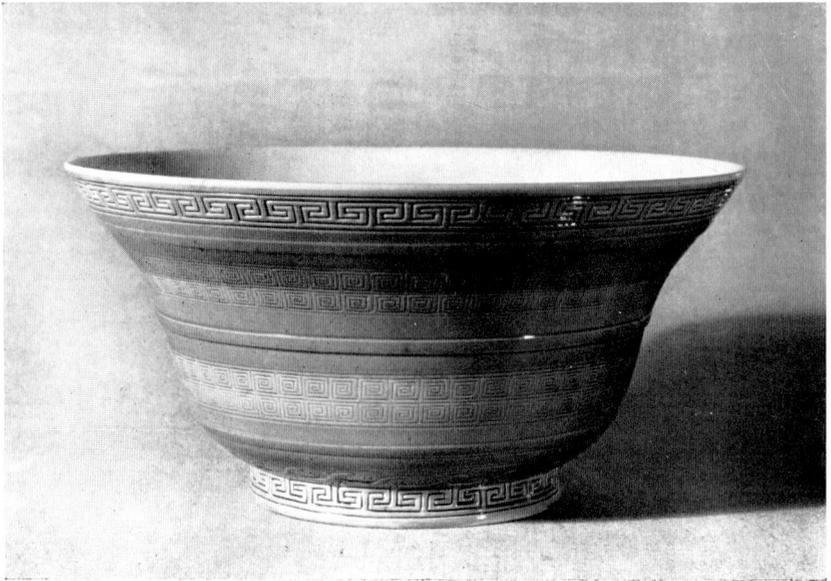

2. *Bowl, covered with apple green glaze. Mark and period of Yung Chêng. Diam. 10·3 in. See page 46*
British Museum

PLATE LXVIII

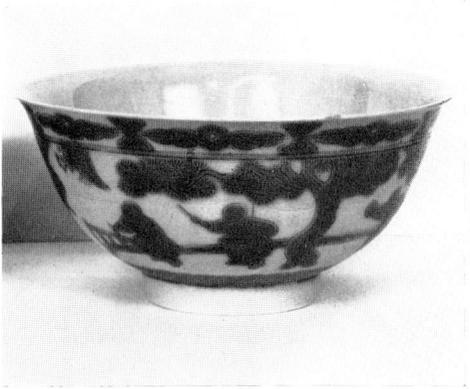

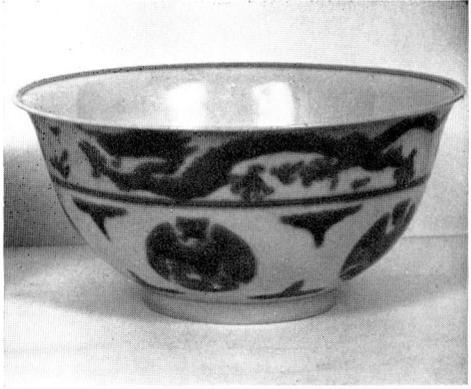

1. Rice bowl, decorated in green glaze on a yellow ground. Mark and
period of Yung Chêng. Diam. 5·8 in.
2. Rice bowl, decorated in green glaze on a yellow ground. Mark and
period of K'ang Hsi. Diam. 5·8 in.

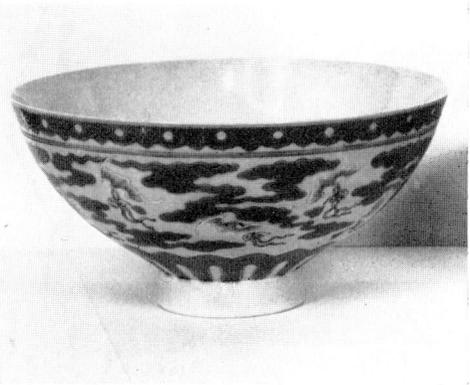

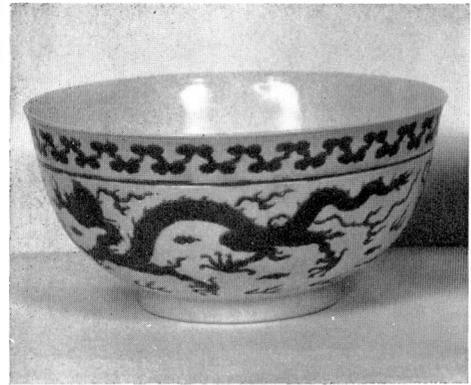

3. Rice bowl, enamelled with red bats in flight, supporting double
gourds amid green glazed clouds; yellow interior. Yung Chêng mark.
Diam. 5·8 in.
4. Rice bowl, engraved and painted in a green glaze, with dragons
disputing pearls on a yellow ground. Yung Chêng mark and period.
Diam. 5·5 in.
All ex Constantinidi Collection. See page 55

PLATE LXIX

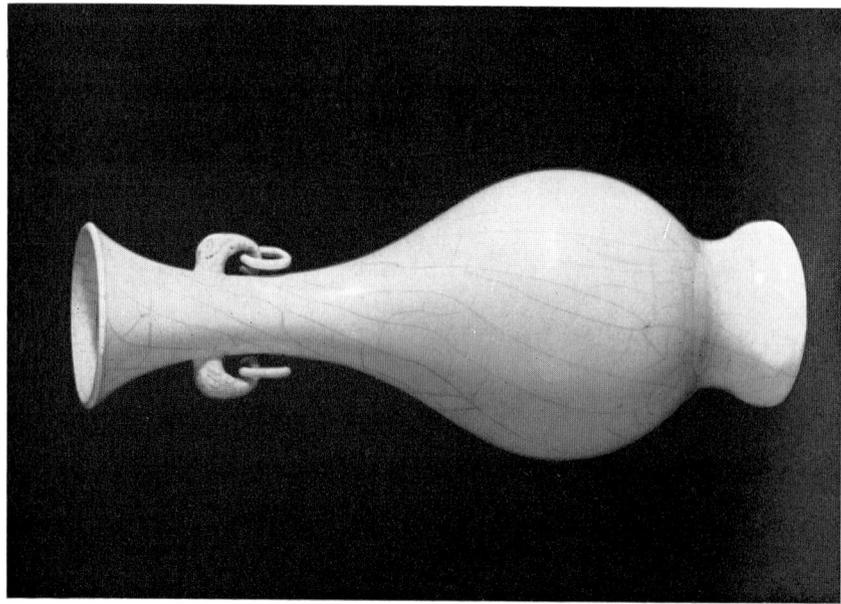

1. *Vase, steatitic with crackled white glaze. Yung Chêng period. Ht. 7·7 in. British Museum. See page 51*

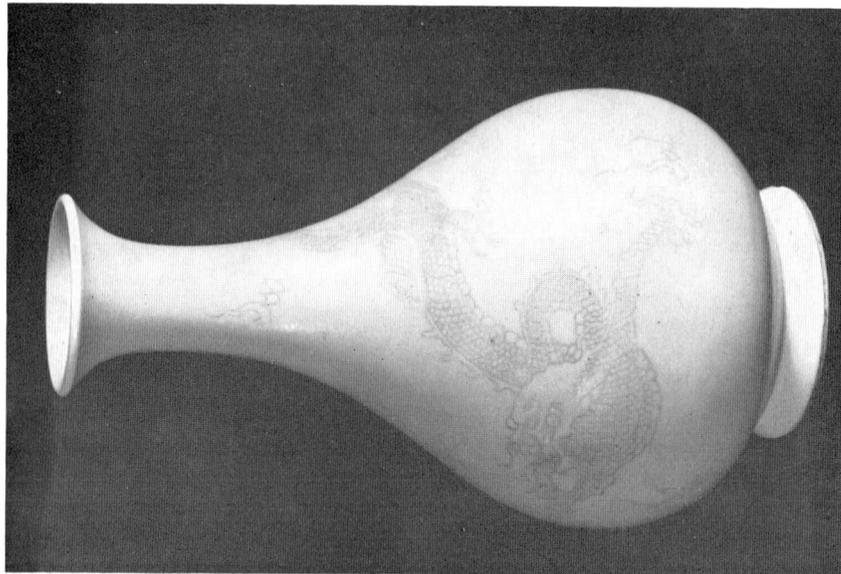

2. *Vase, decorated with incised design picked out in light underglaze blue. Ch'êng Hua mark, K'ang Hsi period. Ht. 7·5 in. British Museum. See page 51*

PLATE LXX

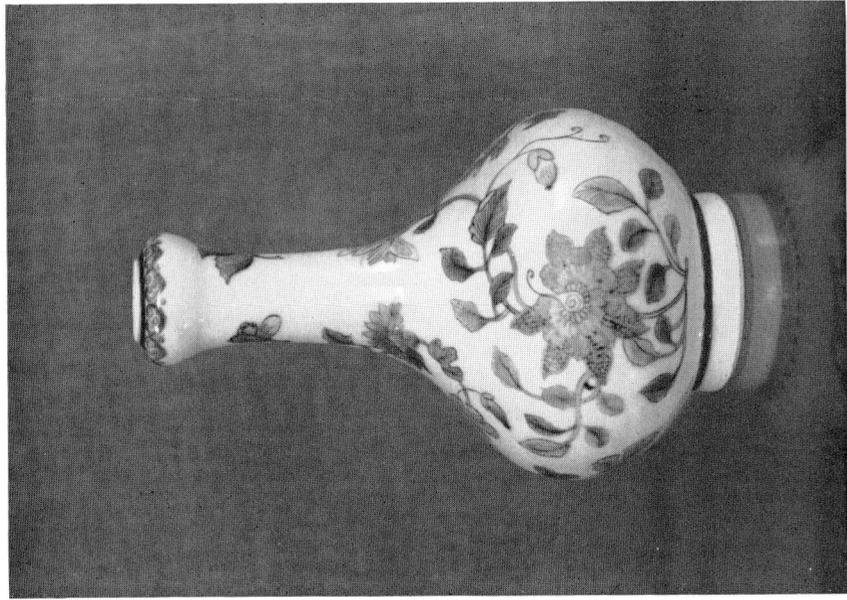

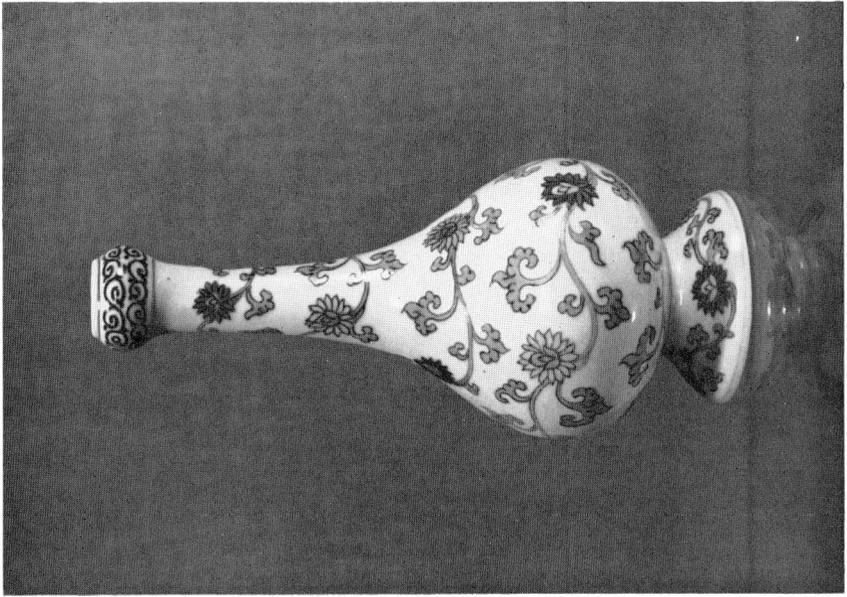

1. *Vase, decorated in 'tou ts'ai' enamels. No mark. Yung Chêng or later. Ht. 7·1 in. British Museum. See page 56*

2. *Vase, decorated in 'tou ts'ai' enamels. Mark of Chia Ching. 17/18th century? Ht. 7·8 in. British Museum (Oppenheim Bequest) See pages 58, 56*

PLATE LXXI

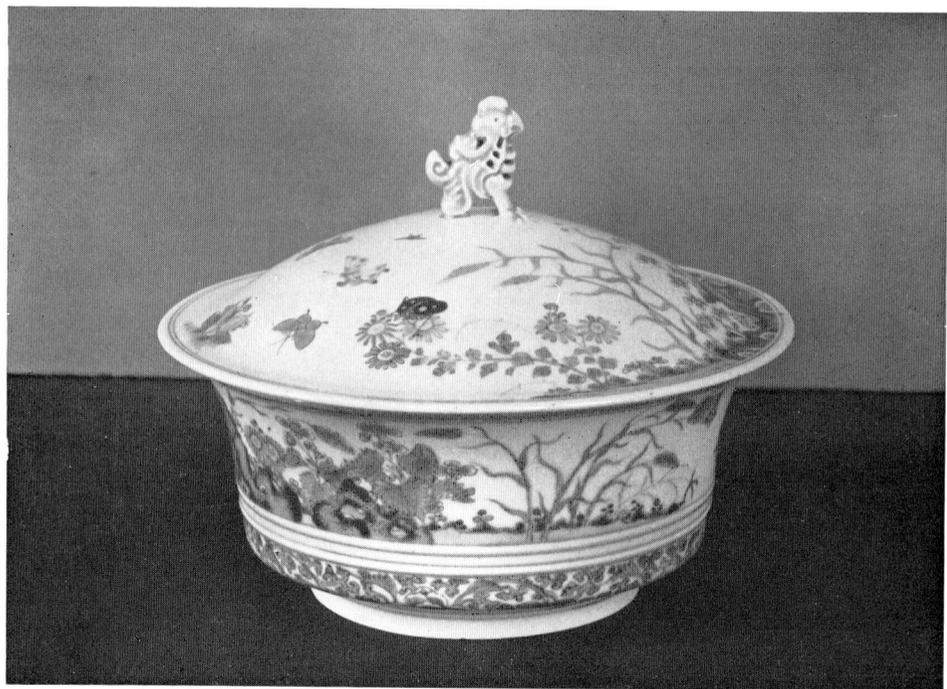

1. *Covered bowl, decorated in 'tou ts'ai' enamels. Mark and period of Yung Chêng. Ht. 6 in. with lid.*
Victoria and Albert Museum. See pages 38, 56

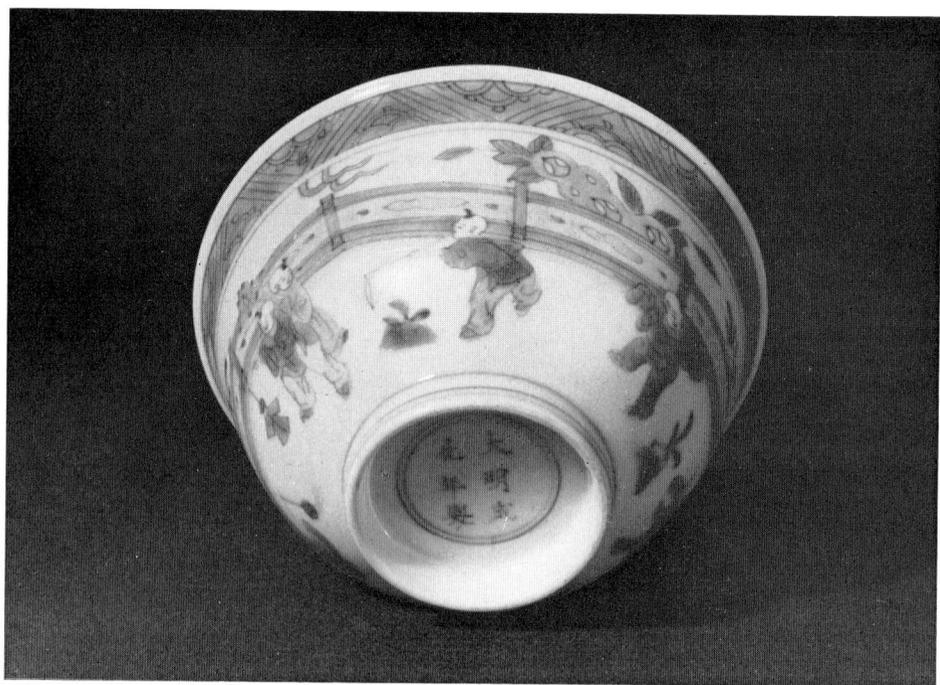

2. *Bowl, decorated in pale underglaze blue, possibly intended for 'tou ts'ai' enamels. Mark of Ch'êng Hua. K'ang Hsi/Yung Chêng transition.*
Diam. 3·8 in. See page 56
S. C. Coles

PLATE LXXII

1. *Covered tea cup, decorated in red and green enamels on a white graviata ground. Mark, Hsieh Chu Chu Jên Tsao (made for the Lord of the Hsieh Bamboos). Early 19th century. Diam. 4·5 in. British Museum. See page 75*

2. *Tea-pot, decorated in 'famille rose' enamels. Mark on the base in blue enamel, 'Pao ho luh ho' (guaranteed to be in sympathy with the 'Six Harmonies'). Ch'ien Lung period. Ht. 5·9 in. Bristol City Art Gallery (Schiller Bequest). See page 58*

PLATE LXXIII

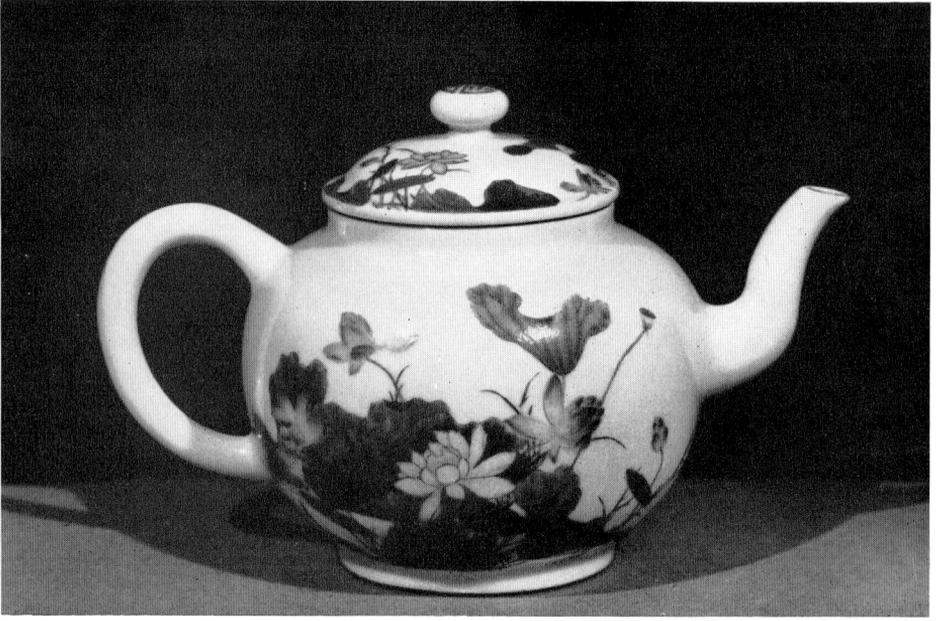

1. *Teapot, decorated in 'famille rose' enamels. Blue enamel mark and
period of Yung Chêng. Ht. 4·5 in.
David Foundation. See page* 58

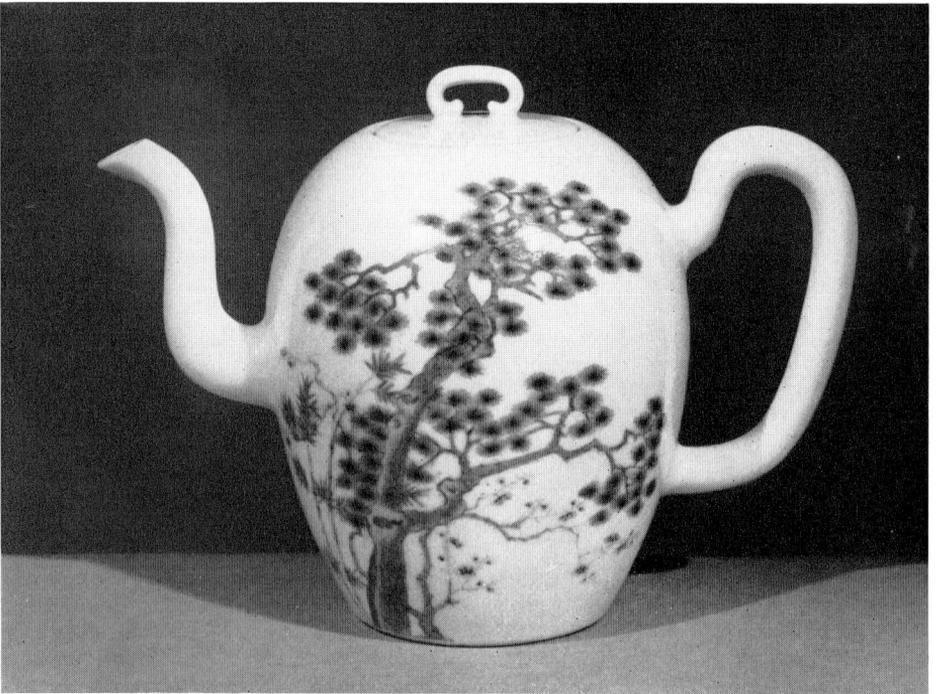

2. *Teapot, decorated in underglaze blue and enamels. Mark and
period of Yung Chêng. Ht. 5·1 in.
David Foundation. See page* 58

PLATE LXXIV

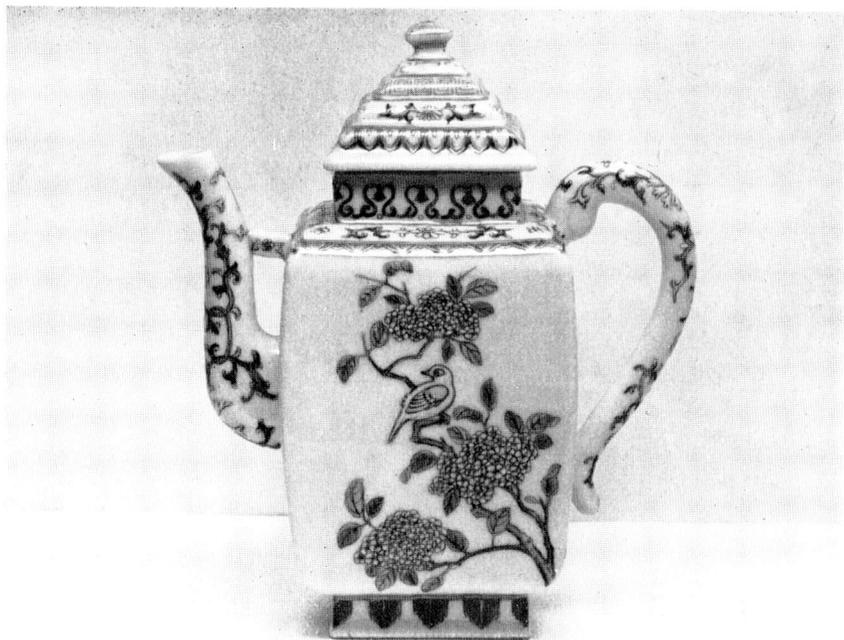

1. *Wine ewer painted in 'famille rose' enamels; reverse, flower, bamboo and butterflies. Raised rectangular mark of Yung Chêng in blue enamel. Ht. 5·5 in.*
Ex Russell Collection. See page 58

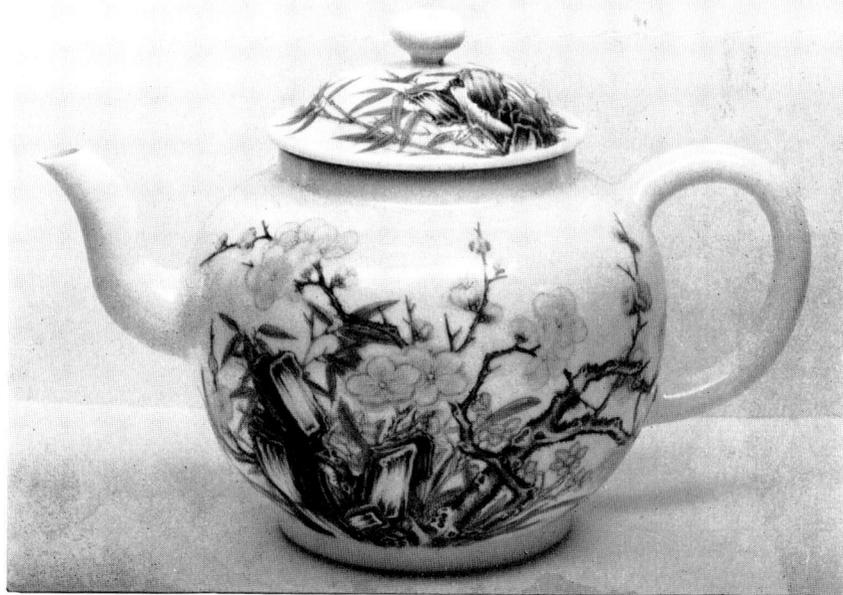

2. *Tea-pot decorated in enamels in Ku Yüeh style; the reverse with a poem and three studio seals. Rectangular mark of Ch'ien Lung in blue enamel. Ht. 4·5 in.*
David Foundation. See page 58

PLATE LXXV

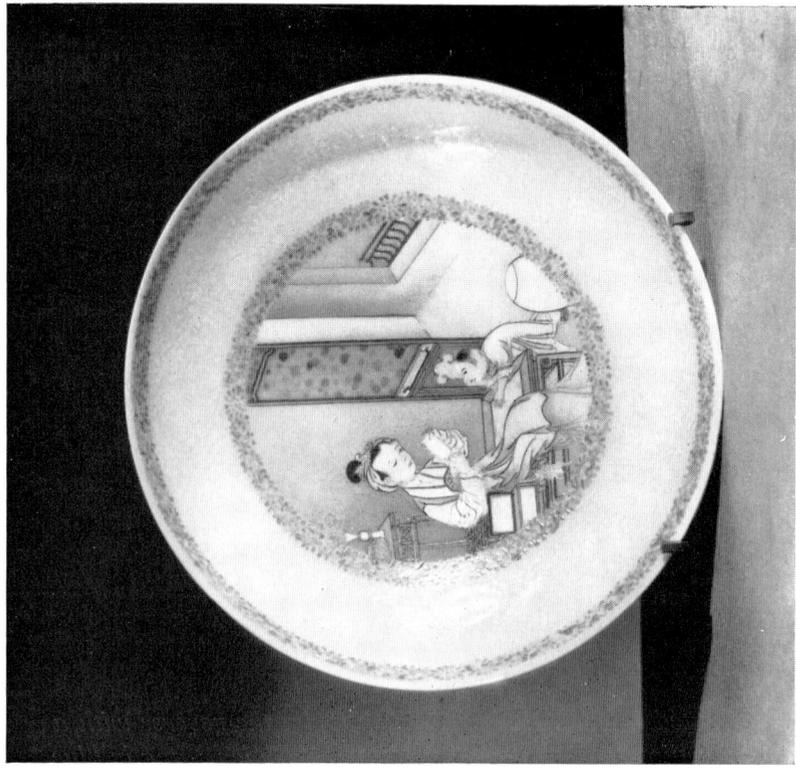

1. One of a pair of dishes, decorated in coloured enamels.
Blue enamel mark and period of Ch'ien Lung.
Diam. 5·2 in. See page 58
The Chinese National Collection

2. Dish, decorated with 'famille rose' enamels and ruby
back. Mark and period of Yung Chêng. Diam. 6 in.
B. Currie. See page 58

PLATE LXXVI

1. Dish, decorated in sepia. Mark and period of Yung Chêng. Diam. 21 in. See page 45
J. G. Verstergh

2. Dish, decorated in coloured enamels and with ruby back. Ku Yüeh Hsüan style. Blue enamel mark and period of Ch'ien Lung. Diam. 6·8 in.
Chinese National Collection. See page 88

PLATE LXXVII

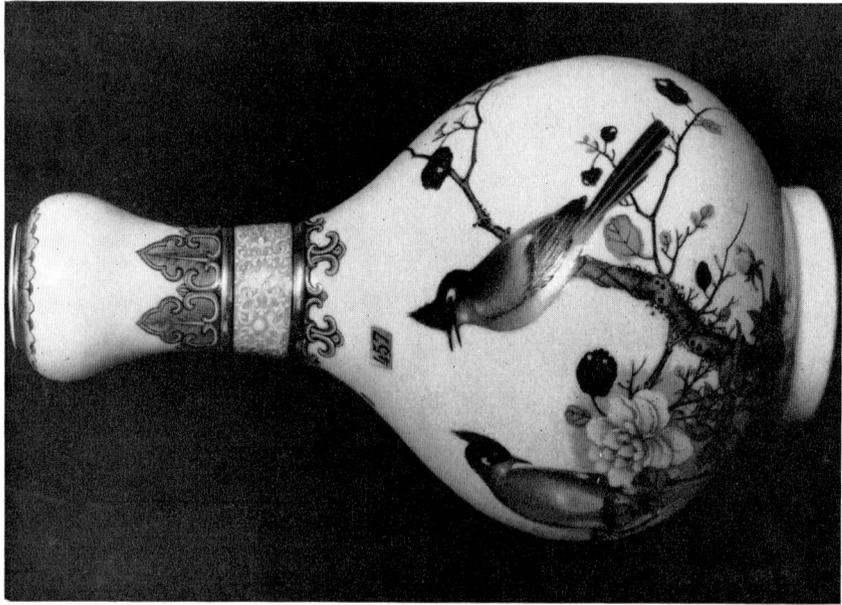

1. *Ku Yüeh Hsüan vase, with poem signed Chang Chun (Enduring Spring)*

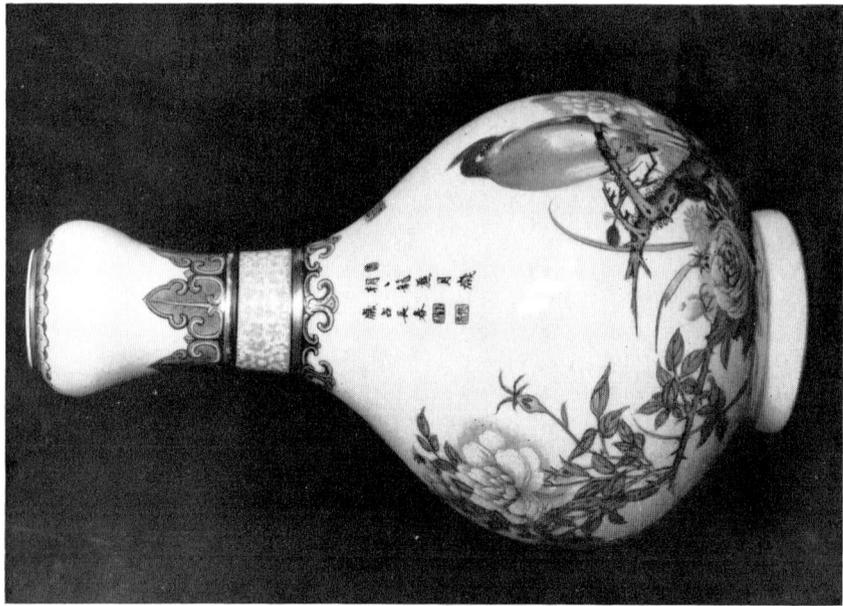

2. *Reverse side. Mark and period of Ch'ien Lung. Ht. 7 in. See page 88 Musée Guimet*

PLATE LXXVIII

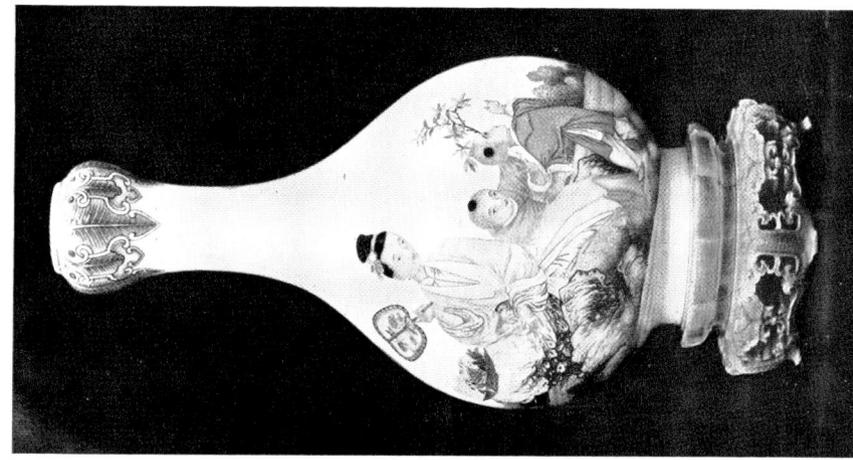

2. *Ku Yüeh Hsüan vase. Poem on side not illustrated. Mark and period of Ch'ien Lung. Ht. 7 in. See pages 88, 95. Freer Gallery Washington D.C.*

1. *Base of vase illustrated Plate Lxxviii. Showing raised enamel mark*

PLATE LXXIX

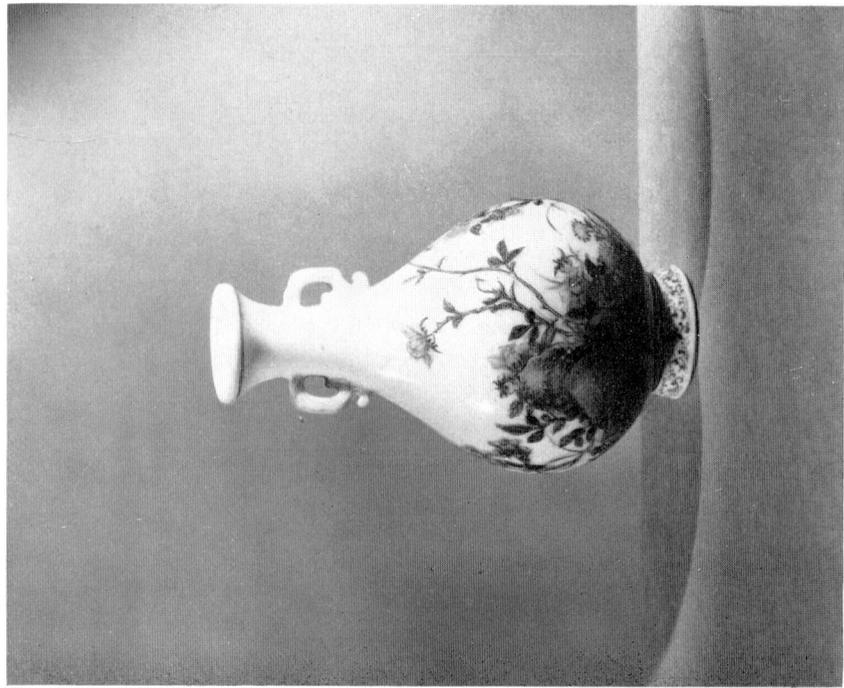

1. Miniature bottle, decorated in 'famille rose' enamels. Ku Yüeh Hsüan style. Blue enamel mark and period of Ch'ien Lung. Ht. 3·7 in. See page 88
David Foundation

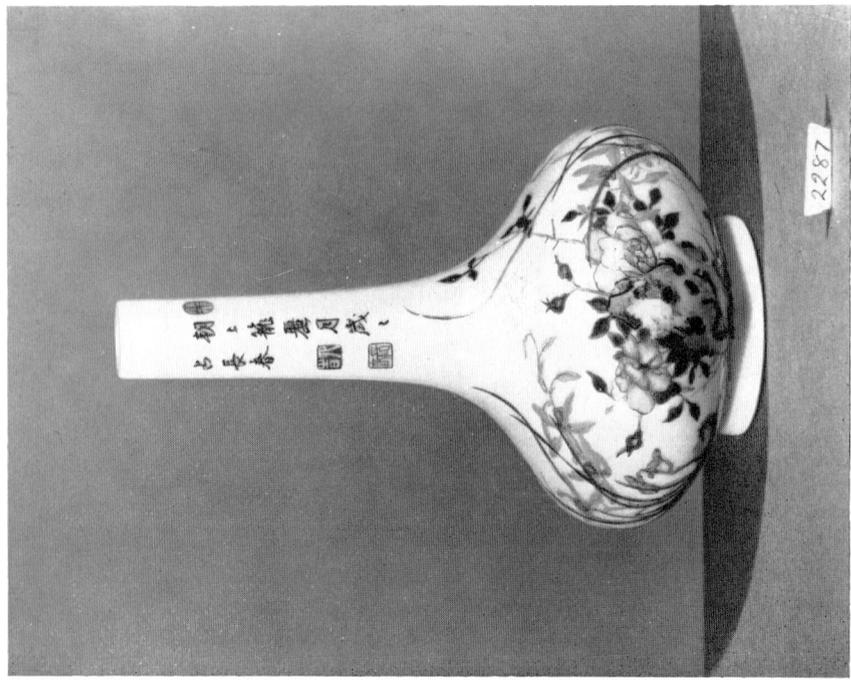

2. Bottle, decorated in 'famille rose' enamels, Ku Yüeh Hsüan style. Blue enamel mark and period of Ch'ien Lung. Ht. 5·5 in. See page 88
David Foundation

PLATE LXXX

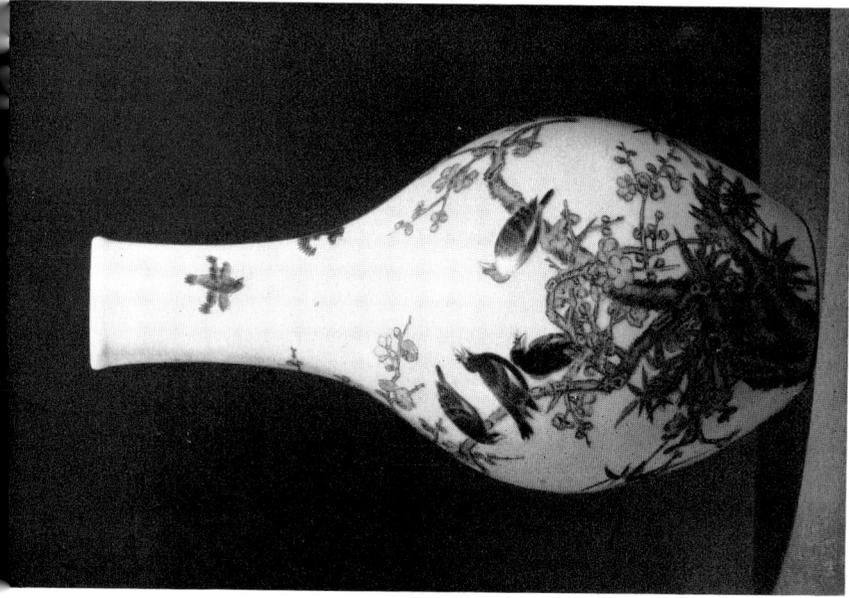

1. Bottle, decorated in coloured enamels, blue enamel mark and period of Ch'ien Lung.
Ht. 8 in. See page 64
Chinese National Collection

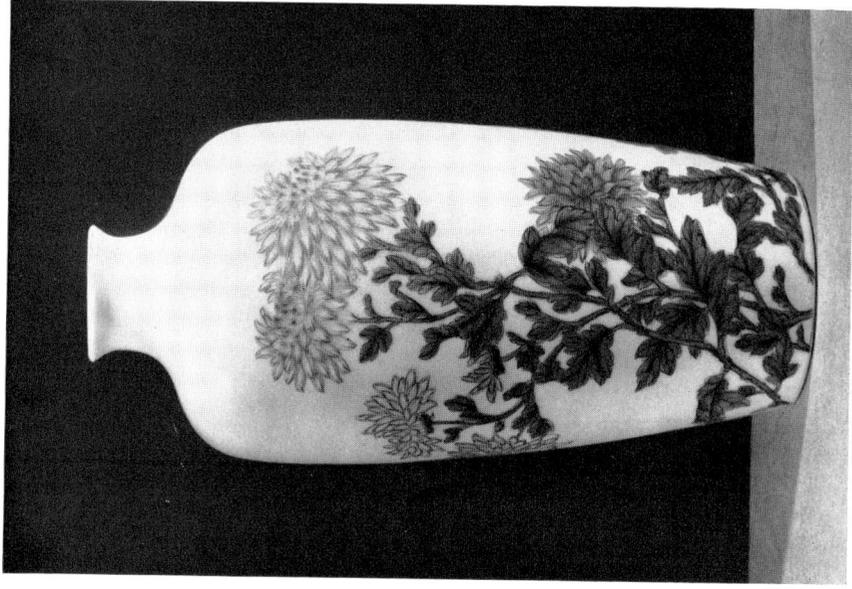

2. Vase, decorated in coloured enamels and with an inscription made by Imperial order'.
Seal mark and period of Ch'ien Lung.
Ht. 8.5 in. See page 64
Chinese National Collection

PLATE LXXXI

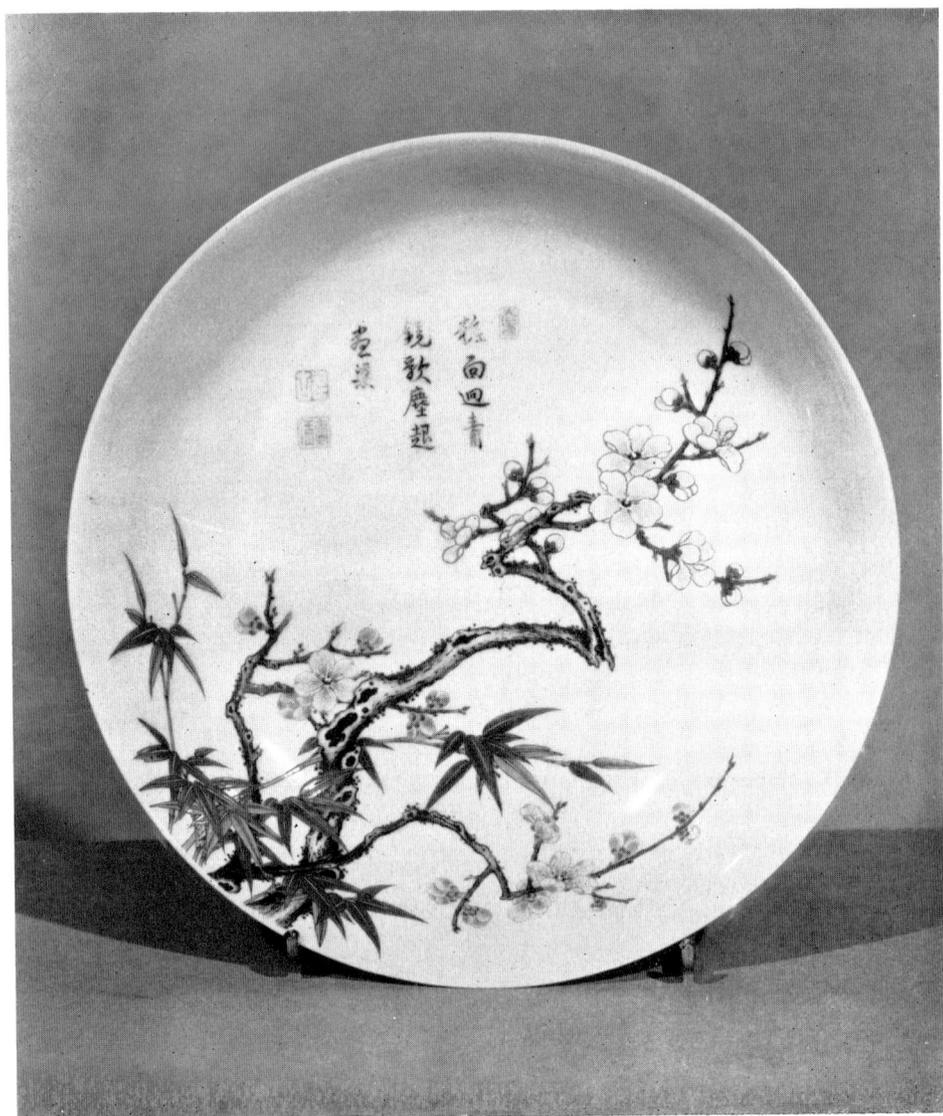

One of a pair of plates, decorated in enamel colours, Ku Yüeh Hsüan
style. Lemon yellow enamel back. Mark and period of Yung Chêng.
Diam. 7 in. See page 88
Chinese National Collection

PLATE LXXXII

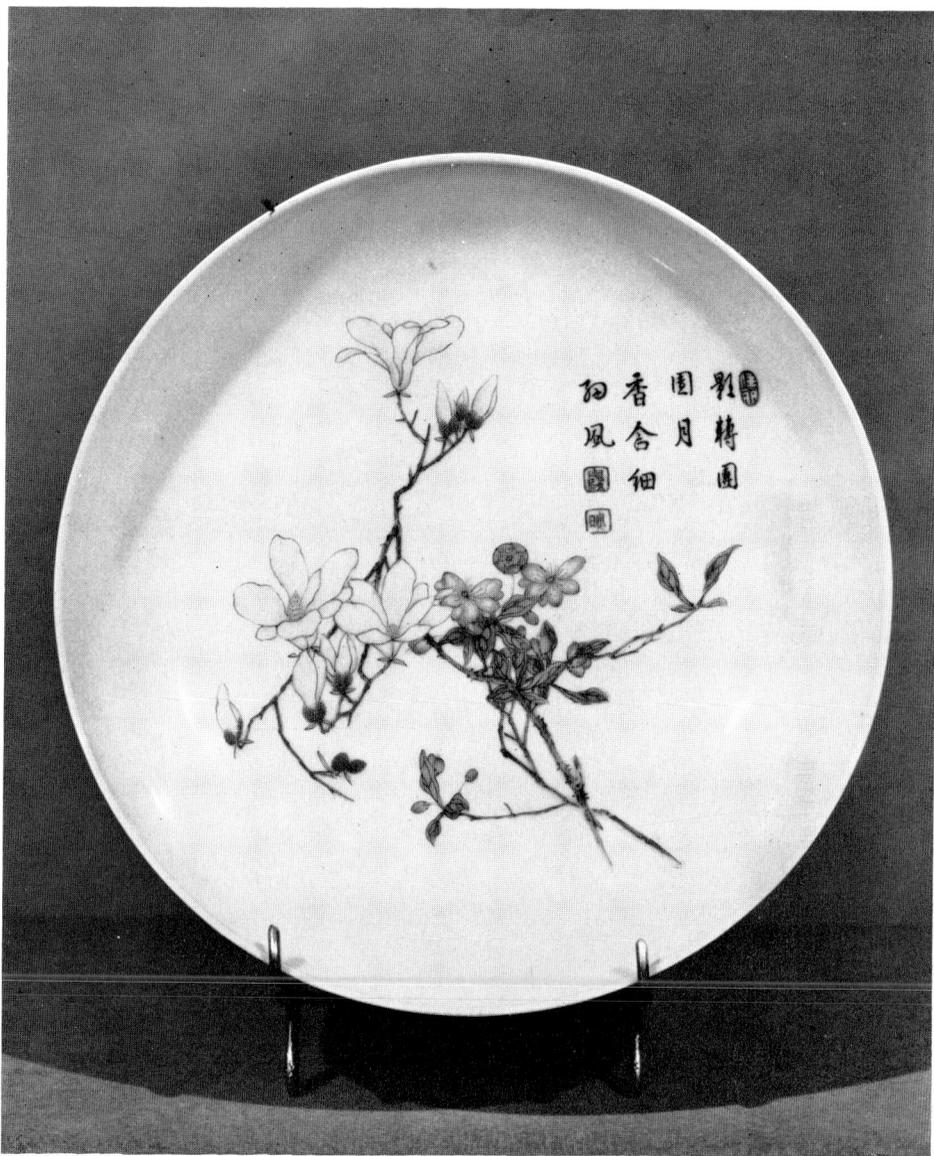

Dish, decorated in 'famille rose' enamels, Ku Yüeh Hsüan style. Green enamelled back. Blue enamel mark and period of Ch'ien Lung. Diam. 5·7 in. See page 88
David Foundation

PLATE LXXXIII

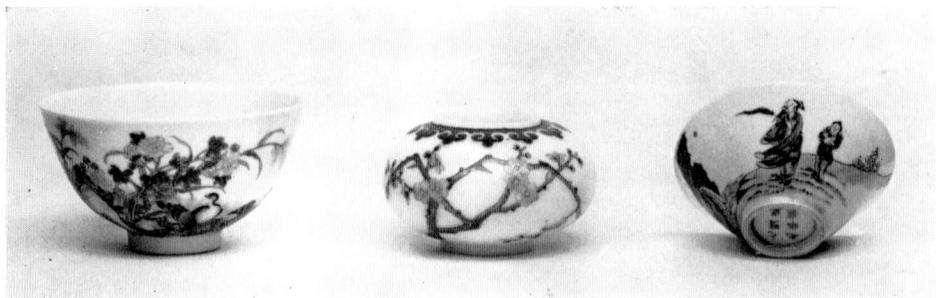

1A. *Eggshell bowl, decorated in 'famille rose' enamels; on reverse, with goose in flight; poem and three 'studio' seal marks. Ku Yüeh style. Rectangular mark and period of Yung Chêng in raised blue enamels. Diam. 3·3 in. Ex Russell Collection. See page 88*

1B. *Glass water pot, painted in brown and pink enamels; blue enamel lappets on shoulders. Mark of Ku Yüeh Hsüan. 18th century. Ht. 2·7 in. Ex Russell Collection. See page 87*

1C. *Wine cup, painted in 'famille verte' enamels with Li T'ai-po gazing at the Falls of Szechwan. Mark of Ch'êng Hua. 18th century. Diam. 2·7 in. David Foundation. See page 69*

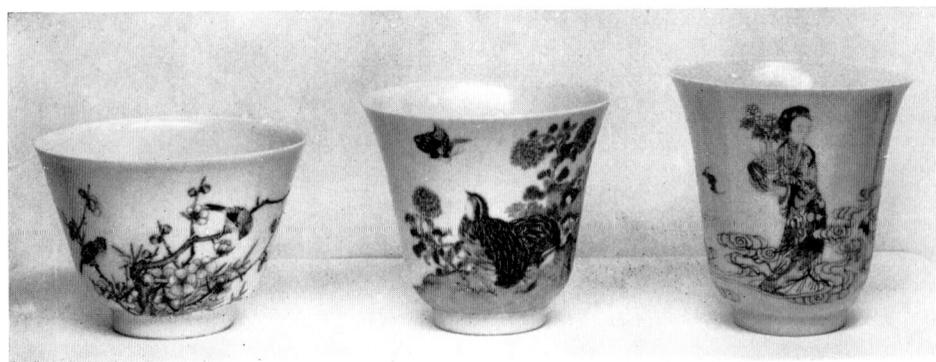

2A. *Eggshell bowl, painted in enamels in the Ku Yüeh style. Mark in seal characters in blue enamels 'mei hua Kuan chih' (made in the plum blossom house). Ch'ien Lung period. Ht. 2·4 in. See page 88. Ex Russell Collection.*

2B. *Semi-eggshell cup, painted in 'famille rose' enamels. Ch'ien Lung period. Ht. 2·7 in. David Foundation. See page 69*

2C. *Semi-eggshell cup, painted in coloured enamels, with the Immortal Lan Ts'ai-ho surrounded by bats. Seal mark of period of Ch'ien Lung. Ht. 3·3 in. Ex Russell Collection. See page 69*

PLATE LXXXIV

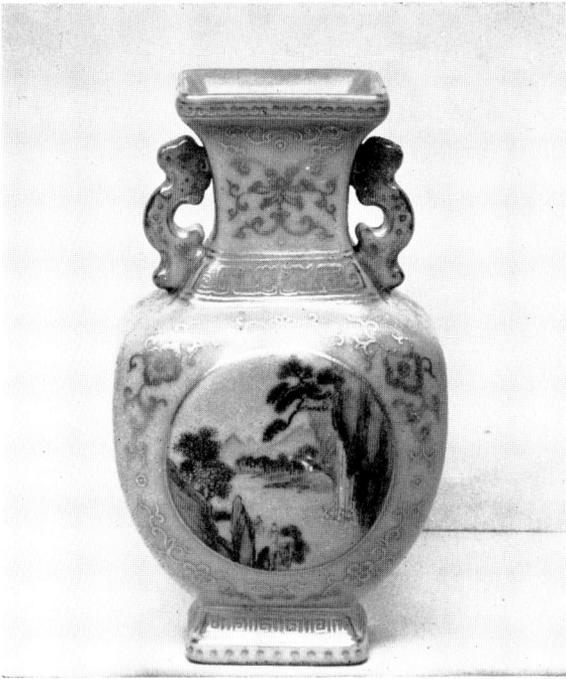

1. *Vase, decorated with foliate scrolls and key fret in gold on a celadon ground and two landscape medallions in coloured enamels. Interior of neck decorated in 'European green'. Seal mark and period of Ch'ien Lung. Ht. 4·6 in.*
Ex Russell Collection. See page 73

2. *Brush pot, painted in coloured enamels, with children playing in a garden. Interior and base decorated in 'European green'. Seal mark and period of Ch'ien Lung. Ht. 3·6 in.*
Ex Russell Collection. See page 67

PLATE LXXXV

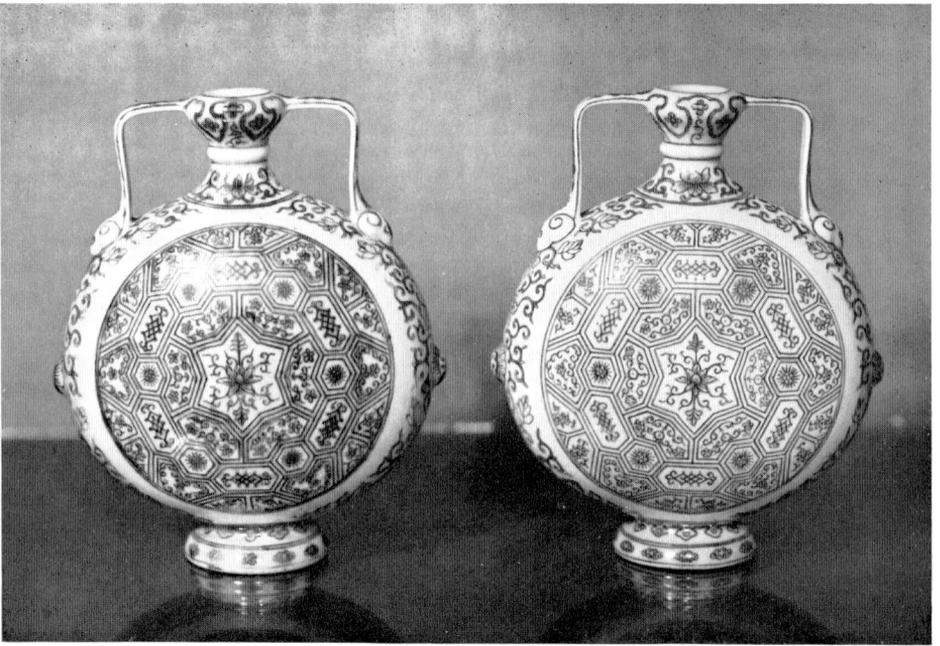

1. *Two bottles, (a) decorated in underglaze copper red, (b) decorated in overglaze gold red. Mark and period of Ch'ien Lung. Ht. 7 in. (a) Malcolm Macdonald (b) Sir H. Garner. See page 69*

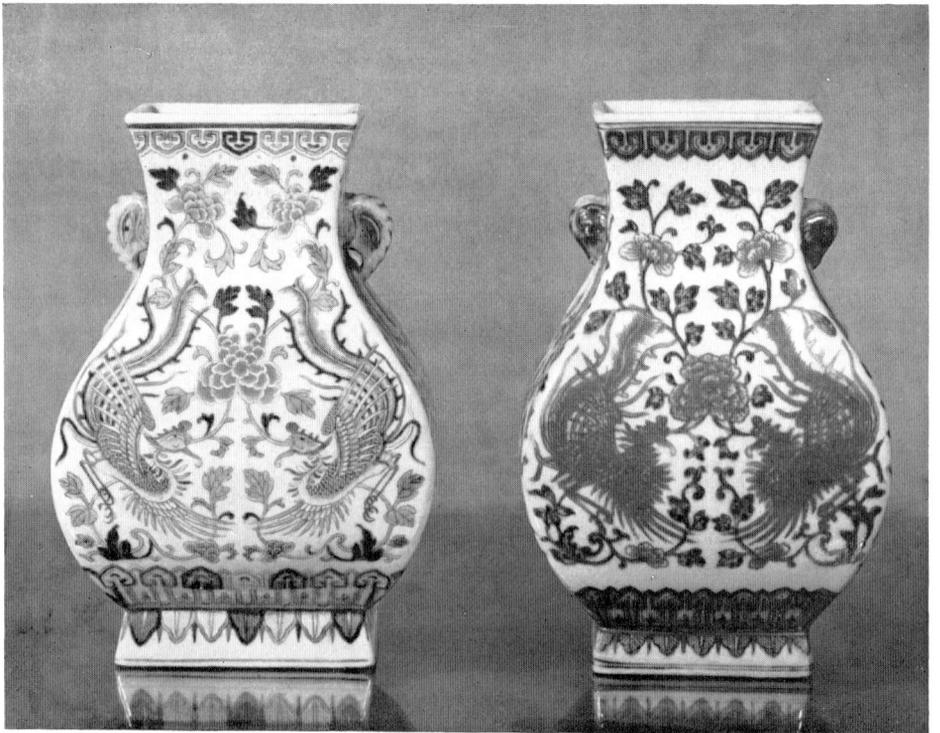

2. *Two vases, (a) decorated in coloured enamels and underglaze blue, (b) decorated in underglaze blue and copper red. Mark and period of Ch'ien Lung. Ht. 6 in. See page 68 (a) Bristol City Art Gallery. (b) Ex Evill Collection*

PLATE LXXXVI

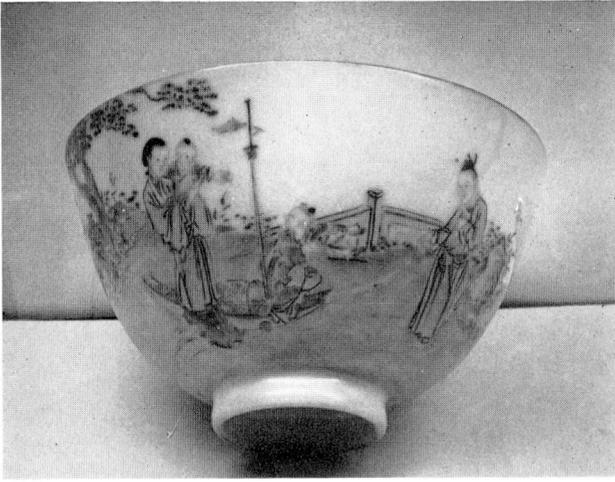

1. *Rice bowl, decorated in overglaze blue enamel with touches of gilding. Seal mark and period of Ch'ien Lung in underglaze blue. Diam. 4·4 in. See page 65*
Sir A. Simms

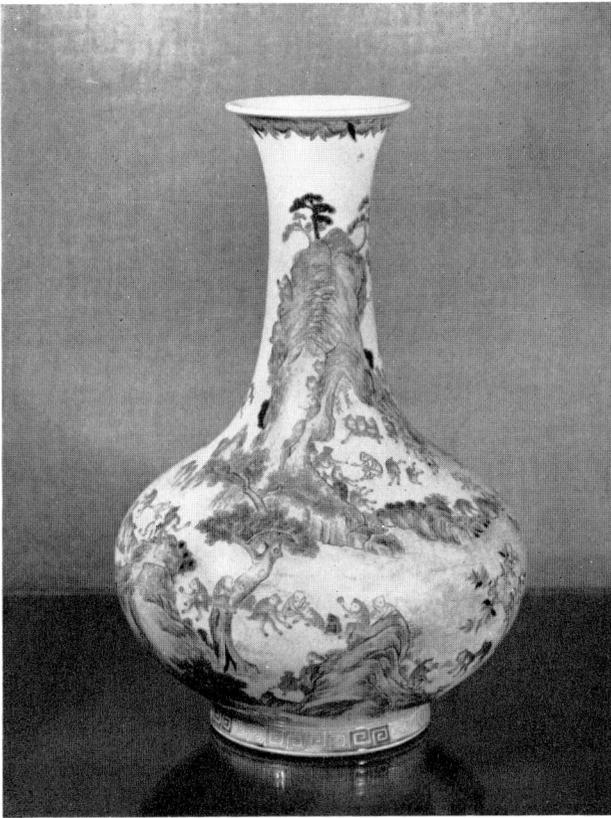

2. *Vase, decorated in coloured enamels. Mark and period of Ch'ien Lung. Ht. 10·6 in. See page 69*
Ex Bruce Collection

PLATE LXXXVII

Vase and cover, decorated in underglaze blue and enamel colours. No mark. Ch'ien Lung period. Ht. 28 in.
Sir John Buchanan Jardine, Bt. See page 68

PLATE LXXXVIII

Vase, painted in coloured enamels, on reverse sides with landscape and swallows. No mark. Ch'ien Lung period or later. Ht. 11·6 in.
Sir Alfred Beit, Bt. See page 74

PLATE LXXXIX

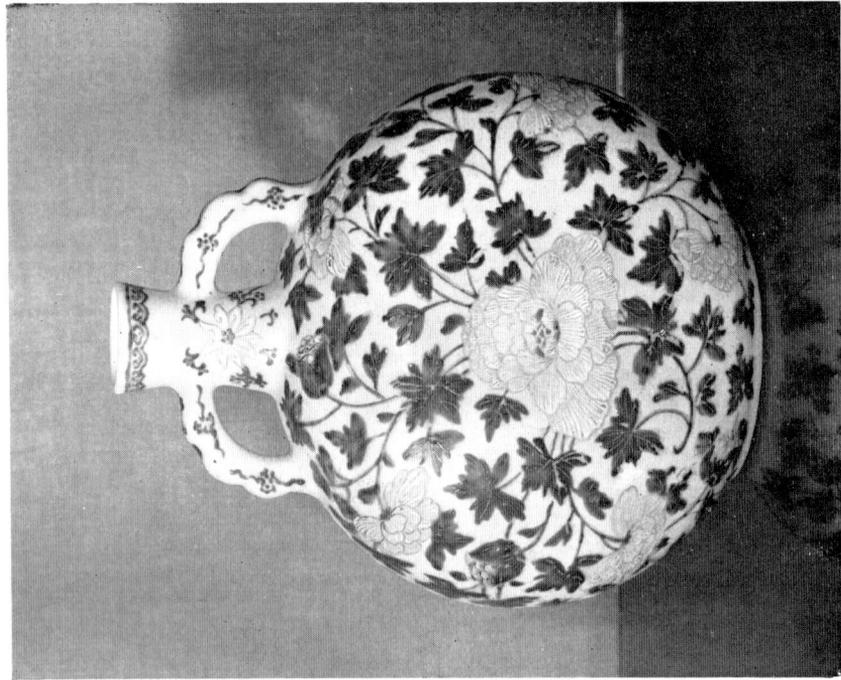

1. Pilgrim bottle, decorated in blue, pink and white enamel. No mark. Ch'ien Lung period. Ht. 12 in. Miss Honor Frost. See page 69

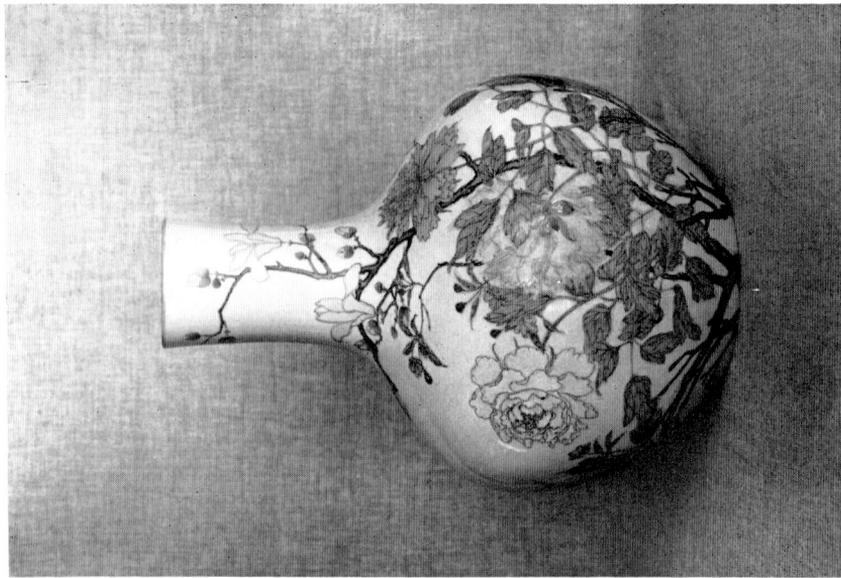

2. Bottle, enamelled in 'famille rose' enamels and iron red. Neck slightly cut down. Mark and period of Yung Chêng. Ht. 20·5 in. R. H. R. Palmer. See page 46

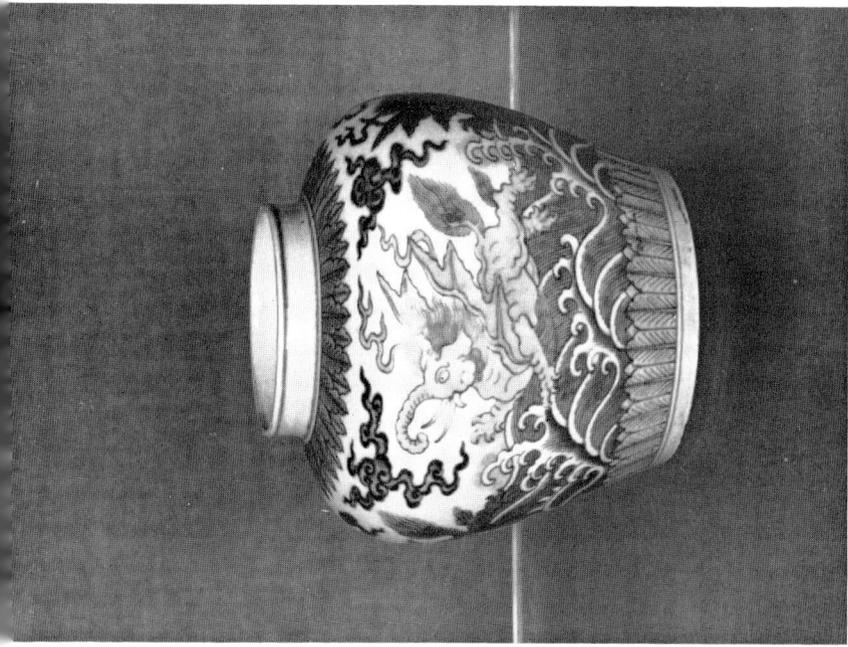

1. Jar, decorated in yellow and red enamels and underglaze blue. T'ien mark. Ch'ien Lung period. Ht. 4·7 in. See page 57
Mrs. Walter Sedgwick

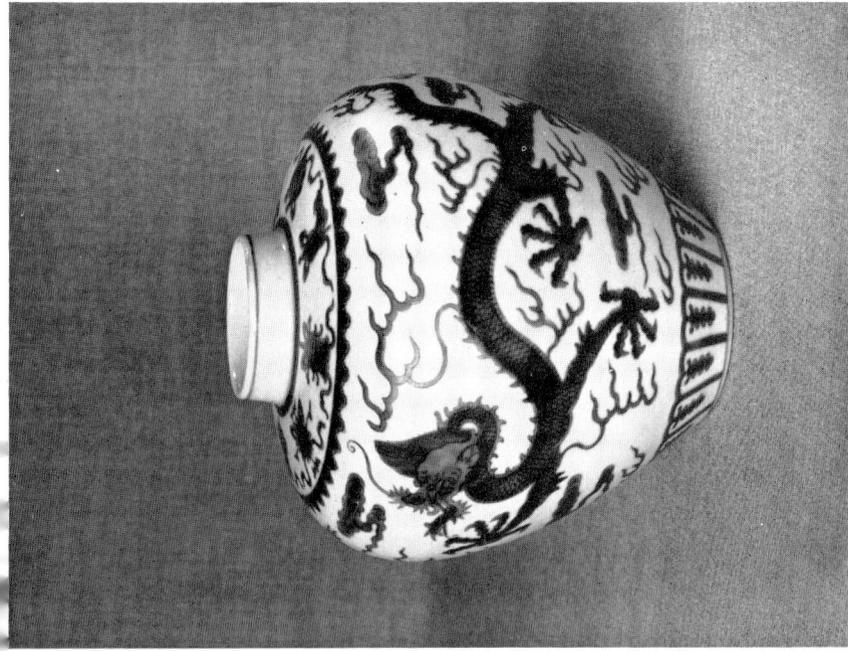

2. Jar, decorated in green enamel. Mark and period of Ch'ien Lung. Ht. 7·5 in. David Saunders. See page 68

PLATE XCI

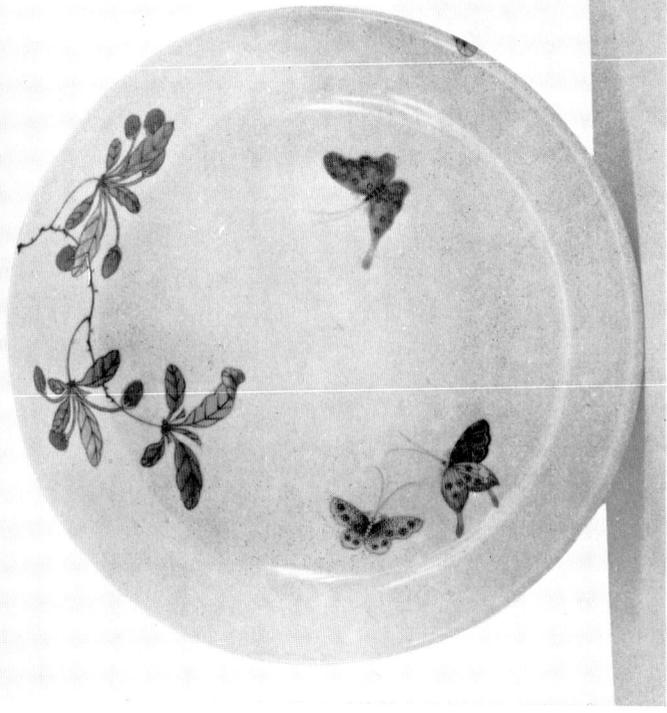

1. *Saucer dish, decorated in 'an hua' and coloured enamels. Mark of Ch'êng Hua. Early 18th century. Diam. 7·7 in. See page 58*

David Foundation

(*This piece should be compared with the Kitchener bowl.*)

2. *Semi-eggshell bowl, painted in soft green and pink enamels. Seal mark and period of Ch'ien Lung. Diam. 4·6 in. Ex Russell Collection. See page 64*

PLATE XCII

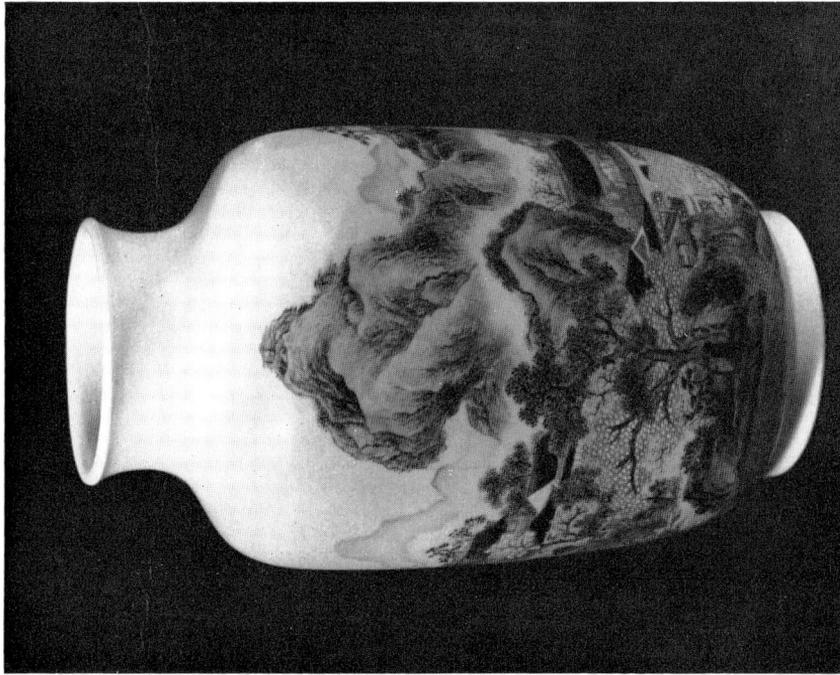

1. *Vase, decorated in coloured enamels. No mark.
Ch'ien Lung period. Ht. 9 in.
British Museum. See page 64*

2. *Saucer dish, with deep ridge at back; decorated
in coloured enamels. Ch'ien Lung mark but prob-
ably later. Diam. 18 in.
Ex Cunliffe Collection. See page 74*

PLATE XCIII

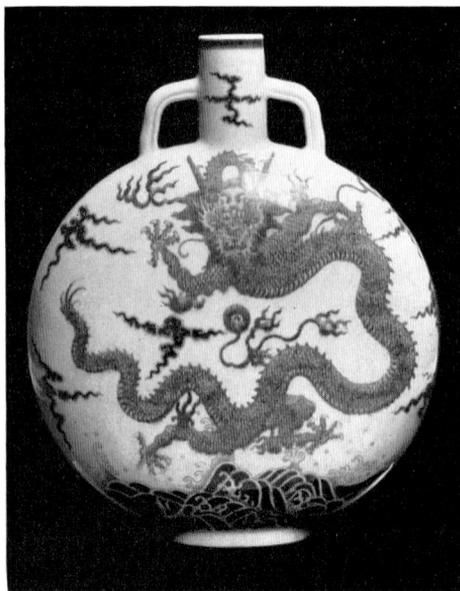

1. *Pilgrim bottle, decorated in underglaze blue and copper red. Mark and period of Ch'ien Lung. Ht. 13 in. See page 69*
Gerald Reitlinger
2. *Pricket candle-stick, decorated underglaze blue. Mark and period of Ch'ien Lung. Ht. 5¼ in. See page 74*
S. C. Coles

3. *Pair of covered cups, decorated in coloured enamels and underglaze blue. Yung Chêng period. Ht. 5·5 in. Diam. 8·5 in.*
Ex Messrs. Sparks. See page 68

PLATE XCIV

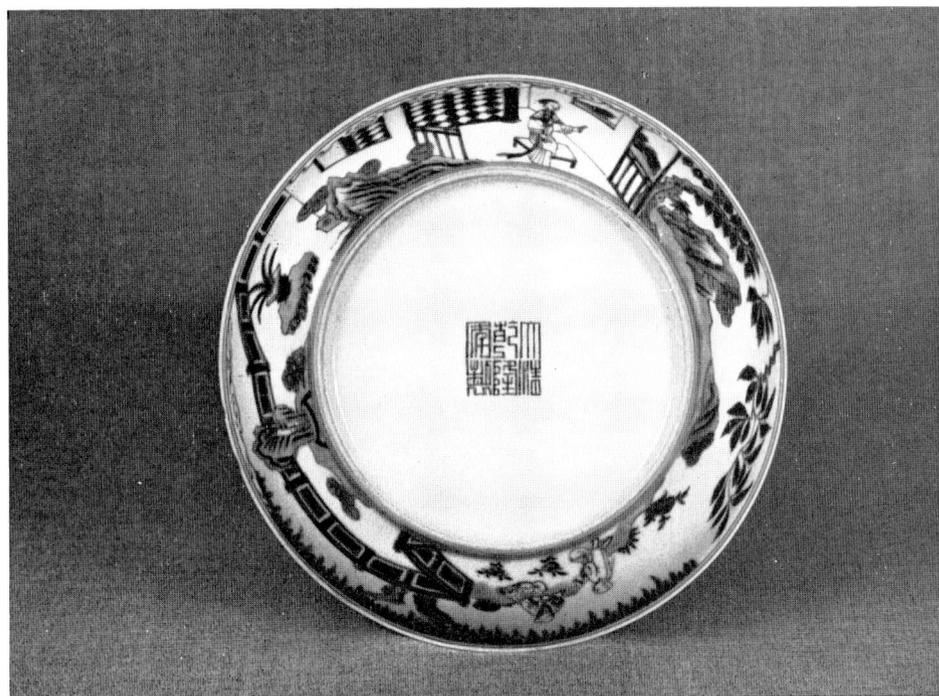

Dish, decorated in underglaze blue. Fig. 1 interior, with the 'three friends'. Fig. 2 reverse. Seal mark and period of Ch'ien Lung. Diam. 7 in. P. J. Donnelly. See page 74

PLATE XCV

(The lasting popularity of this palace service from Hsüan Tê to Kuang Hsu was evidenced at the OCS Blue and White Exhibition, 1953, see Cat. Nos. 67, 93, 305, 313, 318, 320.)

*Celadon vase mounted with ormolu handles in rococo style, flanked by
two smaller celadon vases mounted as ewers. The ewer mounts bear
a crowned 'C' (cuivre); a mark stamped on various metals in France
between the 5th March, 1745, and the 4th February, 1749, to indicate
they had paid tax. Chinese; early Ch'ien Lung. Ht. of vase, 21·5 in.
Ht. of ewers, 11·7 in.
Wallace Collection. See page 30*

PLATE XCVI

*One of a pair of porcelain bowls, decorated in 'famille rose' enamels,
mounted in France in ormolu in rococo style as potpourri vases. A
similar pair once belonged to the Mesdames de France, Louis XV's
sisters. Chinese; Ch'ien Lung period. Width 14·4 in. Wallace
Collection. See page 30*

PLATE XCVII

2. *Vase, with underglaze copper and celadon glazes on a powder blue ground. No mark. Yung Chêng/Ch'ien Lung transition. Ht. 9·5 in.*
See page 66 (footnote 14)
Ex W. W. Winkworth.

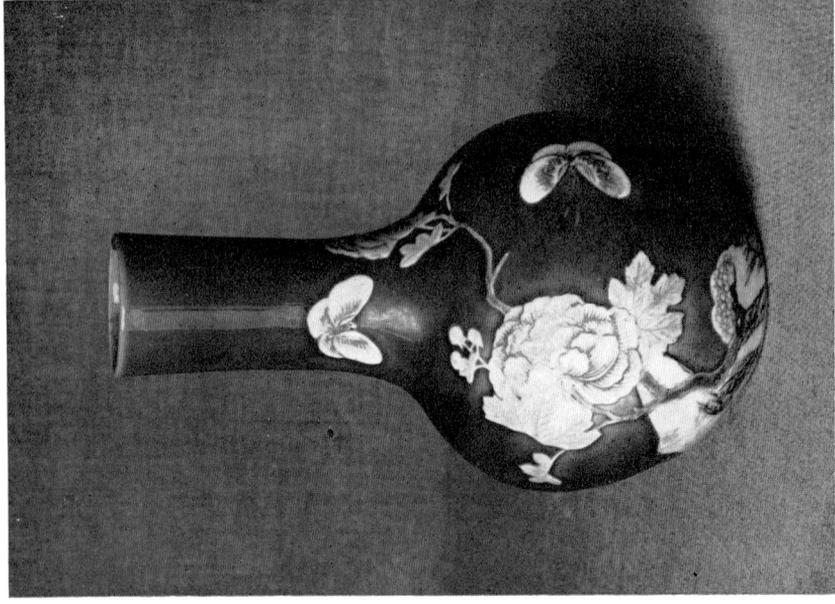

1. *Vase, with underglaze copper glaze, on a dull blue ground with foliage in pale green. No mark. Yung Chêng/Ch'ien Lung transition. Ht. 7 in. See page 66 (footnote 14)*
Ex W. W. Winkworth

PLATE XCVIII

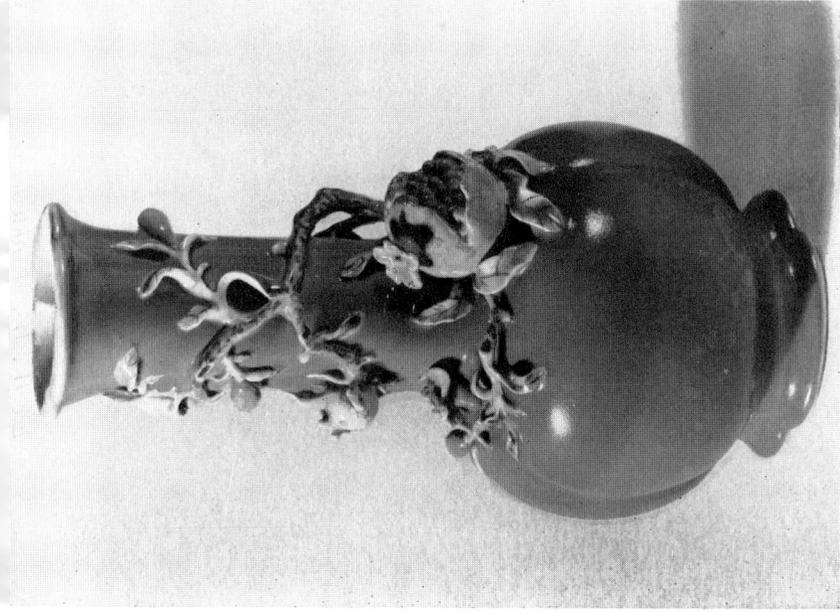

1. *Vase, with moulded decoration in relief on a 'famille rose' ground. Interior 'European Green'. Mark and period of Ch'ien Lung. Ht. 8.2 in. See pages 69, 75*
British Museum

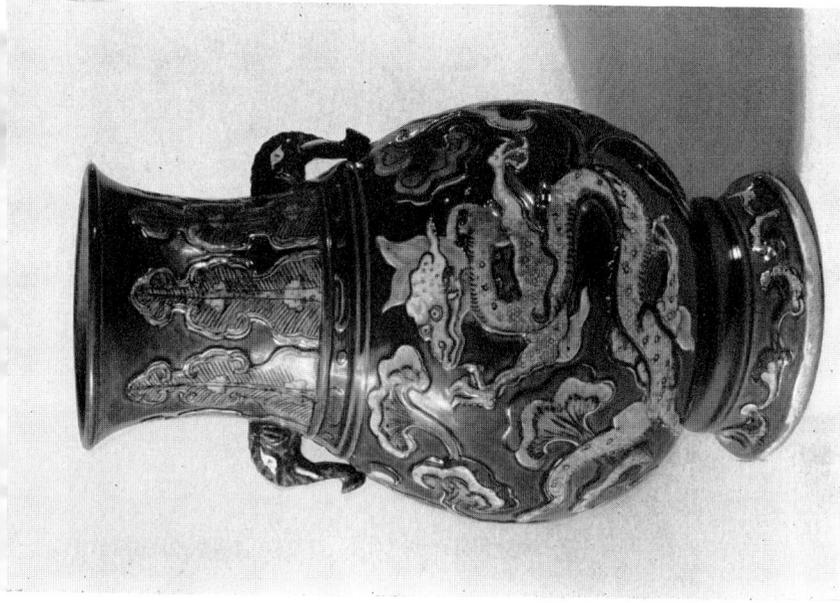

2. *Vase, decorated in underglaze blue and red on a tea-dust ground. No mark. Ch'ien Lung period. Ht. 16.4 in. See page 68*
British Museum

PLATE XCIX

1. Pilgrim bottle, in flambé glazes, red, blue and brown. No mark. 18th century. Ht. 4·5 in. British Museum. See page 67

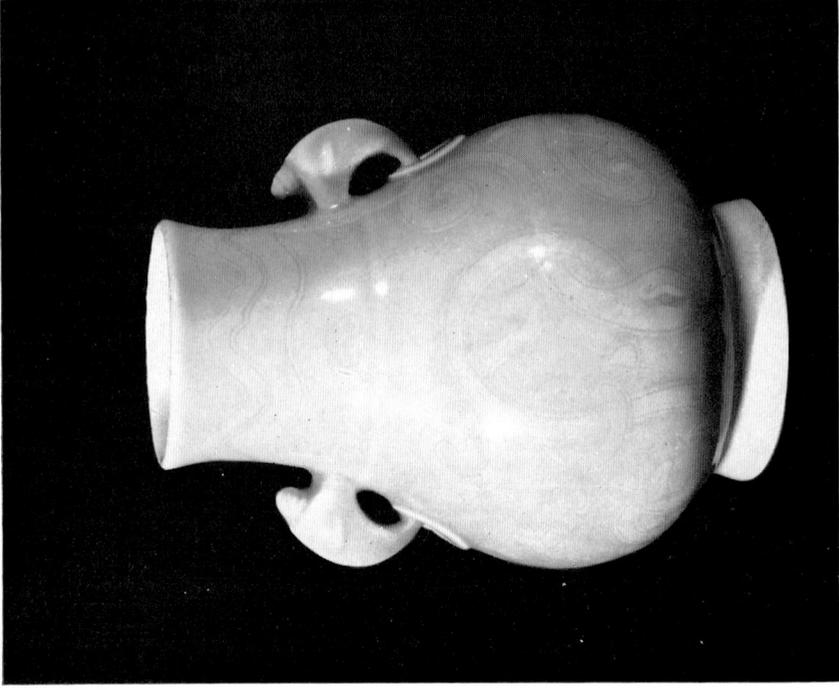

2. Bottle, with light blue celadon glaze. Yung Chêng seal mark and period. Ht. 7·4 in. See page 68
Sir H. Garner

PLATE C

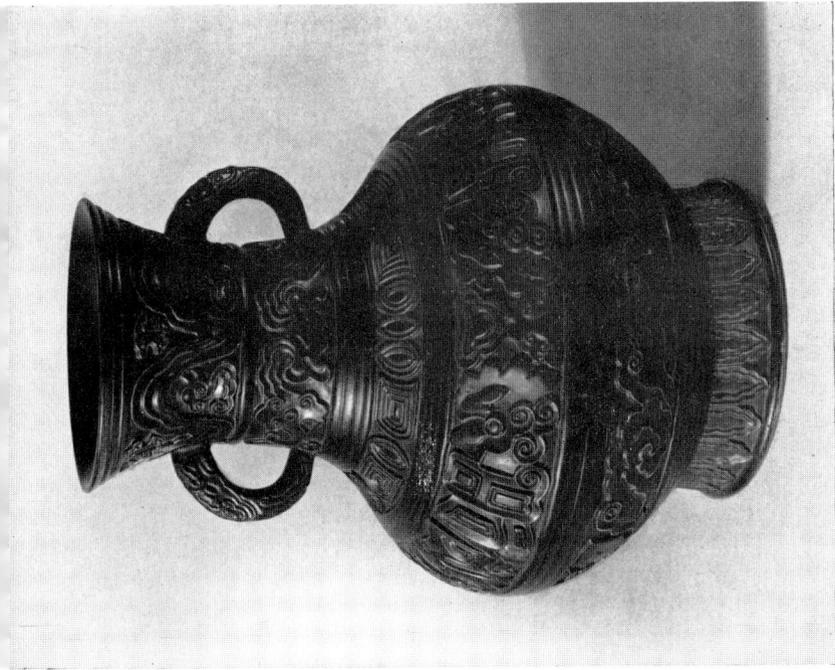

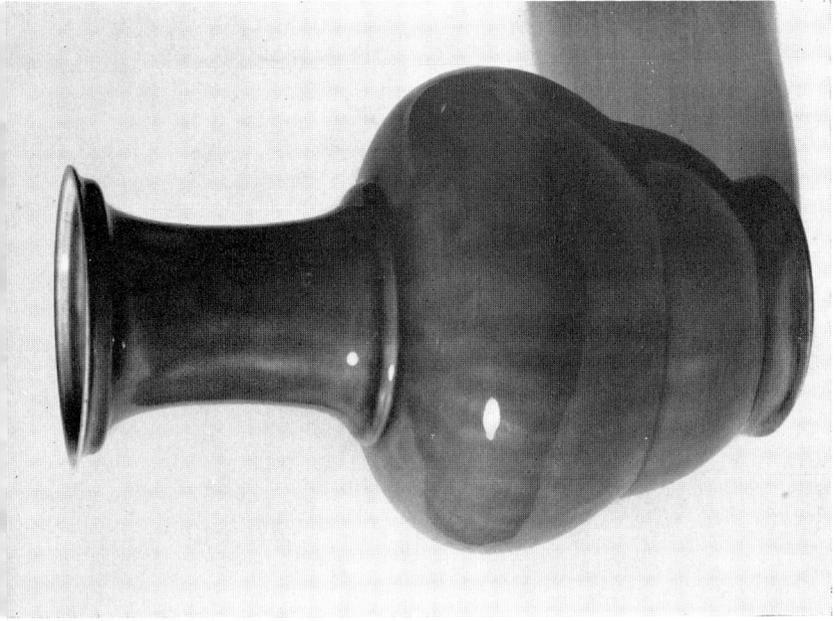

2. *Vase, decorated with a kingfisher or peacock green glaze. No mark. Early 19th century. Ht. 12·8 in. See page 29*
British Museum

1. *Vase, with a black glaze in imitation of bronze. Mark, Ch'ien Yin Shu Yu Chen tang (a gem to be treasured in the Ch'ien Yin study). Ch'ien Lung period. Ht. 12·2 in. See page 65*
British Museum

PLATE CI

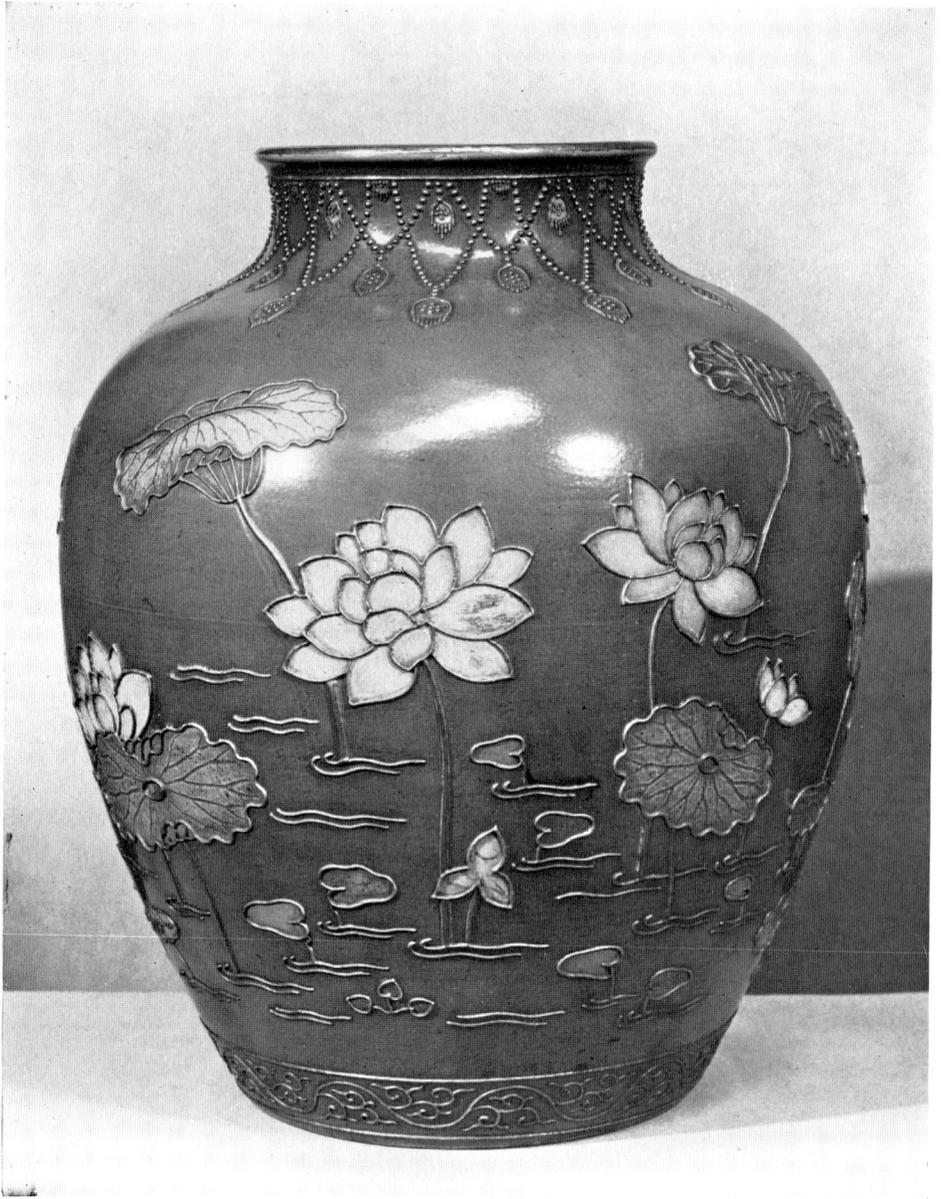

Vase, porcelain imitating cloisonné enamel, in coloured enamels on a blue ground. Mark and period of Ch'ien Lung. Ht. 15·3 in. Ex Bruce Collection. See pages 67, 91 (footnote 20)

PLATE CII

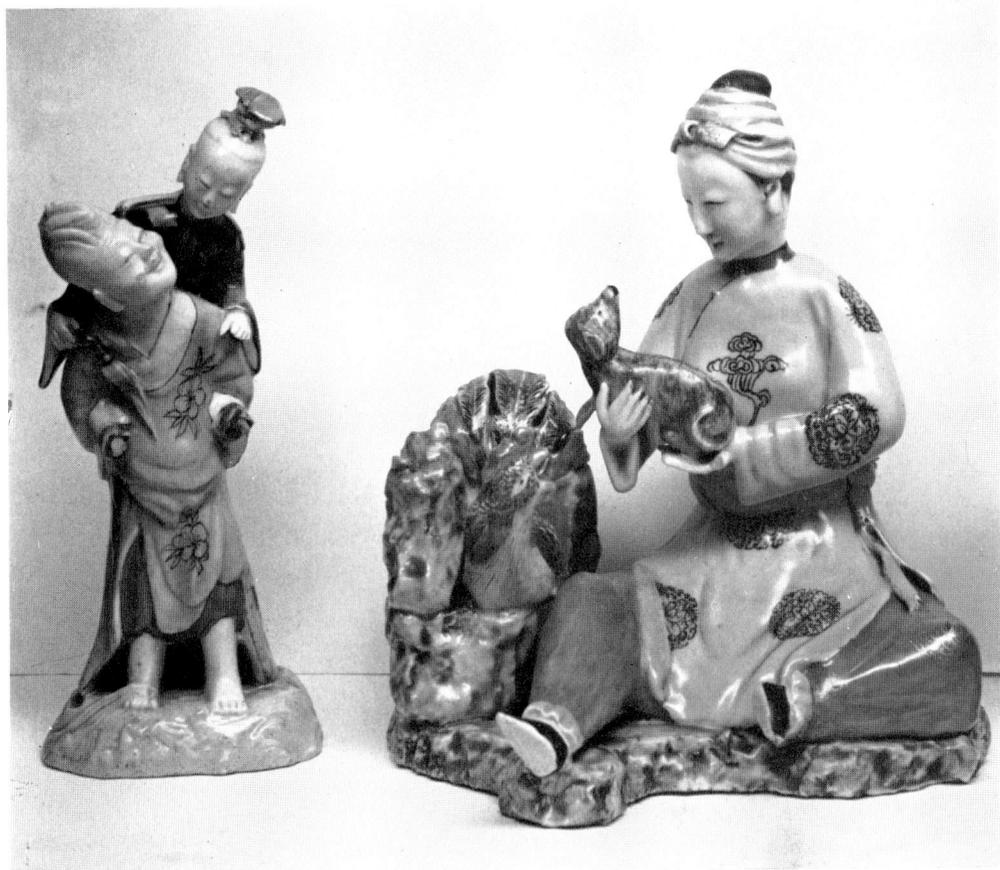

A. *Gentleman carrying a lady in 'famille rose' enamels. Ch'ien Lung*
period. Ht. 8 in. See page 68
G. L. Lazarus Collection
B. *Lady holding a dog, with cock at her side, in 'famille rose' enamels.*
Ch'ien Lung period. Ht. 8·7 in. See page 68
Ex Henry Brown Collection

PLATE CIII

1. *Bowl, incised with lace-work pattern. No mark. Ch'ien Lung period. Diam. 4·2 in. British Museum. See page 73*
2. *Bottle, covered with a tea-dust glaze. Mark and period of Yung Chêng. Ht. 7¾ in. Ex Cunliffe Collection. See pages 45, 68*

3A. *Bottle, covered with a coral red glaze. No mark, Ch'ien Lung or later. Ht. 4 in. British Museum. See page 68*

3B. *Bottle, covered with a robin's egg glaze. Mark and period of Ch'ien Lung. Ht. 4·9 in. British Museum. See pages 46, 68*

3C. *Vase, covered with a lavender blue glaze over a white slip design. Hall mark. 19th century or later. Ht. 3·3 in. British Museum. See p. 74.*

PLATE CIV

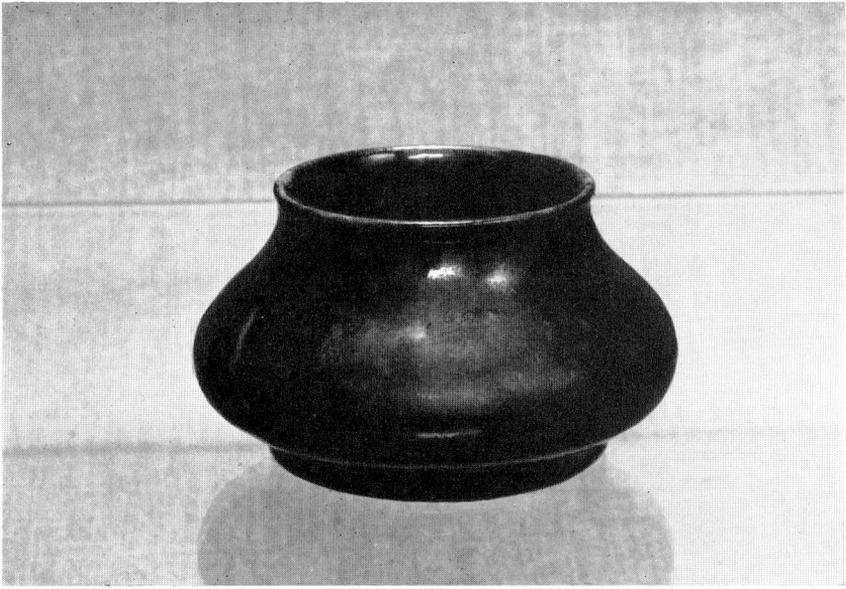

1. *Vase, covered with dark blue mottled glaze in imitation of Kwang-tung ware. Ch'ien Lung period. Ht. 2·5 in. British Museum. See page 57*

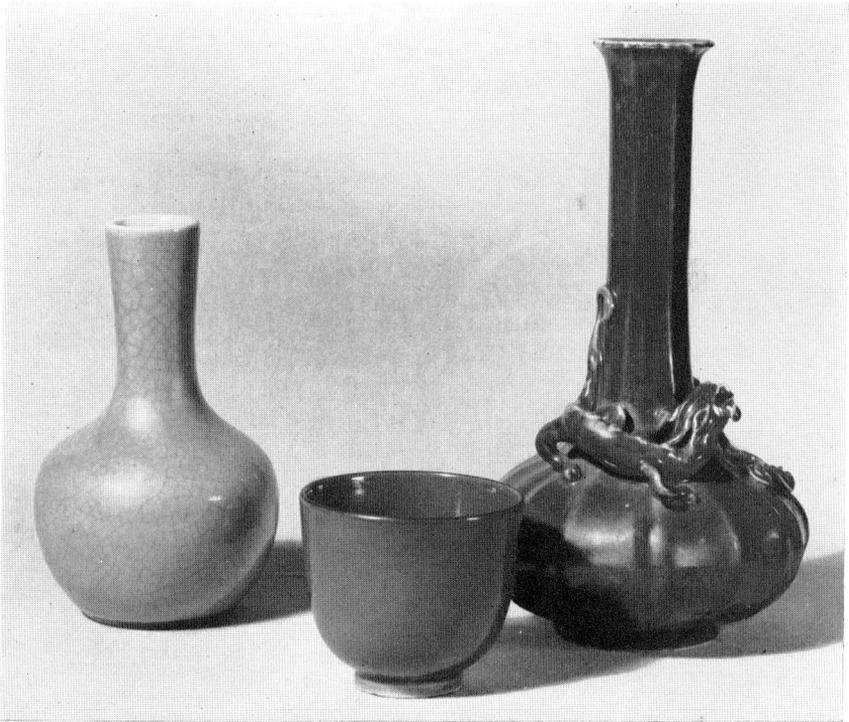

2A. *Vase, covered with 'apple' green glaze. No mark. Early 18th century. Ht. 4 in. British Museum. See page 29*

2B. *Cup, covered with camellia green glaze. No mark. 18th century. Ht. 2·4 in. British Museum. See page 29*

2C. *Vase, covered with 'snakeskin' green glaze. Ht. 7·8 in. 18th century British Museum. See page 29*

PLATE CV

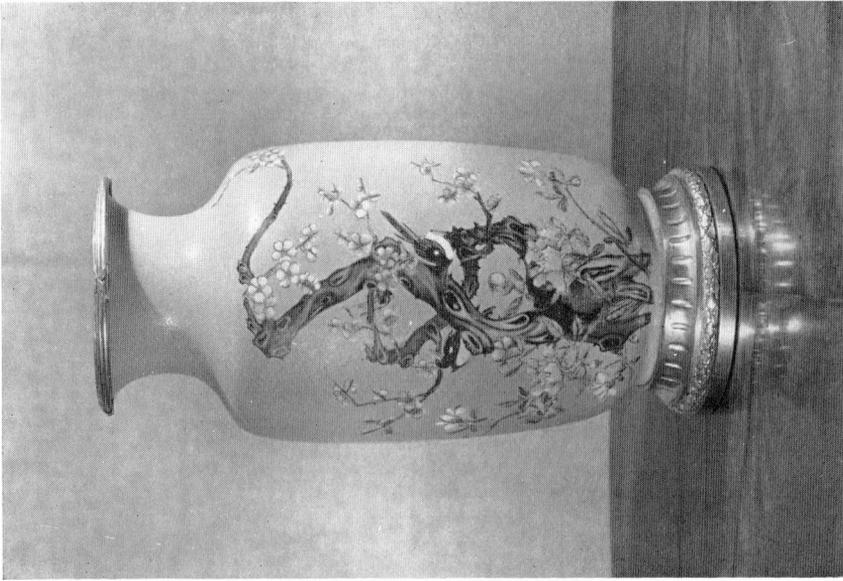

1. Vase, decorated in coloured enamels on a pink 'graviata' ground. Ormolu mounts. Ch'ien Lung period. Ht. 17 in. John Morrison. See page 69

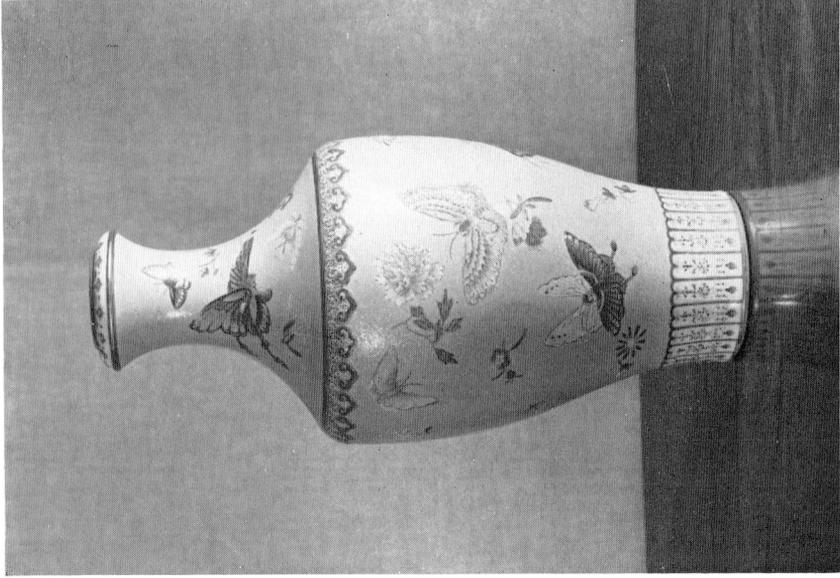

2. Vase, decorated in coloured enamels on a pink 'graviata' ground. Mark and period of Ch'ien Lung. Ht. 17·5 in. John Morrison. See page 69

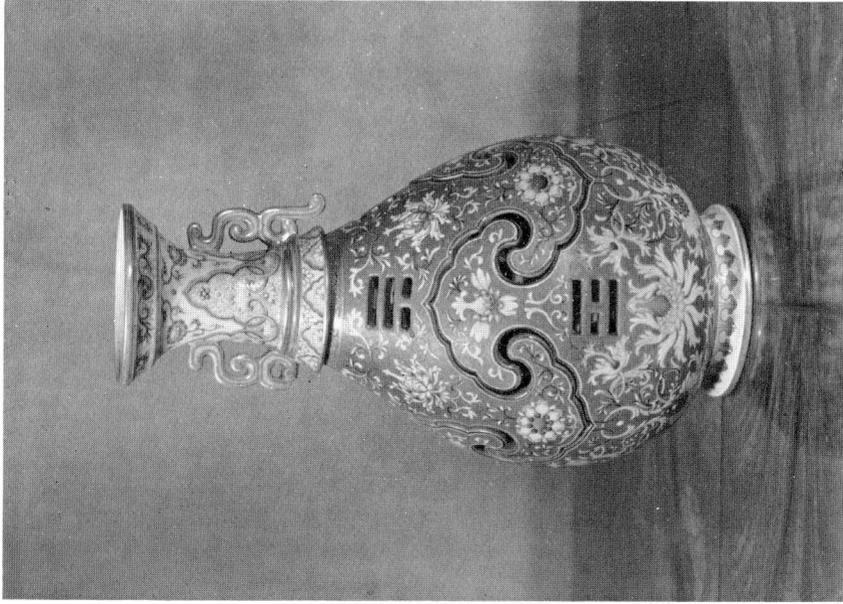

1. Revolving vase decorated in coloured enamels on a pink 'gravaata' ground. Mark and period of Ch'ien Lung. Ht. 11·5 in. John Morrison. See page 69

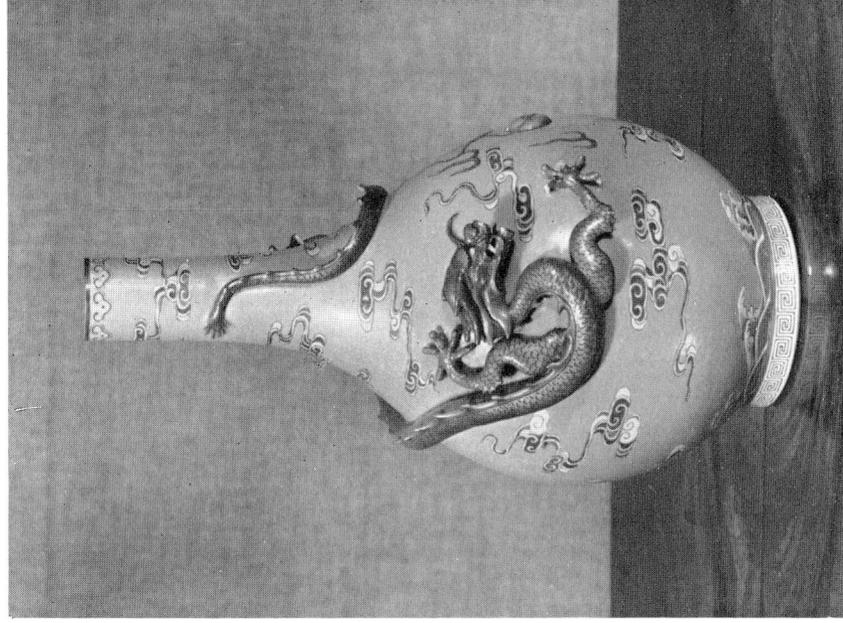

2. Vase, decorated with a coral red dragon modelled in relief on a turquoise blue ground. Mark and period of Ch'ien Lung. Ht. 15 in. John Morrison. See page 69

PLATE CVII

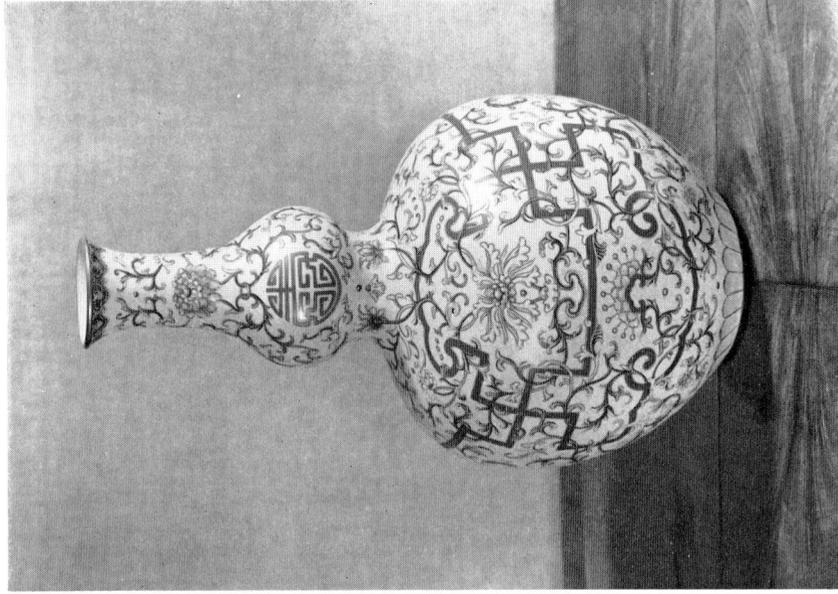

1. *Vase, decorated in coloured enamels on a yellow 'graviata' ground. Mark and period of Ch'ien Lung. Ht. 15·5 in.*
John Morrison. See page 69

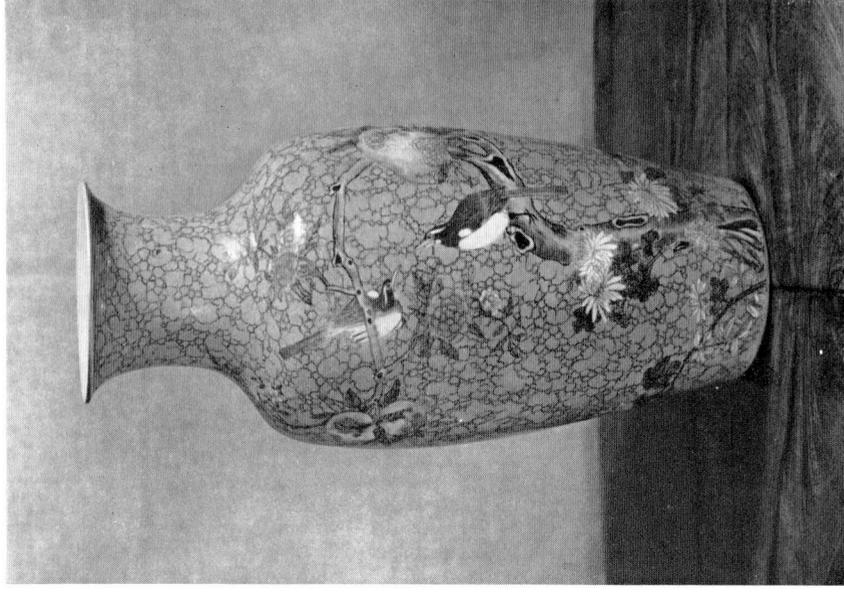

2. *Vase, decorated in coloured enamel on a turquoise blue ground, pencilled with clouds. No mark. Ch'ien Lung period. Ht. 19·5 in.*
John Morrison. See page 69

PLATE CVIII

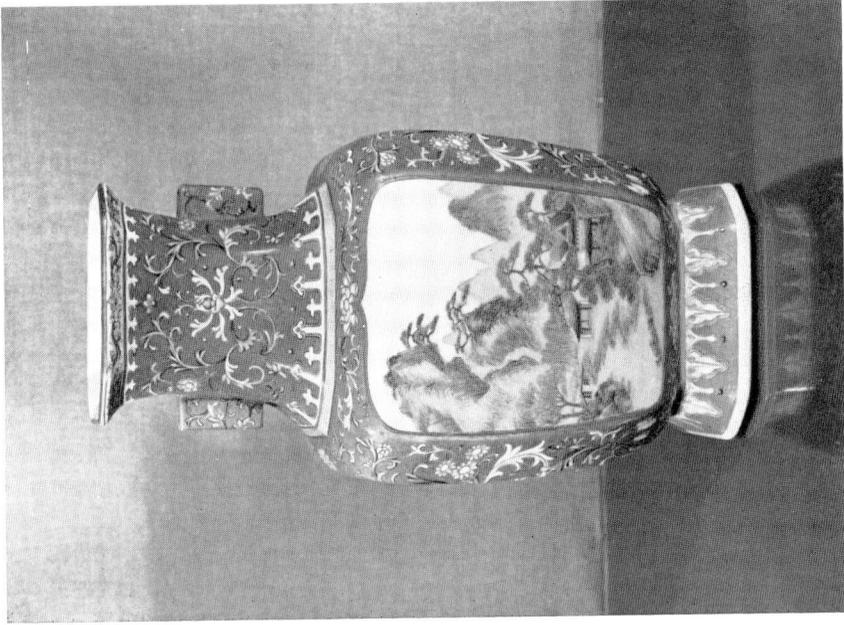

1. *Vase, decorated in enamel colours. Neck and side of foot covered with a dull blue glaze pencilled in gold. Mark and period of Ch'ien Lung. Ht. 27 in. See page 75*

Ex Bruce Collection

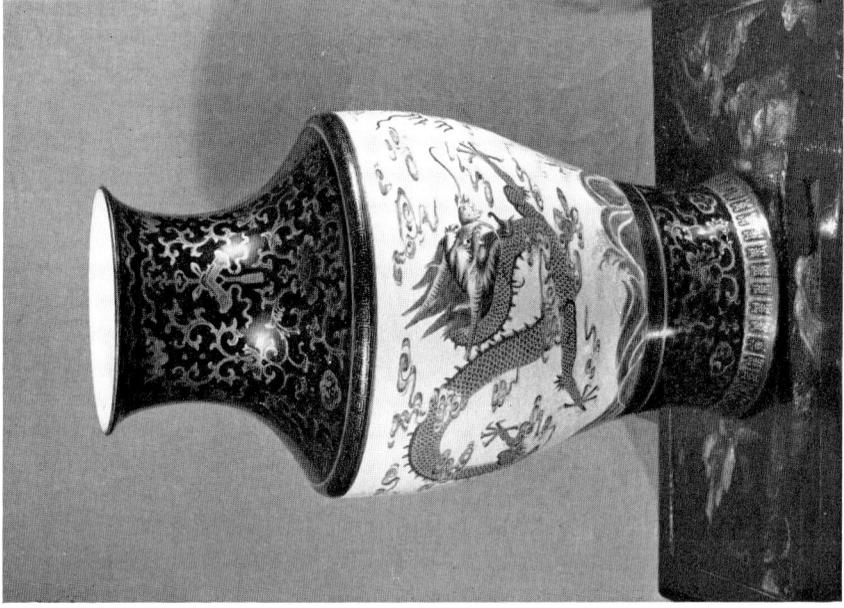

2. *Vase, decorated with enamel colours, with panel on a pink 'graviata' ground. Mark and period of Ch'ien Lung. Ht. 12·8 in. See page 69*

Ex Bruce Collection

PLATE CIX

1. *Cup, soft paste, decorated on underglaze blue. Ch'êng Hua mark,*
Ch'ien Lung or later. Diam. 2·7 in. See page 31
British Museum
2. *Box and cover, in imitation of gold. Mark and period of Ch'ien*
Lung. Diam. 3½ in. See page 67
P. J. Donnelly

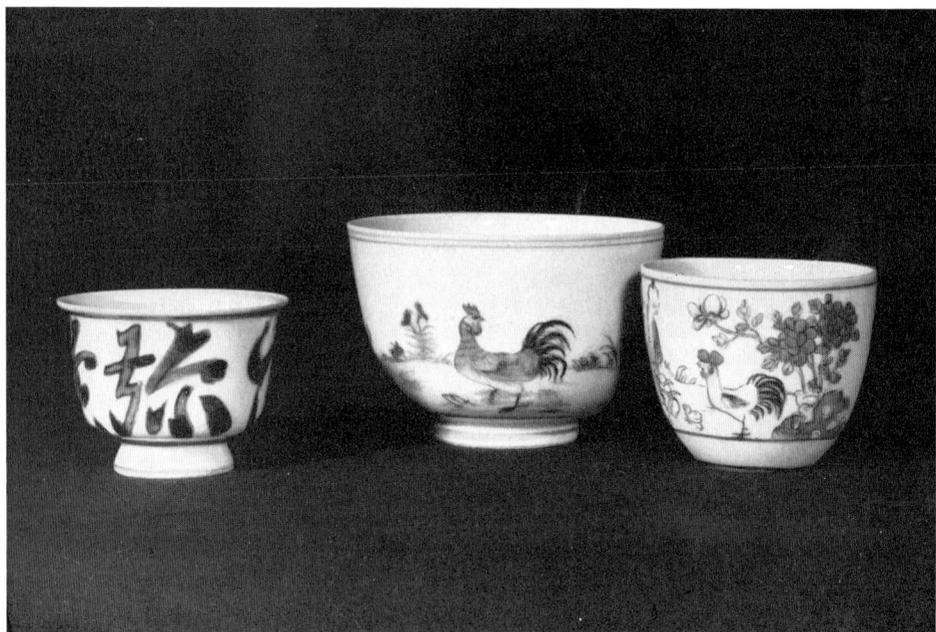

3A. *Cup, decorated in underglaze blue. Mark and period of Tao*
Kuang. Diam. 2·4 in. See page 74
P. J. Donnelly
3B. *'Chicken cup', decorated in coloured enamels. Ch'êng Hua mark,*
Yung Chêng period. Ht. 1·5 in.
N. C. Harrison. See page 39
3C. *'Chicken cup', decorated in coloured enamels. Shop mark. Tao*
Kuang or later. Ht. 1 in.
Ex Messrs. Sydney Moss. See page 39

PLATE CX

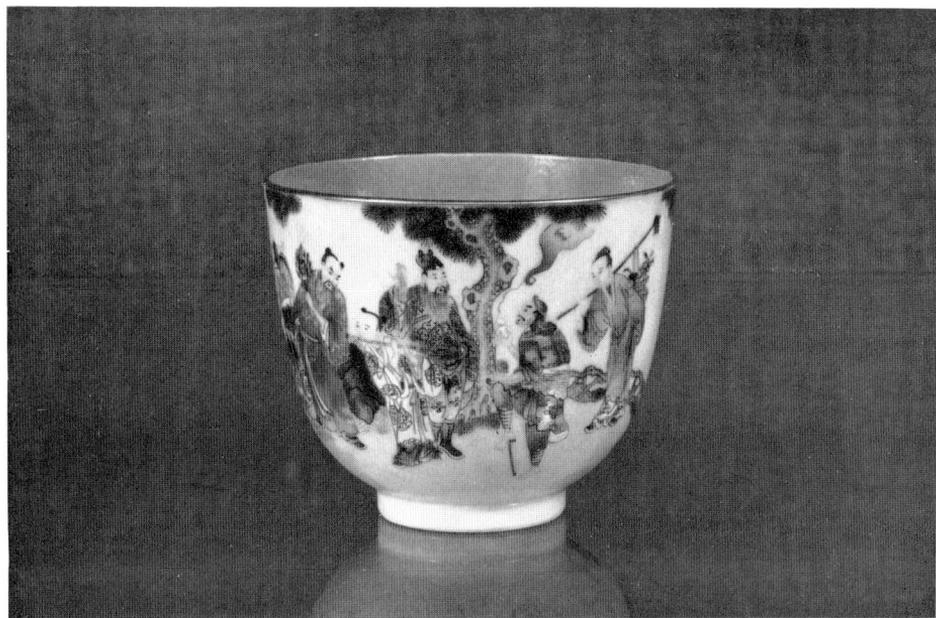

1. *Cup, decorated in enamel colours. Inside in 'European Green'.*
Mark and period of Chia Ch'ing (1796–1820). Ht. 2·5 in.
British Museum. See page 67

2. *Saucer dish, dated to a cyclical year of the reign of Chia Ch'ing*
(1797). Length 6·1 in.
Sir H. Garner. See page 74

PLATE CXI

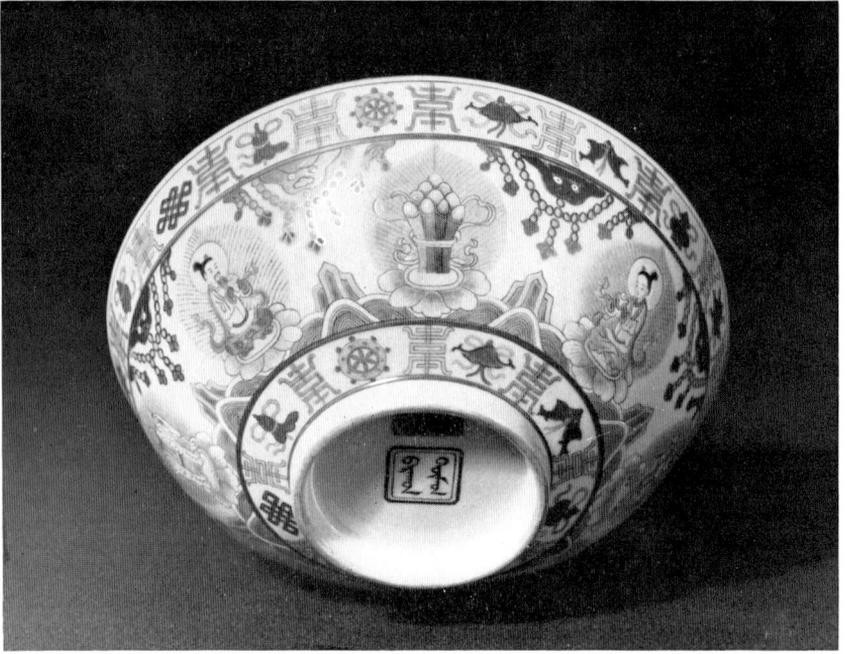

1. *Bowl, decorated in enamel colours. Mark in Mongolian script;*
'Baragon Tumed' (part of a service made for a daughter of Tao Kuang
who married a Mongolian Prince of the Tumed banner). Diam. 7 in.
See pages 74, 100
British Museum

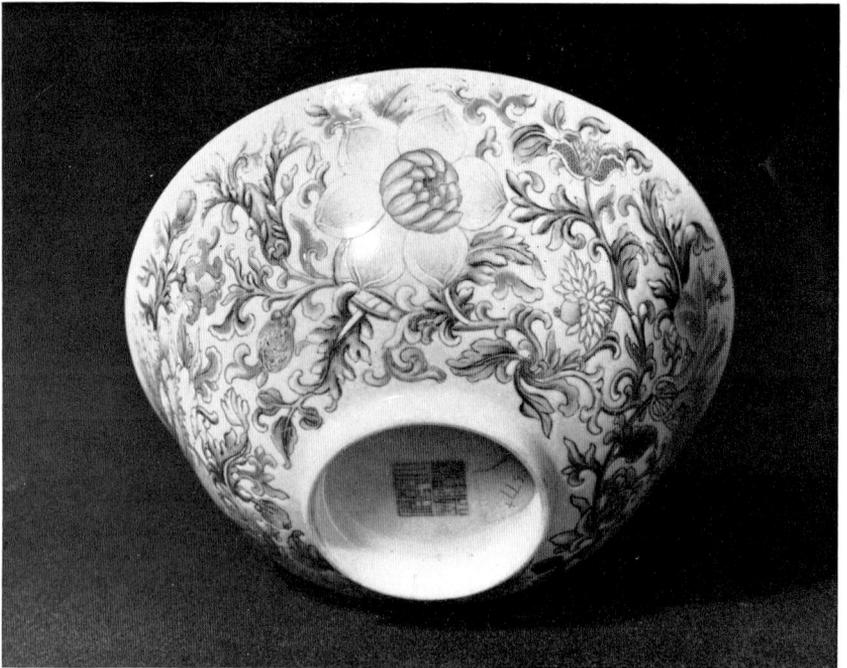

2. *Bowl, decorated in enamel colours on a yellow ground. Mark and*
period of Ch'ien Lung. Diam. 6 in.
British Museum. See page 69

PLATE CXII

1A. *Medallion bowl, decorated in enamel colours on yellow ground.*
Mark and period of Chia Ch'ing. Diam. 7 in.
British Museum. See pages 74, 75

1B. *Medallion bowl, decorated in enamel colours on a blue 'graviata'*
ground. Mark and period of Tao Kuang. Diam. 5·2 in.
British Museum. See pages 74, 75

2A. *Bowl, decorated in coloured enamels and underglaze blue. Mark*
and period of Chia Ch'ing. Diam. 6·5 in.
British Museum
(This design, evidently a palace favourite, is found from Chien Lung
through Tao Kuang and beyond.) See pages 68, 75

2B. *Medallion bowl, decorated in coloured enamels on a yellow*
'graviata' ground. Mark and period of Tao Kuang. Diam. 5 in.
British Museum. See pages 74, 75

PLATE CXIII

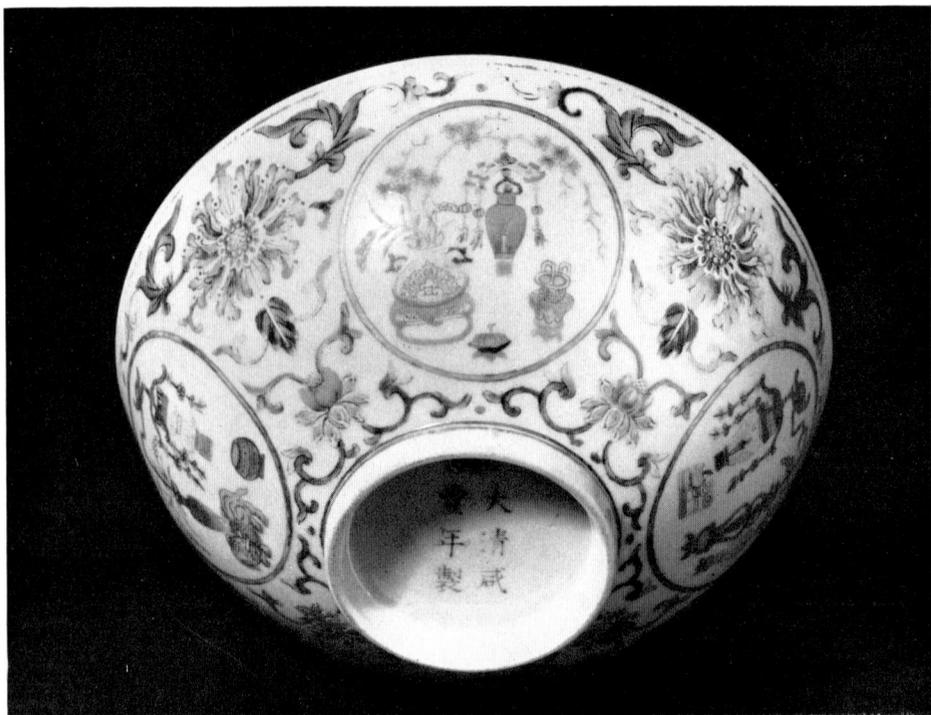

1. *Bowl, decorated in enamel colours. Mark and period of Hsien Fêng (1851–61). Diam. 7 in. See pages 74, 75*
British Museum

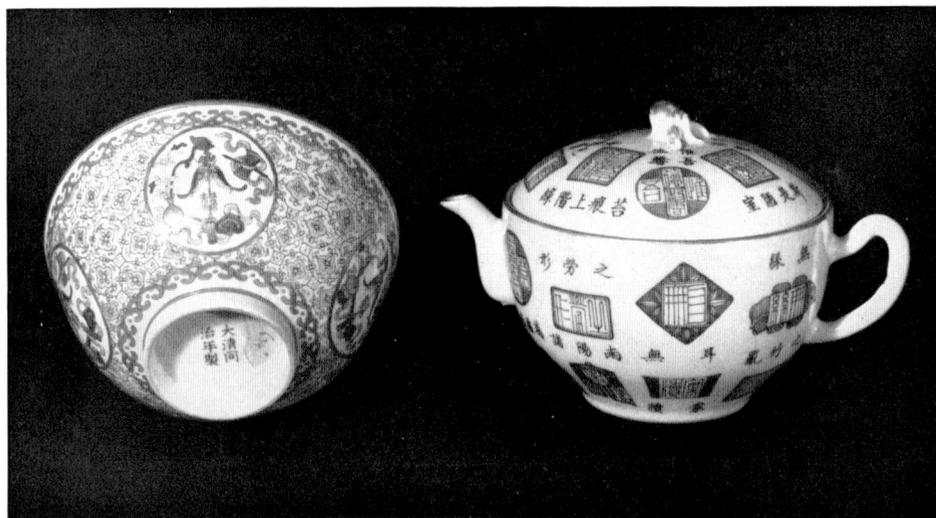

2A. *Bowl, decorated in enamel colours. Mark and period of T'ung Chih (1862–74). Diam. 4·7 in.*
British Museum. See pages 74, 75
2B. *Teapot, decorated in red and black enamels. Mark and period of Kuang Hsü (1875–1908). Ht. 4 in.*
British Museum. See page 76

PLATE CXIV

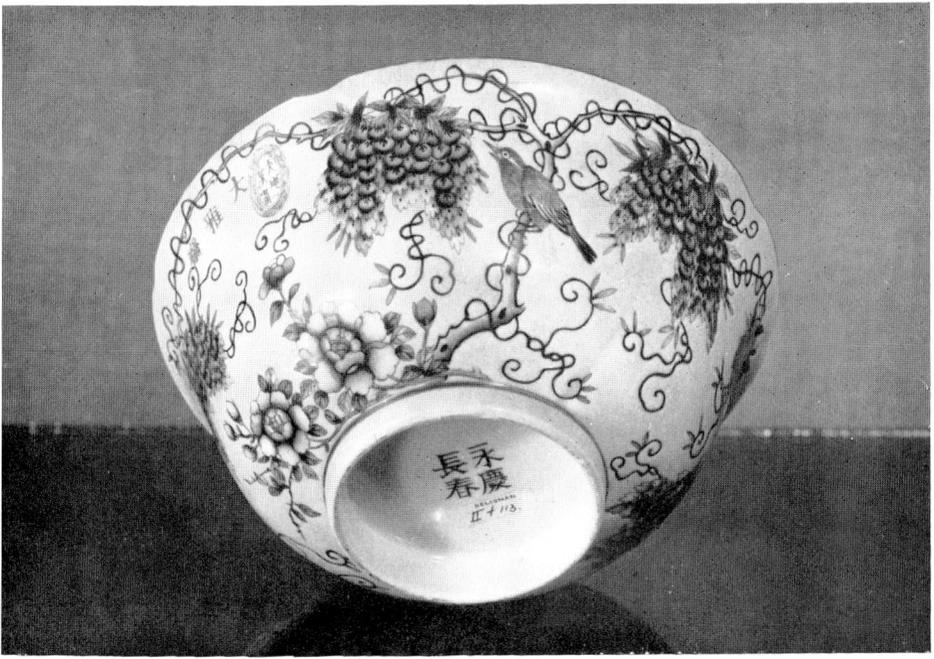

1. *Bowl, decorated in grey and black enamels on a yellow ground. Mark on side: Ta ya chai (Studio of Great Culture). Seal on side: T'ien ti yi chia ch'un (Springtime in Heaven and Earth one family). Mark on base: Yung ch'ing ch'ang ch'un (Eternal prosperity and enduring spring). Made for the Empress Dowager Tz'u Hsi. Diam. 7 in. Mount Trust. See pages 76, 99*

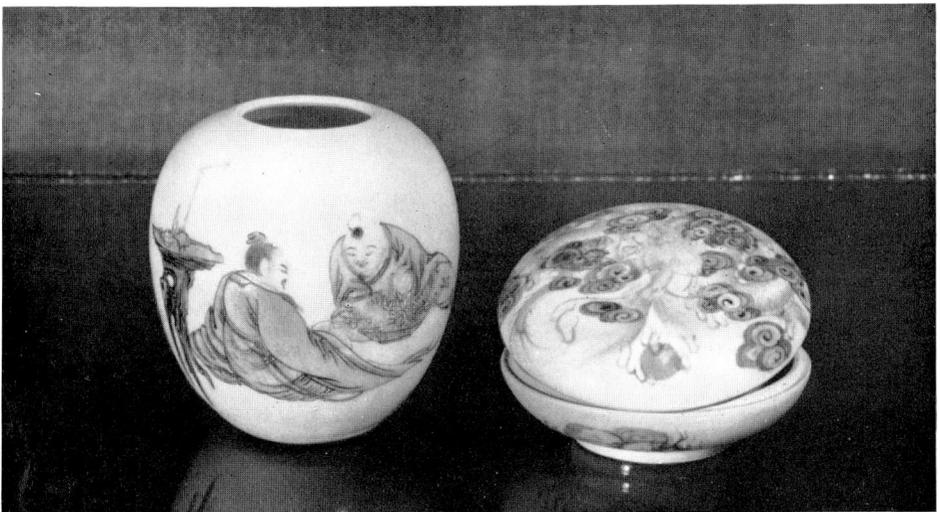

2A. *Brushwasher, decorated in enamel colours. Seal mark: 'Chu fên t'ang chih' (made for the hall where benevolence abounds). Yüan Shih K'ai (1912–16). Ht. 3 in. Mount Trust. See page 76*

2B. *Box and cover, with underglaze blue and copper decoration. Mark 'Chung yang ching chih' (Excellently made by the Central Government). Made in Nanking in 1927. Diam. 3 in. Mount Trust. See pages 76, 77*

PLATE CXV

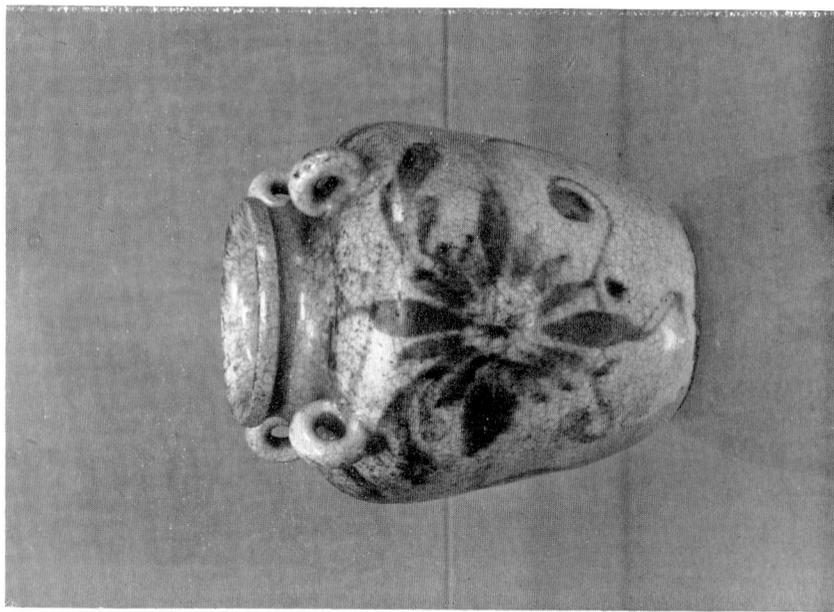

1. Vase, decorated in underglaze blue. Probably provincial ware from Lung-Ch'üan. Inscribed with cyclical year 1659. Ch'ung Chêng period (1628–45). Ht. 9·5 in.

Soame Jenyns. See page 18

2. Vase, decorated in underglaze blue. Provincial ware, probably from Fukien. No mark. 17th/18th century. Ht. 4·7 in.

British Museum. See page 82

PLATE CXVI

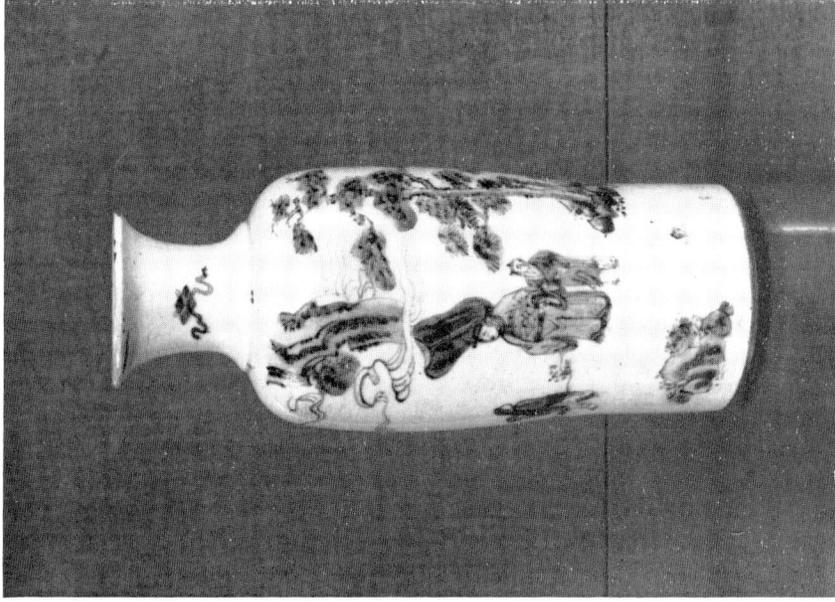

1. Vase, decorated in under-glaze blue. Têhua ware. No mark. 17th/18th century. Ht. 9·5 in. Soame Jenyns. See page 85

2. Vase, decorated in under-glaze blue. No mark. Accretions of sand to footrim. Fukien, 17th/18th century. Ht. 10·8 in. Soame Jenyns. See page 85

PLATE CXVII

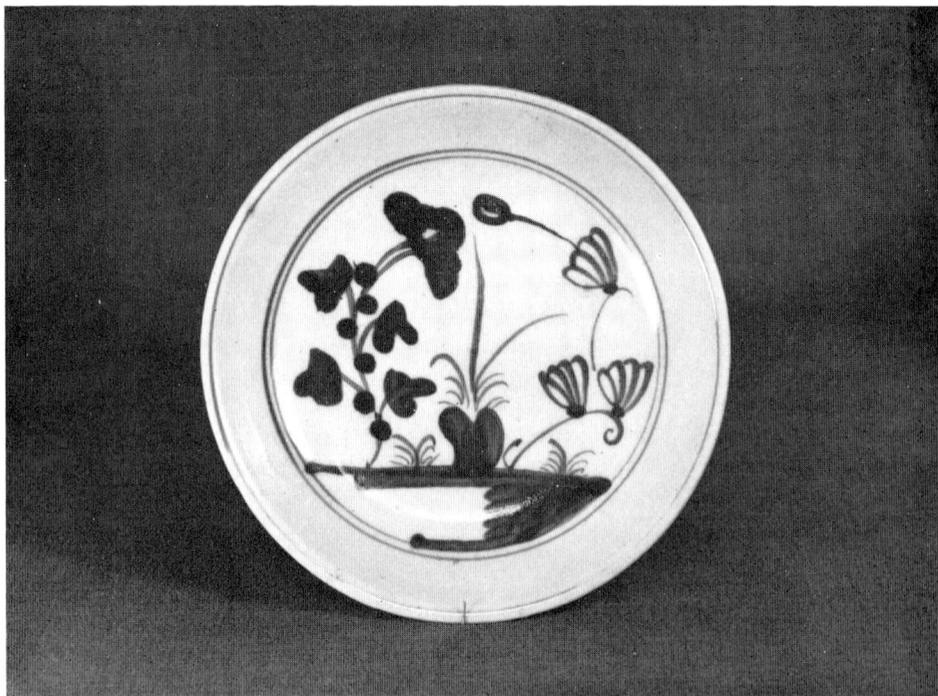

1. *Saucer dish, decorated in underglaze blue. Provincial 18th/19th century. Illegible letter mark. Diam. 7·3 in. British Museum. See page 80 (footnote 11)*

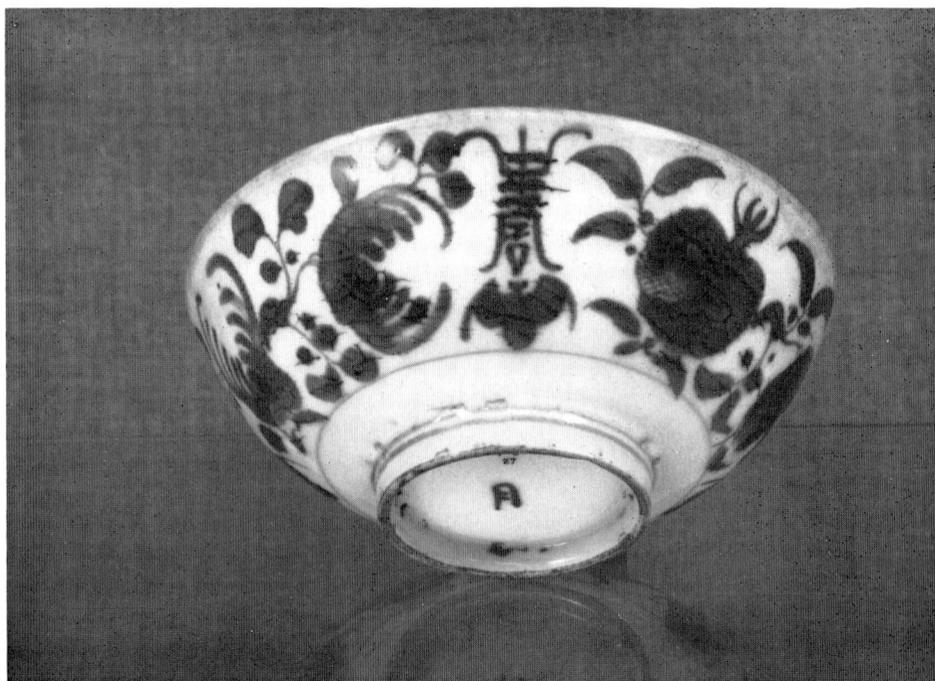

2. *Bowl, decorated in underglaze blue. Moon mark. Provincial 18th/19th century. Diam. 7 in. British Museum. See page 80 (footnote 11)*

PLATE CXVIII

1A. *Mug, made to European form. Têhua ware. 18th century.*
Ht. 3·6 in. British Museum. See page 84
1B. *Cup, decorated in red and green enamel. Made and decorated at*
Têhua. 18th century. Ht. 3 in. British Museum. See page 83
1C. *Mug, made in European form. Têhua ware. 18th century.*
Ht. 3·5 in. British Museum. See page 84

2. *Tea-pot, Têhua ware. 17th/18th century. Ht. 8·1 in.*
British Museum. See page 84

PLATE CXIX

2. *Figure of Kuan Yin, Têhua porcelain. 17th/18th century. Dimensions and owner unknown*
See pages 9 (footnote 18), 85

1. *Vase, Têhua porcelain. No mark. 17th/18th century. Ht. 8·5 in.*
British Museum. See page 84

PLATE CXX